Renaissance to Revolution

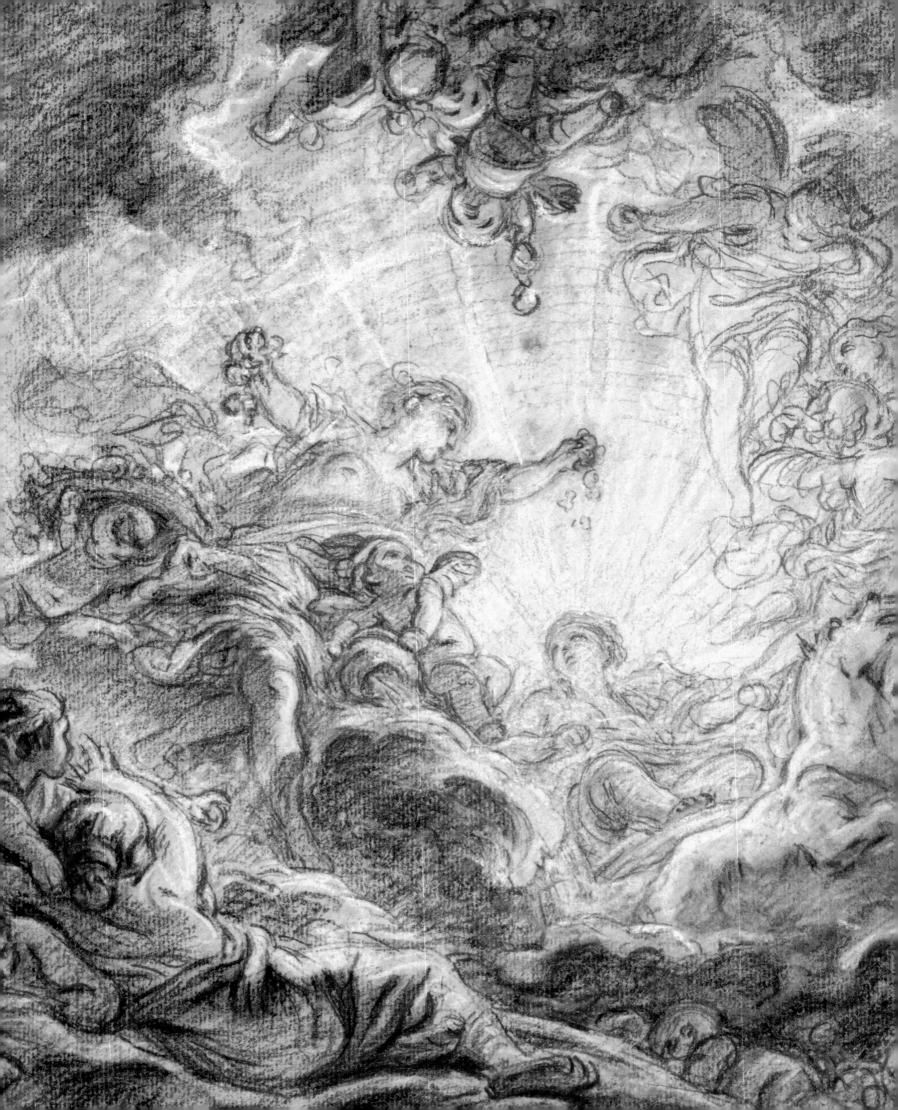

Renaissance to Revolution

*French Drawings from the
National Gallery of Art, 1500–1800*

Margaret Morgan Grasselli

National Gallery of Art, Washington
in association with Lund Humphries

The exhibition is organized by the
National Gallery of Art, Washington.

Exhibition Dates
National Gallery of Art, Washington
October 1, 2009–January 31, 2010

Produced by the Publishing Office
National Gallery of Art, Washington
www.nga.gov

Judy Metro, *Editor in Chief*
Chris Vogel, *Deputy Publisher and Production Manager*
Karen Sagstetter, *Senior Editor*

Edited by Michelle Piranio
Designed by Studio A, Alexandria, Virginia
Typeset in Lexicon No. 2
Printed on GardMatt by Editoriale Bortolazzi Stei s.r.l.,
Verona, Italy

Library of Congress Cataloging-in-Publication Data

National Gallery of Art (U.S.)
Renaissance to revolution : French drawings from the National
Gallery of Art, 1500–1800 / Margaret Morgan Grasselli.
 p. cm.
Includes bibliographical references and index.

ISBN 978-1-84822-043-0

1. Drawing, French—Catalogs. 2. Drawing—Washington (D.C.)—
Catalogs. 3. National Gallery of Art (U.S.)—Catalogs.
I. Grasselli, Margaret Morgan, 1951- II. Title.

NC246.N36 2009
741.944074'753—dc22
2009020374

British Library Cataloguing-in-Publication Data:
A catalogue record for this book is available from the British
Library

Distributed by Lund Humphries, Wey Court East, Union Road,
Farnham, Surrey, GU9 7PT

www.lundhumphries.com
Lund Humphries is a part of Ashgate Publishing.

10 9 8 7 6 5 4 3 2 1

The paper used in this publication meets the minimum
requirements of the American National Standard for Infor-
mation Sciences—Permanence of Paper for Printed Library
Materials, ANSIZ39.48-1992.

Frontispiece: François Boucher, *Aurora Heralding the Arrival of the Morning Sun* (detail), c. 1765 (cat. 56)

Page vi: Hubert Robert, *The Oval Fountain in the Gardens of the Villa d'Este, Tivoli* (detail), 1760 (cat. 84)

Page x: Étienne Delaune, *The Backplate of a Suit of Parade Armor* (detail), c. 1557 (cat. 7)

Page 17: Étienne-Louis Boullée, *Perspective View of the Interior of a Metropolitan Church* (detail), 1780/1781 (cat. 107)

Page 272: Antoine Coypel, *Seated Faun* (detail), 1700/1705 (cat. 35)

Contents

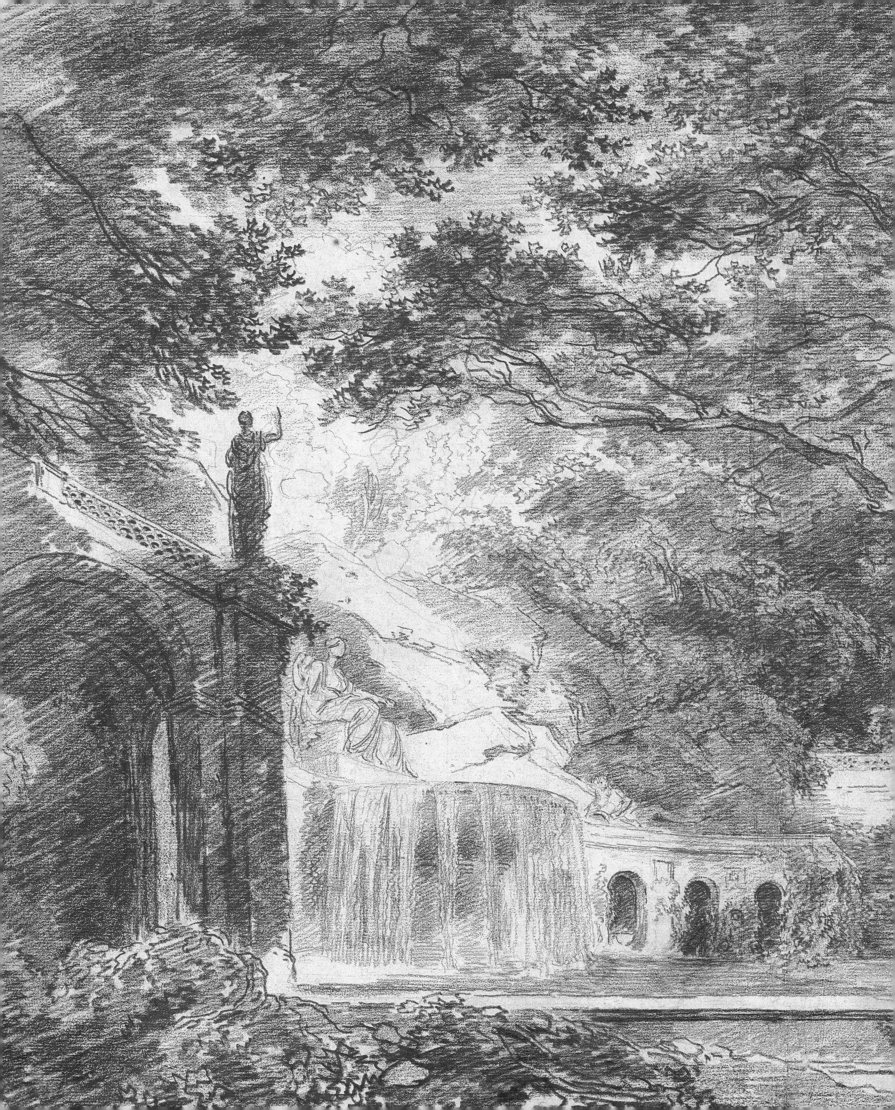

Director's Foreword

Among the National Gallery's extensive holdings of works on paper, the collection of more than nine hundred French old master drawings made between 1500 and 1800 stands out as a particular treasure. These works encompass the glorious beginnings of the French drawing tradition in the sixteenth century with book illumination and the mannerist marvels of the court of Fontainebleau; the proud restraint and stately splendor of the grand manner promoted at Versailles in the seventeenth century; and the exuberant twists of the rococo and the sober nobility of neoclassicism in the eighteenth century. Remarkable for its breadth, depth, and individual masterpieces, this array of works captures in a unique and revealing way the originality, elegance, grace, and spirit that give French drawings their special character and appeal.

Of the National Gallery's entire holdings of drawings, the French School has the deepest roots in the earliest days of the museum's existence, with the first of these works arriving in 1942, just a year after the Gallery opened its doors to the public. Over the next sixty-seven years, thanks to the generosity of innumerable donors, the collection has evolved into one of the Gallery's strongest and most comprehensive. No collection is ever truly "complete," but as one of the premier ensembles of French draftsmanship in the Western Hemisphere, this one now deserves the wider recognition that a full-dress exhibition and catalogue should provide.

We are grateful to Margaret Morgan Grasselli, a respected authority on French drawings and the Gallery's curator of old master drawings, for selecting the works, overseeing preparations for the exhibition, and writing the catalogue. As our resident expert since the early 1980s, she has played an invaluable role in building up the collection and clarifying problematic attributions. She knows these drawings more intimately than anyone else does, and we are pleased that this project has allowed her to share her deep knowledge and boundless love for them.

For those who have never experienced the magic of a chalk study by Antoine Watteau, the voluptuous charms of a nude by François Boucher, the quirky delights of an invention by Étienne Delaune, the sinuosity of a figure by Jacques de Bellange, the vibrancy of a pastel portrait by Maurice-Quentin de La Tour, the sun-drenched heat of a Roman garden by Jean-Honoré Fragonard, or the noble restraint of a composition by Laurent de La Hyre, the works presented here will provide what I hope will be an irresistible visual feast. Even those who are already familiar with French drawings in general and the Gallery's holdings in particular will discover some new treats. Although a number of the drawings have been exhibited and published before, there are many unsung delights—and several new acquisitions and promised gifts—that are served up here for the first time. We hope you will savor them as much as we do.

Earl A. Powell III
Director

Stories of a Collection
Margaret Morgan Grasselli

Like every museum collection, the National Gallery's holdings of French drawings have a character and personality all their own.[1] The works, individually and in groups, have come through gifts and purchases from a wide variety of sources, and now form a unique and ever-evolving representation of French draftsmanship that encompasses great strengths and masterpieces as well as surprising weaknesses. The holdings of eighteenth-century drawings, for example, are particularly deep, with impressive groups by such honored draftsmen as Antoine Watteau, Jean-Honoré Fragonard, François Boucher, Gabriel de Saint-Aubin, and Jean-Baptiste Greuze. An unusual source of pride is the rich concentration of more than 350 designs for book illustrations from the Joseph E. Widener collection, given to the Gallery in 1942, which has been augmented over the years by acquisitions of other book-related drawings by Jean-Baptiste Oudry, Saint-Aubin, Fragonard, and Boucher, among many others. An additional point of distinction is the choice selection of pastels, a smaller and more focused group but significant for the outstanding quality of each example. The collection of sixteenth-century drawings, likewise, may be small, but the individual works are so rare and of such fine quality that the Gallery's group of French Renaissance drawings as a whole now ranks as one of the most noteworthy in the United States. The seventeenth-century holdings, by contrast, though more numerous, are not as rich as one would like, though distinguished works by leading masters such as Claude Lorrain, Jacques de Bellange, Laurent de La Hyre, Simon Vouet, and Robert Nanteuil add important highlights.

The Gallery's collection is less than seventy years old, relatively young compared to other major collections of drawings in the United States and extremely so compared to the Musée du Louvre in Paris, the British Museum in London, and other venerable European institutions that have very long and distinguished histories and much larger holdings. That the Gallery's collection has reached world-class stature in just a matter of decades is a tribute to both the generosity and taste of our donors and the hard work and acuity of the curators who, separately and together, have been responsible for forming it.

The history of the collection consists of essentially three major elements that are distinct in many respects, but also complementary and closely connected: the donations of art that first formed the nucleus of the Gallery's French holdings and continue to be critically important for their growth and expansion; curatorial purchases of works that are intended to enhance, broaden, and enrich the historical portrayal; and the ongoing study of the Gallery's drawings, in concert with advances in connoisseurship, which has led to changes of attribution, some of which are quite significant. What follows here is a brief account of the formation of the collection, not quite a "history" in the sense of a year-by-year summation of gifts and purchases such as one might find in the Gallery's annual reports, but rather a more selective, anecdotal, and at times more personal recounting of some of the principal events, turning points, surprises, disappointments, and coups.

Origins of the Collection: The First Twenty-five Years

The Gallery's debt to its donors is enormous, not only for the collections and individual works they have given, and continue to give, but also for their financial contributions, as every one of the Gallery's art purchases has been funded by private donations. (No federal money has ever been used for that purpose.) For the first twenty-five years of the Gallery's existence, however, the drawing collection was formed entirely through gifts of art and was thus shaped wholly and rather haphazardly by the personal taste and collecting preferences of individual benefactors. The one exception was the highly focused collection of more than 350 drawings related to French eighteenth-century book illustration that came as part of the Widener gift in 1942, just a year after the newly established National Gallery opened its doors to the public.

French drawings formed only a small portion of the immensely rich and varied Widener collection, which included what are now some of the Gallery's most cherished paintings by Raphael, Rembrandt, Titian, and Vermeer as well as sculptures, medals and plaquettes, maiolica, Chinese porcelains, medieval and Renaissance furniture, tapestries, and decorative arts. These parts of the collection had been assembled by Peter A. B. Widener, who died in 1915. The personal collecting interests of his son, Joseph, however, were directed toward French eighteenth-century decorative arts and furniture, prints, illustrated books in fine contemporary bindings, separate and special impressions of the plates from those books, and a host of drawings made in preparation for them. He owned in addition twenty sketches by Rembrandt and his school and an exquisite study of a Netherlandish woman by Albrecht Dürer. The large majority of the French drawings, which were all bought in a relatively short span of time between 1916 and the early 1920s, came out of one of the most spectacular collections of eighteenth-century French illustrated books and related drawings ever formed: that of Louis Roederer, a member of the famous champagne-producing family from Reims. Roederer was an indefatigable collector who spent just five years, from 1875 until his death in 1880, pursuing and buying up the best examples of French book illustration, amassing in that brief period about 6,000 books, 3,000 drawings, and 750 prints.[2] After Roederer's death the collection remained intact in the hands of his nephew and heir Léon Olry-Roederer, and was saved almost miraculously from the family's home in Reims, which came under fire during World War I. In order to help pay for repairs to the Roederer family's war-damaged business facilities, Olry-Roederer sold the entire collection in 1922 through the London firm of Thomas Agnew and Sons to Dr. A. S. W. Rosenbach of the Rosenbach Company in Philadelphia. Widener, who lived in Elkins Park, outside of Philadelphia, was one of the first collectors to be given access to the trove, and among the treasures he selected were 111 drawings, mainly by Hubert Gravelot, for the 1757–1761 edition of *The Decameron* by Giovanni Boccaccio (cat. 63); 130 by various artists, including Boucher, for the 1767–1771 edition of Ovid's *Metamorphoses* (cats. 57, 93); smaller groups of drawings by Gravelot for Jean-François Marmontel's *Contes moraux* of 1765, by Jean-Michel Moreau the Younger for Marmontel's *Les Incas* of 1777, and by Antoine Borel for the 1790 edition of the *Oeuvres* of Philippe-Néricault Destouches (fig. 1); and a manuscript of a play by Charles Collé, *La partie de chasse de Henri IV*, of 1766 with illustrations by Gravelot. Also included in the group were two rare figure studies in the beautiful combination of red, black, and white chalks known in France as *trois-crayons* (literally, three chalks), by Moreau the Younger for two prints from his most famous suite, the *Monument du costume* (cat. 95). Only a few of the works could be said to be by "name" artists, most notably the ones by Moreau and Boucher, and even then, as it has turned out, the number of authentic Boucher drawings in the Widener collection has now been reduced from the four Widener thought he owned to just one (cat. 57).[3] Likewise, a drawing that was supposed to be one of Fragonard's illustrations for the 1795 edition of *Contes et nouvelles en vers* by Jean de La Fontaine has now been relegated to the ranks of anonymity.[4]

None of these attribution changes, however, alters the importance of the Widener collection as one of the great ensembles of French book illustration. Consisting almost entirely of works by artists who are little known outside that particular realm, it forms an intriguing niche collection within the Gallery's holdings. It has maintained its distinctive identity over the years while also being broadened and strengthened with a number of related acquisitions (see cats. 1, 47, 48, 51, 67, 91, 92, 102, and 103), including, most recently, a fine neoclassical piece by Jean-François-Pierre Peyron, given by Jeffrey E. Horvitz (cat. 115).

After the jump start offered by the Widener gift, the collection of French drawings lay nearly fallow for the next twenty years, adding only about twenty drawings during that period. The major contributor was Lessing J. Rosenwald of Jenkintown, Pennsylvania, whose primary focus as a collector was on master prints by European and American artists from the fifteenth century onward, but he also made a point of collecting drawings related to prints and print-making. In 1943 he decided to give his entire collection of prints and drawings to the nation—more than 9,500 works—and then continued to collect specifically for the National Gallery. Over the next thirty-six years Rosenwald donated well over 14,000 more prints, drawings, portfolios, and some illustrated books. Out of those vast

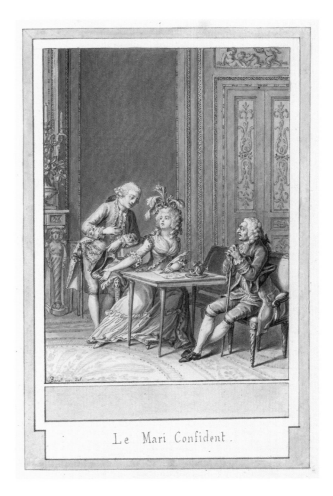

FIGURE 1. Antoine Borel, *The Confident Husband*, 1790, pen and brown ink with gray wash over graphite. National Gallery of Art, Washington, Widener Collection, 1942.9.683

holdings, however, the number of French drawings made before 1800 was minuscule, hardly reaching above a score. Of special note was an outstanding portrait drawing by Nanteuil (cat. 25), the great seventeenth-century portrait engraver whose work as a printmaker was exceptionally well represented in Rosenwald's collection, and six of Fragonard's illustrations for Ludovico Ariosto's *Orlando furioso* (cat. 92), which came, like most of the Widener drawings, from the Roederer collection—to which Rosenwald, also a Philadelphian, had early access. (One of the Fragonards was given in 1943, but five were kept by Rosenwald's wife, Edith, until she donated them in 1978.) Rosenwald also gave a couple of drawings by Gravelot, who was so well represented in the Widener collection, and eight more works related to book illustration: Oudry's humorous interpretation of some of the scenes from Paul Scarron's *Le roman comique* (cat. 47).

Also notable among the drawings in the Rosenwald collection were fine examples by two of France's most original and important printmakers: a study of four horsemen by the seventeenth-century Lorraine master Jacques Callot (fig. 2), made in preparation for his monumental multiplate print of *The Siege of Breda*; and a gently comical and somewhat titillating scene by the eighteenth-century draftsman and chronicler Gabriel de Saint-Aubin, showing a rather prim young woman seated at the foot of a sculpture of a nude faun who looks her over with considerable interest (cat. 68).[5]

A few individual pieces of special note were given by other patrons during the 1940s and 1950s. An important bequest of old master prints in 1949 from R. Horace Gallatin included a small yet evocative wash drawing on blue paper, *The Rest on the Flight into Egypt* by Claude (cat. 24), one of the artist's very last works. A few years later, the Gallery received from Howard Sturges its first drawing by Watteau, a fine example of the *trois-crayons* technique for which the artist was justly famous (cat. 41). This served as a perfect complement to two study sheets that had been given in 1944 by Myron A. Hofer, both under the name of Nicolas Lancret, Watteau's most important follower and a fine painter of *fêtes galantes* and genre scenes in his own right. One of the Lancrets was a particularly beautiful *trois-crayons* drawing (cat. 45); the other, rendered in a combination of black and red chalks but in a subtly different style, was identified many years later as having been drawn by a different Watteau emulator, Jacques-André Portail.[6]

FIGURE 2. Jacques Callot, *Study of Four Horsemen*, 1628 or before, red chalk. National Gallery of Art, Washington, Rosenwald Collection, 1961.17.51

The next significant boost to the Gallery's eighteenth-century drawings came with the arrival in 1963 of thirty-one French drawings from the Samuel H. Kress collection.[7] The gift contained a nice variety of works, including several by artists who had not previously been represented in the Gallery's collection. In addition to drawings by Fragonard (cat. 88), Watteau (cat. 43), and Boucher, there were also landscapes by Jean-Baptiste Hüet and Louis-Gabriel Moreau the Elder (cat. 109); genre scenes by Moreau the Younger, Hubert Robert, and Pierre-Antoine Baudouin; and figure studies by Lancret and Portail. It is notable that several others were highly finished works executed in full color, among them gouaches by Jean-Baptiste Le Paon, Louis-Nicolas van Blarenberghe, and Alexis-Nicolas Pérignon the Elder (cat. 105), a pastel portrait by Maurice-Quentin de La Tour (cat. 59, actually given in 1961), and watercolors by Robert, Jacques-Louis-François Touzé, and Louis-Jean Desprez (cat. 103a). The drawings by these last two artists were related to book illustration, making them especially relevant to the Gallery's holdings. As usual, some attribution adjustments have been made over the years: the one Boucher, an elaborate representation of Danae receiving Jupiter in the form of a shower of gold, is now regarded as the work of a copyist;[8] a Fragonard view in a park has been reattributed to François-André Vincent (cat. 99); a farmhouse interior that was once given to Fragonard has now been reassigned to Robert;[9] and one of the five

landscapes originally attributed to Moreau the Elder is now known to be a copy,[10] while the gouache that was thought to be by Blarenberghe has been recognized as Moreau's own work (see cat. 109, fig.1), leaving the number of Moreaus in the Kress gift unchanged.

By 1966 the collection of French drawings numbered about four hundred pieces, with barely a handful of works from the seventeenth century, and those only by (or attributed to) Claude, Nanteuil, and Callot. In the eighteenth-century group, however, in addition to the rich holdings of the Widener book illustrations, a few small areas of concentration were already forming around the works of some of the leading masters: Watteau, Lancret, and Portail; Boucher, Baudouin, and Hüet; Fragonard and Robert; and the two Moreau brothers. Progress had been made, and the collection entered its second twenty-five years poised for further expansion.

Curators, Collections, and Purchases: The Next Twenty-five Years

After the arrival of the Kress drawings, gifts of French drawings slowed to a trickle for the next fifteen years, but fortunately Ailsa Mellon Bruce, daughter of Andrew Mellon and sister of board chairman Paul Mellon, had established a fund in 1965 that finally made it possible for the museum to purchase art instead of relying solely on donors' gifts. A considerable number of other purchase funds, permanent and temporary, large and small, have been set up since, but Ailsa Mellon Bruce's, which is still being used today, paved the way.

Expanding the portrayal of French draftsmanship was naturally a strong priority in using purchases to build up the drawing collection, but in fact the Gallery at this point still had so many gaping holes in the French holdings that the field was pretty much wide open. However, the first two purchases of French drawings, in 1968, followed the opposite tenet of collecting—buying to strength—by acquiring what was then thought to be the Gallery's seventh drawing by Gabriel de Saint-Aubin and the third by Callot. The latter's *The Holy Trinity in the Tree of Life Adored by Franciscans* (cat. 15) is still highly regarded by connoisseurs of the master's sketches. The Saint-Aubin *Portrait of the Artist with His Younger Brother Augustin*, on the

other hand, once considered a very significant work by this artist, was unfortunately unmasked some years later as a modern fake.[11]

In February 1971 the Gallery's leadership signaled its commitment to building the collection by hiring the museum's first curator of drawings, Konrad Oberhuber from the Graphische Sammlung Albertina in Vienna (he was later my own professor and mentor at Harvard University). During four years at the Gallery, Oberhuber was responsible for the acquisition of a broad range of old master drawings from a variety of schools and eras. For the Gallery's collection of French drawings, his primary concern was to search out works that predated the eighteenth century. One of his very first purchases, in fact, was the chalk study of *Creusa Carrying the Gods of Troy* by Simon Vouet (cat. 17), which is still today one of the Gallery's most admired seventeenth-century drawings. Among the other French works bought during Oberhuber's tenure were several drawings that purported to be by key artists such as Étienne Dupérac, Jacques Androuet du Cerceau, and Toussaint Dubreuil from the 1500s and Poussin, Claude, Pierre Puget, and Jean Jouvenet from the 1600s.[12] However, although the high quality of several of these works is indisputable, almost all of them are now deemed to be by other artists, either followers or masters from other countries. The wonderful red chalk study of *Harpocrates* (fig. 3) that was acquired as the work of Dubreuil, for example, is more likely Italian in origin; a pen-and-wash

FIGURE 3. Anonymous, *Harpocrates*, early seventeenth century, red chalk. National Gallery of Art, Washington, Ailsa Mellon Bruce Fund, 1972.4.1

view of Rome attributed to Dupérac is now considered to be by a Netherlandish artist; a sheet of sculpture studies thought to be the work of Puget is neither his nor French; the one given to Jouvenet is now regarded as a copy; and all three of the drawings that were supposed to be by Poussin (an artist whose oeuvre Oberhuber was then beginning to study deeply and would eventually propose to revise quite dramatically, especially for the early works[13]) turned out to have significant attribution issues, with at least two of the three no longer even classified as French.

In 1974 Andrew Robison was hired as the new curator of prints and drawings, with Diane De Grazia Bohlin, an Italianist, brought on as assistant curator of drawings, joining H. Diane Russell, who was a specialist in seventeenth-century French prints. The next major purchase of a French drawing under this new stewardship came in 1976, an exquisitely serene and classical Claude landscape (cat. 23) that remains to this day the Gallery's most important drawing by the artist. The quest for seventeenth-century objects continued over the next few years, leading to the acquisition of two more excellent drawings by Claude, an unusually fine study of figures purchased in 1978 (cat. 22) and an early landscape with a bridge, given by Mr. and Mrs. Ronald S. Lauder in 1981 (cat. 21); an extraordinary pastel portrait of an old woman by Lagneau (cat. 16); a sheet of spirited pen studies of horses, many copied after Antonio Tempesta, by Callot (cat. 13); and a wonderfully quirky study of a dancing woman with a tambourine by the mannerist painter and printmaker Bellange (cat. 11). The Gallery's small holdings in this area were finally taking on some notable substance.

The Gallery's ongoing interest in eighteenth-century drawings was demonstrated in a different way, through a series of important monographic loan exhibitions on the drawings of Boucher (1973–1974), Fragonard (1978–1979), and Robert (1978–1979), and on the drawings and paintings of Watteau (1984–1985).[14] Not only did these shows bring together many of the best drawings by those artists and contribute to the literature through the accompanying catalogues, they also helped to serve the Gallery's future collecting interests by locating major works that were still in private hands and bringing the curators into contact with the owners. In 1978 and 1979 the Gallery made its first two purchases of drawings by Boucher: *Return to the Fold* (see cat. 71, fig. 1) and *An Allegory of Music*, which was related to a painting of the same

name in the Gallery's collection and had been included in the 1973 exhibition.[15] More important was the donation by Robert and Clarice Smith of a trio of outstanding Boucher drawings, consisting of the artist's most impressive study of the male nude (cat. 52), one of his most beautiful Dutch-style genre interiors (cat. 54), and a voluptuous nude (cat. 58). The first two had been standouts in the Boucher exhibition, and both happened to come up for sale in separate auctions within weeks of each other in April 1978. After bidding successfully on both lots, the Smiths then acquired the female nude from the Galerie Cailleux in Paris in 1979, thus rounding out the group, which they generously gave to the National Gallery at the end of 1980.

The 1980s saw a burst of activity in widening the Gallery's relations with drawing collectors. Purchases of individual works were certainly essential to the development and growth of the collection—and continued apace—but as Andrew Robison fully realized, gifts or partial gifts and purchases of entire collections or parts of collections that were already formed would clearly move the Gallery's holdings forward more quickly and dramatically. In 1974, for example, Andrew became aware of a small but choice collection of eighteenth-century drawings in New York that contained an exceptionally fine drawing by Giovanni Battista Piranesi, one of Andrew's specialties. Belonging to Mrs. Gertrude Laughlin Chanler and consisting of just twenty-five sheets, the collection included six drawings attributed to Boucher (cats. 50, 53), a Watteau compositional sketch (cat. 42) related to the Gallery's own painting of *Italian Comedians*, six large drawings by Fragonard illustrating the famous story of Don Quixote (cat. 91), two sprightly compositions by Saint-Aubin (cat. 65), and some fascinating works by less famous artists.[16] The collection had been formed by Irwin Laughlin, Mrs. Chanler's father, who had close ties to Andrew Mellon, the Gallery's founder, David Finley, the Gallery's first director, and John Russell Pope, the architect who designed Laughlin's Washington home, Meridian House, as well as the Gallery's West Building. Thus, although she had spent many years in other cities, Mrs. Chanler had deep roots in Washington and a long connection to the National Gallery, which included an installation of her drawings there in 1967. The ties were strengthened when she lent her Piranesi to one of the exhibitions that celebrated the opening of the Gallery's East Building in 1978.[17] Fully recognizing in addition the relation-

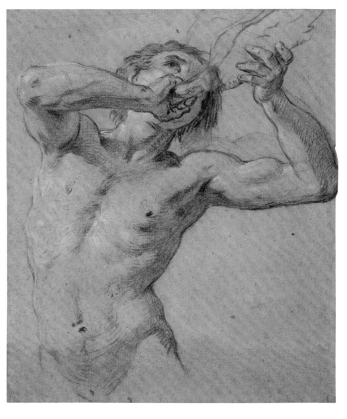

FIGURE 4. Jean-Baptiste Nattier, *A Triton Blowing a Conch Shell*, 1724, black chalk heightened with white. National Gallery of Art, Washington, Gift of Gertrude Laughlin Chanler, 2000.9.19

ship between her Watteau drawing and the Gallery's painting, Mrs. Chanler gradually became convinced that her father's collection would make a significant contribution to the Gallery's holdings. When Andrew proposed, then, that the drawings be presented in a special exhibition with a catalogue in 1982, she kindly agreed. As it turned out, this exhibition became my first project here: I had arrived in January 1980 as a predoctoral fellow and was then retained temporarily (or so it was thought at the time!) as visiting curator of the Watteau exhibition being planned for 1984–1985.[18] Working on the Chanler drawings gave me the chance to learn—on a small scale—most of the ins and outs of organizing an exhibition at the National Gallery, while also giving me the opportunity to get to know Mrs. Chanler, a remarkable lady. In 1990 she formally pledged all the drawings to the Gallery as future gifts; they then remained with her until her death in 1999 and returned here in 2000.

1 Jean Poyet · TOURS (?) C. 1445 – C. 1503 TOURS (?)

The Coronation of Solomon by the Spring of Gihon, c. 1500

pen and black ink with watercolor, heightened with white gouache
213 × 144 (8 3/8 × 5 5/8)
inscribed in pen and brown ink at upper left: ƒ
Patrons' Permanent Fund, 2006.111.3

The refined courtliness of this remarkable drawing clearly links it to the well-established tradition of luxury manuscript illumination in France, but at the same time its execution in ink and watercolor on paper sets it firmly apart. Unlike those highly polished miniature paintings, this is a simple pen study that has been delicately tinted with color. Its importance should not be underestimated, however, for extant French drawings on paper made before about 1520 are exceptionally rare, and this one is extraordinary in every respect. From the confident handling of the pen and the sophisticated use of color to the elegant posing of the figures and the sensitive rendering of the elegiac setting, the drawing reveals the hand of a master. Yet very little is known about Jean Poyet, the painter, decorator, and illuminator from Tours who made it in about 1500.[1] Between 1483 and 1498, Poyet's name appears in a handful of documents that suggest he was closely connected to the royal court. Most notable is the record of a payment made to him in 1497 for a set of illuminations for a small Book of Hours commissioned by the queen, Anne de Bretagne (1477 – 1514).[2] In 1503 he was lauded as one of the "recent and new geniuses" of art,[3] and more than fifty years later, in 1556, he was described "as even more gifted than the Fouquets in perspective and the art of painting."[4] For a time in the nineteenth century, Poyet was thought to have painted the illuminations in one of the great manuscripts from the end of the fifteenth century, the Grandes Heures (Book of Hours) of Anne de Bretagne (Bibliothèque nationale, Paris), until a document was discovered that proved them to be the work of his fellow Touraine artist Jean Bourdichon (c. 1457 – 1521). Thereafter, Poyet faded almost entirely

from view, resurfacing only in the early 1980s, when his name was first linked to several fine manuscripts produced in Tours toward the end of the fifteenth century.[5] Over the course of the last twenty-five years, Poyet's prestige has been considerably restored and a small but impressive oeuvre has been established under his name.

In 1987 Janet Backhouse ascribed to Poyet the present drawing and four others, all executed in the same technique on paper of similar dimensions, an attribution that has now gained general acceptance.[6] The other four compositions in the group all have subjects from the Old Testament: Cain Killing Abel and Abraham Leading Isaac to His Sacrifice, both in the British Museum, London; Joseph Sold into Slavery by His Brothers, in the Museum Boijmans Van Beuningen, Rotterdam; and The Mocking of Elisha, in the Art Institute of Chicago.[7] The subject of the National Gallery drawing has long been identified as the coronation of King David (2 Samuel 5:3), but the prominence of the stream and pool in the foreground indicates that this must instead be the crowning of David's son, Solomon (1 Kings 1:32 – 39), which took place at Gihon, a natural spring near Jerusalem. In accordance with the biblical description, Poyet shows three men—Zadok, Nathan, and Benaiah—anointing the new king, and he places music-making figures atop the royal tent to evoke David's instruction that trumpets be sounded after the coronation. In this drawing, as in the other four, the landscape plays a conspicuous role, but here the pastoral setting, especially the pool in the foreground with the water spouting from the rocks, is executed with particular brilliance. Indeed, the entire landscape is as fine as any produced by Poyet's contemporaries, including two of the most talented landscape draftsmen of all time, the young Albrecht Dürer (1471–1528) in Germany and Fra Bartolommeo (1472–1517) in Florence.

The exact purpose of the National Gallery watercolor and its four companions is not certain, but they were surely originally part of a much larger group of works—or at least what was intended to be a much larger group—for although three of the stories come from Genesis, the other two come from First and Second Kings, skipping over eight books of the Bible in between. The use of watercolor in the drawings has led to suggestions that they were made in preparation for book illuminations, tapestries, or painted glass, perhaps even serving as the vidimus (Latin for "we have seen") that would have been used to obtain approval for the designs from the patron.[8] The most obvious interpretation, based on the scale, orientation, and execution, is that these drawings were made to serve as illustrations to a manuscript of Bible tales, even though such drawn illustrations on paper would have been extremely rare around 1500 (but see cat. 2, from just a dozen or so years later). Ultimately, however, no matter for what purpose they were made, these watercolors, both separately and together, rank among the most extraordinary drawings produced in France at the end of the fifteenth century.

PROVENANCE

Ambroise Firmin-Didot, Paris (1790–1876) (Lugt 119); Louis (1829–1893) or Émile (1829–1875) Galichon, Paris; Eugène Rodrigues, Paris (1853–1928) (Lugt 897) (sale, Frederik Muller, Amsterdam, 12 July 1921, lot 114, as French Master c. 1500); to H. E. Ten Cate, Almelo (1868–1955); C. G. Boerner, Düsseldorf, 1964; private collection (sale, Sotheby's, London, 7 July 1966, lot 94, as anonymous French, c. 1500); to P. & D. Colnaghi, London; private collection (sale, Christie's, New York, 10 January 1996, lot 176, as French School, c. 1500); American private collection; NGA purchase via Salamander Fine Arts, London, in 2006.

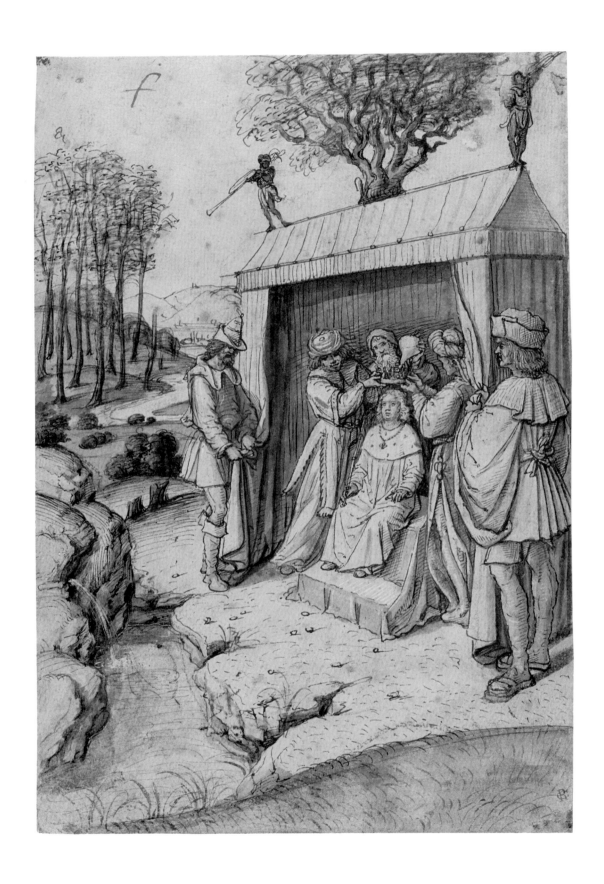

French School · EARLY SIXTEENTH CENTURY
drawings for a *Speculum Principis* for
François d'Angoulême, 1512/1514

2a

"Do Not Eat Beans" (folio 25r), 1512/1514

pen and brown ink with watercolor
163 × 107 (6 7/16 × 4 3/16)
inscribed in pen and brown ink at left above the plants: *Fabe*, and at right above the
standing man: *Pythagoras*
Woodner Collection, Gift of Andrea Woodner, 2006.11.45

This unusual series of drawings was made by an unknown French artist between 1512 and 1514 to illustrate a compendium of moral teachings based on ancient and modern aphorisms, witticisms, and precepts. The original manuscript, essentially a *Speculum Principis*, or Prince's Mirror, included thirty-seven drawings, a separate explanatory text, and further textual inscriptions on the backs of some of the drawings.[1] The entire manuscript was bound early on, perhaps even from the moment of its creation, with a copy of Josse Clichtove's 1511 edition, published in Paris, of *Dogma moralium philosophorum*, an anonymous medieval tract on the cardinal virtues. The bound volume remained intact until after it was sold by the London antiquarian book dealers Maggs Brothers in the 1940s. Thereafter, the binding, which was in poor condition, was apparently discarded, together with the manuscript text, and both are now lost. In addition, the inscriptions on the backs of some of the drawings were obliterated, although some can still be read with the aid of ultraviolet light. Thirty-three of the drawings remained together; two drawings on three leaves, which had become separated from the manuscript, turned up at auction in 1964 and are now in other collections; and three other pages have disappeared.[2] Fortunately, the inscriptions, drawings, and binding—but not the text pages—were photographed in about 1940 for Fritz Saxl, director of the Warburg Institute in London, thus preserving critical information about the order of the drawings and allowing scholars to consider and interpret the images and inscriptions in a meaningful manner.[3]

Through analysis of internal evidence, including the handwriting in the inscriptions, Jean Michel Massing has shown that the manuscript was compiled by François Demoulins—or Du Moulin—(fl. 1501–1524), a Franciscan monk, scholar, and humanist who served first as tutor and then as chaplain to the young François d'Angoulême, the future François I of France (1494–1547).[4] In addition, Massing deduced that the manuscript was made for François himself, not only because the images include several dolphins—referring to François' status as heir presumptive, although he was not officially the "dauphin"—but also because the style of ornamentation on the original brown calf binding connects the manuscript to other books that are known to have been in the library of the future king.[5] Massing also noted that the presence of the dolphins indicates that the manuscript must have been completed by the end of 1514—before the death of Louis XII on 1 January 1515 and the coronation of François twenty-four days later. In addition, he pointed out that motifs used in one of the images in the manuscript were borrowed from a woodcut included in a book published in May 1512, indicating that the drawings were completed only after that date.[6] That *terminus post quem* is in line with the 1511 publication date of Clichtove's *Dogma moralium philosophorum*, with which the manuscript was once bound.

All the drawings in the series are executed in pen and brown ink; several are enhanced with touches of brown or black wash, and some also have red. A few are partially or completely colored, in the manner of full-color miniatures, and one is embellished with gold. The draftsman responsible for these works has yet to be identified and is likely to remain anonymous for some time to come. Once thought to be the work of an artist from the circle of the German master Hans Holbein the Younger (1497–1543),[7] the drawings are now believed to be French in origin. A suggestion that they came from the workshop of Jean Perréal (1457?–1530) and are perhaps by the so-called Master of the Clubfeet (Maître des Pieds-bots), a Lyonnais artist influenced by Perréal, has not borne up under scrutiny.[8] No other work by this particular hand has yet been identified, making it all the more difficult to determine the authorship. Even without a name, however, the drawings stand out for the striking originality of their compositions, their witty interpretations of the written word, and their charming combination of naïveté and sophistication.

A majority of the drawings illustrate ancient and modern aphorisms whose moral messages and many layers of meaning would have been considered appropriate for the instruction of a prince.[9] Most of the sayings were chosen from the *Adagiorum chiliades*, the "thousand proverbs" collected and analyzed by the Dutch humanist Erasmus and first published under that title in Venice in 1508. Many were based on the *symbola* (sayings) of the ancient Greek mathematician and philosopher Pythagoras, also included in Erasmus' book, and Pythagoras himself is portrayed in two of the images: *"You Shall Not Have Swallows under the Same Roof"*[10] and *"Do Not Eat Beans"* (cat. 2a). Three other compositions illustrate a poem (*Dialogue on Hope*)[11] and an epigram (*A Dialogue on Human Favor*; cat. 2b) by the contemporary Parmese poet Bernardino Dardano. Another, *A Fool Feeding Flowers to Swine*, is based on one of the "moral sayings" from Henri Baude's fifteenth-century *Dictz moraux pour faire tapisserie* (Moral Sayings for the Making of Tapestry);[12] and two others illustrate related epigrams on Opportunity by the ancient Greek poet Posidippus and the Roman poet Ausonius.[13] Finally, a couple of the images are *ekphraseis*, or the reconstructions of pictures based on literary descriptions, most notably, *The Calumny of Apelles* (cat. 2c).

A Dialogue on Human Favor (folios 15v and 16r), 1512/1514

pen and brown and black ink, heightened with gold on two joined sheets

163 × 214 (6 7⁄16 × 8 7⁄16)

the figures labeled in pen and brown ink from left to right: *Libido, Legum Codex:, Honor:, Fastus:, Opulentia:, Fauor:, Assentatio:, Inuidia:*; and inscribed above the figure of Favor in four separate discs: *Fortuna, Casus:, Forma:, Dotes/Animi*

Woodner Collection, Gift of Andrea Woodner, 2006.11.34.a

The Calumny of Apelles (folio 6r), 1512/1514

pen and brown ink with watercolor

163 × 109 (6 7⁄16 × 4 5⁄16)

Woodner Collection, Gift of Andrea Woodner, 2006.11.30

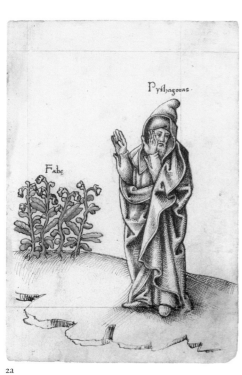

2a

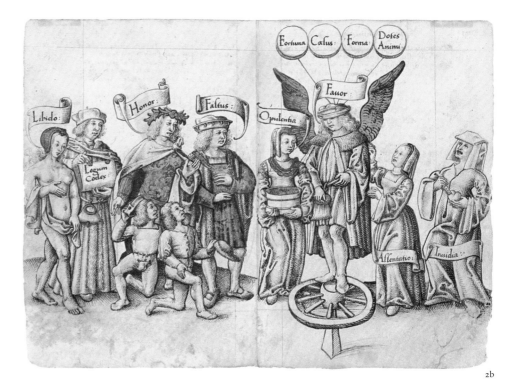

2b

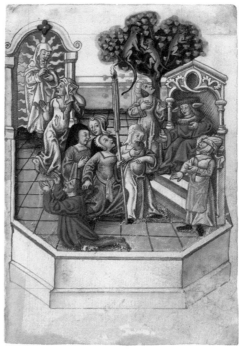

2c

2d

"Do Not Turn Back When You Arrive at the End"
(folios 26v and 27r), 1512/1514

pen and brown ink with watercolor on two joined sheets
164 × 217 (6 7/16 × 8 9/16)
inscribed in pen and brown ink on the house at upper left: *Domus Hominis Prudentis..*;
the figures standing at left labeled: *Cupiditas Vite*, *Medicus*, and *Pharmacopehela*; the

woman with a spear at center labeled: *Ratio*; inscribed in the wheels on the cart on
which she stands: *Vir* and *Prudens*; on the chariot at upper right: *Saturnus*; on the coffin-
shaped cart at right center: *Finis Vite*; and on the chariot at lower right: *Mars*
Woodner Collection, Gift of Andrea Woodner, 2006.11.55

Several of the compositions, especially those drawn on two-page spreads, are very complex, with many figures that are often labeled individually and accompanied at times by brief legends and inscriptions to assist the prince in identifying the subject and construing the meaning(s) of the scenes. *"Do Not Turn Back When You Arrive at the End"* (cat. 2d), for example, based on a passage in the *Adagiorum chiliades*, advises him to accept death gracefully when his time comes. In the drawing, the prudent man (*vir prudens*) is taken from his house by an angel riding on a wheeled platform that rolls over a devil. The man embraces a skeletal figure, Death, who rides in a coffin-shaped wagon with skulls inscribed on the wheels. The wagon, marked "Finis Vit[a]e" (the end of life), is drawn by two ravens, messengers of death. Saturn, riding in his chariot at the top of the composition, carries the scythe often associated with Father Time, thus representing the passage of time that leads eventually to death. Near the bottom, Mars in his chariot drawn by two horses brandishes a sword, thus suggesting the arrival of death through violence or war. At far left, standing in front of the prudent man's house, are a doctor, a pharmacist, and a woman representing the Desire for Life, who want to save the man from Death. They are being staved off by a woman representing Reason, for death is the natural end to life and to resist it is not rational. Every detail of the drawing contributes to both the richness of the representation and the depth and complexity of the overall meaning.

Other illustrations are simpler and more straightforward in presentation, using a limited number of figures—often just one or two—to convey the message. Several drawings, for example, show a man wearing a fool's hood adorned with asses' ears, who is engaged in obvious acts of stupidity, such as feeding roses to pigs, slicing a crown with a sword, or going into a lion's den armed with a haunch of meat (cat. 2e). The overt meaning in these drawings is easily understood, but for François d'Angoulême, these images would also have carried deeper messages relating to the pitfalls of life at court and warnings about the consequences of his actions as a wealthy and powerful ruler. He would have recognized the lion's den as a metaphor for the court, for example, and would have been wary of courtiers who, having greedily accepted gifts and benefits from him, would then turn on him and eat him alive. Similar messages were expressed in other drawings that present the central figure either as an ordinary man or as a courtier who more obviously represents François himself, even if such depictions were not intended as actual portraits. That is the case in the image of a man standing between Covetousness (who has money bags fastened all over her dress, beats her own drum, and toots her own horn) and Dissimulation (dressed partly in a lovely gown and partly in mourning, and accompanied by a fox and a monkey wearing monks' habits) (cat. 2f). The message for the prince would have been to watch out for courtiers who are avaricious and those who try to hide their true natures.

If at first these illustrations seem somewhat coarse in execution and naïve in composition, especially as compared to the highly polished miniatures that generally ornamented illuminated manuscripts of this period, once their instructional purpose is understood and the layers of meaning realized, they become far more intellectually and visually exciting. The rarity of such drawings in France in the early years of the sixteenth century, the humanist content, the integral relationship of text and image, and the high station of the personage for whom the work was intended all combine to elevate this unique suite to an unexpectedly important place within the history of French drawings as a whole, even without knowing the name of the artist.

PROVENANCE

François d'Angoulême, later François I of France (1494–1547); private collection (sale, Sotheby's, London, 13 July 1937, lot 64 [unsold]; reoffered at Sotheby's, London, 15–17 November 1937, lot 546); Maggs Bros., London, by 1941; William H. Schab Gallery, New York; purchased by Ian Woodner, New York (1903–1990); by inheritance to his daughter Andrea Woodner, New York, 1990; gift to NGA in 2006.

2e

"Feed Not Things That Have Sharp Claws" (folio 38r), 1512/1514
pen and brown ink with watercolor
163 × 109 (6 7/16 × 4 5/16)
Woodner Collection, Gift of Andrea Woodner, 2006.11.44

2f

A Courtier Standing between Covetousness and Dissimulation
(folio 14r), 1512/1514
pen and brown ink with watercolor
163 × 107 (6 7/16 × 4 3/16)
inscribed in pen and brown ink above the figure at left: *Convoitise:*; above the man at
center: *lhomme de/court.*; and above the woman at right: *Simulacion:*
Woodner Collection, Gift of Andrea Woodner, 2006.11.31

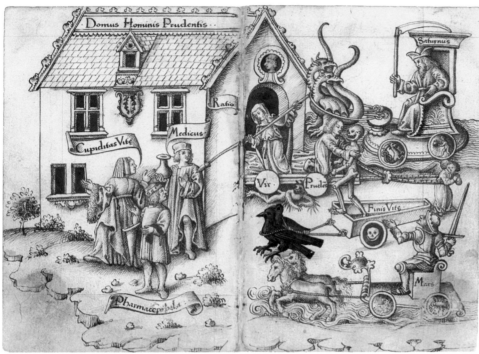

2d

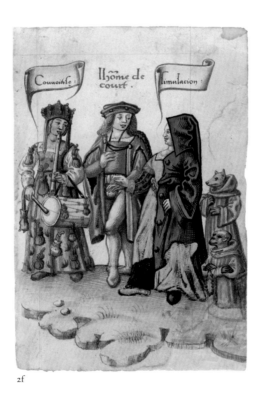

2f

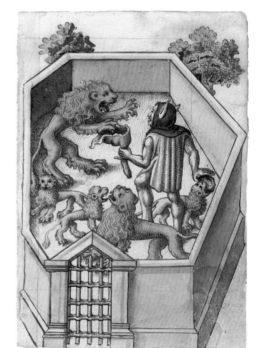

2e

Benvenuto Cellini · FLORENCE 1500 – 1571 FLORENCE
A *Satyr*, 1544/1545

pen and brown ink with brown wash over black chalk with framing line in brown ink
416 × 203 (16 ⅜ × 8)
inscribed by the artist in brown ink at lower right: *alla porta di Fontana/Bellio di bronzo p[er] piu/di dua volte il vivo b[raccie] 7/erano dua variati*
Woodner Collection, Patrons' Permanent Fund, 1991.190.2

Summoned to the French court by King François I (1494 – 1547) in 1540, the Florentine goldsmith and sculptor Benvenuto Cellini soon embarked on an ambitious program to create a grand ceremonial entrance for the king's favorite château at Fontainebleau. As he recalled in his *Autobiography*:

I corrected the proportions of the doorway, and placed above it an exact half circle; at the sides I introduced projections, with socles and cornices properly corresponding: then, instead of the columns demanded by this disposition of parts, I fashioned two satyrs, one upon each side. The first of these was in somewhat more than half-relief, lifting one hand to support the cornice, and holding a thick club in the other; his face was fiery and menacing, instilling fear into the beholders. The other had the same posture of support; but I varied his features and some other details; in his hand, for instance, he held a lash with three balls attached to chains. Though I call them satyrs they showed nothing of the satyr except little horns and a goatish head; all the rest of their form was human.[1]

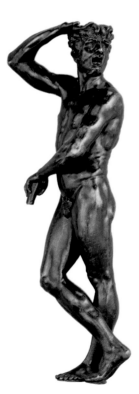

FIGURE 1: Benvenuto Cellini, *Satyr*, modeled c. 1542/1543, cast 1543/1544, bronze. The J. Paul Getty Museum, Los Angeles

Work on the project began in 1542, and full-scale clay models of the two colossal satyrs — which were each more than ten feet tall — were apparently ready to be cast in bronze in 1545 when Cellini abruptly left the court and returned to Italy.[2] The appearance of the satyr with the club is recorded in this magnificent drawing, whose inscription confirms its connection with the proposed Porte Dorée (Golden Entrance): "for the gate of Fontainebleau — of bronze, more than twice life size: *7 braccie* — there were two variants." The same figure, with some differences in the facial expression, also survives in a small-scale bronze (57.6 centimeters in height) in the J. Paul Getty Museum, Los Angeles (fig. 1).[3] A bronze statuette of the second satyr — on a similar scale (56.5 centimeters) and corresponding to Cellini's description — was discovered in the Royal Collection, London, in 2002.[4]

The satyr with the club was intended to be placed to the left of the portal at Fontainebleau; the one with the flail, to the right. Each figure would thus have had its back to the entrance, its head turned to look over its shoulder at those who entered.[5] In keeping with Cellini's note that the satyrs would be presented "in somewhat more than half-relief," shadows along the Washington satyr's right arm, back, buttocks, and right thigh indicate that the sculpture was to be positioned against a wall. This is corroborated by both of the small bronzes, in which the figures simply end where they would have been attached to the supporting walls.[6]

Cellini's knowledge of and admiration for the sculpture of Michelangelo (1475 – 1564) are abundantly evident in the two small bronzes, but even more so in this exquisitely rendered drawing. The imposing figure evokes the well-proportioned forms of such famous nudes by Michelangelo as the *David* in Florence and the slaves from the tomb of Pope Julius II in Rome.[7] Cellini skillfully translates into two dimensions the firm plasticity and smoothly muscled surface of the sculpted form and the precise chiseling of the face and hair. Although only a handful of drawings by Cellini

are known, and none approaches the completeness and complexity of the National Gallery drawing, this one sheet bears proud witness to Cellini's brilliance as a draftsman.

Scholars have disagreed as to the exact placement of the National Gallery drawing within the course of Cellini's work on the Porte Dorée and the satyr sculptures. It is now generally accepted, however, that it was not made as a preliminary study for the large bronze, but rather was copied from the finished full-scale clay model.[8] Cellini could have made it as a record of one of the major achievements of his five-year stay at the French court — something he could show to prospective patrons upon his return to Italy — but it now seems more likely, as Denise Allen has suggested, that Cellini made the drawing as a *modello*, a guide for the assistants in his studio who would be working on the chasing and finishing of the bronze cast.[9] That would account for the highly detailed and sculptural treatment of the head, for example, and the delicate modeling of the musculature and the surface of the body as a whole. Allen also proposes that such a beautifully rendered and highly finished drawing would have been suitable for presentation to the king, and Cellini may indeed have intended to give it to him, but the phrasing of his own inscription, written in the past tense, indicates that the artist must have kept the drawing and taken it back to Italy with him.[10]

PROVENANCE

John Barnard, London (d. 1784) (Lugt 1419); Sir Thomas Lawrence, London (1769 – 1830) (Lugt 2445); Hans M. Calmann, London (1899 – 1982); William H. Schab Gallery, New York; purchased in 1959 by Ian Woodner, New York (1903 – 1990); by inheritance to his daughters, Dian and Andrea Woodner, 1990; NGA purchase in 1991.

Étienne Delaune · MILAN 1518/1519 – 1583 PARIS

The Backplate of a Suit of Parade Armor, c. 1557

pen and black ink with gray wash and faint traces of black chalk
390 × 308 (15 5/16 × 12 1/8), irregular
Woodner Collection, 1991.182.20

Étienne Delaune was one of the most prolific and appealing French designers and printmakers of the mid-sixteenth century. Trained as a metalsmith and registered in Paris in 1546 as a *compagnon orfèvre* (companion goldsmith), he was appointed principal medalist to Henri II (1519–1559) in 1552.[1] Although he remained in that post only for five months, by the mid-1550s Delaune was designing a wide variety of luxury items for the court, from jewelry, tableware, and banquet ornaments to hand mirrors and suits of armor. A Protestant, Delaune left France after the Saint Bartholomew's Day massacre in 1572, living first in Strasbourg and then in Augsburg before returning to Paris in 1580. Through his prints, which numbered more than 450 in all, he played a key role in the dissemination of the French taste in ornament design throughout Europe.

Like the *Design for a Morion-Burgonet* by Jean Cousin the Elder (cat. 5), which shares the same provenance, this oddly shaped drawing is a design for part of a highly decorated suit of armor, in this case, for the left half of the backplate. Whereas Cousin's efforts in this field are hardly known, Delaune's are surprisingly well documented, thanks

largely to the album of 170 drawings for French arms and armor, many certainly by Delaune, in the Staatliche Graphische Sammlung, Munich.[2] Among the surviving pieces of armor produced from his drawings are such masterpieces as the *Emperor Harness* made for Henri II in about 1555, now in the Metropolitan Museum of Art, New York (detail, fig. 1), and the *Hercules Harness* made for the Holy Roman Emperor Maximilian II (1527–1576) in about 1556/1557, now in the Kunsthistorisches Museum, Vienna.[3]

The National Gallery's drawing for a backplate, like all Delaune's armor designs, reflects a dramatic departure from the style of ornament used in the mid-1540s by Cousin, evident in his drawing for a helmet (cat. 5). In place of Cousin's strongly geometrical strapwork, Delaune traces a more delicate design of foliate motifs, called rinceaux, embracing a variety of fantastic creatures, allegorical figures, warriors and princes, and even a camel readied for battle. The inclusion on Delaune's drawing of some of the details that would appear on the other half of the backplate — such as the seated figure at right — shows that the overall design would have been symmetrical, with each of the elements of the decoration on the left side balanced by a matching or closely similar element on the right. Occupying the exact center is a figure of winged Victory holding a sword in each hand and standing between two seated men, one of whom is clearly a king. Because Delaune has placed Victory directly between them, the men may well be interpreted as the victor (crowned) and the vanquished (uncrowned), although the defeated man still wears a broad, curved sword at his side. Delaune may have intended for those figures and the other warriors included in the design to refer to specific personages of ancient history, but so far they remain unidentified.

No suit of armor corresponding to the National Gallery drawing is known to survive, but two related drawings are included in the Munich album: a preliminary drawing in black chalk by Delaune for the right half of the same backplate, with

almost all the figural elements virtually identical, but in reverse, to those on the Washington page; and a red chalk copy, not by Delaune, after the Washington drawing and in the same direction.[4] Also in the Munich album is a small study (93 by 77 millimeters) of a figure mounting a reclining mule, a motif that would undoubtedly have been used, as Bruno Thomas noted, in the lower right corner of the right half of the backplate to balance the man with the camel at lower left in the National Gallery design.[5]

Delaune's armor designs were meant to serve as actual-size models for the armorers and metalsmiths who would execute the many pieces of the individual harnesses. Since the person for whom the Victory armor was designed was fairly narrow in the chest (less than 34 inches), Thomas posited that it was intended for a youth of about sixteen or seventeen, and suggested that it was made for the young Charles IX (1550–1574) in about 1567.[6] However, the character of the Washington design and the organization of the figures and the ornamental rinceaux seem to be more closely related to the *Emperor Harness* designed by Delaune in the mid-1550s. Indeed, a drawing for the breastplate of the *Emperor Harness* (Victoria and Albert Museum, London) is very similar in conception, medium, and execution to the National Gallery design.[7] Presuming that the Washington drawing was made at about the same time or a little later, in about 1557, it is possible that the armor was intended for Henri's older son, François (1544–1560), who ascended the throne in 1559 at the age of fifteen and died in the following year. It is not known whether the harness was ever executed.

FIGURE 1: *Breastplate of the Emperor Harness* (detail), c. 1555, steel. The Metropolitan Museum of Art, New York, Harris Brisbane Dick Fund, 1939

PROVENANCE

Chevalier de Kirschbaum, Solingen (member of a family of sword manufacturers), until 1840; Hippolyte-Alexandre-Gabriel-Walter Destailleur, Paris (1822–1893) (Lugt 740; sale, Morgaud, Paris, 26–27 May 1893, lot 7, a volume consisting of 97 folios); to Alfred Beurdeley, Paris (1847–1919) (sale, Rahir, Paris, 31 May 1920, lot 123); Henri Grosjean-Maupin, Paris (1875–1953) (sale, Hôtel Drouot, Paris, 26–27 March 1958, lot 43); private collection (sale, Hôtel Drouot, Paris, 15 March 1989, lot 12); purchased in 1989 by Ian Woodner, New York (1903–1990); Ian Woodner Family Collection; gift to NGA in 1991.

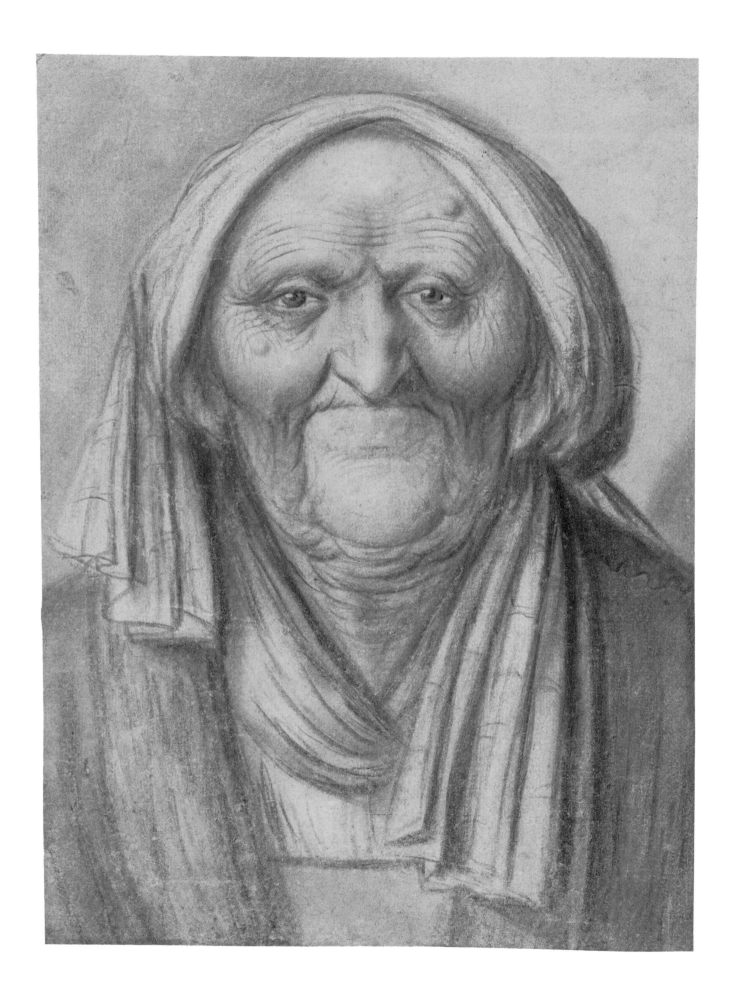

17 Simon Vouet · PARIS 1590 – 1649 PARIS
Creusa Carrying the Gods of Troy, c. 1635

black chalk heightened with white chalk on blue paper with framing line in brown ink
277 × 203 (10 5/16 × 8)
watermark present, undeciphered
Ailsa Mellon Bruce Fund, 1971.17.3

This outstanding study sheet is the work of Simon Vouet, one of the most influential figures in seventeenth-century French painting and the acknowledged father of the grand manner. The son of an obscure Parisian artist, Vouet was a prodigy who gained early recognition as a painter and rose quickly to the pinnacle of his profession. After traveling to Constantinople with the French ambassador in 1611, he settled in Rome in 1613, where he accumulated a number of honors, including many important commissions, the award of a pension from Louis XIII (1601–1643) in 1618, and his election as president of the Accademia di San Luca in 1624. Influenced at first by the tenebrist realism of Caravaggio (1571–1610), Vouet soon adopted a more Venetian sense of light and color combined with a type of classicism associated with the Carracci family in Bologna, but filtered through the vision of two of their former followers, Guido Reni (1575–1642) and Giovanni Lanfranco (1582–1647). When he was recalled to Paris in 1627

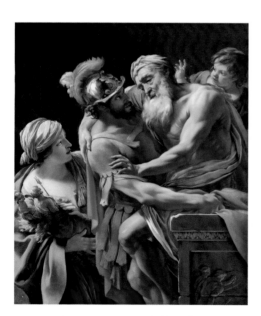

FIGURE 1: Simon Vouet, *Aeneas and His Family Preparing to Flee Troy*, c. 1635, oil on canvas. San Diego Museum of Art (Museum Purchase)

to take up the post of first painter to the king, Vouet achieved instant popularity with his new style. He quickly established himself as the painter of choice for the decoration of royal and noble residences in and around Paris, and his art became the model of excellence for several generations of French painters.

In preparing his paintings, Vouet adopted a system that was based on practices taught by the Carracci in their art academy, involving the production of many preliminary drawings, from the first compositional sketches through studies of individual figures and details of heads, hands, and drapery to the final model drawings.[1] The present study sheet—one of Vouet's most strikingly beautiful, in large part because of the freshness of the media and the bold blue of the paper—was identified in 1986 by Frederick Cummings as a study for the figure of Aeneas' wife, Creusa, in *Aeneas and His Family Preparing to Flee Troy* (fig. 1).[2] The figure in the drawing is very similar to the one in the painting, with only slight changes to Creusa's turban and mantle and to the shawl wrapped around the two idols—the household gods of Troy—that she is cradling in her arms; a trident is also added to the right-hand statue. Creusa's hands in the painting follow closely the positions of the separate hand studies at the top of the Washington sheet; presumably, Vouet would also have made a more detailed study of her head and face elsewhere. Here, the juxtaposition of the studies on the page is particularly elegant and the delineation of the figure of Creusa is exceptionally rich and pictorial. Vouet was an expert in combining black and white chalk to create full-bodied, monumental forms, but here he wields the media with such potent immediacy that Creusa is imbued not only with a remarkable vitality but also with a sense of urgency, a quality that is considerably muted in the painting.

By showing the Trojan gods in the hands of Creusa, Vouet at first seems to depart from the story as described by Virgil. In Book II of *The Aeneid*, we are told that old Anchises holds the statues as

he is carried out of the burning city on the shoulders of his son, Aeneas.[3] In the San Diego painting, however, Vouet specifically chose to portray a scene that takes place just before the family flees, when Anchises, responding to an omen, finally agrees to leave and Aeneas moves to lift him from his chair.[4] Once he is settled on Aeneas' back, Anchises will take the gods from Creusa, who has already wrapped them up in anticipation of their departure.[5] During the actual escape, Creusa will be lost and killed, but Aeneas, his young son, Ascanius, and Anchises all survive and the idols remain safe.

Both the Washington drawing and the related painting were clearly made after Vouet's return to Paris, when the artist was at the height of his powers, but opinions about the exact date of execution vary, ranging from the early 1630s to about 1640.[6] Indeed, establishing a chronology for Vouet's undated works is notoriously difficult. However, the dynamic movement of the figure toward the viewer in the drawing and the bold confidence of the strokes, together with some close compositional similarities between the San Diego picture and a painting of *Lot and His Daughters* in the Musée des Beaux-Arts in Strasbourg, dated 1633,[7] seem to point to a moment in the mid-1630s.

PROVENANCE
Private collection (sale, Sotheby's, London, 23 March 1971, lot 107); Yvonne Tan Bunzl, London; NGA purchase in 1971.

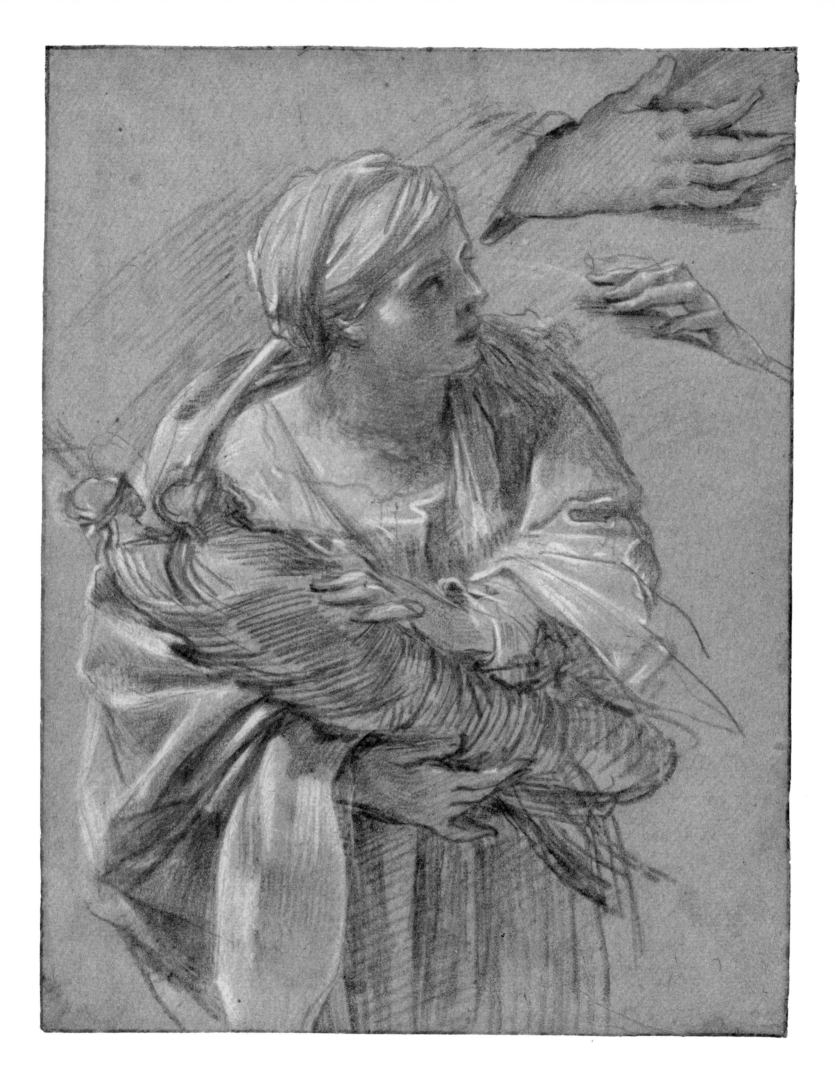

Nicolas Poussin · LES ANDELYS 1594–1665 ROME
Road along a Winding River, c. 1648?

pen and brown ink, squared in black chalk
107 × 165 (4 3/16 × 6 1/2)
verso: fragmentary letter written by the artist in pen and brown ink
Gift of Dr. and Mrs. George Baer, 1986.96.2

This small, staccato sketch is an unexpectedly spontaneous and abbreviated work by one of the most deliberate and rational masters of the seventeenth-century French classical style, Nicolas Poussin. Using a surprising array of short-hand jabs, flicks, and scribbles, he evokes a verdant corner of nature with figures strolling serenely along a tree-lined pool. The calmness of the scene is belied by the nearly feverish jitter of many of the pen strokes; from at least 1642 onward, the artist was afflicted by an intermittent and ever-worsening tremor that made it difficult for him to draw a smooth line. Here, the visible weakness in Poussin's hand adds poignancy to the drawing, while also bearing witness to the artist's unbowed spirit.

Poussin regarded drawing as an essential part of his activity as an artist and he made hundreds of studies over the course of his career.[1] Although his early training is poorly documented, he reportedly spent his youth "ceaselessly filling his books with an infinity of different figures that his imagination alone made him produce."[2] After his arrival in Rome in 1624, he continued to draw assiduously. For the landscape settings in his paintings, nature itself was his most important resource, and one of his favorite activities—called an "indispensable necessity" by Pierre-Jean Mariette, who once owned the Washington study[3]—was to

walk through the countryside outside Rome and draw what he saw there. Joachim von Sandrart (c. 1606–1688) wrote that some of these trips were made with Claude Lorrain (cats. 21–24) and other foreign artists in Rome.[4] What Poussin learned on his trips to the campagna he later translated in his studio into well-ordered and neatly groomed stagelike settings for his history subjects.

Although this small study is squared with a grid of black chalk for transfer, the precise scene has not yet been convincingly linked with any other paintings or drawings by Poussin. Pierre Rosenberg and Louis-Antoine Prat noted some similarities with the distant landscape visible in the upper right corner of the drawing *The Birth of Bacchus* (Fogg Art Museum, Harvard University, Cambridge), made in preparation for the corresponding painting (also in the Fogg) of 1657, though that connection seems very slight.[5] Much closer in many of the details is the left part of Poussin's painting *Landscape with the Funeral of Phocion* (fig. 1), where pairs of figures walk along a wide path that curves along the edge of a body of water, just as they do in the Washington sketch. As in the drawing, the path in the Phocion picture also winds around irregular hummocks of earth and rock, but whereas the drawing shows only natural forms, the canvas features a number of massive buildings. If the Washington sheet can plausibly be

connected to that composition, then it can be dated to about 1648, the year given by André Félibien as the date of the painting.[6] The relationship may be more generic than specific, however, for the marked tremor in the strokes of the drawing could indicate that it was actually made some years after that picture, in the mid- to late 1650s.

Landscape studies drawn only in pen and ink are quite rare in Poussin's oeuvre, and the attributions of many that are ascribed to him are problematic.[7] Closest to the Washington sheet in many ways—though larger, more complete, and more precisely executed—is one in the British Museum, London, dating from 1649/1650.[8] Coincidentally, both drawings bear on their versos long drafts of letters written by Poussin to his friend Paul Fréart de Chantelou (1609–1694), but are otherwise unrelated in content. Since the Washington sheet was trimmed on both sides and the bottom, the text of that letter unfortunately does not make much sense, but it does contain several references to copying and mentions Poussin's friend Cassiano dal Pozzo (1588–1657) in the French form of his name, Chevalier du Puy. Presumably excess paper around the landscape study was cut away to improve its appearance, resulting in the loss of part of the letter. This may have been done by Mariette, a knowledgeable and voracious eighteenth-century collector who owned the drawing and would have been more interested in the sketch than in the contents of the letter. In any case, it was certainly Mariette who affixed the study to the type of blue mount he reserved for his best drawings, for he no doubt regarded even the smallest scrap from the hand of an iconic artist like Poussin as a cherished prize.

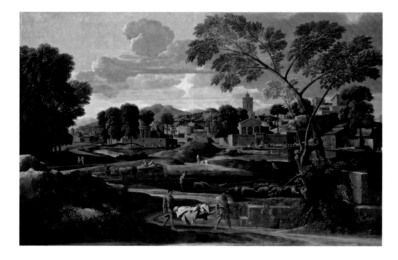

FIGURE 1: Nicolas Poussin, *Landscape with the Funeral of Phocion*, c. 1648, oil on canvas. Earl of Plymouth, Oakly Park, on loan to the National Museum of Wales, Cardiff

PROVENANCE
Pierre-Jean Mariette, Paris (1694–1774) (Lugt 1852; sale, Paris, 15 November 1775–30 January 1776, part of lot 1328 or 1329); Maurice Marignane, Paris and Marseille (b. 1879) (Lugt 1872); Hans M. Calmann, London (1899–1982); Curtis O. Baer, New Rochelle, New York (1898–1976); his son and daughter-in-law, Dr. and Mrs. George Baer, Atlanta, Georgia; gift to NGA in 1986.

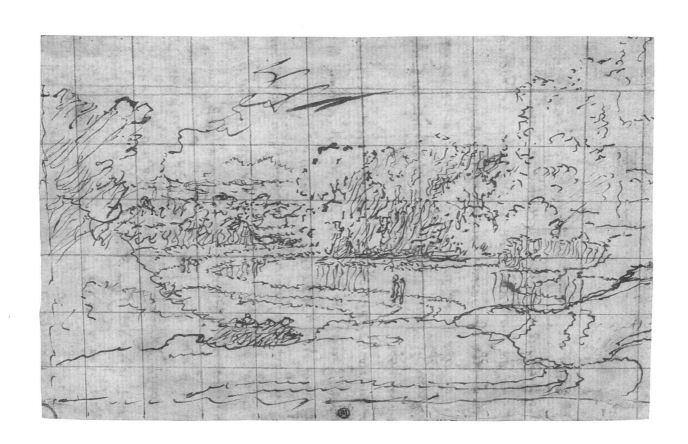

Jacques Stella · LYON 1596–1657 PARIS
October: Honey-Gathering, c. 1645

pen and brown ink with gray wash over graphite, corrected with white gouache
227 × 301 (8 15/16 × 12 1/16)
Promised gift of Donald Stone

One of the preeminent French painters of the seventeenth century, Jacques Stella enjoyed the patronage of kings, cardinals, and princes, yet within decades of his death, his fame was eclipsed.[1] He had earned the highest honors—being named first painter to Louis XIII (1601–1643) and knighted as a member of the chivalric order of Saint-Michel (an exceptional rarity for an artist)— yet by the middle of the eighteenth century his standing had declined so far that he was remembered only as just another follower of Nicolas Poussin (cat. 18). Indeed, many of Stella's works were already misattributed to Poussin himself, his close friend from a seventeen-year stay in Italy (1617–1634) and his occasional collaborator. Only very recently has Stella been fully restored to his proper place in the pantheon of major French artists.

Drawing was an integral part of Stella's working process, but it was also a form of entertainment for him: he frequently spent the evening hours, when there was not enough light to paint, making series of finished drawings on a variety of themes.[2] Sometimes he chose the kind of serious biblical subjects he treated in his large-scale altarpieces and smaller devotional pictures—The Passion, for example, and the Life of the Virgin[3]—but more often he drew more lighthearted genre scenes, including children playing, country pastimes, and allegorical renderings of the months and the seasons. He appears to have retained possession of most of these sheets, for upon his death in 1657 his family inherited more than one thousand drawings by his hand.[4] His three nieces, all trained as printmakers, took advantage of this cache of ready-made model drawings by their uncle to make and publish prints after them.[5] As it happens, this particular composition of *October* was engraved in reverse, not, apparently, by one of the nieces but by an as-yet-unidentified printmaker, as part of a series of the Twelve Months of the Year published by Jean Mariette in the late seventeenth century.[6]

This scene of country folk banging pots at a swarm of bees is one of four surviving drawings by Stella for that set, each one showing rustic activities appropriate to the month represented. The three others, all executed in the same medium and corresponding closely in size, are *February: Masquerade* (private collection); *June: Sheep-Shearing* (Fogg Art Museum, Harvard University, Cambridge); and *September: Apple-Picking* (J. Paul Getty Museum, Los Angeles).[7] All four drawings are remarkable not only for the overall completeness of the conception and rendering but also for the imaginative and realistic details that add charm and authenticity to each scene. To represent the month of October, Stella chose to depict not the actual gathering of honey, but rather an activity called "tanging"—the raucous beating of pots and pans (and in the case of the little boy at right in the drawing, one of his wooden shoes)—that was thought to encourage a swarm of bees to alight.[8]

Seen against an extensive landscape, the foreground figures are remarkably sculptural in form and attitude and they move with a stately, dance-like grace that belies their cacophonic occupation. The overall style of the drawing and the rendering of the figures find their closest equivalents in Stella's studies from the mid-1640s, such as *The Baptism of Christ* (Musée du Louvre, Département des Arts graphiques, Paris) of 1645, and one of Stella's largest and most elaborate drawings, *The Rest on the Flight into Egypt* (private collection), signed and dated 1646.[9] In contrast to the somewhat self-conscious formality of those religious pieces, however, *October* presents a more relaxed and naturalistic type of scene that not only reflects Stella's close observation of the world around him but also underlines his personal affection for subjects taken from daily life.

PROVENANCE
Eric Coatelem, Paris, 2001; Donald Stone, New York (b. 1942).

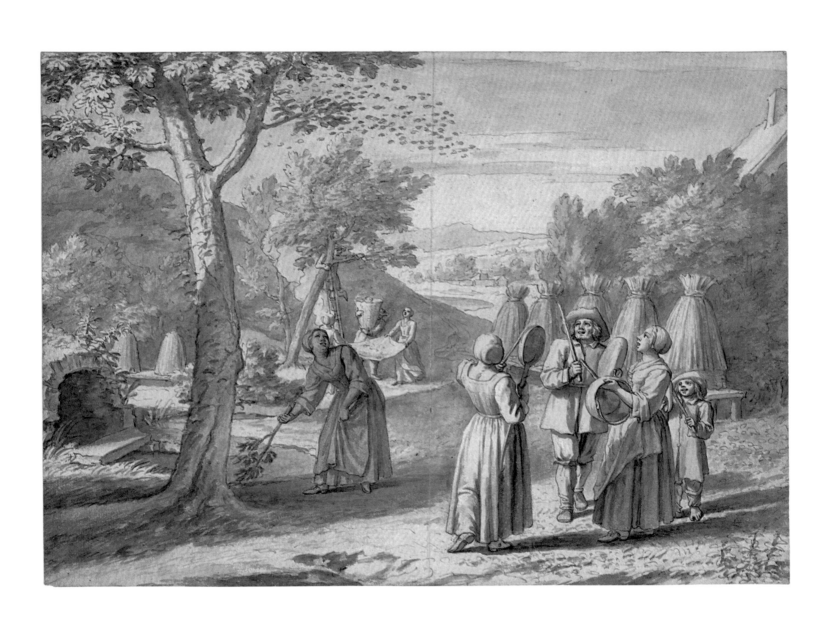

Laurent de La Hyre · PARIS 1606–1656 PARIS
The Presentation in the Temple, c. 1648

black chalk and gray wash with framing line in black ink
446 × 291 (17 9/16 × 11 7/16), arched top
inscribed by the artist in black chalk at center on the bottom step: *par la [parle? porte? pour?] Raison*; inscribed by another hand in pen and brown ink at lower right: *La Hire.*; inscribed in another hand, apparently German nineteenth-century, in graphite across the bottom of the mount: [illeg.] *van Suchtelen, Chevalier de Damery (Paris, 18. Jh) u. J. B. Glomy (Paris 19. Jh)*; verso, inscribed in brown ink at center: *Charlotte Ganault*; and in another hand in brown ink at lower right: *Damery/1757*
Julius S. Held Collection, Ailsa Mellon Bruce Fund, 1984.3.14

Laurent de La Hyre made this magisterial composition in preparation for a painting, signed and dated 1648, that was discovered only in the mid-1980s, in a parish church in the department of Loiret, about eighty-five miles south of Paris (fig. 1). Nothing is known about the origins of the painting, which is now in exceptionally poor condition, neither for whom it was made nor for which church; the date of its arrival in the town of Château-Renard, where it now resides, is also not recorded. Originally executed in the same format as the Washington drawing, the painting is now rectangular: the arched top was cut off at an unknown date.[1] The painted composition otherwise follows quite closely the disposition of the figures and the architectural setting in the National Gallery sheet, with some adjustment of the details. The fluted columns in the drawing, for example, are smooth in the painting; the arch in the background is moved to the right to better frame Joseph's head; and the circular

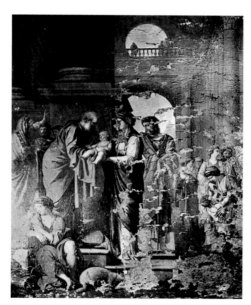

FIGURE 1: Laurent de La Hyre, *The Presentation in the Temple*, 1648, oil on canvas. Château-Renard (Loiret) (from the reproduction in exh. cat. Grenoble and elsewhere 1989–1990, 279)

window above the arch is enlarged and a balustrade is set in front of it. The poses of the principal figures are very similar in both, though the drawn figures are slightly more relaxed and less stiffly upright in bearing than their painted counterparts. As a result of the removal of the arched top from the painting, the figures there appear larger and more monumental than in the drawing, and the space seems to be significantly more compressed.

The National Gallery drawing is a prime example of the highly structured and emotionally restrained style known as Parisian Atticism, which evolved in the work of La Hyre, Jacques Stella (cat. 19), and a few of their contemporaries in the 1640s, driven in part by the temporary return of Nicolas Poussin (cat. 18) to Paris in 1640–1642. A modern reinterpretation of the classical ideal (hence the name referencing Attica and ancient Greece), this austere and highly refined manner relied on a strongly geometrical, gridlike compositional structure—created here mainly through the architectonic setting—and calmly dignified figures in ancient draperies presented in statuelike attitudes. In his drawings, La Hyre softened the rigidity of the compositions with his feathery chalk strokes, delicate handling of the light, gracefully draped fabrics, and sweet facial expressions. His favorite combination of media was the black chalk and gray wash he used here, sketching out the entire composition in chalk and then using light gray wash to add subtlety and depth to the shadows. Closely comparable in style and execution is a series of seventeen drawings from about 1646/1647 (Musée du Louvre, Département des Arts graphiques, Paris), made for a set of tapestries illustrating episodes from the life of Saint Stephen.[2] Several of these have architectural settings similar to the one in the Washington sheet, including steps in the foreground, columns placed on tall plinths, and high arches.[3] Another drawing from approximately the same period, also stylistically similar but perhaps not quite as fine in execution, is *Cornelia, Mother of the Gracchi, Refusing Ptolemy's Crown* (Ashmolean Museum, Oxford).[4]

La Hyre came relatively late to the strongly classicizing style of these drawings, having immersed himself in every step of his training in the more self-consciously affected mannerist tradition. He first studied with his father, Étienne (c. 1583–1643), a well-to-do painter turned wine inspector, before spending three years at the royal château of Fontainebleau, from 1622 to 1625. He then worked with Georges Lallemant (c. 1575–1636), an artist from Nancy who was also steeped in the mannerist style. Unlike so many of his compatriots, La Hyre never traveled to Italy to complete his artistic studies, but instead remained in Paris, where his career prospered. He was admired in particular for his command of perspective and architecture, which played important roles in the construction of his compositions throughout his career. From about 1630 onward, he received numerous important commissions, first from the churches and monastic orders, and then from wealthy private patrons, including Cardinal Richelieu (1585–1642). La Hyre's move toward a more classicizing style and his participation in the development of Parisian Atticism in the 1640s immediately preceded the founding of the Académie royale de peinture et de sculpture (hereafter Académie royale) in Paris in 1648 and his assumption of a leadership role as one of its original twelve professors or "ancients." In that capacity he ensured his place as one of the key exemplars of the peculiarly French version of classical art that flourished during the reign of Louis XIV.

PROVENANCE

Possibly Charlotte Ganault, whose name is inscribed on the verso in what appears to be a seventeenth-century hand; unidentified collector (mark at lower right in red-brown, P B surmounted by a crown, century unknown; not in Lugt); Chevalier de Damery, Paris (d. c. 1803) (Lugt 2862), by 1757, with his mount made by the eighteenth-century mountmaker J. B. Glomy (Lugt 1119); Count J. P. van Suchtelen, Saint Petersburg (1751–1836) (Lugt 2332); private collection (sale, Dorotheum, Vienna, 2 June 1964, lot 270, pl. 92); purchased by Julius S. Held, Bennington, Vermont (1905–2002) (his mark, JSH in ligature, in black ink on the verso, not in Lugt); gift to NGA in 1984.

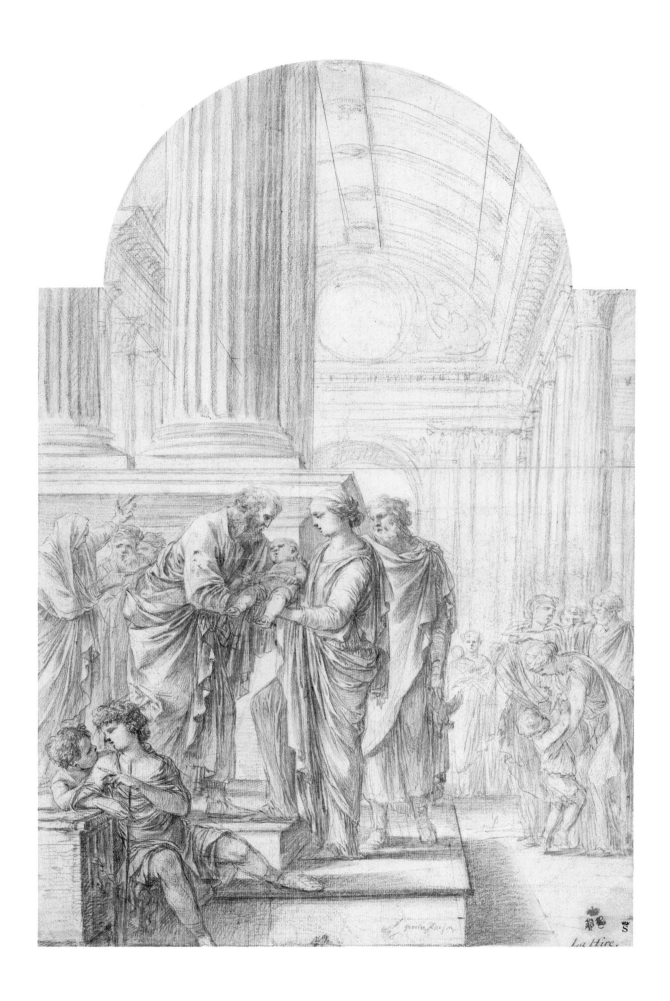

21 Claude Gellée, called Claude Lorrain

CHAMAGNE (LORRAINE) 1604/1605 – 1682 ROME

Landscape with a Bridge, 1630/1635

pen and brown ink with brown wash over black chalk
205 × 269 (8 × 10 9⁄16)
Gift of Mr. and Mrs. Ronald S. Lauder, 1981.68.1

From the very beginning of his long career, Claude Lorrain (so-called for his place of birth) devoted himself to the study of nature, basing his paintings on an unusually intimate understanding of the world around him. He made regular forays into the countryside around Rome to sketch, but the drawings he produced there were not intended to serve as specific models for his paintings. Rather, Claude used them as a means to probe deeply into the outward appearance and underlying forms of animate and inanimate objects, the characteristic features of terrain and topography in the Roman campagna, the movement and reflective qualities of water, and above all the visual effects of light and atmosphere. He then took what he learned on these sketching trips and constructed a new kind of ideal landscape, firmly rooted in nature but more perfect and rationally organized. Claude's landscapes became prized and admired for their Arcadian tranquility, brilliant light (often with a rising or setting sun), balanced compositions, and keen observation of nature. His new vision of the world served as the model and inspiration for generations of artists in Europe—and later in America—well into the nineteenth century.

In spite of Claude's reputation as one of the great landscapists of all time, the details of his life remain largely obscure. Born in the duchy of Lorraine of peasant stock, he went off to Rome as a young teenager and except for a year in 1625–1626 spent working with Claude Deruet (cat. 12) back in Lorraine, he passed the rest of his career in Italy. Whether he first arrived in Rome to perfect his talents as a pastry chef, as Joachim von Sandrart (1606–1688) claimed, or to further his education as a painter, as Filippo Baldinucci (1625–1697) noted,[1] remains unclear, but he did study with the German painter Goffredo Wals (c. 1595–1638) in Naples in about 1620 and thereafter with Agostino Tassi (1578–1644) in Rome. Claude lived for many years in the part of Rome frequented by foreign artists, and he is known to have made sketching trips into the Roman campagna with his fellow countryman Nicolas Poussin (cat. 18) as well as with northern artists such as Sandrart and Pieter van Laer (c. 1592–1642).[2] From the 1630s onward, Claude enjoyed the patronage of many noble families in both France and Italy and quickly established himself as one of the leading artists working in Rome.

Many of Claude's nature studies, most of which were made during the first decades of his career, are drawn in a remarkably free, nearly abstract manner with bold sweeps of rich brown wash and bright reserves of white paper.[3] Sometimes he used a pen to add definition and texture to the forms, as he did here; otherwise he relied only on his brush to create dramatic contrasts of light and shade. In the drawing presented here, the darkness of the elements in the foreground and the shadowing of the trees in the middle ground heighten the sense of brilliant sunlight illuminating the bridge and emphasize both the solid geometry of the stone supports and the angularity of the wooden span. The broadly generalized, rather schematic handling of the foliage and the simplified outlining of the forms suggest that this sheet dates from relatively early in Claude's career. Marcel Roethlisberger placed it in about 1638, but H. Diane Russell suggested, more plausibly, that it was made in or before 1635.[4]

The drawing was one of eighty-one originally contained in the so-called Wildenstein album (also called the Norton Simon album), now dispersed.[5] That album was probably put together after Claude's death by his heirs and consisted of a particularly impressive selection of works from the full length of the artist's career. Included in the same album was another depiction of the bridge seen in the Washington drawing (private collection, New York).[6] The identical span appears again in a third sheet (location unknown), which bears an inscription identifying it as the Ponte di Molo near Tivoli.[7] Although bridges are common elements in Claude's compositions, this particular one does not appear in any of his paintings.

PROVENANCE

(?) Queen Christina of Sweden (1626–1689), in Rome from 1655–1689; Don Livio Odescalchi, Duke of Bracciano, Rome (1652–1713), and by descent in the Odescalchi family until the late 1950s; private collection; Mr. and Mrs. Ronald S. Lauder, 1970s; gift to NGA in 1981.

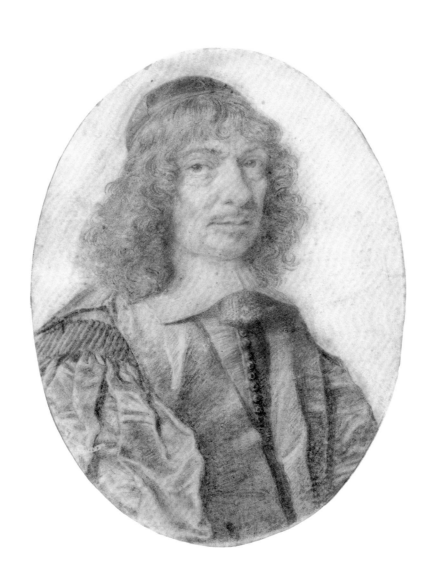

26 Atelier Assistant of Charles Le Brun

FRENCH SCHOOL, SEVENTEENTH CENTURY

Head of a Macedonian Soldier, c. 1668

pastel with black, red, and white chalk with framing line in brown ink
390 × 285 (15 5/16 × 11 3/16)
inscribed in brown ink at lower left: *C le Brun,* and at lower right: *92*
Julius S. Held Collection, Ailsa Mellon Bruce Fund, 1984.3.15

Until very recently, this arresting pastel was universally thought to be the work of Charles Le Brun (1619–1690), the nearly omnipotent painter to Louis XIV (1638–1715) who directed artistic activities at Versailles and at the Gobelins tapestry manufactory on the outskirts of Paris for nearly three decades. The pose, expression, and helmet of the man in the study are exactly the same as those of a warrior in the center foreground of Le Brun's monumental painting *The Battle of Arbela* (fig. 1), completed before February 1669 and one of a series of five works depicting famous battles and triumphs of Alexander the Great.[1] In recent years, however, some scholars have expressed doubts as to the pastel's authorship, suggesting that it might be the work of Le Brun's pupil and collaborator François Verdier (cat. 30),[2] who is known to have made pastel copies after some of the heads from Le Brun's Alexander paintings.[3] However, the National Gallery drawing appears to have very little in common with three suavely finished and quite refined pastels of heads in the Musée du Louvre, which are indeed copied from the Alexander paintings and are plausibly thought to belong to the Verdier group.[4] In fact, its visual effect is opposite in nearly every respect to the Louvre trio, from the raw power of its execution to the unblended intensity of the colors.

Ultimately, the energetic wielding of the chalks and the numerous pentimenti in the shaping of the man's helmet in the Washington pastel argue

against its classification as a copy, but there is currently not enough information to identify with certainty the particular artist who was responsible for making it. The idea that its author was Verdier may yet prove to be correct, but unfortunately nothing is known about his work as a pastellist beyond the copies in the Louvre. Furthermore, no pastels of this type have yet been found that can be attributed to any other members of Le Brun's vast army of assistants, which included at various times Charles de La Fosse (cats. 32, 33), Claude Audran II (1639–1684), René-Antoine Houasse (c. 1645–1710), Adam Frans van der Meulen (cat. 27), Louis Licherie (1629–1687), Michel Corneille II (cats. 28, 29), Louis de Boullogne the Younger (cat. 34), and Jean Jouvenet (1644–1717), among many others. In that immensely busy and productive workshop, Le Brun would have frequently delegated tasks to his assistants at every stage of the production of his works, entrusting even important and prominent passages to his most advanced collaborators.

For the set of Alexander's battles alone, three of which (including *The Battle of Arbela*) measure more than 4.5 by 12.5 meters, hundreds of drawings were made in preparation, many by Le Brun himself, but quite a number by his assistants.[5] Almost fifty surviving drawings in the Louvre show the development of *The Battle of Arbela*,[6] including three featuring the Macedonian warrior in the National Gallery study. One is an

early compositional drawing in which the soldier appears prominently in the foreground in a pose that is already very close to the one used in the final painting; another is a handsome study sheet filled with several sketches of the figure and related details; and the last is a quick sketch of his head included on another sheet.[7] The National Gallery drawing was most likely made toward the very end of the preparatory process, possibly to serve as a model for the artist who was assigned to depict the Macedonian soldier in the final canvas. No other pastel studies relating to any of the Alexander paintings are known, however, so it is uncertain whether pastels such as this one were produced regularly in Le Brun's studio, or if this work was made in response to some unusual circumstance. In fact, even in the Louvre's encyclopedic collection of drawings by Le Brun and members of his studio, the surviving pastels— other than the Verdier copies—consist only of a few portraits, most notably of Louis XIV, and a number of figure studies for tapestry designs.[8]

PROVENANCE

Julius S. Held, Bennington, Vermont (1905–2002) (his mark, JSH in ligature, in black ink on the verso, not in Lugt); NGA purchase in 1984.

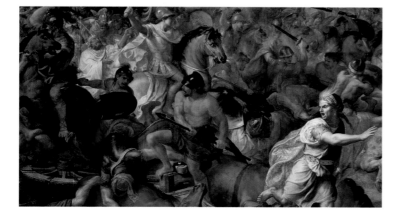

FIGURE 1: Charles Le Brun, *The Battle of Arbela* (detail), 1669, oil on canvas. Musée du Louvre, Paris

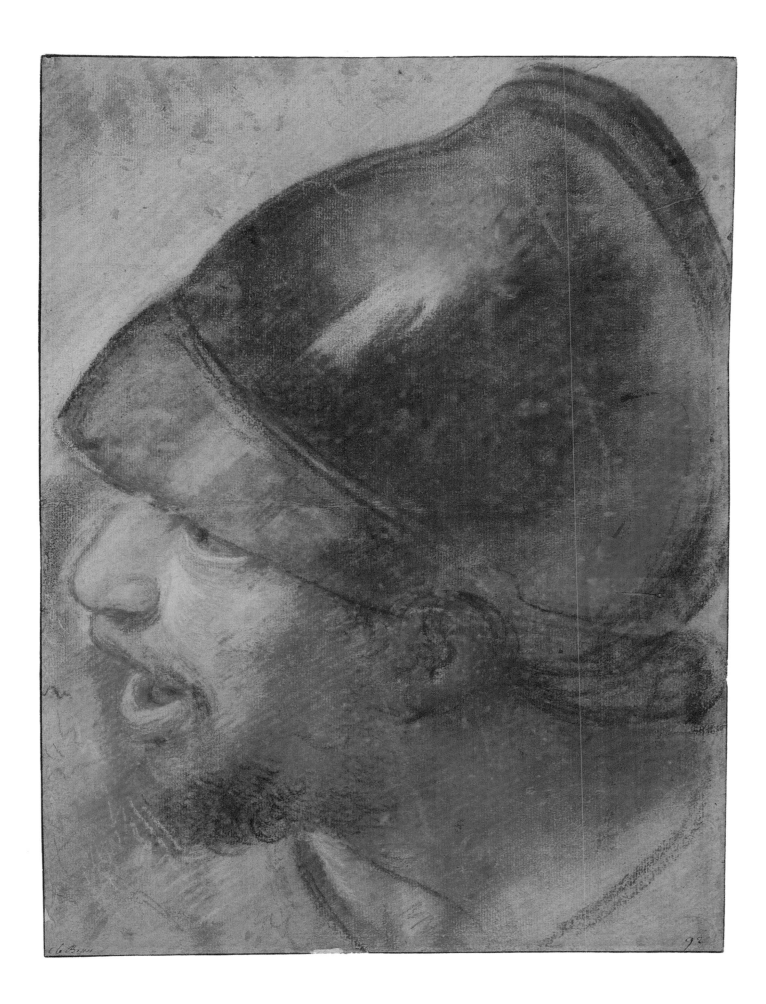

27 Adam Frans van der Meulen · BRUSSELS 1632–1690 PARIS
French Troops before Salins and the Surrounding Hills
1668/1670

red chalk over black chalk surrounding red chalk counterproof, on two joined sheets, incised overall for transfer
488 × 1328 (19 1/8 × 52 1/4)
The Ahmanson Foundation, 2008.88.1

At the same time that the evolution of the idealized, classical landscape was reaching its height in Italy in the works of Claude Lorrain (cats. 21–24) and Nicolas Poussin (cat. 18), a less formal and more naturalistic style influenced by the northern traditions from Holland and Flanders was also developing in France. This second vision of landscape, which featured a heightened sense of realism that was sometimes combined with topographical precision, was ideally suited to—and became a prominent part of—the tapestries, paintings, and prints commissioned by Louis XIV (1638–1715) to celebrate his achievements as a monarch, most notably his expansion of France's borders through military conquest. The accurate rendering of the places he had subjugated was an important element of the king's personal campaign of self-aggrandizement, and the Flemish painter Adam Frans van der Meulen was among the principal artists who played a key role in this.

Van der Meulen learned his craft in his native Brussels, studying with the court painter Pieter Snayers (1592–1667) for five years before entering the Brussels painters' guild as a master in 1651. As a specialist in depicting battles and landscapes, he was invited by Charles Le Brun (1619–1690) in 1664 to work at the newly founded Gobelins tapestry manufactory in what is now the thirteenth arrondissement of Paris. There he undertook a variety of projects, including the publication of a large set of prints recording views of the châteaux and civic buildings belonging to the crown, undertaken with Israël Silvestre (1621–1691),[1] and an important group of tapestries known as *The History of the King*.[2] Van der Meulen apparently had a knack for getting along at court and managed to curry favor with a host of important patrons, including the king himself, who stood as godparent to one of the artist's many children.

Another indication of the special status Van der Meulen enjoyed as a favorite of the king was his admission to the Académie royale in 1673 without submitting the requisite reception piece. He remained in France for the rest of his life, having become a naturalized citizen in 1672.

Van der Meulen made the present drawing as part of his work in 1668/1670 in preparation for a set of large engravings (matching the size of this drawing) that commemorate Louis' conquest of the Franche-Comté region, now part of eastern France. In the distance it shows the town of Salins, seen from the south in the valley of the Furieuse River, nestled below three mountains. The troops of the duc de Luxembourg (1628–1695), one of Louis XIV's courtiers and generals, are leaving the town after securing it for the king in early February 1668. This particular drawing was made at the end of the carefully considered creative process that Van der Meulen used in the production of the views, which would then be engraved by professional printmakers, most notably Adriaen Frans Boudewijns (1644–1711), a fellow Fleming who married Van der Meulen's sister in 1670. The process began with a trip to the Franche-Comté in 1668, when Van der Meulen traveled to Salins to make a large-scale graphite drawing of the town in situ (Musée du Louvre, Département des Arts graphiques).[3] After returning to his studio, he then made a very precise copy in red chalk of the same view on the same large scale (now lost). From this he took the counterproof—thus reversing the view—that is seen here as the central part of the National Gallery drawing.[4] In this way, he ensured that the landscape, which would be reversed again in the printmaking process, would be seen in the correct orientation in the final engraving. Van der Meulen then completed the composition by adding all the figures, expanding the landscape on both sides and the bottom, and completing the sky. The whole design was then incised in order to transfer it to the copper plate.[5]

While the figures in the National Gallery drawing are executed in a rather loose style with numerous pentimenti, the landscape is rendered with exceptional beauty and refinement, demonstrating why Van der Meulen's talents in this genre were so valued by the king. His delineation of the town, the mountain crags, the vineyards, the farm buildings, and all the other features of the countryside around Salins is remarkable not only for the attention to detail but also for the fine precision of the strokes. The parts of the landscape that he added around the counterproof are slightly more broadly drawn than the central view of the town, but the two parts are so dexterously integrated that the transitions between them are completely seamless.

Hundreds of drawings by Van der Meulen are preserved in the French national collections in the Département des Arts graphiques at the Louvre and the Mobilier national, Paris.[6] Among them are many other drawings related to the artist's work on the prints commemorating the king's conquests, but only a few of the red chalk transfer drawings are known, making the Washington sheet a rare survivor.[7]

PROVENANCE
French private collection until 2004; Didier Aaron, London; NGA purchase in 2008.

28 Michel Corneille II · PARIS 1642–1708 PARIS
The Purification of Aeneas, c. 1663

pen and brown ink with blue wash over traces of graphite, squared in graphite, with framing line in brown ink
227 × 334 (9 15/16 × 13 1/8)
signed in pen and brown ink on the pedestal at center: *Corneille* (partially abraded), and signed(?) again in pen and black ink at lower left: *M. Corneille*.; inscribed in graphite on the verso at center, below a graphite study of a kneeling woman with a staff: *Corneille del.*
watermark: three stars in a circle
Ailsa Mellon Bruce Fund, 1994.1.1

This handsome work with the striking blue washes is the work of Michel Corneille II, one of the leading painters in Paris in the second half of the seventeenth century.[1] A precocious talent who was the son and brother of painters, he trained first with his father Michel (1601–1664), one of the twelve founders of the Académie royale and also its rector, and then with Charles Le Brun (1619–1690) and Pierre Mignard (1612–1695). At the age of only seventeen, Corneille won a special prize from the Académie — before the Prix de Rome was officially instituted — that took him to Italy for four years of study. There he was particularly enthralled by the art of Annibale Carracci (1560–1609), whose work he copied extensively; he also studied closely the works of Nicolas Poussin (cat. 18) and Raphael (1483–1520). Upon his return to Paris in 1663, Corneille was admitted as a member of the Académie royale and his career flourished thereafter with patronage from both the church and the court. Many of his most important works have not survived, however, and his reputation has languished since the eighteenth century. In recent years it was further tarnished by the discovery that he had retouched with white gouache a large number of drawings by other masters in the collection of Everard Jabach (1618–1695) — most now in the Musée du Louvre, Département des Arts graphiques, Paris — thus permanently compromising their appearance.[2] Also diluting the quality and character of his oeuvre are innumerable tracings and copies that are neither elegant nor particularly attractive.[3] Corneille was nevertheless one of the major artists of his time, and as more work is done on his oeuvre, he will surely regain some measure of his former standing.

The present drawing seems to be a work from Corneille's youth, made either in Rome, as the Italian origin of the paper would suggest,[4] or shortly after his return to Paris. It is ambitious in conception and accomplished in execution, indicating the hand of an artist who is already well skilled in his craft. The organization of the composition, the evocation of classical antiquity, and even the figure types show the young Corneille translating the lessons he was learning from his favorite exemplars — especially Poussin and Carracci — into his own idiom. Here, the influence of Poussin is particularly strong, especially his late paintings of mythological subjects such as *The Birth of Bacchus* (Fogg Art Museum, Cambridge), done in 1657 for his close friend and contemporary the artist Jacques Stella (cat. 19).[5] Corneille declares his emerging individuality, however, both in his choice of blue wash, rare even for himself, since he typically used brown or gray wash, and in his lively pen work and use of light to animate the scene. The squaring indicates that the drawing was probably made in preparation for a painting, but nothing is known about the project or if it was ever completed. Corneille did execute a print of the same subject, which is significantly different in composition;[6] he also made two other drawings of it, one in the Graphische Sammlung Albertina, Vienna, and the other in the print room of the Warsaw University Library.[7] Of those two, the Warsaw sheet has more in common with the National Gallery drawing, presenting essentially the same cast of characters (but with the addition of Jupiter and Ganymede), differently disposed and placed in a more landlocked setting.

The story of Aeneas' purification and deification is told by Ovid in Book XIV of the *Metamorphoses*.[8] The Trojan warrior's mother, Venus, pleaded with Jupiter and the other gods to deify her son so that he would not have to again cross the river Styx and reenter the noxious precincts of Pluto, which

he had already visited on his long journey from Troy to Latium. Having received the agreement of all the gods, she went to the river god Numicius and asked him to wash Aeneas' body to remove all its mortal impurities. In Corneille's drawing, Venus watches from a cloud as the bearded Numicius and two nymphs cleanse her son, half-reclining on the ground on the bank of the Numicus River. The inclusion of the rising sun in the form of Apollo, who is not mentioned by Ovid, may have been intended to have a symbolic meaning, referring to Aeneas' resurrection as a god.[9]

PROVENANCE

Private collection (sale, Drouot-Richelieu, Paris, 22 November 1991, lot 36); Succi Limited, London; NGA purchase in 1994.

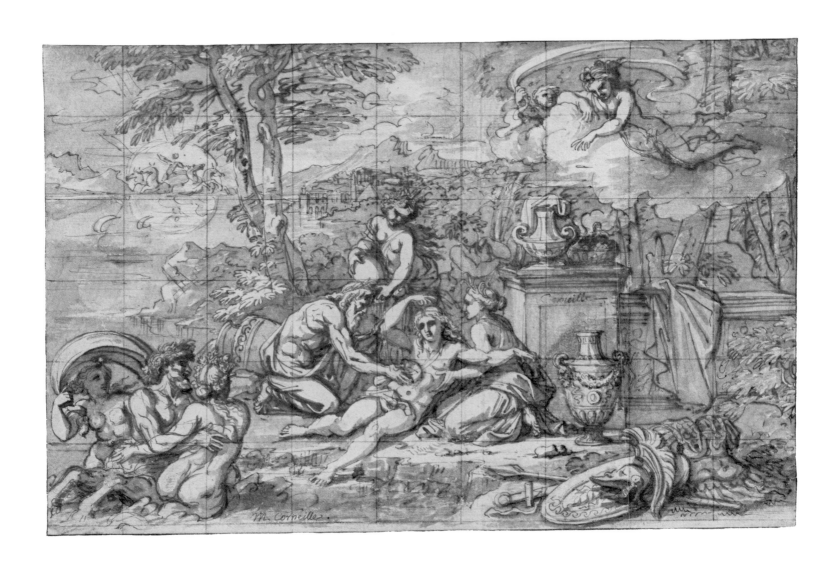

Michel Corneille II · PARIS 1642 – 1708 PARIS
Studies of Women's Heads, 1680s or 1690s

black and red chalk heightened with white chalk on light brown paper with framing line in brown ink
288 × 187 (11 5/16 × 7 3/8)
inscribed by the artist in black chalk across the bottom: *le nez Et le visage un peu Court*
Ailsa Mellon Bruce Fund, 1986.16.1

In addition to elaborate compositional drawings like the preceding work (cat. 28), Corneille also made numerous study sheets filled with sketches of individual figures, heads, hands, and other details executed in preparation for his paintings and tapestry designs. In several sheets, including this one, he specifically studied heads, drawn either in black chalk heightened with white or, as here, in the combination of red, black, and white chalks known in France as *trois-crayons*.[1] The National Gallery sheet is a particularly engaging example of this type of drawing by Corneille, with several studies of the heads of young women arranged attractively on the page. Characteristic of his hand are the light, confident touch; the assured mixture of the three chalks; the delicate, open network of strokes that create the shadows; and the deft touches of white that form the highlights. Such sheets of sketches recall the work of Corneille's third teacher, Pierre Mignard (1612 – 1695), who was also accustomed to combining a mélange of chalk studies on a single page in a similar manner. Also reminiscent of Mignard, who sometimes annotated his drawings with brief inscriptions, Corneille wrote across the bottom of the Washington sheet: "the nose and the face a little short."[2]

Because there is no catalogue raisonné of Corneille's corpus—and indeed, very little has

been written on his work at all—it is sometimes difficult to connect his drawings to finished projects. Five of the heads on this sheet, however, seem to be related to Corneille's preparations for a painting of *Juno Commanding Aeolus to Unleash the Winds* (location unknown, perhaps never completed), which is known through two compositional drawings: a pen-and-wash sketch in the Victoria and Albert Museum, London (fig. 1), and a more finished red chalk drawing heightened with wash and gouache that was sold in Paris in 1988.[3] Most closely related to both compositions is the study at upper right on the Washington sheet, which corresponds very exactly to the head of the central figure of Juno in overall pose and expression, and even shows a similar diadem in her hair. Four other heads from the National Gallery drawing appear to have been made in preparation for some of the handmaidens surrounding Juno, at least as their poses were roughed out in the London sheet. These connections are a bit more speculative because of the sketchiness and overall lack of specific detail in that composition, but the tilt of the head, twist of the neck, and angle of the glance of each of the figures seem to correspond. The study at upper left, for example, appears to be related to the attendant situated just behind and above Juno's hip in the London sketch, while the study at right center may be linked to the

handmaiden seen just above Juno's legs. The head study at lower left may be connected to the winged figure supporting Juno at center, while the one at lower right could be related to the figure reclining in the clouds to the left of the goddess' feet. Even after making these individual head studies, Corneille apparently continued to refine the poses and the composition as a whole. By the time he completed the second and more detailed larger version of the composition that passed through the Paris showrooms, each of the figures was changed in such a way that the relationship with the Washington study sheet was no longer so clear.

With no datable work to connect it to, or any other internal evidence to go by, establishing a date for this drawing is quite problematic. It is surely a more mature work than the National Gallery's compositional study (cat. 28), most likely made in the early 1660s, but otherwise it could have been produced at just about any other point in Corneille's career. The winsome sweetness of the faces and the sophisticated play of gazes down the page, however, suggest that these studies may belong to a relatively late phase, no earlier than the 1680s and perhaps as late as the 1690s. That would place it during the period when the weighty classicism of the seventeenth century was being transformed into the lighter, more insouciant idiom of the eighteenth century. In many ways, this drawing anticipates the great sheets of head studies executed by Antoine Watteau (cats. 39 – 44) in the late 1710s using the same *trois-crayons* technique, even to the linking of the individual studies into a continuous, curving motion on the page.[4]

FIGURE 1: Michel Corneille II, *Juno Commanding Aeolus to Unleash the Winds*, 1680s or 1690s, pen and ink with wash. Victoria and Albert Museum, London

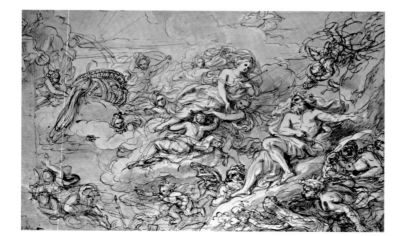

PROVENANCE
Private collection (sale, Christie's, London, 11 – 13 December 1985, lot 171); NGA purchase via David Tunick in 1985.

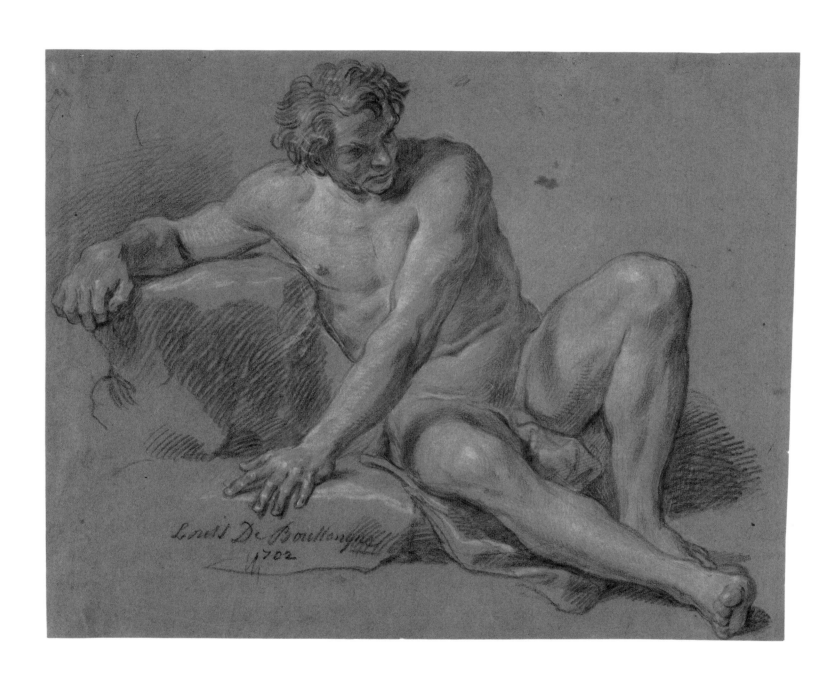

Antoine Coypel · PARIS 1661 – 1722 PARIS
Seated Faun, 1700/1705

red and black chalk heightened with white chalk on blue paper
402 × 274 (15¾ × 10¾)
watermark: P
Gift of Lois and Georges de Ménil, in Honor of the 50th Anniversary of the National
Gallery of Art, 1989.65.1

This enchanting drawing belongs to a small group of studies by Antoine Coypel of fauns supporting floral garlands, all seen from below and all brilliantly executed in *trois-crayons*. Two are in the Ashmolean Museum, Oxford, and the National Gallery of Canada, Ottawa, and two others were sold at auction in 1975.[1] These once formed part of an album of drawings, most of which were by Coypel's contemporary Louis de Boullogne the Younger (cat. 34), who had signed or initialed a number of the sheets. For a long time, all of the faun studies were thought to be by Boullogne, but that attribution has now been set aside because Boullogne worked almost exclusively in two-chalk combinations — red or black chalk heightened with white chalk, or in red chalk alone — whereas Coypel was a master of the *trois-crayons* technique.[2]

Coypel's expert use of the three chalks here, as in so many other drawings by him, bears striking witness to his leading role in the Rubéniste faction of the Académie royale, which championed Rubensian color, rather than Poussiniste line and design, as the essential element of good painting (see cat. 32 for a brief discussion of this artistic "quarrel"). A member of an extensive family of seventeenth- and eighteenth-century French painters, he studied with his father in Paris and then spent two years with him in Italy when his father directed the French Academy in Rome in 1673–1675. Antoine was admitted to the Académie royale in 1681 as a precocious twenty-year-old and flourished under the patronage of the Orléans family, becoming first painter to the duc d'Orléans in 1688. Thereafter, he became one of the leading artists of his generation and as such played a key role in the transition of French art from the classical gravitas of the seventeenth century to the lighter style and subject matter of the eighteenth century. He was in fact one of the most admired artists of his day and was rewarded toward the end of his life with two of the highest honors of his profession: the directorship of the Académie royale in 1714 and the post of first painter to the king in 1715.

Although the faun drawings are not related to any of Coypel's known decorative projects, most of which were destroyed in the eighteenth century, both the bold combination of the chalks and the vibrant, monumental forms link them to the hundreds of figure drawings he made in preparation for his paintings. Closest in execution and spirit are his numerous studies for the decoration of the Gallery of Aeneas in the Palais Royal, Paris, painted between 1702 and 1706.[3] Perhaps Coypel had considered using fauns such as these in place of the caryatids and male nudes with which he finally decided to surround the central ceiling design. More likely, however, the fauns were intended for some other major decoration project that was either destroyed or never completed and would now be entirely unknown were it not for the survival of this small group of studies.

PROVENANCE

From an eighteenth-century album of French drawings that was dismantled in the early 1950s; P. & D. Colnaghi, London, 1953; Hardy Amies, London (sale, Sotheby Parke Bernet, London, 8 December 1972, lot 7, as Louis de Boullogne the Younger); to Baile; private collection (sale, Sotheby's, London, 6 July 1987, lot 57, as Boullogne); W. M. Brady, New York; NGA purchase with funds donated by Mr. and Mrs. Georges de Ménil in 1989.

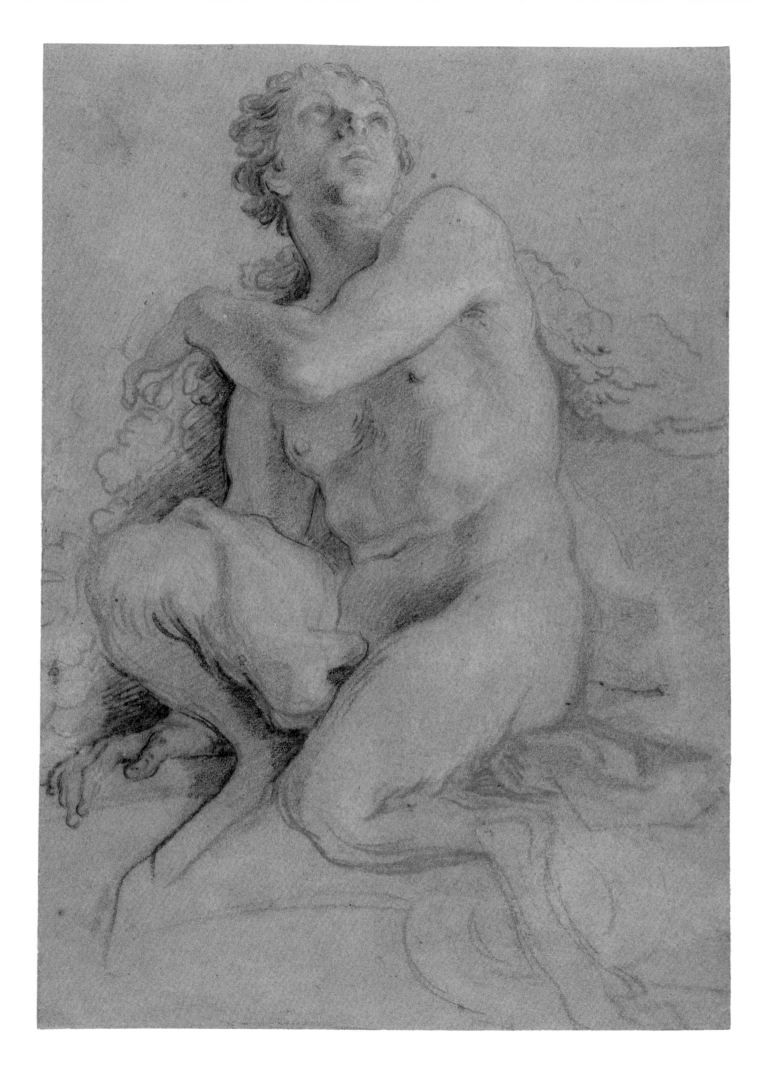

orange-red, white, and black chalk, squared for transfer in black chalk, on blue paper
329 × 241 (12 ¹⁵⁄₁₆ × 9 ½)
inscribed in pen and brown ink at lower right: *84*; and in graphite on the mount at
center left: *Coypel*
Woodner Collection, Gift of Andrea Woodner, 2006.11.11

The National Gallery drawing is one of eighteen surviving studies made by Coypel in preparation for a large ceiling fresco, *Love Triumphing over the Gods* (fig. 1), which was completed in 1708.[1] The ceiling was commissioned by Coypel's principal patron, Philippe II, duc d'Orléans (1674–1723), to decorate a salon of the private residence he had built in 1704 for his mistress, Mademoiselle de Séry, comtesse d'Argenton (1684–1748).[2] In the painting, Venus' pose is largely the same as in the drawing, with changes made only to the position of her left arm and the arrangement of the draperies across her lap. To clarify the goddess' identity in the painting, Coypel added a swan, placing it on the cloud below Venus and positioning it so that its left wing supports her left foot. The putto who is visible above Venus' left shoulder in the drawing also appears in the painting, though his expression and the position of his head are altered there to give him a more mischievous demeanor.

The fresco presents an unusual variation on the theme of the Triumph of Love, with dozens of playful putti teasing the gods by stealing their attributes. Apollo's lyre, Diana's quiver of arrows,

Pan's pipes, Hercules' club, and Neptune's trident are among the objects the cherubs pilfer, casting the gods into an unaccustomed state of consternation. Not even Venus is immune from their pranks, for if the putto in the Washington drawing seems to be crowning the goddess with a floral wreath, his much naughtier pose and expression in the painting make it clear that he is actually stealing it.

For Coypel, as for most academicians of his time, drawing was an everyday activity that was critically important in the development of his compositions. Beginning with rapid sketches, he would first work out the general disposition of the figures and then make separate studies of every figure, no matter how minor. For an extensive piece such as *Love Triumphing over the Gods*, he would likely have made dozens of preparatory drawings, including the eighteen that are now known. All but one were executed in a rich combination of red, black, and white chalks,[3] and all were squared for transfer in black chalk, as was Coypel's usual practice. The Washington study, though, was the only one executed on blue paper, adding an extra

element of color and enhancing the brightness of the whites. The *trois-crayons* technique was his preferred medium from very early in his career,[4] and as this sheet and the study of a *Seated Faun* (cat. 35) attest, Coypel wielded his chalks with considerable éclat. They also show that he used the colors in different proportions, depending on the particular needs of the moment, so that in the study of the faun, the red and black chalks dominate, but here he chose to use only a few touches of black chalk for accents and shadows, relying on a dense orangy-red sanguine and more generous amounts of white to create a warmly human yet suitably regal Venus for his ceiling.

PROVENANCE

Baron Louis-Auguste de Schwiter, Paris (1805–1889) (Lugt 1768; sale, Hôtel Drouot, Paris, 20–21 April 1883, lot 26); Strölin et Bayser, Paris; purchased in 1973 or before by Ian Woodner, New York (1903–1990); by inheritance to his daughter Andrea Woodner, New York, 1990; gift to NGA in 2006.

FIGURE 1: Antoine Coypel, *Love Triumphing over the Gods* (detail), 1708, fresco. Banque de France depot, Asnières, France

recto

verso

Antoine Watteau

VALENCIENNES 1684–1721 NOGENT-SUR-MARNE

The Bower, c. 1716

red chalk and red chalk counterproof
402 × 268 (15 ⅞ × 10 ⁹⁄₁₆)
Ailsa Mellon Bruce Fund, 1982.72.1

Universally regarded as one of the most richly talented artists of the eighteenth century, Antoine Watteau received his initial training in his native Valenciennes before moving to Paris in about 1702/1703. There, after copying old master paintings for a hack merchant on the Pont Notre-Dame, he worked in the ateliers of Claude Gillot (cats. 37, 38) and the ornamentalist Claude Audran III (1658–1734). Hoping to study the art and antiquities of Rome, Watteau competed for the Académie royale's Prix de Rome in 1709; although he won a second prize, he never made the journey to the Eternal City. Instead, he was *agréé* (awarded provisional membership) by the Académie royale in 1712 and was *reçu* (accepted as a full member) in 1717 with the submission of a *fête galante*, a new genre of painting in which elegant couples are shown promenading, dancing, conversing, flirting, or making music in the open air.

Watteau was recognized early for the exceptional beauty of his drawings. He made his mark first with studies executed in red chalk alone and then, beginning in about 1715, with striking works in *trois-crayons* (see, for example, cat. 40). Watteau's drawings were so much admired in his own time that just a few years after his early death, two volumes containing 351 etchings after his studies, the so-called *Figures de différents caractères,* were published by his friend Jean de Jullienne (1686–1766), a remarkable tribute to one of France's greatest draftsmen.[1]

During his years with both Gillot and Audran, Watteau designed ornaments and arabesques, yet very few complete compositions, either painted or drawn, survive.[2] The National Gallery is fortunate to have two examples: *The Gallant Gardener*, an early work from about 1711 (see cat. 37, fig. 1); and *The Bower*, from a few years later, presented here. The latter is one of the most impressive and elaborate drawings of this type, and indeed one of Watteau's largest study sheets of any subject. In this lively work, two-dimensional ornamental elements form a proscenium-like framework for nudes, satyrs, and putti frolicking in a lush landscape setting. Every element of the drawing — the rich variety of the chalk strokes, the wealth of decorative invention, the confident description of each detail, the summary indications of form and volume, the pulsating sense of energy running through the whole — indicates that it dates from the height of Watteau's maturity, c. 1716.[3] It was presumably made in preparation for a painted wall decoration, but it is not known whether the project was ever completed. (Such works usually had a short life span, in accordance with the changes of taste and fashion.) The drawing, however, was engraved by Gabriel Huquier (1695–1772), a highly skilled and inventive printmaker who made prints after many of Watteau's arabesque designs.[4] Because parts of the drawing were so broadly sketched, Huquier had to interpolate some of the details; he also simplified and clarified the design as a whole, with the result that his highly finished print is very different in appearance from Watteau's freely drawn sketch.

As is the case in two other drawings in the National Gallery collection, by Adam Frans van der Meulen and Jean-Honoré Fragonard (cats. 27, 86), counterproofing played an important role in the execution of this piece.[5] Watteau used it here, however, to ensure that the ornamental framework for his composition would be symmetrical.

To that end, he first drew in only the fanciful scrolls, Greek keys, draped materials, and trellises that would make up the left half of the ornament, leaving the right side of the sheet entirely blank. He then counterproofed those elements by folding the sheet in half lengthwise and rubbing the verso to create a pale mirror image of his drawing on the right side of the sheet. (The fold line is still visible, especially just below the central figures.) Watteau then strengthened the counterproofed lines on the right side of the page with fresh strokes of chalk, touched up parts of the left side, introduced the figures groups on either side, and added the central landscape with its barely discernible dancers. He probably also added each of the four corner pieces at this point, for they constitute the only parts of the ornamental framework that are not repeated exactly in the left and right halves.[6] The end result is a remarkably complete and thoroughly delightful composition that shows with unusual clarity its evolution and the continuous flow of Watteau's creative impulses.

PROVENANCE

Edmond (1822–1896) and Jules (1830–1870) de Goncourt (Lugt 1089; sale, Paris, 15–17 February 1897, lot 349); purchased by Brénot for Camille Groult (1837–1908); his son Jean Groult (1868–1951); his son Pierre Bordeaux-Groult (1916–2007) (sale, Palais d'Orsay, Paris, 14 December 1979); private collection; Wildenstein, New York; NGA purchase in 1982.

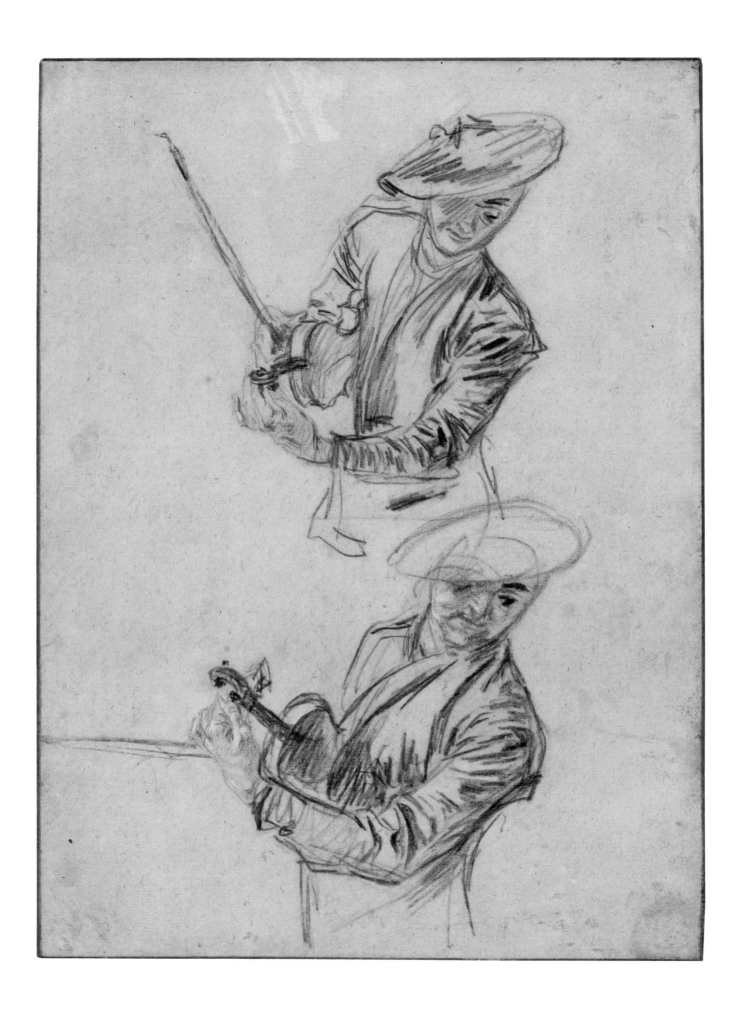

Antoine Watteau

VALENCIENNES 1684–1721 NOGENT-SUR-MARNE

Italian Comedians Taking Their Bows, c. 1718

red chalk and graphite
178 × 185 (7 × 7 ¼)
Gift of Gertrude Laughlin Chanler, 2000.9.27

The theater was a prime source of inspiration for Watteau throughout his career, undoubtedly due at least in part to his early association with Claude Gillot (cats. 37, 38).[1] Like Gillot, he sometimes painted actual scenes from known plays, but more often he blurred the line between the stage and his painted "real" world by including easily recognizable stage characters, such as Pierrot and Harlequin, in scenes of love and wooing that resemble in many ways his *fêtes galantes*. He is even said to have had theater costumes in his studio for his models to pose in, and in both his paintings and his drawings, many of the figures wear outfits that are clearly theatrical in nature.[2]

In the present composition, Watteau sketched a troupe of actors onstage taking a curtain call, a subject he explored in at least three other compositional studies: a similarly spirited rendering of the whole troupe, but with Pierrot placed more to the right, the other members of the cast in different poses, and no stage setting in the background (British Museum, London);[3] a quick sketch of five actors with a guitarist (Mezzetin or Scaramouche) at center, flanked by Pierrot and Crispin (École nationale supérieure des Beaux-Arts, Paris);[4] and a study of three (or more) actors, again including Pierrot and Crispin, but this

time standing near a fountain ornamented with a sculpture of a nude woman (Musée Jacquemart-André, Paris).[5] Loosely connected in terms of subject and execution, the four drawings do not otherwise form a coherent group, but seem to have been made almost at random as Watteau toyed with different variations on a possible theme for one or more pictures. They may even have been made over a period of years, for it is in these kinds of quick sketches that Watteau's style varies the least and remains closest to his roots in Gillot's studio; one finds even in his late studies the same long, slender forms and tapered hands and feet that he learned from Gillot in about 1704/1707 (see, for example, cat. 37). Dating these compositions can therefore be quite problematic, and indeed the British Museum sheet, which is the most Gillotesque of the group, has been placed as early as c. 1711 and as late as c. 1717.[6]

The dating of the Washington sheet, by contrast, has remained relatively consistent, ranging only between 1717 and 1719 because of its long-recognized connection with Watteau's painting *Italian Comedians* (fig. 1), which he is known to have given to his doctor, Richard Mead, during a trip to England in 1719–1720. Of the four compositional drawings showing actors taking their

bows, the present study is the closest in spirit and composition to that painting, not only in the central placement of Pierrot and the choice of an architectural setting but also in the quality of the attitudes—if not the actual poses—given to the main figures. That the sketch, like the painting, belongs to the later years of Watteau's career is indicated by the masterly ease of execution, the supple, well-rounded forms, the firm spatial structure, and the well-balanced arrangement of the figures, not to mention the particular way in which the artist added a few touches of graphite to enhance the three figures at right. Watteau used a similar combination of sanguine and graphite in another late compositional drawing, *The Pleasures of Love* (Art Institute of Chicago), which is related to a painting executed in about 1718 (Gemäldegalerie, Dresden).[7] For the most part, however, Watteau preferred to work out his compositions directly on the canvas, with the result that lively ensemble studies like these, in which he captured with unusual brilliance and energy some remarkable moments of inspiration, are all too rare.

PROVENANCE

Charles-Philippe, marquis de Chennevières, Paris (1820–1899) (Lugt 2072; sale, Paris, 5–6 May 1898, lot 205); Marius Paulme (1863–1928) (Lugt 1910; sale, Galerie Georges Petit, Paris, 13–14 May 1929, lot 260); Thomas Agnew and Sons, London; The Hon. Irwin Boyle Laughlin, Washington (1871–1941) (his mark, IL in a circle, in red at lower right, not in Lugt); his widow, Therese Iselin Laughlin, Washington (d. 1958); their daughter, Mrs. Gertrude Laughlin Chanler (1914–1999); gift to NGA in 2000.

FIGURE 1: Antoine Watteau, *Italian Comedians*, c. 1720, oil on canvas. National Gallery of Art, Washington, Samuel H. Kress Collection, 1946.7.9

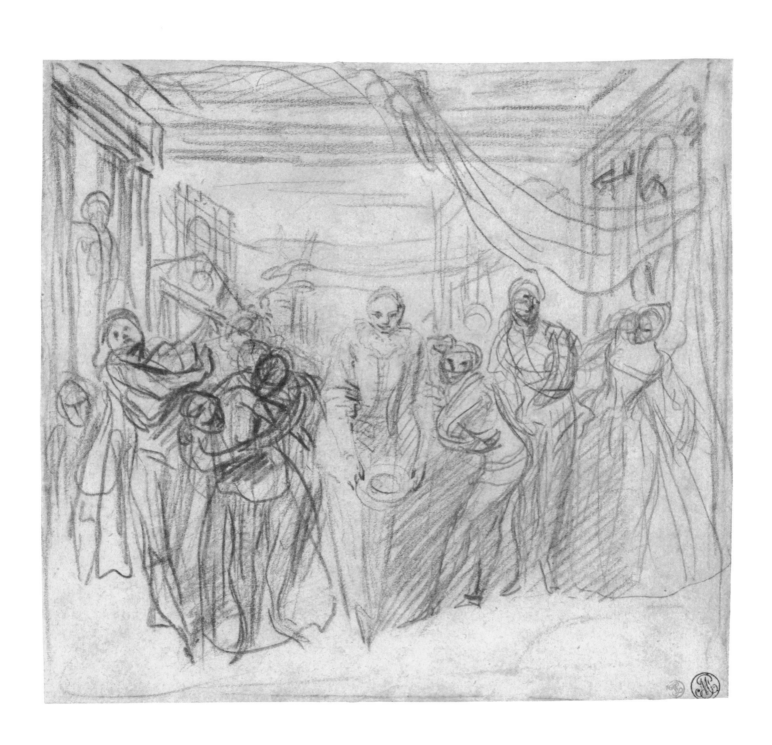

43 Antoine Watteau

VALENCIENNES 1684–1721 NOGENT-SUR-MARNE

Three Studies of a Woman's Head and a Study of Hands, 1718/1719
verso: *View of a House, a Cottage, and Two Figures*

red chalk and graphite with black chalk and pink wash; verso: red chalk
179 × 159 (7 1/16 × 6 1/4)
watermark: F♡ FONTAINE, all enclosed in a long oval
Samuel H. Kress Collection, 1963.15.34.a, b

Around the time he was accepted as a full member of the Académie royale in 1717, Watteau began to mute the striking colors and contrasts in his *trois-crayons* drawings. He achieved this by softening his strokes of red and black chalk and smudging them with a stump, using graphite and sometimes light brown or pink washes to act as middle tones, and omitting the bright white. The present drawing was made from exactly this kind of mixture of techniques, and the visual effect is markedly different from the artist's earlier three-chalk pieces (see cats. 40, 41). The three studies of heads are each drawn with slight variations in the combination of the media, with the head at upper left being the most complete and the most complex in its rendering. The one at upper right is somewhat sketchier, with a lighter touch in the modeling of the face—except for the darker accents that define the features—and the hair and decorative cap left partially unfinished. Oddly disjunctive is the combination of wash and chalk in the third study, in which the features are

nicely indicated with a few touches of chalk, but the hair, suggested by some scribbled lines and rough patches of wash, seems uncharacteristically messy. Particularly elegant, by contrast, is the study of the hands in red chalk and graphite with some smudges of black chalk, especially in the beautifully observed and delicately rendered details of the fingers.

Three of the four studies on this page—namely, the hands and the two heads at upper left and lower right—were used in one painting, *The Contredanse* (present location unknown; see fig. 1 for the print after it).[1] In fact, the head and hands on the left side of the Washington sheet were both used in the same figure: the woman at right in the painting (at left and reversed in the print) who is seated on the ground and leans on the knee of a young man next to her. One might imagine, given Watteau's usual working method (see cat. 40), that those two detail drawings were not originally intended to be used together, but the existence of another sketch for the entire figure—on a sheet of diverse studies in the École nationale supérieure des Beaux-Arts, Paris[2]—suggests otherwise. That one shows a woman in the exact pose of the figure in the painting and wearing the identical dress (except for a slight change in the sleeve), but whereas the rendering of the dress in the Paris figure is quite detailed, the hands and the head are only vaguely indicated. It appears, then, that after Watteau chose that figure for inclusion in *The Contredanse*, he embarked on the Washington sheet specifically to work out in two separate but related studies the position of the hands, the tilt of the head, and the details of the facial features and expression. When he went on to make two more drawings of his model's head on the same page, Watteau may not have intended to use either one in the same painting; it is possible that he made the decision to include the one at lower right in the picture only as the composition evolved.

On the verso of the National Gallery sheet is a scene of two figures standing before a thatched cottage, with a larger house behind them. That the composition was originally almost twice as large is revealed by an etching, in reverse, made by François Boucher (cats. 50–58) after Watteau's original drawing: about a third of the composition was trimmed off the left side and a smaller slice was taken from the right.[3] Presumably the Washington sheet was cut down by a former owner, perhaps in an effort to improve the composition of the heads on the recto or to separate off other head studies that could by themselves make another complete drawing. Even in its fragmentary condition, the farm view is an important work because although Watteau is known to have sketched regularly from nature, few of those studies have survived. Fourteen were etched by Boucher for the two volumes of *Figures de différents caractères* (see cat. 39), but only two of the original drawings—this one and another in the State Hermitage Museum, Saint Petersburg[4]—are known. That is probably because Watteau frequently drew his landscapes and studies from nature on the versos of sheets of figure studies, many of which were subsequently pasted down on mounts.[5] The Washington landscape, in fact, was discovered only in 1980, when the drawing was removed from its old backing.

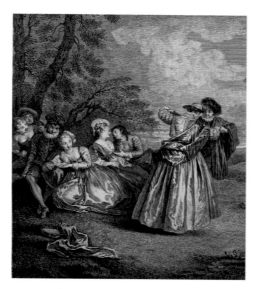

FIGURE 1: Étienne Brion, *The Contredanse* (after Antoine Watteau) (detail), 1731, etching and engraving. National Gallery of Art, Washington, Widener Collection, 1942.9.2093

PROVENANCE

Charles Gasc (active mid-nineteenth century) (apparently bears his mark at lower left, Lugt 544, but not included in his sale, Paris, 17 January 1865); L. Tabourier, Paris (d. c. 1898) (sale, Hôtel Drouot, Paris, 20–22 June 1898, lot 144); Richard Owen, Paris; purchased in 1937 by Samuel H. Kress, New York (1863–1955); gift to NGA in 1963.

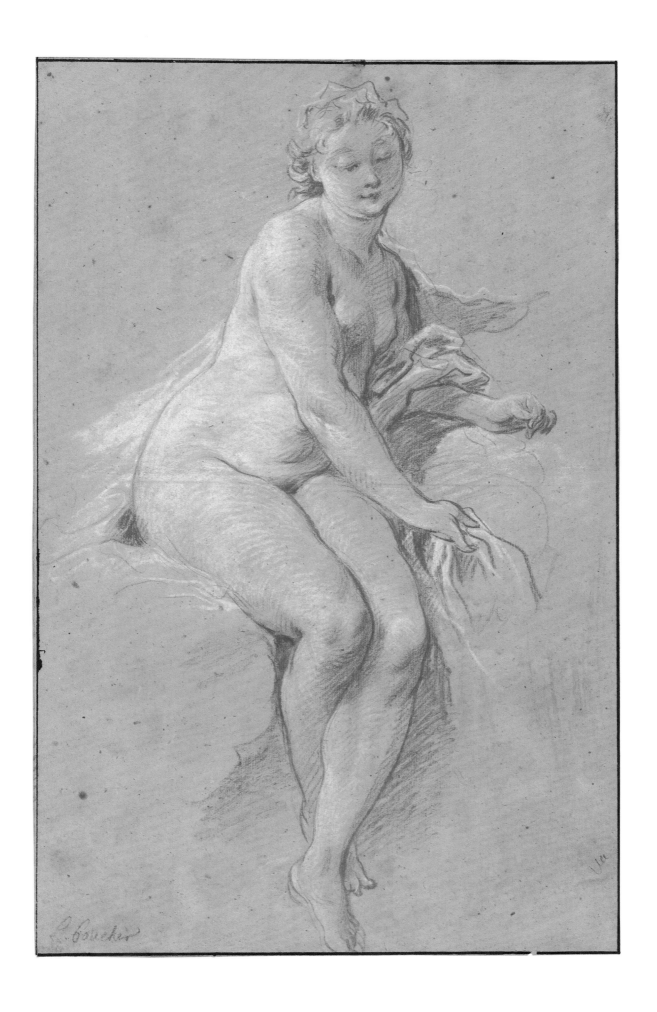

Sancho Fleeing from the Servants of the Duke, 1735/1736

black chalk and gray wash heightened with white gouache on light brown paper
273 × 339 (10 ¾ × 13 ⁵⁄₁₆)
inscribed in pen and dark brown ink at lower left: *F. Boucher*, and in pen and light brown ink at lower left, partially concealed by the white heightening: *Boucher*; on the verso, inscribed in pen and brown ink at lower left: *F. Boucher/* [illeg.] *L'empereur*; numbered in graphite at center: *3396*, and at upper left in another hand, *325*
Gift of Arthur L. Liebman, 1992.87.9

Boucher's background as a printmaker led him to be involved throughout his career with book illustration. His first such project was a set of drawings made for the 1729 edition of *Histoire de France depuis l'établissement de la monarchie française* (History of France since the Establishment of the French Monarchy) by Gabriel Daniel.[1] Regularly thereafter, over the long span of his career, Boucher worked on many other illustration projects, culminating with the sumptuous 1767–1771 edition of *Les Métamorphoses d'Ovide*, published by Noël Le Mire and Pierre-François Basan (see cats. 57, 93). For many of these projects, including the Ovid, Boucher was not the sole illustrator, but rather just one of many. The present drawing, for example, was his only contribution to a set of thirty prints, plus a title page, illustrating the famous Spanish novel *El ingenioso hidalgo Don Quijote de la Mancha* (The Ingenious Gentleman Don Quixote de la Mancha) by Miguel de Cervantes Saavedra, first published in Spain in 1605. Twenty-four of the prints, engraved by various artists after paintings by Charles-Antoine Coypel (1694–1752), had originally been published as a suite in 1724, titled *Les principales aventures de l'admirable Don Quichotte* (The Principal Adventures of the Admirable Don Quixote).[2] In the 1730s the set was expanded by the addition of six more plates, two each designed by Pierre-Charles Trémolières (1703–1739) and Charles-Nicolas Cochin I (1688–1754),

and individual pieces drawn by Jacques-Philippe Le Bas (1707–1783) and Boucher. The publication of the print by Pierre Aveline (c. 1702–1760) after Boucher's drawing was announced in April of 1737.[3]

Boucher's drawing is uncharacteristically careful and detailed in execution, surely because it was intended to serve as a model for a professional engraver, and also because it had to conform in style and conception to the set of prints based on Coypel's paintings. Boucher's hand is clearly evident in the figures and faces of the women, however, and there can be no question that the drawing is his. The scene he depicts is taken from chapter 32 of Part II of the story,[4] when Don Quixote and his squire, Sancho Panza, are guests in the palace of the duke and duchess. During dinner, to make fun of the ludicrous knight-errant, some serving girls come to the table with fresh soap and water to wash Don Quixote's beard, then leave him all lathered up while they fetch more water. To make it seem like this is a local custom instead of a cruel joke, the duke insists that they also wash his beard. Thereafter, some kitchen boys try to wash Sancho in like fashion, but the water they propose to use is dirty and Sancho flees from them in horror, claiming that such a washing would be worse than doing penance. That is the moment depicted by Boucher, but he diverges from the text in one important detail: he shows Sancho with a moustache but otherwise clean-shaven, and thus the kitchen boys cannot be trying to wash his beard, but must be attempting to shave him instead. The title in Aveline's print follows that change: *Sancho Is Pursued by the Duke's Kitchen Boys Who Try to Shave Him with Dishwater.*

Boucher's composition was engraved again in about 1746 by Pieter Tanjé (1706–1761), but in vertical format (with the architecture extended well above and slightly below the figures) and on a smaller scale, with the image reduced to about 193 by 151 millimeters.[5] It was published with similarly reduced versions of the other thirty prints by Pieter De Hondt (1696–1764) in The Hague in 1746, in two separate quarto editions with explanatory texts, one in French and the other in Dutch.[6]

PROVENANCE

Probably Gabriel Huquier (1695–1772) (sale, 1771, among the "desseins encadrées" [framed drawings]); M. Paignon-Dijonval (1708–1792); by inheritance to Charles-Gilbert, vicomte Morel de Vindé (1759–1842); Jean Masson, Amiens and Paris (1856–1933) (Lugt 1494a; sale, Galerie Georges Petit, Paris, 7–8 May 1923, lot 26); private collection (sale, Hôtel Drouot, Paris, 26 November 1969, lot 6); Rosenberg and Stiebel, New York; Arthur L. Liebman, Lake Forest, Illinois (1918–1991); gift to NGA in 1992.

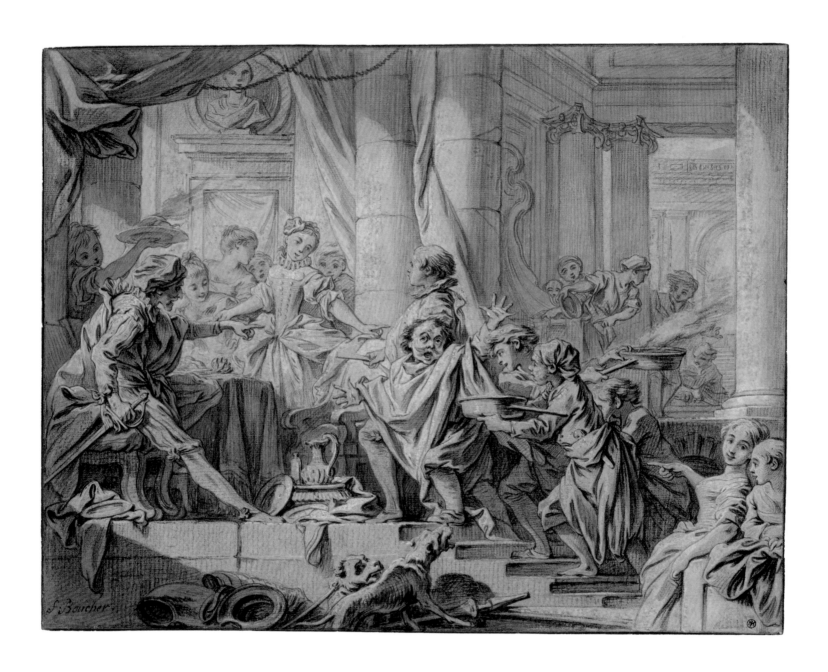

François Boucher · PARIS 1703 – 1770 PARIS
Apollo, c. 1752

black chalk and stumping, heightened with white chalk on greenish-gray paper
544 × 365 (21 7/16 × 14 3/8)
inscribed (signed?) in black chalk at lower right: *f. Boucher*; stenciled in brown ink at lower left: *34*; numbered in pen and brown ink at lower left: *14-2* (?); numbered in brown ink in the circular stamp of the ECOLE ACCADEMIQUE DE DESSINS D. ORLEANS: *49*; on the verso, inscribed in pen and magenta ink at center left: [illeg.] *34 mai 1854*, and in another hand in graphite at center: *Academie par Francois Boucher*; numbered in pen and brown ink at lower left: *T 18a*, with matting notes in graphite at center right
Gift of Robert H. and Clarice Smith, 1980.64.1

Although Boucher was known primarily for his delectable studies of naked women (cats. 50, 57, 58), he was also a master of the male nude, as this superlative sheet shows. Like all French artists of his time, Boucher started making *académies*, as studies of the male nude were called, as a student and continued to draw them throughout his life. From 1737 onward, he served as one of the twelve professors at the Académie royale who were responsible for posing the model for two-hour classes each working day for the period of a month (on this subject, see also cat. 31). This eloquent sheet, in which the rendering is as proud and confident as the model's pose, was the product of one of those life-drawing sessions.

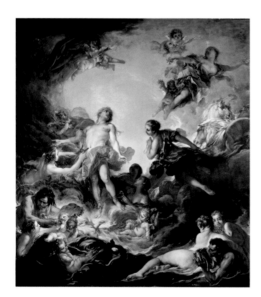

FIGURE 1: François Boucher, *The Rising of the Sun*, 1753, oil on canvas. By kind permission of the Trustees of The Wallace Collection, London

The pose of the figure in this drawing is virtually the same as that of Apollo in one of Boucher's most important and famous compositions, *The Rising of the Sun* (fig. 1).[1] Completed in 1753, that painting and its pendant, *The Setting of the Sun* (Wallace Collection, London), were commissioned by Madame de Pompadour (1721–1764), Louis XV's favorite, as models for tapestries that were intended to hang in the king's bedroom at her newly completed château de Bellevue.[2] The Washington drawing was regarded for a long time as a study done specifically for the figure of Apollo,[3] but lately it has been suggested that Boucher might instead have made it after the painting was completed. In the first scenario, the sheet would have served as a presentation drawing, recording a figure whose pose and demeanor Boucher felt were particularly successful;[4] in the second, Boucher's satisfaction with the figure of Apollo in *The Rising of the Sun* would have inspired him afterward to pose the model in one of his life-drawing sessions at the Académie in the same attitude.[5] Certainly the figure was drawn from the posed model, and the full-length presentation and the high degree of finish indicate that this could well be one of the drawings that Boucher executed during a drawing session at the Académie. However, for him to have made such a perfect drawing of the model in the same pose as his completed Apollo (with only slight differences in the turn of the right leg and in the position of the right foot and one finger of the right hand), not only would his model have needed to replicate the pose of the painted figure in every detail—with the arms, chest, head, and left leg held in precisely the same angles and positions—but also Boucher himself would have needed to sit in exactly the right spot in the room to show the same point of view as in the picture. A third scenario, which places the drawing before the completion of the painting, seems more logical: at the very moment he was actually working out the composition, Boucher would have taken advantage of a life-drawing session at the Académie royale to pose the model in

the attitude he wanted to use for the painted Apollo. Satisfied with the resulting drawing, he would then have used it as his guide for the figure of the god in the painting, adjusting the position of the right leg and foot to fit the shape of the wave that supports him there. Such a chain of events accounts not only for the *académie* style of the National Gallery drawing but also for its preparatory relationship to the figure of Apollo in *The Rising of the Sun*.

Boucher's satisfaction with this drawing was certainly not misplaced, for in every respect it exudes tremendous suavity and beauty. Inflections in the black chalk contours emphasize the masculine muscularity and power of the form, and the combination of shadow and brilliant white light mediated by the green-gray tone of the paper gives texture to the flesh as well as sculptural solidity to the body. One of the most remarkable features is Boucher's use of the stump as an additional drawing tool, not simply smudging chalk strokes with it, but actually using chalk dust on the stump to render parts of the study. The brilliance of the draftsmanship and the proud bearing of the figure make this without a doubt one of the greatest *académies* of the eighteenth century.[6]

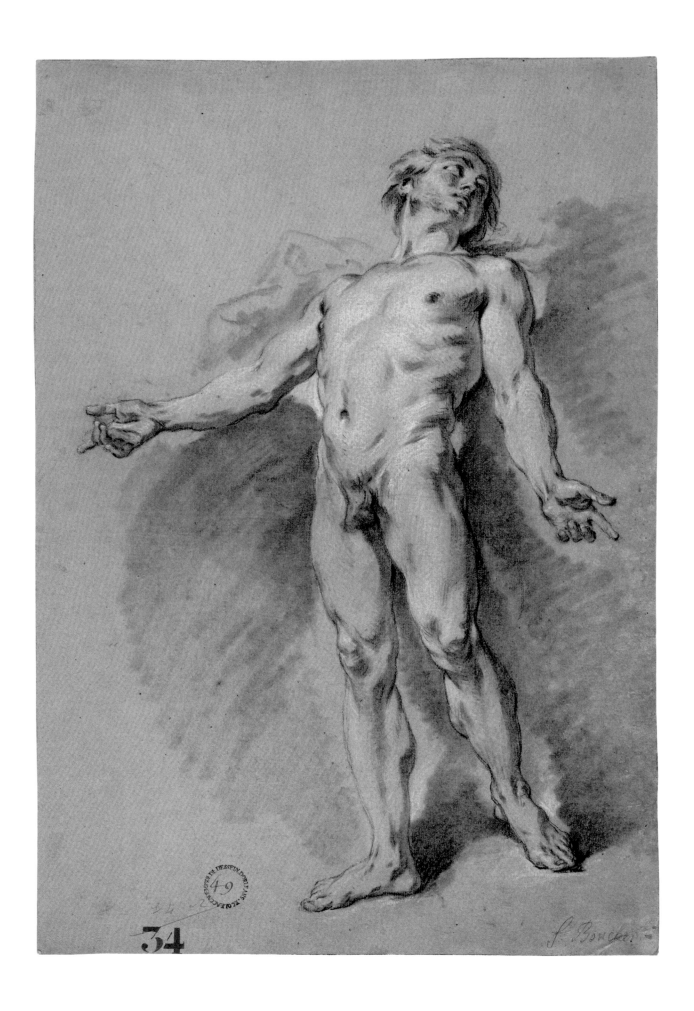

34

f. Boucher

black chalk, pen and brown ink with brown wash, heightened with white gouache and white chalk
240 × 293 (8 $\frac{7}{16}$ × 11 $\frac{1}{2}$)
Gift of Gertrude Laughlin Chanler, 2000.9.2

Boucher was not generally known as a painter of religious subjects, yet he produced several such works in the first years of his career and a more significant number in the last two decades of his life. His return to biblical subjects in about 1750 seems to have been sparked by a commission from Madame de Pompadour (1721–1764) for an altarpiece that would adorn the chapel at the château de Bellevue. Boucher's painting, a Nativity entitled *The Light of the World* (now in the Musée des Beaux-Arts, Lyon), was completed in 1750 and exhibited in the Salon that year (fig. 1). Until recently, a number of composition drawings of Nativities and Adorations, including the work presented here, were believed to have been made as part of Boucher's preparations for that picture.[1] It is appealing to think that he played with a variety of compositional ideas for that one important—and for him, unusual—commission before he hit on the final solution. It is now thought, however, that he experimented with variant designs after his work on the altarpiece was completed. Working in diverse media, he explored different formats,

interpretations, figural arrangements, and even subjects—he also executed a number of works depicting the Adoration of the Magi, for example. Indeed, as Alastair Laing has pointed out, the style of execution of these compositional drawings and oil sketches does not belong to the late 1740s, when Boucher began work on the painting, but instead to a later phase of his career, from the mid-1750s to the beginning of the 1760s.[2] It is very likely, moreover, that these variations were made not in preparation for other paintings but rather as independent works that were intended to be sold or perhaps given to special friends or patrons.

In the National Gallery drawing, Boucher chose a horizontal orientation—as opposed to the vertical presentation of *The Light of the World*—moved the Holy Family to the right, added a far livelier crowd of shepherds and peasants, and filled the center of the composition with brilliant light, both natural—from a torch—and supernatural, emanating from the Christ Child.[3] He also included a number of symbols that add visual texture to the scene and enhance its meaning. The trussed lamb in the foreground, for example, connotes Christ's identity not only as the lamb of God and shepherd to his flock but also as the sacrificial lamb; the apple being held out by a woman refers to the original sin of Adam in the Garden of Eden, Mary's birth without sin, and Christ's atonement of Man's sin through his death and resurrection. The dove held by the same woman alludes to the Holy Spirit and perhaps also to the two turtledoves that were taken to the temple by Mary to effect her purification after the birth of Christ (Luke 2:22–35). The burning torch held out toward the center of the composition by the standing man at left represents the enlightenment brought to the world by the birth of Jesus and also invokes truth and divine wisdom. A strangely disjunctive note is struck by the hunched figure of Joseph at far right, who clumsily extends his bare legs toward the center of the composition. Boucher showed Joseph with similarly naked legs, placed prominently in the foreground, in another drawn version of the

Nativity that was engraved in 1756 by Jacques-Gabriel Huquier le fils (1730–1805).[4] Closest to the National Gallery sheet in overall format and general composition—but with somewhat less drama in the light effects and more subdued reactions from the peasants—is a drawing, thought to date from about 1761/1762, that was on the art market in London and New York in 2002.[5] Sharing the ebullient spirit of the Washington piece, but differently organized, is a grisaille in the Kunsthaus Heylshof, Worms, representing *The Adoration of the Magi*.[6]

Boucher's turn to religious subjects at the midpoint of his career, though apparently instigated by the commission from Madame de Pompadour, may also have been prompted by the artist's desire to carve out a niche as a "serious" artist—he was frequently criticized for his lightweight subject matter—and perhaps also by his ambition to be appointed first painter to the king, a position that was left vacant by the death of Charles-Antoine Coypel in 1752. (Boucher finally realized that goal in 1765.) In the late 1750s and early 1760s, moreover, Boucher's son-in-law Jean-Baptiste Deshays (who died in 1765 at the age of thirty-five; cats. 70–72) was gaining recognition, including much coveted praise from the critic Denis Diderot, for his religious and historical pieces, thus perhaps inspiring a spirit of competition in his father-in-law.

PROVENANCE
Charles-Philippe, marquis de Chennevières, Paris (1820–1899) (Lugt 2072; sale, Paris, 5–6 May 1898, no. 19); Marius Paulme, Paris (1863–1928) (Lugt 1910; sale, Paris, 13 May 1929, no. 18, pl. 13); purchased in 1929 by the Hon. Irwin Boyle Laughlin, Washington (1871–1941); his widow, Therese Iselin Laughlin, Washington (d. 1958); their daughter, Gertrude Laughlin Chanler, New York (1914–1999); gift to NGA in 2000.

FIGURE 1: François Boucher, *The Light of the World*, 1750, oil on canvas. Musée des Beaux-Arts, Lyon

François Boucher · PARIS 1703 – 1770 PARIS
Crêpes, 1761/1763

pen and brown ink with brown wash over traces of graphite on a mount made by Jean-Baptiste Glomy (1711–1786) (Lugt 1119) with framing line in brown ink
348 × 233 (13 11/16 × 9 1/8)
inscribed in pen and dark brown ink on verso in a nineteenth-century hand: *vente Randon de Boisset no. 342 du catalogue/vente Eugene Tondu* followed by words that have been obliterated; inscribed in graphite below that in a different hand (barely visible): *Vente Randon de Boisset/no du Cat 342/Vente* [illeg.]; inscribed in brown ink at lower right in a different hand: [erased] *at Marquis of/Lansdown's* [erased] and numbered *32*
Gift of Robert H. and Clarice Smith, 1980.64.2

Very few drawings demonstrate Boucher's enduring interest in Dutch and Flemish art as clearly and memorably as this charming domestic scene rendered in his version of a Rembrandt-style chiaroscuro. Both the subject—a woman and her children in a rustic kitchen—and the pen-and-wash medium are unusual for Boucher, but the drawing itself is one of his most brilliant and beguiling works. The dark pen lines describing the figures and the setting, the dense brown washes that envelop and define the forms, and the evocation of light dappling the shadowed space— economically suggested by a few deft reserves of white paper—combine to create an image of remarkable beauty and visual appeal. While it is entirely French in style and spirit, the drawing's roots in the works of Adriaen van Ostade (1610– 1685), Rembrandt van Rijn (1606–1669), and other Dutch antecedents are patently clear.

FIGURE 1: François Boucher, *A Kitchen*, c. 1762, pen and brown ink with brown wash. Location unknown (from the reproduction in Ananoff 1966, fig. 18)

Boucher was familiar with and responded to Netherlandish art from the earliest moments of his career. Among his first independent works, made when he was still studying in Italy in the late 1720s, were a number of Flemish-inspired landscapes with peasants and animals.[1] After his return to Paris in 1731, he continued to tap northern sources in his landscapes and genre paintings, always filtering the scenes through an unabashedly French aesthetic. Late in his career, in the mid-1760s,[2] he made a trip to the Netherlands with his friend and patron Pierre-Louis-Paul Randon de Boisset (1708–1776), the king's receiver general of finances who owned more than one hundred paintings and drawings by Boucher as well as an outstanding collection of art by Dutch and Flemish masters. Boucher, too, collected Netherlandish paintings, drawings, and prints, and owned nearly one thousand of them by the end of his life.[3]

Boucher first explored kitchen themes, based loosely on Dutch seventeenth-century genre pictures, in a small group of paintings from the mid-1730s.[4] He then seems to have abandoned the subject until the 1750s and 1760s, when he returned to it in a number of finished drawings, some of which served as models for prints.[5] Like all of Boucher's compositions of this type, this work shows poor country folk who are attractive and serene, not the raucous and ragged lowlife characters that populate many northern genre scenes. Boucher's buxom young matron and her three children reside not in squalor but contentedly in a delightfully cluttered space in which every detail is cloaked in charm. Poverty could hardly be more appealing. Within the small group of Boucher's domestic interiors, one other composition (location unknown) is particularly close to the Washington drawing in subject, with a similar arrangement of the space but a different organization of the figures (fig. 1).[6] In this second drawing, also sometimes called *Crêpes*, the central focus of the composition is moved from the mother, who occupies the middle of the Washington sheet, to the fireplace at right. The poses and positions

of the figures are all changed, except for those of the girl seated on the ground and seen from behind in the foreground: she is repeated almost line for line, but with a different hairstyle and dress, and she is now holding the baby on her lap. The same girl also reappears in the identical pose in another interior (not specifically a kitchen) that is now known only through an engraving by Jean-Charles Le Vasseur (1734–1816), *The Fruits of the Household*.[7]

The style of the National Gallery drawing places it very close in time to Boucher's mid-1760s journey with Randon de Boisset, and because this sheet once belonged to Randon, it is very tempting to think that Boucher made it "in the Dutch style" specifically for his patron as a memento of their travels together. In it, Boucher did not strive to imitate exactly the appearance and spirit of an actual Dutch drawing, but rather sought to render homage to Rembrandt and his school in his own rather elegant and wholly French manner.

PROVENANCE
Pierre-Louis-Paul Randon de Boisset (1708–1776) (sale, Paris, 27 February 1777, lot 342); to the Chevalier Lambert [Sir John Lambert] (1728–1799) (sale, Paris, 27 March 1787, lot 232); to Jean-Baptiste-Pierre Le Brun (1748–1813) (sale, 11 April 1791, lot 303); to Walton; Eugène Tondu (sale, Paris, 24–25 March 1865, lot 59); Henri Duval (sale, Paris, 6 May 1868, lot 9); bought by Monseaux; Henry Charles Keith Petty Fitzmaurice, 5th Marquess of Lansdowne, London and Bowood (1845–1927) (not in the marquess' sale of old master drawings, Sotheby's, London, 25 March 1920); Wildenstein, New York, by 1957; Mr. and Mrs. Lester Francis Avnet, Palm Beach, by 1968; Mr. and Mrs. Howard Weingrow, New York, by 1972 (sale, Christie's, London, 11 April 1978, lot 160); Mr. and Mrs. Robert H. Smith, Bethesda, Maryland, 1978; gift to NGA in 1980.

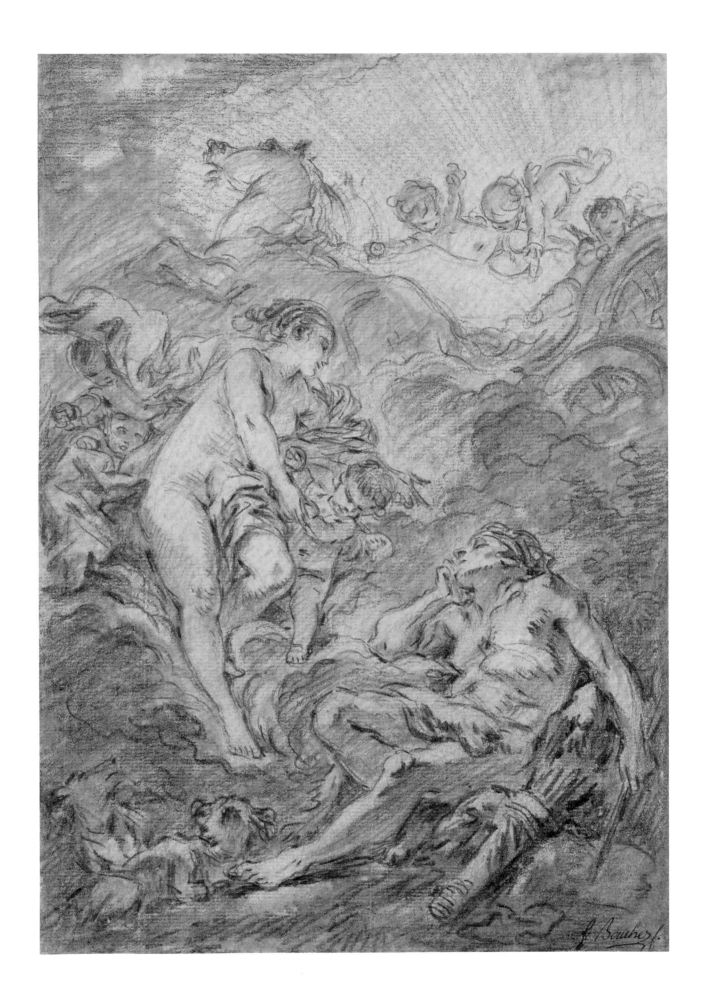

François Boucher · PARIS 1703 – 1770 PARIS

A Nude Woman Reaching to the Right, c. 1769

black chalk with stumping, heightened with white chalk on brown paper (formerly blue), on a mount made by Jean-Baptiste Glomy (1711–1786) (Lugt 1085), with framing line in brown ink
273 × 394 (10 ¾ × 15 ½)
Gift of Robert H. and Clarice Smith, 1980.64.3

This lively study was made in preparation for Boucher's last great project: a set of six paintings of mythological subjects, possibly commissioned by Jean-François Bergeret de Frouville (1719–1783), the younger brother of Jean-Honoré Fragonard's friend and patron Pierre-Jacques-Onésyme Bergeret de Grancourt (1715–1785; see cat. 100).[1] This set, in which all the works measure more than two meters in height, constituted a huge undertaking for an artist who was in failing health and whose eyesight had been troubling him for some time. Nevertheless, all six paintings were completed in 1769, undoubtedly with considerable help from studio assistants. The Washington figure, certainly made by Boucher himself, was drawn as a study for a sea nymph that appears in

FIGURE 1: François Boucher, *Juno Commanding Aeolus to Unleash the Winds* (detail), 1769, oil on canvas. Kimbell Art Museum, Fort Worth

FIGURE 2: François Boucher, *Two Studies of a Nymph*, c. 1769, black chalk heightened with white chalk on brown paper (originally blue). Musée du Louvre, Département des Arts graphiques, Paris

the lower center of the painting *Juno Commanding Aeolus to Unleash the Winds* (fig. 1),[2] in which the bed the model reclines on in the drawing becomes the outstretched leg and hip of another nymph.

As comparison of this female nude with Boucher's c. 1733 study of *Aurora* (cat. 50) shows, the artist remained constant to his preference for plump, well-rounded models, but his rendering of the flesh and form had changed significantly over time. The most obvious difference between the two drawings lies in the choice of medium: red and white chalks on brown paper for the early sheet as opposed to black and white chalks on blue (altered to brown by exposure to light) for the late one presented here. The warm rosiness provided by the sanguine in the earlier study is thus transformed by the use of black in the late work to a cooler, more silvery effect. In *Aurora*, Boucher emphasized the contours with long, strong strokes of the chalk and bathed the figure in a bright, sharply focused light, thus creating a sense of firm flesh and supple, well-contained forms. For the sea nymph here, by contrast, he softened and inflected the outlines, modulated the shadows, and expanded the use of white to craft a more malleable, marshmallow-soft texture for the skin. The same characteristics of both form and execution can be found in other late drawings by Boucher, most notably a study for the Washington nymph's companion in the same painting. That sheet, in the Oskar Reinhart Collection "Am Römerholz," Winterthur,[3] shows a woman of similarly ample proportions—perhaps even the identical model—reclining on what appears to be the same couch.

Boucher claimed to Sir Joshua Reynolds (1723–1792), when the English artist visited Paris in 1768, that he no longer used models when he was working on his paintings,[4] but that assertion is clearly contradicted by the National Gallery and Winterthur studies. Boucher gave considerable thought and effort to the posing of the two sea nymphs in the foreground of *Juno Commanding*

Aeolus to Unleash the Winds and made drawings from the live model as an important part of their genesis. The pose of the woman in the Washington sheet, for example, is very close to that of the sea nymph in the painting except that her back is turned more toward the viewer and the left parts of her back and buttocks are more visible. Moreover, the positions of her arms and hands match the painting almost exactly, with only a minor change to the nymph's right index finger. Boucher restudied the nymph in two sketches on a single sheet in the Musée du Louvre (fig. 2),[5] and arrived at the final position of the nymph's back and torso in the second study at the bottom of the page. In both renderings on that sheet, he experimented with the model's arms—stretching out the left arm and pulling the right back in one sketch, and holding out the right arm and folding the left across her chest in the second—so that neither figure reaches out in the same manner as the nymph in the painting. That Boucher was considering reverting to the arm position found in the Washington drawing, however, is shown by a lightly sketched pentimento of the left arm thrust forward in the lower study on the Paris sheet, which thus shows the model reaching out with both arms. Ultimately, the sea nymph in the painting is a conflation of the one study from the Louvre sheet and the National Gallery figure. Presumably Boucher made yet another drawing showing the nymph in the final pose, but at this late stage of his career, he may simply have adapted the painted figure from the studies he had already made.

PROVENANCE
Léon Michel-Lévy (1846–1925) (sale, Galerie Georges Petit, Paris, 17–18 June 1925, lot 26); to Schoeller; Collection Monsieur A. G. (sale, Paris, 8 May 1934, lot 84); Cotnareau Collection; Galerie Cailleux, Paris (mark in black at lower left, C..x in an oval, not in Lugt); Mr. and Mrs. Robert H. Smith, Bethesda, Maryland, 1979; gift to NGA in 1980.

Maurice-Quentin de La Tour

SAINT-QUENTIN 1704 – 1788 SAINT-QUENTIN

Claude Dupouch, c. 1739

pastel on blue paper
594 × 494 (23 ⅜ × 19 ⅜)
Samuel H. Kress Collection, 1961.9.76

In a century that boasted a remarkable number of highly talented and innovative French pastellists, Maurice-Quentin de La Tour was the trailblazer who first pushed the newly fashionable medium of pastel beyond its established pictorial limits. Within the broad confines of the genre of portraiture, he explored both the painterly and the draftsmanly qualities of these dry sticks of saturated pigment and set the highest standard of excellence for their use. Above all, he reveled in the brilliance and subtleties of the pure, undiluted colors and produced a host of works that rival oil paintings in their scintillating freshness.

In 1719, at the age of fifteen, La Tour arrived in Paris from his native Picardie and was apprenticed to the now-obscure painter Claude Dupouch (c. 1686–1747), the subject of the present portrait.[1] La Tour was therefore in Paris in 1720/1721 when the visit of the Venetian pastellist Rosalba Carriera (1675–1757) brought pastel portraiture to the forefront of fashion. From that moment on, La Tour seems to have committed himself to mastering the genre. By the mid-1730s he had established himself as the leader in the field and was duly admitted to the Académie royale (*agréé* in 1737 and *reçu* in 1746), where he regularly exhibited at the biennial Salons. He attracted a clientele that ranged from the royal family and Louis xv himself to prominent noblemen and financiers to actors, writers, and clergymen. He also made an unusually large number of drawings and pastels of his own visage

and drew likenesses of many of his fellow artists. The prominent critic Denis Diderot (1713–1784), while not always appreciative of La Tour's efforts, nevertheless recognized his particular gifts: "Resemblance is certainly a large merit of La Tour's portraits, but that is neither their principal nor their sole merit. All the parts of painting are also there. The knowledgeable and the ignorant admire them without ever having seen the people. That is because there are flesh and life therein."[2]

Such life radiates from the National Gallery's pastel of Dupouch, about whom very little is known. The son of a painter and art dealer, he was a member of the Académie de Saint-Luc in Paris, where he taught drawing.[3] He married Jeanne-Anne Petit, the daughter of another painter, in 1711 and after her death in 1743 he lived with the portraitist Nicole de Sainte-Martin, who was the uncle of Jean-Baptiste Oudry (cats. 47, 48). Following in his father's footsteps, Dupouch not only painted his own works—none of which seem to have survived under his own name—but also bought and sold the works of others.

The circumstances surrounding the execution of this portrait of La Tour's former master—whether it was a commission or a gesture of friendship—are not documented. Even for La Tour, who was known for an easy informality in the presentation of his sitters, this depiction of his mentor is unusually casual, as if the older artist, interrupted in his work, had just turned away from his easel to pass the time with a good friend. The portrait captures perfectly the close relationship that must have existed between the sitter and the artist, conveying Dupouch's genial features with both sensitivity and sympathy and revealing a true sense of warm humanity.

As is often the case with La Tour's portraits, this one exists in other versions, three of which are currently known. Two are in private collections and one other, which remained in La Tour's possession until his death, is now in the Musée Antoine-Lécuyer in the artist's hometown of Saint-Quentin.[4] The latter pastel has been praised for its psychological acuity and the rendering of the tactile qualities of the different fabrics,[5] but the National Gallery portrait is also remarkably penetrating and the overall execution is exceptionally fine. In fact, one particular detail that sets the Washington pastel apart from the other three is the handling of the fabric of Dupouch's coat. Whereas here the material has a distinct texture and pattern picked out with finely differentiated touches and strokes, in the other three versions it is more smoothly and summarily drawn and clearly took less time and effort to render. Indeed, close study of each detail in the Washington portrait reveals that every stroke was set down purposefully and every surface was treated with precision and care, as if the artist was capturing the image for the very first time, not simply copying something he had already drawn before. This likeness therefore has a more complex play of light and texture than the others and a richer visual effect, which may ultimately lead to its acceptance as the prime version.

PROVENANCE

Marquis Soffrey de Beaumont-Beynac, château de La Roque, Dordogne; Galerie Cailleux, Paris, 1955; purchased in 1956 by Samuel H. Kress, New York (1863–1955); gift to NGA in 1961.

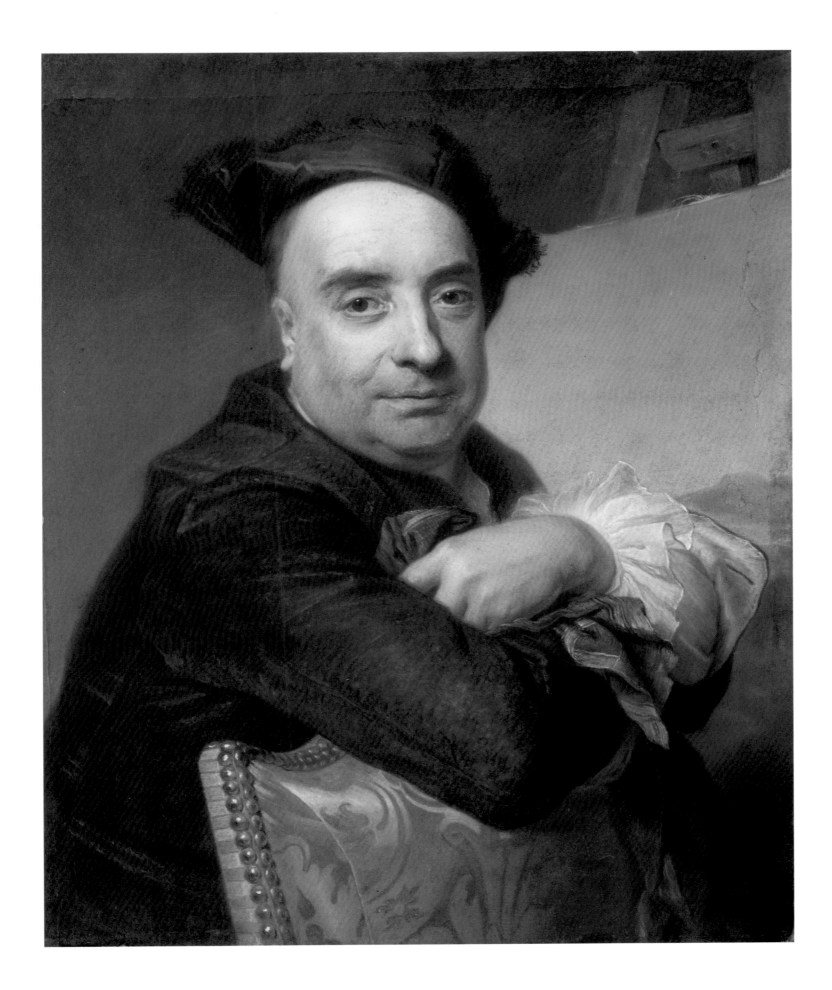

Joseph-Marie Vien · MONTPELLIER 1716–1809 PARIS
album of drawings of Rome and the surrounding countryside, 1744/1750

bound volume with fifty-two drawings on twenty-six leaves, preceded by two added leaves with drawings by Charles-Louis Clérisseau (1721–1820) in a mid-nineteenth-century binding black chalk and graphite
album pages: 425 x 277 (16¾ × 10¹⁵⁄₁₆)
inscribed on third folio (the first with drawings by Vien) in graphite at upper right:
Etudes par Clerisseau
Mark J. Millard Architectural Collection, 1983.49.150–203

This volume is one of three albums in the National Gallery collection that contain drawings made by young artists while they were studying at the French Academy in Rome. This one, containing fifty-two landscape studies by Joseph-Marie Vien, is the earliest of the trio, with drawings made between 1744 and 1750. The next (cat. 82) preserves sketches, mainly after antique sculptures, made by Hubert Robert, when he lived in Rome between 1754 and 1765; and the last (cat. 112), the most encyclopedic of the three, bears a variety of works by Jacques-Louis David, who was there from 1775 to 1780. As such, the drawings span a period of more than three decades, and the three volumes as a group give some sense of the types of drawings students were expected to make as they explored Rome's incomparable riches of ancient and modern art or sketched views of the great monuments, ruins, villas, gardens, and fountains in both the city and the surrounding countryside.

Vien received his initial training in his native Montpellier, mainly with a portraitist named Legrand and with the architect and painter Jacques Giral (1684–1749), but he also spent some time as a decorator of faience ceramics in a local manufactory. He entered the studio of Charles-Joseph Natoire (cat. 81) in Paris in 1740 and won the Prix de Rome three years later. After six years in Italy, he returned to Paris to begin what turned out to be an exceptionally long career that included several official honors—appointments as director of the French Academy in Rome in 1775 and first painter to the king in 1789; membership in the Légion d'Honneur in 1804; and elevation to the nobility in 1808, at the age of ninety-two. Vien is now best known as one of the inaugurators of the neoclassical style in France in the 1750s and as the teacher of important leaders of neoclassicism such as David (cats. 112, 113) and Jean-François-Pierre Peyron (cat. 115).

All fifty-four of the drawings in the album presented here were once thought to be the work of Charles-Louis Clérisseau (1721–1820), an arch-

itect and painter who specialized in topographical and fanciful classical landscapes dominated by architectural ruins. The spine of the nineteenth-century binding, in fact, is embossed *Clerisseau/Fragments/d'Architecture/Etudes de/Paysages* and the third folio is inscribed *Etudes de Clerisseau*, following the belief at the time that Clérisseau was the author of them all. Thomas McCormack, however, accepted only the first two works in the album as his (neither of which is particularly impressive, nor was either original to the album)[1] and considered the fifty-two black chalk and graphite sketches of Rome and the environs, which were unlike any other authentic works by Clérisseau known to him, as the work of another, unknown artist.[2] He and Pierre Rosenberg first suggested that those fifty-two were the work of Vien in 1986,[3] a proposal that won provisional support from Thomas Gaehtgens and Jacques Lugand, who included the drawings in their monograph on Vien in 1988.[4] Confirming the attribution are two other landscape drawings by Vien, both of which are signed and dated: *The Waterfall at Terni* of 1746, in the Institut néerlandais, Paris, and *A Composition Inspired by the Campo Vaccino in Rome* of 1748, in the Musée Magnin, Dijon (fig. 1).[5] Of those two, the latter

is particularly close to the drawings in the National Gallery album not only in subject and handling—especially in the abstraction of the foliage, the compression of the space, and the construction of the buildings and ruins—but also in size. In fact, four of the sheets in the album are nearly identical in dimensions to the Dijon page and are remarkably similar in execution (cat. 60a, for example),[6] and it is tempting to think they could have originally formed part of the same sketchbook. All the other drawings in the album are smaller, with several measuring about 130 by 190 millimeters and a number of others about 115 by 180 millimeters. These must have come from at least two other sketchbooks. All the drawings are clearly by the same hand, though some are more cursory jottings (cat. 60b) while others are done in the tighter, more controlled style of Vien's study in the Musée Magnin. The individual sketchbook pages seem to have been mounted into the album more or less randomly, two to a page, with no indication of or concern for the order in which they were originally made. None of the drawings are inscribed, and the sites represented in many of them have not yet been identified (cat. 60c).[7] Among the recognizable

FIGURE 1: Joseph-Marie Vien, *A Composition Inspired by the Campo Vaccino in Rome*, 1748, black chalk. Musée Magnin, Dijon

63a

Hubert-François Gravelot

Second Day, Second Story: Rinaldo d'Asti and the Widow, c. 1757

pen and gray ink with brown wash
113 × 57 (4 7⁄16 × 2 ¼)
signed in pen and black ink below the image at lower right: *H. Gravelot inv.*, and inscribed by the artist in pen and black ink with touches of brown wash at lower center: *II. Journée, Nouvelle 2.*
Widener Collection, 1942.9.698

63b

Hubert-François Gravelot

Tenth Day, Ninth Story: Saladin Bestows Rich Gifts on the Sleeping Torello, c. 1757

pen and black ink with brown wash over touches of red chalk
113 × 57 (4 7⁄16 × 2 ¼)
signed in pen and black ink over traces of red chalk at lower right: *H. Gravelot inv*, and inscribed by the artist at lower center: *X. Journée, Nouvelle 9.*
Widener Collection, 1942.9.760

63a

63b

Hubert-François Gravelot
Nine Children Listening to a Girl Tell a Story; A Boy Handing a Purse to a Girl Seated on a Bed, c. 1757

pen and gray ink with brown wash
143 × 81 (5 ⅝ × 3 3/16)
signed in pen and gray ink at center: *H. Gravelot inven.*; inscribed by the artist at upper center: *P.108./Introduction à la VIII. Journée.*, at center above the lower image: *Gulfart et la Femme de Gasparin.*, and at lower center, *P.113.*
Widener Collection, 1942.9.782

By setting Boccaccio's tale in contemporary times, instead of keeping it in the fourteenth century, Gravelot was able to depict the costumes and settings of his own day in delightful detail. That is the case with his illustration of the story of Rinaldo d'Asti, the victim of a robbery who is discovered lying in the street by a maid (cat. 63a). She brings him into the house of her mistress, a fashionable young widow, who takes a fancy to him and invites him to dine and to share her bed. Gravelot chose to depict the moment when Rinaldo is introduced to the widow in her well-appointed salon, thus allowing him to pay special attention to the furnishings and décor, including carved *boiseries* (wood panelings), a tall étagère, an ornate fireplace, and a rococo clock.

Gravelot was no less adept at transporting the reader to other times and places in accordance with the stories set in distant and unfamiliar locales. Indeed, a great part of the appeal of his illustrations stems from his ability to treat both ordinary and foreign subjects with inordinate skill and boundless imagination. That is beautifully evident in his illustration of the story of Saladin and Torello, for example, for which he delighted in creating a suitably strange and grand setting for the court of a Middle Eastern ruler (cat. 63b). Captured during a crusade, Torello d'Istria is recognized by Saladin as the man who had welcomed him into his own home years earlier when the ruler had been traveling disguised as a merchant. Torello, upon learning that his wife thinks he has died, is frantic to return to her before she marries another, and Saladin's court magician agrees to help by transporting him on a magnificent bed. After

Torello falls asleep, Saladin orders his minions to place beside him piles of sumptuous gifts that will magically travel home with his friend. Gravelot surely decided to show this last scene because of the host of opportunities it afforded him for depicting exotic objects and lavishly imagined details.

Perhaps even more alluring and inventive are Gravelot's designs for ornamental tailpieces that feature children imitating, parodying, or mutely commenting on the particular stories they follow. Some of these designs are purely decorative, but many of them serve as additional illustrations to the stories or assist in giving a more complete understanding of the individual tales. In the two illustrated here, for example (cat. 63c), the top image shows the ten children, corresponding to Boccaccio's ten ladies and gentlemen, gathered in a garden to enjoy the next set of stories, while the bottom image presents a scene from the first story of the eighth day, complementing the one drawn by Cochin for that same tale (cat. 63e). Both illustrate the story of Madonna Ambruogia, wife of Guasparruolo Cagastraccio, who secretly agrees to sleep with her husband's friend Gulfardo if he will pay her 200 gold florins for the privilege. Disillusioned by her greed, Gulfardo finds the perfect way to punish her: On the pretext of needing money for a business deal, he borrows the florins from Guasparruolo himself, who is about to leave on a trip. Gulfardo then pays the money to Ambruogia, as she has demanded (the scene shown in the tailpiece). Upon Guasparruolo's return, Gulfardo, who has spent several nights with his friend's wife, declares that his deal has fallen through and that he has returned the money to Ambruogia. Since Gulfardo had made sure that a witness was present when he gave the money to her (a detail omitted in Gravelot's tailpiece), Ambruogia is forced to confirm his statement and to return the money to her husband (the moment illustrated by Cochin).

The National Gallery is fortunate to own more than 160 drawings by Gravelot, including not only the designs for the 1757 Boccaccio discussed here, but also illustrations to the *Contes moraux* (Moral Stories) by Jean-François Marmontel, some of his contributions to Ovid's *Metamorphoses*, his designs for a three-act play by Charles Collé, *La partie de chasse de Henri IV* (The Hunting Party of Henri IV), bound into a manuscript of the dialogue, as well as individual designs for ornamental pieces and isolated plates for various other illustrated books. To be able to represent so many different facets of a tireless and versatile illustrator such as Gravelot is both fortunate and revealing.

PROVENANCE

Forty-five of the illustrations by Gravelot and all 65 tailpieces (on 33 sheets) belonged to Frédéric Villot (1809–1875) (Lugt 996; sale, Paris, 25 April 1870, lot 1278); those 45 illustrations were bought by Baron James E. de Rothschild (1844–1881), and the 65 tailpieces were bought by Paignon-Dijonval, who also owned 4 other finished illustrations by Gravelot; 16 more finished illustrations by Gravelot and 2 by Cochin belonged to Marie-Joseph-François Mahérault (1795–1879) (sale, Paris, 27–29 May 1880, lots 27, 97); the provenance of the other 2 Cochin drawings, 2 more by Gravelot, and the 7 by Charles Eisen is not known; all 111 drawings were brought together by Morgand et Fatout, Paris, 1880, and sold to Louis Roederer, Reims (d. 1880); inherited by his nephew, Léon Olry-Roederer, Reims and Paris (d. 1932); sold through Thomas Agnew and Sons, London, to the Rosenbach Company, Philadelphia, 1922; acquired by Joseph E. Widener, Elkins Park, Pennsylvania (1871/1872–1943); gift to NGA in 1942.

63d

Hubert-François Gravelot

*Second Day, Seventh Story: The Duke of Athens Contemplating
the Sleeping Princess Alatiel (after François Boucher)*, c. 1757

pen and gray ink with brown wash

112 × 58 (4 7/16 × 2 5/16)

inscribed by Gravelot in pen and gray ink over traces of red chalk below the image:
F. Boucher inv, and at lower center: *II. Journée, Nouvelle 7.*
Widener Collection, 1942.9.703

63e

Charles-Nicolas Cochin II

*Madonna Ambruogia Gives Her Husband the Two Hundred Florins
She Was Given by Gulfardo in Payment for Her Favors*, c. 1757

graphite on vellum

110 × 55 (4 5/16 × 2 1/8)

signed in graphite at lower left: *Cochin del.*, and inscribed by the artist at lower center:
a femme Avare gallant escroc
Widener Collection, 1942.9.740

63c

63d

63e

The Divertissement from Voltaire's "La princesse de Navarre," 1745

red chalk
143 × 171 (5 ⅝ × 6 ¾)
inscribed in graphite across the bottom: *Princesse de Navarre*; numbered on the verso in graphite at lower right: *50*
Ailsa Mellon Bruce Fund, 1989.5.1

Gabriel de Saint-Aubin was a tireless draftsman who captured the spirit of contemporary Parisian life in literally thousands of sketches and drawings. As his brother Charles-Germain (1721–1786) wrote, "He drew at all times and in all places," and as Jean-Baptiste Greuze (cats. 73–76) supposedly quipped, Saint-Aubin suffered from a "priapism of drawing."[1] The son of an embroiderer to the king, Saint-Aubin apparently received his first training within his own family and in the 1740s is known to have worked with an essentially unknown artist by the name of Sarrazin or Sarazin, who may have been Jean-Baptiste Sarrazin (active 1740–1793), a painter and stage designer and a member of the Académie de Saint-Luc, Paris.[2] By 1747 Saint-Aubin was teaching at the private art academy of Jacques-François Blondel (1705–1774), having already established himself as a draftsman of considerable talent.[3] Aspiring to a career as a history painter, he continued his studies with Étienne Jeaurat (1699–1789) and Hyacinthe Collin de Vermont (1693–1761), but when he failed three

FIGURE 1: Charles-Nicolas Cochin II, *Theatrical Performance in the Riding Ring at Versailles Celebrating the Marriage of the Dauphin, February 23, 1745* (detail), 1746, engraving. Philadelphia Museum of Art: Purchased with the W. P. Wilstach Fund, 1958

times to win the Prix de Rome, he rejected serious painting and focused his efforts instead on drawing and printmaking. His subjects ranged from current events, street scenes, popular locales, festivals, and entertainments to allegories, book illustrations, portraits, and theater subjects, as here. Among Saint-Aubin's most delightful and unusual sketches are the tiny reproductions of works of art by other artists that he drew in the margins of collection and auction catalogues and in the *livrets* (booklets) of the biennial Salons sponsored by the Académie royale. The small scale and casual nature of the majority of his sketches have led to his characterization as a *petit maître* (little master), but the sheer size of his output, the rich variety of his subject matter, and the originality of his vision taken all together make him one of the most beloved—and most entertaining—French draftsmen of the eighteenth century.

The theater scene depicted here comes from *La princesse de Navarre*, a "heroic" comedy in three acts by Voltaire (1694–1778) with music by Jean-Philippe Rameau (1683–1764),[4] commissioned to inaugurate the celebrations surrounding the marriage in 1745 of the French dauphin, Louis, to Infanta Marie-Thérèse-Antoinette-Raphaele, the daughter of Philip V of Spain. The play was performed twice, on 23 February 1745 and again four days later, in a temporary theater constructed in the riding school at Versailles and designed to be disassembled in a single night. In the divertissement that concludes the play, Amour commands the Pyrenees that separate France from Spain —the two countries joined by the union of the newlyweds—to fall and the mountains are miraculously replaced by the temple of Love. In the Washington drawing, Saint-Aubin has chosen to portray the moment after the emergence of the temple, when Hymen, the god of marriage, arrives on the scene and dances with Amour, observed by members of the chorus. According to the stage directions included in Voltaire's text, "They [the gods] run from each other and chase each other by turn; they reunite, embrace, and exchange the

torch."[5] Indeed, the torch that is customarily carried by Hymen is here held by Amour. Coincidentally, in an engraving by Charles-Nicolas Cochin II of the first performance of the play (fig.1), the same divertissement appears onstage in the background, but Cochin chose to focus on a scene before the arrival of Hymen, when Amour is sitting on his throne.

The precise dating of the opera's presentation locates Saint-Aubin's drawing in 1745, when the artist was only twenty-one years old. The basic elements of his style are already established, especially in the drawing of the heads, which are reduced to simple ovals with dots and dashes marking the placement of the features. His understanding of gesture and movement is conveyed in the jaunty carriage of the two central actors and the way they relate to each other, but his youth, too, is apparent in the somewhat awkward handling of Amour's physique. Perhaps because of his training with Sarrazin, Saint-Aubin filled much of this small sheet with stage scenery, while his association with Blondel comes through in the assured rendering of the columns and temple in the distance. Not surprisingly, the inimitable charm that will be a keystone of Saint-Aubin's style throughout his life is already much in evidence here, as he invites the viewer to experience his world through his uniquely personal vision.

PROVENANCE
Eugène Rodrigues (1853–1928) (Lugt 897); Hazlitt, Gooden & Fox, London; NGA purchase in 1989.

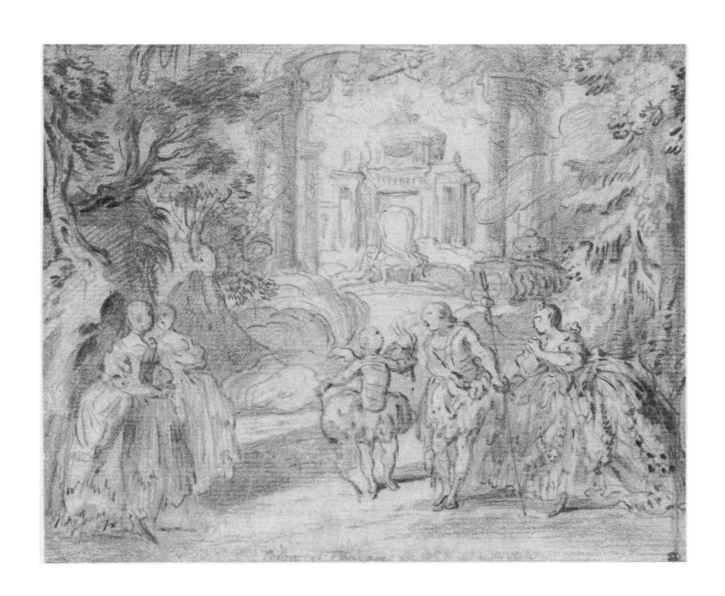

65 Gabriel de Saint-Aubin · PARIS 1724 – 1780 PARIS
Ballet from "The Rival Fairies," 1748
verso: *Sketches of Dancers and Heads of Putti*

pen and black ink with gray wash with a loose border line in pen and gray ink
137 × 206 (5 ⅜ × 8 ⅛)
inscribed by the artist in pen and gray ink at lower left: *ballet des fée rivalles italiens*
Gift of Gertrude Laughlin Chanler, 2000.9.23.a, b

The rather abbreviated inscription along the bottom of this sheet, written by Saint-Aubin himself, identifies the scene presented here as a ballet from the four-act play *Les fées rivales* (The Rival Fairies).[1] Written by the Venetian actor Carlo Antonio Veronese (1702 – 1762), with music by Adolphe-Benoît Blaise (1716 – 1772), that piece was first presented at the Comédie italienne in Paris on 18 September 1748. Saint-Aubin apparently made his drawing at about that time, thus allowing it to be dated quite precisely in the fall of that year. Saint-Aubin preferred to use pen for most of his drawings, and this early sketch already shows the nervous, spidery thin lines and the fluid, delicate touch that are essential characteristics of his style. Like the figures in the previous sheet, from 1745 (cat. 64), the dancers here are drawn with the abbreviated faces and hands and the smoothly oval or round heads that are typical of the artist's earlier works. With scarcely more than three or four dots, he gives each face an extraordinary amount of expression and personality. At the same time, his quick, spirited line imbues each figure with such vitality that they all literally seem to dance on the page, considerably lighter in step and carriage than the red chalk figures of three years before.

On the verso of the present sheet Saint-Aubin made three cursory sketches of more figures performing other pas de deux and a pas de trois from the same ballet. To the right, the heads of winged putti drawn on a larger scale and with a much stronger stroke, however, have no relation to the play and could be either idle jottings or quick studies for a completely different and now unknown project.

As this drawing and the previous sheet bear witness, the theater was a favorite subject of Saint-Aubin's, one to which he returned throughout his career. Sometimes, he drew both the stage action and the attending audience.[2] In such examples, the entertainment is provided as much by the spectators who are there to see and be seen as by the play itself. On other occasions, however, as is the case here, he drew only the action on the stage, with no obvious references to the scene's theatrical nature. Even without Saint-Aubin's inscription identifying it as a ballet from *The Rival Fairies*, however, contemporary aficionados of the dance would have known that this was not simply a private ball held in a Parisian residence. In the mid-eighteenth century, threesomes, winding arm-holds, sprightly kicks, and prolonged physical contact among the partners such as those seen here were not a normal part of social dancing, but were instead distinctive features of theatrical entertainments.[3] Coincidentally, the step executed by the three dancers on the verso of this sheet is also seen in Jean-Michel Moreau the Younger's rendering of a performance at Versailles, *May Ball* (cat. 94), also in the National Gallery's collection.

Until 1873 this drawing was paired with another sketch by Saint-Aubin of a scene from the overture of the same play (present location unknown).[4] That composition is vertical rather than horizontal in format, so the two works were not actually true pendants. Nevertheless, they were executed in the same medium and share many features that indicate they were surely made within a very short time of each other.

PROVENANCE
Alexis-Nicolas Pérignon the Younger (1785 – 1864) (sale, Paris, 30 – 31 May 1864); his son, Alexis-Joseph Pérignon (1806 – 1882) (sale, Paris, 17 – 24 May 1865, no. 141); private collection (sale, Paris, 20 – 21 May 1873, no. 127); M. Audouin, by 1877; Thomas Agnew and Sons, London; purchased in 1917 by the Hon. Irwin Boyle Laughlin, Washington (1871 – 1941); his widow, Therese Iselin Laughlin, Washington (d. 1958); their daughter, Gertrude Laughlin Chanler, New York (1914 – 1999); gift to NGA in 2000.

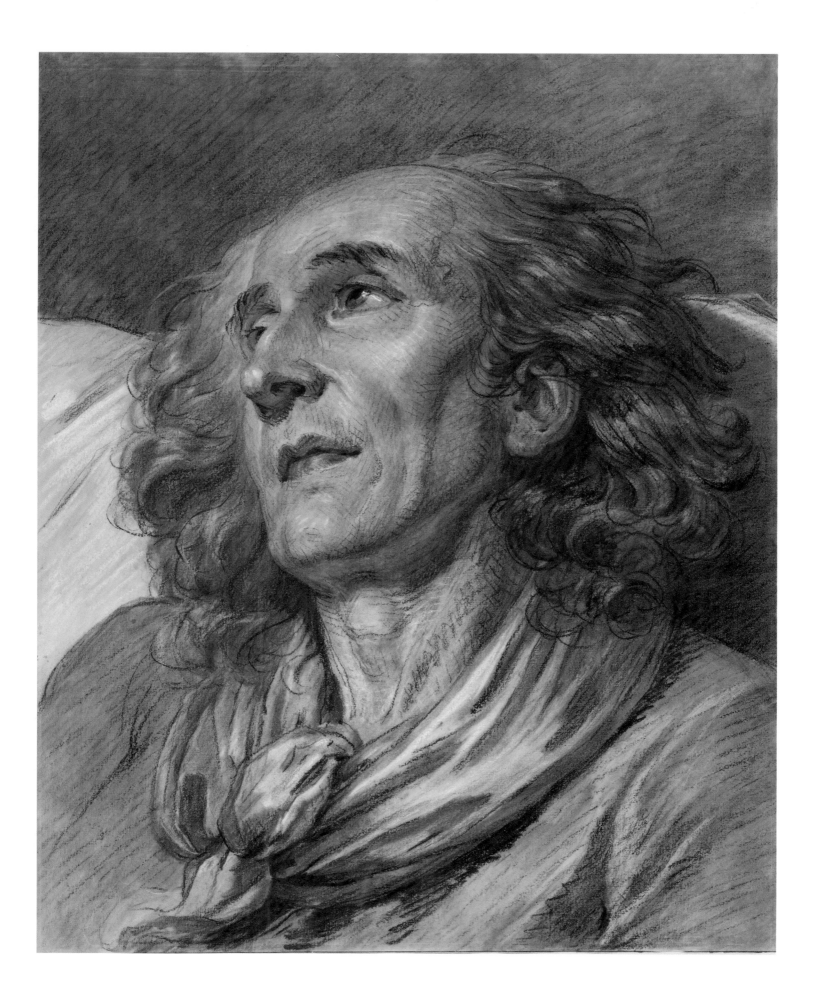

pastel with red, black, and white chalk and stumping on light golden-brown paper
440 × 322 (17 5/16 × 12 11/16)
New Century Fund, 2000.15.1

In contrast to the previous work (cat. 73), which Greuze made as a finished drawing after one of his painted figures, this tour-de-force sketch served as a preparatory study. Specifically, it is a study for the title figure in *The Well-Loved Mother* (fig. 1), in which the mother of a large family is both pleased and overwhelmed by the enthusiastic attentions of her adoring children.[1] The Washington study was exhibited in 1765 at the biennial Salon of the Académie royale, together with a sketch of the projected composition, and was seen there by Diderot, who remarked upon the unexpectedly erotic effect of the pose and expression of the mother when removed from the context of the composition:

Do you see this beautiful fishwife with her generously proportioned form and her head thrown back? The paleness of her face, the disorder of her headdress, the mingled expression of pain and pleasure on her countenance betray a feeling which is sweeter to experience than seemly to paint.... That half-opened mouth, those swimming eyes, that attitude of abandonment, that full throat, that voluptuous combination of pain and pleasure make all honest women blush and lower their eyes at this place in the Salon. And yet, in the finished picture by its side, we have the same attitude, the same eyes, the same throat, the same combination of passions, and not one of these ladies sees anything in it to offend her modesty.[2]

Diderot went on to praise the drawing specifically for its fidelity to nature and the "almost incredible gradations of tone in the forehead, and from the forehead to the cheeks, and from the cheeks to the throat."[3] The rendering of the throat and neck is in fact one of the most beautiful passages of the drawing, with extraordinarily subtle blending of the chalks and the most delicate touches of light and shadow. Much looser and more energetic are the broadly descriptive strokes of both chalk and stump in the woman's cap and dress, heightened by emphatic patches of bright white. Greuze's use of the golden brown paper combined with the chalks to simulate the effect of gold or yellow fabric is especially striking and gives the drawing the appearance of a full-color pastel when in fact it is drawn mainly with red, black, and white chalks, with only some touches of other colors. The extraordinary freshness of the chalks—especially the whites—adds to the brilliance of the visual effect.

The model here is Greuze's own voluptuous wife, Anne-Gabrielle Babuti (1732–after 1811), whom he married in 1759. (She also posed for another National Gallery drawing, *Head of a Woman Looking Back over Her Shoulder*, fig. 2.) Theirs was a stormy union, punctuated by her scandalous behavior and his frequent public humiliations at her hands. They were formally separated in about 1785 and divorced in 1793, shortly after divorce was made

legal in France. Significantly, their two daughters, then twenty-nine and thirty-one years old, chose to live afterward with their father. That their mother served much earlier as the model for the "well-loved" matriarch in the Washington drawing is therefore a wonderful, though perhaps unintentional, irony. Diderot's characterization of her as a "fishwife" in the passage quoted above was undoubtedly prompted by his personal acquaintance with her and her shameful conduct. In the final painting, which was completed in 1769 and had become by then a group portrait of the family of the marquis de Laborde, the mother's features are different and are presumably those of the marquise.

PROVENANCE

Pierre-Joseph-Victor de Besenval, Paris, 1765 (d. 1791) (perhaps his sale, Paris, 10 August 1795, lot 86); Jacques Doucet, Paris (1853–1929), by 1899 (sale, Galerie Georges Petit, Paris, 5 June 1912, lot 73); to Danlos for Édouard de Rothschild, Paris (1868–1949); François Coty (d. 1934) (sale, Galerie Charpentier, Paris, 30 November 1936, lot 21); private collection, France, and by descent (sale, Paris, 15 November 1999, lot 59); Thomas Agnew and Sons, London; NGA purchase in 2000.

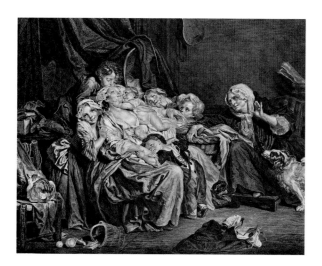

FIGURE 1: Jean Massard, *The Well-Loved Mother* (after Jean-Baptiste Greuze), 1775, engraving with etching (detail). National Gallery of Art, Washington, Katharine Shepard Fund, 2009.2.1

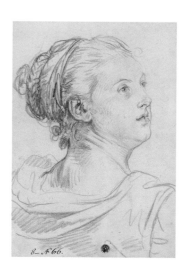

FIGURE 2: Jean-Baptiste Greuze, *Head of a Woman Looking Back over Her Shoulder*, c. 1760, red chalk. National Gallery of Art, Washington, Ailsa Mellon Bruce Fund, 1981.50.1

75 Jean-Baptiste Greuze · TOURNUS 1725–1805 PARIS
Sacrifice to Love, c. 1766

brush and gray and black wash over graphite with framing line in dark brown ink
407 × 354 (16 × 13 15⁄16)
inscribed in pen and brown ink on the mount below the drawing at lower left: *greuze fecit*, and at lower center: *offrande à l'amour*; inscribed in graphite on the verso of the mount at upper left: *2653*, at center: *G.*, below that in graphite in another hand: *no 145*, in graphite at lower left and across the lower edge: various mounter's notes
Bequest of Lore Heinemann in memory of her husband, Dr. Rudolf J. Heinemann, 2000.97.1

Chalk was Greuze's favored medium for his studies of heads, figures, hands, and other details, but for his compositions he preferred to use brush and wash, usually over a rough sketch in graphite or black chalk. He created preliminary compositional studies like the one presented here with a combination of broad, painterly washes that suggest the play of light and shadow and finer strokes that define details of contour, clothing, setting, and form. The overall effect is both boldly pictorial and subtly atmospheric.

FIGURE 1: Jean-Baptiste Greuze, *Votive Offering to Cupid*, c. 1767, oil on canvas. By kind permission of the Trustees of The Wallace Collection, London

Sacrifice to Love is a preliminary study for Greuze's painting *Votive Offering to Cupid*, which was completed by 1767 and exhibited in the Salon of 1769 (fig. 1).[1] The sketch was undoubtedly made at a relatively early point in Greuze's preparations for the picture, for the composition not only is in reverse to the final work but also shows several significant differences in the details. In the painting, for example, the statue of Cupid presents the supplicant with a floral wreath instead of his bow and arrow; the man at right in the drawing, who is waiting to make his own offering, is eliminated; and the shape and ornamentation of the pedestal holding the sculpture is altered. The pose of the young woman, on the other hand, remains essentially unchanged (except for its reversal), and the scene takes place in the same kind of walled enclosure set within a sylvan retreat.

The subject of a young woman making a sacrifice to the son of Venus in the hopes of finding her true love had its origins in the first neoclassical strains of the early 1760s, as Anita Brookner has pointed out.[2] Greuze surely knew at least one of the two compositions of closely similar subjects that Carle Van Loo (1705–1765) exhibited at the Salon of 1761 (locations unknown),[3] and two other paintings of sacrifices that Joseph-Marie Vien (cat. 60) presented at the Salon of 1763 (locations unknown).[4] All four show a woman outdoors and wearing classical dress, either offering a floral garland to a statue or placing a pair of doves on an altar. In many ways, Greuze's scene appears to combine details from the works of both artists: presenting the supplicant in a glade and pairing her with a stone sculpture, as in the two works by Van Loo and one of the Viens; and showing her offering doves, as in the other Vien.

Greuze, who had a special predilection for representing the highly emotional responses of females to the tragedies and triumphs of love, would have certainly been drawn to such a subject. Although the scene presented here is clearly indebted to the examples of both Van Loo and Vien, Greuze ultimately made it entirely his own. Not only did he add lightness and energy to the subject through the dynamic poses of the young woman and the sculpted Cupid — which seems to have come to life to offer her his bow and arrow — he also enlivened the composition with the addition of the smoke billowing from the altar set behind the girl, the restless play of light and shadow over the figures, and the robust handling of the trees and foliage. The cloying sentiment and officious moralizing that intrude in so many of Greuze's compositions are minimized here by the delightful interaction between the girl and the sculpture, but they are more evident in the final painting, where the figure of Cupid is more obviously carved from stone and his relationship with the girl has less of a human spark. There, the supplicant is literally about to be crowned by Love, but even as she is depicted in her moment of success, the consequent danger to her virtue is evoked by the inclusion of a bas-relief of *Pan and Syrinx* on the sculpture's base.[5] In the painting, moreover, Greuze makes it perfectly clear through the gathering of the girl's drapery between her legs exactly what is at risk.

PROVENANCE

Marquiset collection (sale, Paris, April 1870); Jean Groult, Paris (1868–1951) (sale, Hôtel Drouot, Paris, 20 March 1941, lot 12); Dr. Rudolf J. Heinemann, New York and Lugano (d. 1975); his wife, Lore Heinemann, New York and Lugano (d. 1996); gift to NGA in 2000.

Jean-Baptiste Greuze · TOURNUS 1725–1805 PARIS
The Ungrateful Son, c. 1770

red chalk on brown paper with framing line in black ink
427 × 331 (16 13/16 × 13 1/16)
inscribed in graphite on the verso at center: *34⁷ × 44*, and in graphite at lower right: *90*
Gift in memory of Douglas Huntly Gordon and in Honor of the 50th Anniversary of the National Gallery of Art, 1991.91.1

This riveting drawing is another of Greuze's famous *têtes d'expression*, more typical than the *Bust of an Old Man* (cat. 73) in that it is executed in his favorite medium of red chalk alone, but just as eloquent in its visual effect. This, too, is an independent piece derived from the artist's work on a painting, in this case, *The Paternal Malediction: The Ungrateful Son* (fig. 1).[1] Greuze developed the picture over a period of at least twelve years, exhibiting a drawing of the composition at the Salon of 1765 (now lost) and completing the canvas only in 1777. An early sketch of the composition (fig. 2)—but not the one that was exhibited at the Salon[2]— shows considerable differences compared to the final painting, not only in the general disposition of the figures but also in the complete reversal

FIGURE 1: Jean-Baptiste Greuze, *The Paternal Malediction: The Ungrateful Son*, 1777, oil on canvas. Musée du Louvre, Paris

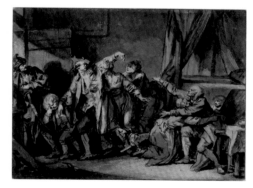

FIGURE 2: Jean-Baptiste Greuze, *The Paternal Malediction: The Ungrateful Son*, c. 1770, brown and gray wash over graphite. Palais des Beaux-Arts, Lille

of the image. In that drawing, the figure of the son who inspired the Washington sheet is shown facing in the same direction as here, but in the painting he looks the opposite way. That suggests that the National Gallery drawing stemmed from an intermediate stage of Greuze's work on the project, before he inverted the composition. It may also have preceded the final working out of the accursed son's expression, for the man in the Washington sheet seems to convey a somewhat milder combination of surprise and sadness than the eye-bulging horror seen in the face of his painted counterpart. As *Bust of an Old Man* already demonstrated, however, Greuze's expressive heads were not faithful copies of his original figures, but rather adaptations that could differ significantly in some of the details affecting the emotional message. The artist probably made this one, judging from the bravura execution and the emphatic use of cross-hatching to model the forms, in the late 1760s or early 1770s.[3]

The inspiration for some of Greuze's expressive heads lay in the famous treatise by Charles Le Brun (1619–1690) on the depiction of the passions, in which he attempted to codify the representation of common emotions by establishing a standardized facial expression for each one.[4] As Edgar Munhall has recognized, for the head of the ungrateful son Greuze quoted heavily from Le Brun's interpretation of "physical pain"—itself based on the face of one of the boys in the famous ancient sculpture of *Laocoön and His Sons* (Vatican Museums, Vatican City)—using the same twist of the neck and turn of the head looking back to the right.[5] He even parted the man's hair in the same place, although he lengthened the locks and modernized the style. At the same time, he modified the agonized expression of Le Brun's head by altering the mouth, leaving the lips parted but softening the pronounced rictus of suffering. Ultimately, however, Greuze's transformation of the Le Brun model comes through the power of his execution and the force of his own artistic personality, which allowed him to change the

original's programmatic representation of an emotion into a spirited and altogether human image that is unmistakably his own.

Greuze produced a large number of such sanguine drawings of expressive heads, but rarely were they as eloquent and arresting in their visual impact as this one. This particular sheet was surely admired from the very moment of its completion, for Munhall has identified at least five copies of it.[6]

PROVENANCE

Prince Wladimir Argoutinsky-Dolgoroukoff, Paris (1875–1941) (Lugt 2602d; sale, Sotheby's, London, 4 July 1923, lot 41); Dr. Tancred Borenius, London (1885–1948); Mrs. W. H. Hill, Boston; Mrs. Smith, New York; purchased in 1942 by Douglas H. Gordon, Baltimore (1903–1986) (his mark, G in an oval, stamped in black ink on the verso; not in Lugt); Mrs. Douglas Gordon; gift to NGA in 1991.

Louis Carrogis, called Carmontelle · PARIS 1717–1806 PARIS
Monsieur and Madame Blizet with the Actor Le Roy, c. 1765

watercolor and gouache over red and black chalk with touches of graphite
278 × 185 (10 ¹⁵⁄₁₆ × 7 ⁵⁄₁₆)
inscribed in brown ink on the verso across the top (partially obliterated): *Mr et mad Bli...t mr L.. roi acte[...]*; in brown ink just below that: *Blizet*; in graphite below that: *par Carmontell*; written in graphite across the center: *M. & Mme Blizet et Mr LeRoy,/acteur-*; in graphite at lower center: *11 dess*; and in graphite at lower right: *85*
Gift of Ruth Carter Stevenson in memory of Sir Geoffrey Agnew, 1987.56.1

Among the most recognizable works of art produced in the eighteenth century are the uniquely idiosyncratic portrait drawings of Carmontelle. Executed in a delicate mixture of black and red chalk and usually illuminated with watercolor and gouache, they almost invariably present the sitter(s) full length and in profile in an outdoor setting. The visual character of these drawings is unmistakable and resembles nothing else made during the period.

Little is known about Carmontelle's training as an artist, though the sensitive use of the chalks in the delineation of his subjects' faces shows a debt to Jacques-André Portail (1695–1759), whose work he must have known.[1] He was born Louis Carrogis, the son of a shoemaker, but at some point early on in his career, he changed his name to the more noble-sounding "Carmontelle." After being employed as a tutor in several aristocratic households, he served as aide-de-camp to the chevalier de Pons Saint-Maurice (1712–1791) during the Seven Years' War (1756–1763). In that capacity he drew maps for the campaign as well as portraits and caricatures of the officers and soldiers with whom he served. After the war, the chevalier

FIGURE 1: Carmontelle, *Madame la duchesse de Mortemart,* c. 1770, red and black chalk with gouache and gray wash. National Gallery of Art, Washington, Gift of Arthur L. Liebman, 1992.87.5

obtained a post for Carmontelle as tutor to the young duc de Chartres in the household of the duc d'Orléans, where, because of his easy temperament, agreeable manner, and quick wit, he soon made himself an indispensable and most welcome member. He orchestrated entertainments, wrote theatrical pieces based on proverbs, designed parks and gardens, and even wrote critiques of contemporary art. Above all, he also made hundreds of portrait drawings of the people he encountered through the Orléans family, from the highest to the lowest in social station. Although he sometimes gave his sitters replicas of their portraits, Carmontelle kept most of them for himself, arranging them chronologically in albums, beginning in 1755 with one of his benefactor, the chevalier de Pons Saint-Maurice (Musée Condé, Chantilly).[2] At the time of his death, he owned thirteen albums containing 750 portraits.[3]

As Carmontelle's portraits gained renown in French social circles, it must have become something of an honor to sit for him. The appeal of his work was explained by his friend Baron von Grimm (1723–1807), who also posed for him: "He has the ability to seize in singular fashion the air, carriage, spirit of the figure. Every day it happens that I recognize out in the world some people I have only seen in those albums."[4] He goes on to say that it took just two hours for Carmontelle to complete a drawing with "surprising facility." Working with such speed, the artist was not interested so much in producing penetrating psychological studies of his sitters, but instead concentrated on the accurate but unemotional — and perfectly composed — rendering of the features and contours of the profiles. The clothing worn by the subjects played a key role in establishing their social identities; it also served as an important compositional element that brought both harmonious colors and visually attractive patterns to the designs.

The identification of the sitters in the very fine Carmontelle drawing presented here comes from the old inscriptions on the back of the drawing's

mount, but efforts to discover more about them have not yielded useful results so far. In the absence of any biographical information about the sitters, including their dates of birth or their ages here, the hairstyles and clothes suggest that this triple portrait must have been drawn in the mid-1760s, give or take a year or two. The instrument played by Madame Blizet is a musette, a type of bagpipe equipped with a small bellows instead of a blowpipe for supplying air to the bag. Adapted from the more countrified cornemuse and featuring a pleasing, delicate sound, it became fashionable among the elite classes during the reign of Louis XV and was often made of expensive materials.[5] Jacques-Martin Hotteterre (1674–1763), who invented it, and Jean-Philippe Rameau (1683–1764) were among the composers who wrote music for the musette, often in duets with other instruments such as the violin, as is shown here.

The National Gallery drawing holds a special place within Carmontelle's oeuvre as one of the very few to include three or more people, for the vast majority portray only a single subject (fig. 1). In the present drawing, as in some of those other group portraits, music plays an important role, not only in classifying the sitters as cultivated and talented people but also giving a purpose to the grouping and visual interest to the scene.[6] By posing the sitters in a concertlike situation, Carmontelle was able to take advantage of his preference for profile likenesses, for the subjects could then be presented as if they were playing for an audience that includes, in this case, not only M. Le Roy, seated at right, but also the viewer. The conceit is utterly charming and lifts this particular sheet well above the level of Carmontelle's more typical works.

PROVENANCE

Ambroise Firmin-Didot (1790–1876) (Lugt 119; sale, Hôtel Drouot, Paris, 16 April–12 May 1877, lot 85); Mr. and Mrs. Charles Wrightsman (sale, Sotheby Parke Bernet, New York, 5 May 1984, lot 11); William H. Schab Gallery, New York; NGA purchase with funds donated by Ruth Carter Stevenson in 1987.

Jean-Baptiste Lallemand · DIJON 1716–1803? PARIS
Dawn Landscape with Classical Ruins, 1760s?

gouache
324 × 481 (12¾ × 18 15⁄16)
signed in white gouache at lower right: *lallemand f*
Phillips Family Fund, 1983.41.1

Jean-Baptiste Lallemand's serene landscapes are descendants of those composed by Claude Lorrain a century earlier (cats. 21, 23, 24), but are firmly eighteenth-century in both conception and execution. Lallemand belonged to the generation of French landscapists—including his near contemporaries Claude-Joseph Vernet (1714–1789), Charles Michel-Ange Challe (cat. 61), and Charles-Louis Clérisseau (1721–1820), followed by the younger Hubert Robert (cats. 82–85)—who all worked at about the same time in Rome and were deeply inspired by the architectural capriccios of Giovanni Paolo Panini (1691–1765) and Giovanni Battista Piranesi (1720–1778). The fourteen years Lallemand spent in Italy, from 1747 to 1761, provided him with visual material that would last a lifetime, and he continued to tap into it long after he returned to France. Although his later paintings and gouaches often focused on topographical views— he provided 140 drawings of French locales for the twelve-volume publication *Déscription générale et particulière de la France* (General and Specific Description of France), also known as the *Voyage pittoresque de la France* (Picturesque Voyage of France), produced between 1781 and 1796[1]—he also continued to paint the imaginary scenes that evoked his love of ruins and his experiences in Rome. He was a member of the Académie de Saint-Luc—having been admitted as a master in 1745—and although he remained outside the exalted realms of the Académie royale, he enjoyed the support of a number of minor nobles—some as far away as Russia—for whom he made paintings or gouaches that were intended specifically to decorate salons and other interior spaces of country châteaux and urban hôtels.[2]

As a draftsman, Lallemand did his best work in gouache, and the handsome sheet in the National Gallery bears convincing witness to his command of the medium. Drawn with a confident touch and easy control of the brush, it demonstrates the artist's skill in depicting the forms and textures of both man-made and natural elements, while also showing his masterly manipulation of light. As is the case with so many of Lallemand's invented views, this one is a picturesque combination of looming ancient ruins, a waterfall and stream, animals and their guardians crossing a bridge, plumelike trees, and the morning (or evening) sky. Most likely it was once paired with another work of similar scale, execution, and subject that would have balanced this composition, very much in the manner of Lallemand's pendant paintings representing *Morning* and *Evening* in the Musée des Beaux-Arts, Dijon.[3]

Lallemand sometimes elevated his genre landscapes to a higher intellectual plane by turning them into backdrops for biblical stories or scenes from ancient history. The Baptism of Christ, the Flight into Egypt, and the Good Samaritan are among the subjects that he is known to have painted,[4] but in general his compositions were pastorals and idealized visions of nature and antiquity that apparently had no didactic purpose. It is tempting, however, to think that he might sometimes have included certain visual cues that would invite more thoughtful contemplation of his works. Here, for example, the man and woman with a baby at lower left can be understood as referring to the Flight into Egypt, as can the woman riding a donkey across the bridge. The fisherman dipping his net in the river might call to mind the many references to fish and fishing in the Bible, including the stories of the loaves and fishes (Matthew 14:16–21), the calling of the apostles to be fishers of men (Matthew 4:18–20), and the miraculous draft of fishes (John 21:5–14). The water itself can be taken as referring to the Baptism, and so on. It is perfectly possible, on the other hand, that Lallemand was content simply

to compose beautiful landscapes from a somewhat standardized and limited set of elements, regardless of their inherent symbolic meanings, and felt that was sufficient to please and engage his audience.

Because so much of Lallemand's work consists essentially of variations on particular landscape themes, it is difficult to date individual pieces without his own inscriptions or documentary evidence. Nothing in the present drawing indicates whether it was executed during Lallemand's years in Rome or later on in France, though it appears to be the work of a master at the height of his powers, perhaps in the 1760s. No matter the specific date of execution, however, this one work conveys in remarkable fashion the essence of Lallemand's personality as an artist and encapsulates a good part of his achievement as a master of the landscape capriccio.

PROVENANCE
Private collection (sale, Christie's, London, 20 March 1973, lot 140); purchased by Mrs. Scharf; David Tunick, New York; NGA purchase with funds donated by Neil and Ivan Phillips in 1983.

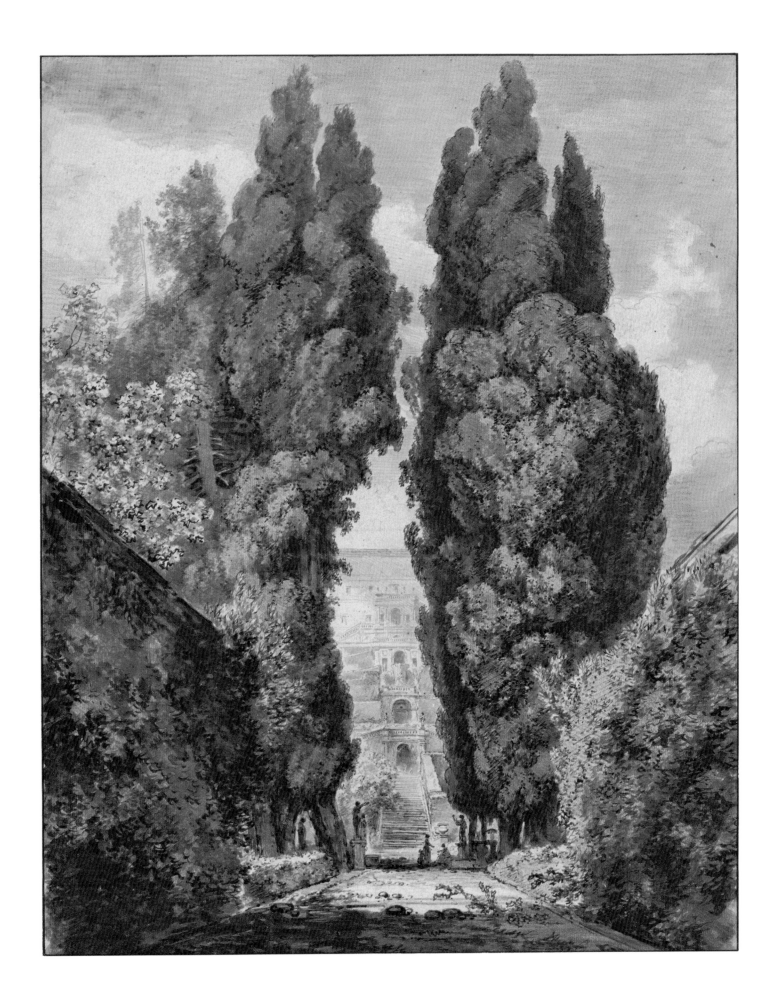

Jean-Honoré Fragonard · GRASSE 1732–1806 PARIS
A Stand of Cypresses in an Italian Park, c. 1760

red chalk
235 × 377 (9 ¼ × 14 ⅞)
inscribed in graphite on the verso at lower center: *III:5JNB*
Patrons' Permanent Fund, 1991.4.1

The grand vision of nature that Fragonard developed during the summer of 1760 at the Villa d'Este in Tivoli (see cat. 86) continued in the drawings he made of other locations in and around Rome at about the same time. A particularly beautiful example, in remarkably fresh condition, is this luminous rendering of an unidentified Italian park. It shares with the Tivoli views a number of characteristic features, including the mass of towering cypresses dwarfing tiny figures, the evocation of the white heat of an Italian summer, and the frothy masses of foliage that threaten to engulf man-made boundaries. It is closest in both mood and composition to one particular Tivoli drawing, *The Fine Group of Cypresses at the Villa d'Este, with a View of the Organ Fountain* (fig. 1),[1] which features a similarly dense mass of majestic cypresses, placed slightly left of center and set off against more distant elements of a light-drenched park. Both drawings exhibit a similarly rich texturing of every surface and delicate nuancing of the shadows, and both include the same jagged sawtooth strokes that energize the forms. Even though the National Gallery sheet is no more than half the size of the Villa d'Este drawing, the composition is equally monumental, while the execution is even finer and more precisely controlled.

One of the remarkable features of Fragonard's drawings of parks and gardens is the tacit invitation they offer the viewer to roam around the spaces, to explore the paths and hidden corners, to wander through openings in hedges and walls to the areas, suggested but unseen, that lie behind. These views are an exercise in visual delight, conveying the sense of Fragonard's own pleasure in strolling through such locales. He became so familiar with the elements of Roman gardens and was so adept at drawing them that he was soon able to render imagined places as easily and as convincingly as real ones. The question has been raised, in fact, as to whether the present drawing represents an actual site or is a capriccio based on the artist's personal experience of Italian gardens.[2] The serene perfection of the scene argues in favor of an invented view, but the beautiful articulation of the stand of cypresses at center—with the characteristic massing of the foliage, the glimpses of deeply shadowed trunks, the bowed limbs that have separated from the central clumps— seems remarkably natural and authentic. At this early stage in his career, it seems more likely that Fragonard would have based a drawing like this on a real view, perhaps correcting and refining it as he worked.

PROVENANCE

H. Dreux (sale, Paris, 3–4 February 1870, lot 43); Marie-Joseph-François Mahérault (1795–1879) (sale, Paris, 27–29 May 1880, lot 52); M. Lemarié, by 1889 (according to Portalis); purchased in 1921 by Marius Paulme (1863–1928) (Lugt 1910; sale, Galerie Georges Petit, Paris, 13 May 1929, lot 82, pl. 55); to Richard Owen, Paris; purchased in 1929 by John Nicholas Brown, Providence, Rhode Island (1900–1979); David Tunick, New York; NGA purchase in 1991.

FIGURE 1: Jean-Honoré Fragonard, *The Fine Group of Cypresses at the Villa d'Este, with a View of the Organ Fountain*, 1760, red chalk. Musée des Beaux-Arts et d'Archéologie, Besançon

88 Jean-Honoré Fragonard · GRASSE 1732–1806 PARIS
Terrace and Garden of an Italian Villa, 1762/1763

red chalk over traces of black chalk
248 × 376 (9 ¾ × 14 ¹³⁄₁₆)
Samuel H. Kress Collection, 1963.15.11

This densely worked red chalk rendering of a walled garden was probably made a little later than the two previous drawings (cats. 86, 87), most likely after Fragonard's return to Paris at the end of 1761.[1] Setting this one apart from the earlier Italian views, in terms of composition, is the tightly constructed and enclosed space, which is intimate and confined instead of panoramic and expansive. In handling, too, neither the stylized treatment of the contorted tree limbs jutting from the foliage at left and center nor the quick, scintillating dots and flicks of the chalk in the light-struck patch of foliage at center have corollaries in the Villa d'Este drawings. In many ways, the National Gallery drawing is most closely related to one of Fragonard's best-known compositions, *The Little Park*, executed in several different versions and media between c. 1761 and c. 1775.[2] The bottom halves of both compositions, marked by their stagelike space, rich masses of foliage spilling over the garden walls, and a selective use of lighting in the enclosed areas are remarkably similar. One particular rendition of

The Little Park (fig. 1), a retouched counterproof like cat. 86, also includes, in the brown wash additions made by Fragonard himself, an angular tree and jagged limbs that are very close in appearance to the ones that are so prominent in the National Gallery's *Terrace and Garden of an Italian Villa*. The earliest version of *The Little Park*, a red chalk drawing (private collection), probably dates from 1760/1761, when Fragonard was still in Italy, but the others were most likely made after his return to Paris. His etching of the subject is generally dated to 1763, and the counterproof taken from one of the sanguine drawings could have been retouched at any point up to 1765 or even slightly later.[3] Since landscape drawing seems to have become less of a preoccupation for Fragonard upon his return to France (except for his retouching of red chalk counterproofs), the National Gallery drawing should probably be dated no later than 1762 or 1763.

As has sometimes been proposed regarding the previous drawing (cat. 87), this one may not represent an actual garden; instead, it could be

the artist's invention based on his knowledge and experience of the Italian landscape. Certainly all the elements included here — the balustrade, colonnade, sculpted bust, paved courtyard, benches, and stone fountain, not to mention the tall cypresses and cascading foliage — would have been familiar to him from the several years he spent in Rome.

PROVENANCE

Gaston Le Breton, director general of the museums of Rouen (1845–1920) (sale, Hôtel Drouot, Paris, 6–8 December 1921, lot 63); Eugène Rodrigues (1853–1928) (Lugt 897; sale, Hôtel Drouot, Paris, 28–29 November 1928, no. 113); Richard Owen, Paris; purchased in 1936 by Samuel H. Kress, New York (1863–1955); gift to NGA in 1963.

FIGURE 1: Jean-Honoré Fragonard, *The Little Park*, 1760/1761 and c. 1765, pen and brown ink with brown and gray wash and some white gouache over red chalk counterproof. Private collection, New York

91b

Don Quixote and Sancho Panza Witness the Attack on Rocinante, 1780s

black chalk with gray and brown wash
421 × 287 (16 9/16 × 11 5/16)
Gift of Gertrude Laughlin Chanler, 2000.9.7

91b

Jean-Honoré Fragonard · GRASSE 1732–1806 PARIS
illustrations for Ariosto's *Orlando furioso*, 1780s

These two sheets belong to a series of more than 170 drawings made by Fragonard to illustrate the great epic poem *Orlando furioso* by Ludovico Ariosto (1474–1533), the first definitive edition of which was published in 1532. The circumstances under which Fragonard embarked on this long series of drawings are not known. For years scholars assumed that he made them for a new illustrated edition of Ariosto's work, which never came to fruition. At the same time, however, they acknowledged that Fragonard's bold yet sketchy handling of the scenes would have been inordinately difficult for engravers to translate into prints. In addition, the large number of illustrations involved would have made the cost of such a publication prohibitively expensive. The fact

FIGURE 1: Jean-Honoré Fragonard, *Isabella Abandons Her Home to Follow Odorico and His Men*, 1780s, black chalk and stumping with brown and gray wash. National Gallery of Art, Washington, Gift of Edith G. Rosenwald, 1978.10.1

that two French editions of *Orlando furioso* had only recently been published—in 1773 by Baskerville and in 1775–1783 by Brunet and Laporte—makes it illogical to suppose that an astute publisher would have proposed the production of yet another deluxe edition in the 1780s, the period to which these drawings can be dated for stylistic reasons.[1] Supporting that dating is a print that seems to have been executed after one of the drawings by the amateur engraver the comte de Paroy (1750–1824), which was exhibited at the Salon of 1787. No impression of the print is currently known, however, making it difficult to verify the identification, but the description in the Salon *livret* seems to correspond to the scene depicted in Fragonard's drawing *The Hermit, the Donkey, and the Demons*, from Canto VIII, 31–32.[2] The testimony of the artist's grandson Théophile, moreover, places the execution of both the *Don Quixote* (cat. 91) and the Ariosto drawings during the last twenty-five years of Fragonard's career, thus dating the earliest ones, at least, to the first part of the 1780s.[3]

The tighter execution of the *Don Quixote* drawings—as compared to the progressively looser handling of the Ariosto series—suggests that Fragonard embarked on the illustrations of the classic Spanish novel first. In fact, a number of the Ariosto compositions, especially those taken from the earlier cantos, are very close in execution to the *Don Quixote* drawings and seem to have been made within a short time of them.[4] Over time, however, Fragonard's handling of the Ariosto drawings became remarkably unrestrained—in both the chalk and the wash—with a more delicate touch overall and less emphasis on individual contours. Many of the illustrations of scenes from the later cantos remained very sketchy, and if the *Don Quixote* drawings had been made *after* these later Ariosto studies, they would surely have reflected some of the same lightness and freedom. The greater variety of execution in the *Orlando furioso* illustrations also indicates that they must have been executed over a much longer period of time than those for *Don Quixote*. They range from

spirited black chalk sketches, clearly unfinished, to fully worked-up images in chalk and wash. Many of them feature a wild tangle of chalk strokes with which Fragonard searched out his compositions, before using his brush to firm up the final solutions (fig. 1).

The first drawing shown here (cat. 92a) illustrates Canto IV, 43, in which a magical beast known as a hippogryph—part eagle and part horse—eludes capture by the female knight Bradamante, sister of Rinaldo: "He waited until she was close, then spread his wings and rose into the air, and settled a little further off on the hill slope. She followed him and, just as before, he rose into the air and settled yet a little further off—like a crow luring a dog after it hither and thither across the sandy scrub."[5] Bradamante's suitor, the African knight Ruggiero, is shown on horseback at right, and observing them both from the clouds above is, most likely, the wizard Atlante, who controls the hippogryph. As he intends, Bradamante will fail to catch the animal, but Ruggiero will be tricked into mounting him instead, to be carried off against his will to the island of Alcina. Bradamante's pursuit of the hippogryph is one of Fragonard's most enchanting Ariosto images, set in an undefined world of swirling clouds and brilliant silvery light. The only suggestion of an earthbound location is provided by the tall palm tree that cuts diagonally through the composition, creating a visual link between the winged steed and the sorcerer above.

93a

Charles Eisen
The Great Flood, 1765
graphite on vellum
image: 134 × 89 (5 ¼ × 3 ½)
signed and dated in graphite below the image at lower left: *C.ʰ.. Eisen. inv. et fecit 1765.*
Widener Collection, 1942.9.855

93b

Charles Eisen
Jupiter and Callisto, 1765
graphite on vellum
image: 132 × 89 (5 ³⁄₁₆ × 3 ½)
signed and dated in graphite below the image at lower left: *C.ʰ.. Eisen, inv...et..f. 1765.*
Widener Collection, 1942.9.883

93a

93b

the *Metamorphoses*, however, is his illustration for Book v, Fable 2 (pl. 59; see cat. 93c), engraved in reverse by Jean Massard (1740–1822). There, Perseus, at the celebration of his marriage to Andromeda, holds up the head of the hideous Gorgon Medusa to turn Phinneas, the pretender to his wife's hand, and Phinneas' cohorts to stone.[9] Other fine examples of Monnet's work are his seductively languorous rendering of *Jupiter and Io* (pl. 19; see fig. 1), his charming take on *Echo Changed into a Voice* (pl. 45), and his handsomely executed and remarkably fresh *Meleager Presenting the Head of the Calydonian Boar to Atalanta* (pl. 86).[10]

Moreau the Younger (see also cats. 94, 95) contributed twenty-six designs to the *Metamorphoses*. It was his first major job as an illustrator, but he quickly proved himself to have a special talent for the genre. His first four designs, made in 1766, including *Phaeton at the Palace of the Sun* (pl. 24; see fig. 2),[11] were drawn in graphite on vel-

lum, the technique used by Eisen. Moreau quickly shifted, however, to his own preferred medium, pen and ink with wash on paper, and produced a remarkable set of drawings that stand out from the rest of the Ovid designs—with the possible exception of the ones made by Boucher (see cat. 57)—for their richly pictorial compositions, smooth contours, finely nuanced washes, silvery light, and elegant forms.

A particularly fine example of his work is *The Sacrifice of Iphigenia* (cat. 93d), engraved in reverse by Le Mire in 1769 to illustrate Book xii, Fable 1 (pl. 119), which describes the beginnings of the Trojan War.[12] In this particular episode, Iphigenia, daughter of King Agamemnon, is about to be offered as a sacrifice to the goddess Diana, who has prevented the Greek ships from setting sail for Troy with unfavorable winds: in the words of the priest Calchas, "Virgin blood must satisfy the virgin goddess' anger."[13] Impressed by the princess'

willingness to give up her own life for the good of her people, Diana intervenes, blinding the priests and onlookers with clouds and replacing Iphigenia with a doe. Other particularly compelling examples of Moreau's work as an illustrator for the Ovid volumes are *The Rape of Proserpine* (pl. 62), *The Trojan Ships Changed into Sea Nymphs* (pl. 134), and *The Death of Caesar* (pl. 140).[14] The most arresting is his candle-lit rendering of the emaciated figure of Famine hovering over the sleeping King Erysichthon (pl. 89; see fig. 3), preparing to curse him with an appetite that can never be satiated.[15]

The 130 Ovid drawings in the National Gallery's collection constitute an extraordinary trove by some of the best book illustrators working in France during the reign of Louis xv. Small in scale but powerful in effect, the images are almost without exception exquisitely drawn and brilliantly conceived, capturing with spirit and inspiration the complex combination of poetry, pathos, passion, triumph, and tragedy in Ovid's ancient tales. As a group, they form one of the Gallery's unique treasures of eighteenth-century French draftsmanship.

PROVENANCE

Antoine-Auguste Renouard (1765–1853) (sale, Paris, 20 November 1854, lot 1128); comte Adolphe-Narcisse Thibaudeau (d. 1856) (sale, Paris, 19–25 April 1857, lot 825); baron Jérôme Pichon (1812–1896); Louis Roederer, Reims (d. 1880); to his nephew, Léon Olry-Roederer, Reims and Paris (d. 1932); sold through Thomas Agnew and Sons, London, to the Rosenbach Company, Philadelphia, 1922; Joseph E. Widener, Elkins Park, Pennsylvania (1871/1872–1943); gift to NGA in 1942.

FIGURE 2: Jean-Michel Moreau the Younger, *Phaeton at the Palace of the Sun*, 1766, graphite on vellum. National Gallery of Art, Washington, Widener Collection, 1942.9.876

FIGURE 3: Jean-Michel Moreau the Younger, *Famine and King Erysichthon*, 1767, pen and black ink with gray wash over faint traces of graphite. National Gallery of Art, Washington, Widener Collection, 1942.9.1010

François-André Vincent · PARIS 1746–1816 PARIS
Noah Leading the Animals into the Ark
(after Giovanni Benedetto Castiglione), 1774

gray-brown wash heightened with white gouache over black chalk on light brown paper (originally blue)
419 × 556 (16 ½ × 21 ⅞)
signed and dated in brown ink at lower left: *Vincent R. 1774* [words scratched out]; signed again at later date in brown ink at lower right: *Vincent*
Ailsa Mellon Bruce Fund, 2007.80.1

One of the most gifted young draftsmen at the French Academy in Rome in the early 1770s was François-André Vincent, who had an almost chameleon-like ability to change his style and an extraordinary facility with the brush. He probably learned the rudiments of drawing from his father, a miniaturist, before he entered the Paris studio of Joseph-Marie Vien (cat. 60) in 1760. Vincent remained there until 1768, when, at just twenty-two years of age, he won the Prix de Rome. After studying for three years at the École royale des élèves protégés in Paris, he departed for Rome in 1771, spending four productive years there as a *pensionnaire* of the king and creating some surprisingly powerful and beautiful drawings for such a youthful artist.

As the date inscribed on the present drawing indicates, it was made when Vincent was in Italy, probably in Rome, though he spent time in Naples in April and May.[1] It is a copy after a brush drawing by the seventeenth-century Genoese artist Giovanni Benedetto Castiglione (1609 or before–1664), whose paintings of landscapes, animals, biblical scenes, and patriarchal journeys were greatly admired by a number of French eighteenth-century artists, including François Boucher and Jean-Baptiste Deshays (see cat. 71).

The specific composition copied by Vincent, which happens to be owned in part by the National Gallery (fig. 1), is an outstanding example of the bravura oil drawings on paper for which Castiglione was justly famous, demonstrating both the exceptional brilliance of his brushwork and the beauty of his color.

In copying the Castiglione, Vincent did not attempt to replicate the virtuoso qualities of the original, but instead drew the animals, figures, and ark in monochrome and in a smoother, more finished style that makes each individual element more distinctly defined and the spatial relationships somewhat clearer. That is not to say that Vincent's copy is pedantic or dull, however, for that is not at all the case. His use of the black chalk is assured and the brown washes are delicately nuanced, but it is his handling of the whites that is particularly eye-catching as he creates effects of light and texture that bring the image to life. The goat in the foreground, seen from behind and drawn almost entirely with white gouache, is a thoroughly arresting piece of draftsmanship. In most of the details, Vincent follows Castiglione's composition and the poses of the figures and animals quite closely, but he also made a few changes. At left, for example, he altered the position of

the bearded man urging the animals onward, twisting his right shoulder forward, turning his face into three-quarter profile, and even changing the hand that holds the stick from the left to the right. In addition, the dog at lower left in the Castiglione is transformed by Vincent into a pig; the shape of the head of the second deer is changed and the horns eliminated; the horns of the goat seen from behind in the foreground are shortened; and a bird, probably a second turkey, has been added behind the first, at Noah's feet. While Vincent's copy is perfectly recognizable as a reiteration of a work by Castiglione, his translation of his seventeenth-century model is palpably more eighteenth-century in both execution and spirit.[2]

PROVENANCE
Private collection (sale, Christie's, London, 3 July 2007, lot 140); NGA purchase via Hazlitt, Gooden & Fox, London, in 2007.

FIGURE 1: Giovanni Benedetto Castiglione, *Noah Leading the Animals into the Ark*, c. 1655, brush and oil paint on brown paper. National Gallery of Art, Washington, Partial and promised gift of Gilbert Butler, in Honor of the 50th Anniversary of the National Gallery of Art, 1991.221.1

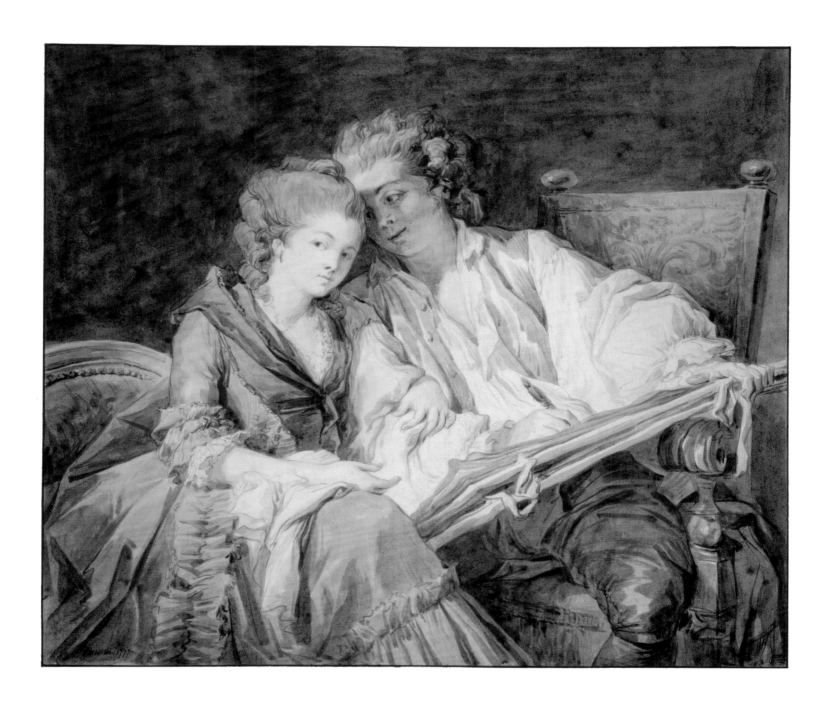

pen and black ink with gray wash and graphite with touches of white gouache with
border line in black ink drawn by the artist
sheet: 324 × 247 (12 ¾ × 9 ¾); border: 288 × 218 (11 ⁵⁄₁₆ × 8 ⁹⁄₁₆)
Ailsa Mellon Bruce Fund, 1987.63.1

During the second half of the eighteenth century, Paris was home to a number of foreign artists who made their mark on French art in a variety of ways. One of them was Sigmund Freudenberger (known as Freudeberg in France), who arrived there in 1765 after training in Basel for three years with the portraitist Jakob Emanuel Handmann (1718–1781). Most of Freudenberger's activity during his eight years in Paris revolved around making designs for prints, principally of fashionable life and mildly titillating boudoir scenes in the style of Pierre-Antoine Baudouin (cat. 78). His greatest single project was the creation of twelve compositions for *Suite d'estampes pour servir à l'histoire des moeurs et du costume des Français dans le dix-huitième siècle* (Suite of Prints Serving as a History of the Manners and Modes of the French in the Eighteenth Century), which was published in 1774, a year after he had returned to Bern. Much more than a set of fashion plates, the prints provide

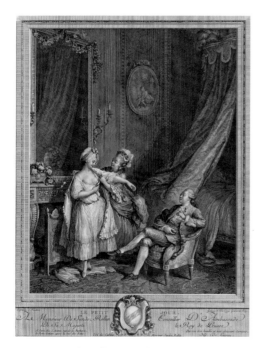

FIGURE 1: Nicolas Delaunay, *Early Morning* (after Sigmund Freudenberger), late 1770s, etching and engraving. National Gallery of Art, Washington, Widener Collection, 1942.9.2341

an enchanting glimpse of the privileged and pleasure-filled existence of the aristocracy and the *haute bourgeoisie* of the time, taking an intimate and somewhat idyllic look at their social milieu and their daily pursuits and entertainments while also focusing on the broader context of contemporary taste and style.

Although the drawing presented here was not made specifically for Freudenberger's suite, it shares the same spirit and style of presentation, and one can imagine that it was made with a second set of prints in view. The second and third suites (published in 1777 and 1783) of what came to be known simply as the *Monument du costume* were entrusted to Jean-Michel Moreau the Younger (see cat. 95), however, perhaps because the first set did not enjoy the commercial success that had been expected or perhaps because it was thought that a French artist, rather than a Swiss one, might more appropriately represent the country's modes. In any case, Freudenberger had returned to Bern in 1773, and although he continued to make drawings and gouaches of fashionable genre scenes in the French style, he also took up other projects, including painting portraits, illustrating books, and depicting Swiss peasant scenes and costumes.[1]

The present composition was engraved in reverse by Nicolas Delaunay (1739–1792) at an unknown date, probably in the late 1770s (fig. 1).[2] It is not known if this drawing is the one that was then in the collection of David Alphonse de Sandoz-Rollin (1740–1809), the Prussian minister to France, and served as the engraver's model for Delaunay's print.[3] Its unfinished state would speak against that possibility, as would the several differences in the details of the final print. There, the woman on the left wears a cap, for example, and the head of the woman helping her to undress is clearly reflected in the mirror. In addition, in the print, the oval painting on the wall in the background shows an image of Venus and Cupid (which is only lightly indicated in the drawing),

and the fireplace screen is placed and decorated differently. Delaunay therefore either took some liberties with the composition in producing the engraving, as he sometimes did, or he was working from a different, more finished version of it that is now lost. It is equally possible, however, that Freudenberger had abandoned the composition because he was no longer involved with the *Monument du costume* suites and thus never made a more complete version of it. In any case, Delaunay's print has been called "one of the prettiest" of the type.[4]

One of the special attractions of the National Gallery drawing is its combination of completeness and incompleteness and the unusual way in which it shows Freudenberger developing the details of his composition. He first drew it in graphite, filling the entire page except for an inch at the bottom, which would have been reserved for the title in the print. He then used that space to make a separate study of the right arm of the central figure, changing very slightly the bend of the wrist and the position of the fingers. Then, after the scene was fully sketched in graphite, he drew a border line in pen and ink, well inside the original dimensions of the sheet, thus indicating what the exact size of the print would be. Leaving the elements that fell outside the border untouched, he then worked up the central part of the sketch in wash, picking out some details in pen and ink, making a change in the position of the gentleman's left leg, and omitting the table at left altogether. The end result is a composition of exceptional charm that also gives a thoroughly delightful behind-the-scenes view of how the artist worked it up.

PROVENANCE
Possibly David Alphonse de Sandoz-Rollin (1740–1809); Victorien Sardou, Paris (1831–1908) (sale, Galerie Georges Petit, Paris, 27–29 April 1909, lot 72); Kate de Rothschild, London; NGA purchase in 1987.

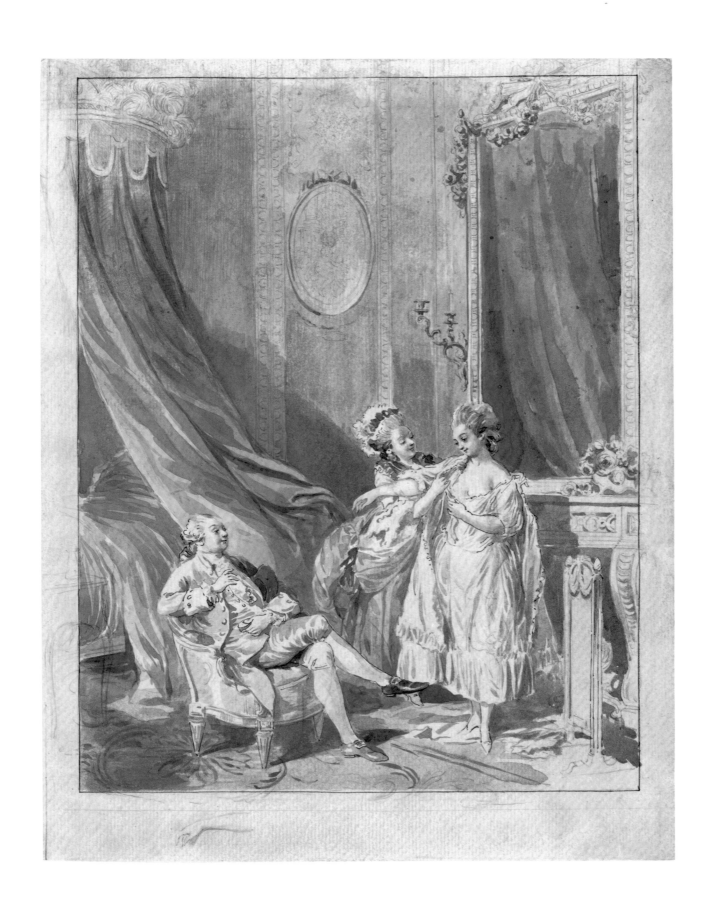

Charles-Nicolas Cochin II · PARIS 1715–1790 PARIS
illustrations for *Almanach iconologique*, 1774/1775

With both parents working as professional print-makers, Charles-Nicolas Cochin II naturally also became an engraver and enjoyed a long career that prospered unabated through the 1780s. In fact, through his close friendship with the marquis de Marigny (1727–1781), brother of Madame de Pompadour and the director of the king's buildings from 1751 to 1773, Cochin was for a time one of the most powerful artists in France. He was even awarded full membership in the Académie royale in 1751 without submitting the requisite reception piece. (He had been *agréé* ten years earlier.) In addition to illustrating more than two hundred books,[1] he also wrote several tomes of his own, mainly theoretical in nature, which were intended to educate his readers about contemporary art and to influence the public view of the art of their time.

The drawings presented here belonged to a suite of ninety-eight designs made by Cochin to embellish the *Almanach iconologique*, a pocket-sized annual publication that was begun by Hubert-François Gravelot (cat. 63) in 1765 and came out each year until his death in 1773. Cochin then provided the illustrations for the next eight volumes, with the seventeenth and final one published in 1781.[2] Gravelot's idea was to create an almanac

FIGURE 1: *Almanach iconologique*, eighteen bound volumes, 1765–1781, with one volume held open. National Gallery of Art, Washington, Ailsa Mellon Bruce Fund, 1988.59.1–18

that also included a suite of allegorical figures devoted to a particular iconographical theme, such as the Arts, Sciences, Muses, or Months, with notes giving the meaning and rationale attaching to the details and symbols in each image. For the images and the explications, he drew heavily on the emblem books of Cesare Ripa (d. 1622), which had long been the standard reference for artists for the design and interpretation of allegorical representations. In the first ten volumes of the *Almanach*, including the first one illustrated by Cochin, each image focused on a single figure with its attributes. Thereafter, however, beginning with the eleventh suite published in 1775 (for which the two drawings presented here were made) and continuing through the last one, Cochin combined two or more figures in a single design. With the final seven suites all devoted to representations of the Virtues and Vices, each Virtue could thus be shown with the Vices that were most clearly opposed to it. With this change in the program, Cochin was able to reduce the number of images required to complete the project while also relieving the repetitious dullness inherent in a long series of individual figures.[3]

The two drawings in the National Gallery are executed in the finely sharpened red chalk that Cochin customarily used for the allegories both large and small he designed for prints and book illustrations. In the first one (cat. 102a), he depicted the opposite emotions of Gaiety (or Joy) and Grief (or Sorrow), which he captured with considerable charm and delicacy. As the accompanying text in the *Almanach* explains, Gaiety is personified by a young woman crowned with flowers and wearing a white dress, dancing in a meadow while she scatters green leaves and blossoms. To show the mood-lifting effects of alcohol, the woman carries a thyrsus entwined with leaves, grapes, and a banner emblazoned with the Latin word for hilarity. Grief, by contrast, is represented by a somber man who is partially shrouded by a corner of his black mantle and is squeezing absinthe (bitter wormwood) into a cup. Cut into the man's chest

is a bleeding wound that connotes profound heartache.[4] The design was engraved in reverse by Jean Massard (1740–1822) and appears as plate V in the *Almanach iconologique* of 1775 (fig.1).

In the second drawing (cat. 102b), Cochin shows Friendship as a young woman who is dressed in white to express her open, candid spirit and crowned with pomegranate blossoms mixed with myrtle, whose scents spread the sweetness of close companionship. She holds her heart in her hand and pets a dog, symbol of faithfulness. A withered young elm tree at her feet is entwined with a green vine, signifying that a relationship begun in prosperous times will always endure and that friendship is even more essential during hard times. The Latin words inscribed on the altar, *Longe et Prope*, meaning far and near, and *Mors et Vita*, meaning death and life, indicate that true friendship survives every circumstance. The second young woman, Useless Friendship, holds a swallow's nest. The birds are seen as fair-weather friends since they flee at the approach of winter. Finally, Hatred is personified by an angry figure with Medusa-like tresses, carrying a dagger encircled by a snake and a dark lantern, whose light can be obscured by a cover.[5] This design was engraved in reverse by Jean-Jacques Le Veau (1729–1785) and appeared as plate IV in the 1775 *Almanach*.

Both of these drawings, together with several others in the Gallery's collection,[6] are precisely and beautifully drawn and make it clear why Cochin was so long in demand as a book illustrator, print designer, and portraitist.

PROVENANCE

According to Portalis 1877, passed through a sale at Féral in Paris in 1876; private collection; Galerie Cailleux, Paris; NGA purchase in 1987.

102a

Gaiety and Grief, 1774/1775

red chalk with touches of black chalk with border lines drawn by the artist
sheet: 127 × 79 (5 × 3⅛); border: 108 × 63 (4¼ × 2½)
inscribed in red chalk across bottom: *L'Allegresse : Le chagrin.*; numbered in red chalk at
top center: 5; inscribed in red chalk in the banner on the thyrsus: *HILARITAS*
Ailsa Mellon Bruce Fund, 1987.29.2

102b

Friendship, Useless Friendship, and Hate, 1774/1775

red chalk with touches of black chalk with border lines drawn by the artist
sheet: 127 × 79 (5 × 3⅛); border: 107 × 64 (4³⁄₁₆ × 2½)
inscribed in red chalk across bottom: *L'Amitié; L'Amitié Inutile; la haine.*; numbered in red
chalk at top center: 4; inscribed in red chalk across the top of the altar at center: *LONGE
ET PROPE*, and in red chalk across the bottom: *MORS ET VITA*
Ailsa Mellon Bruce Fund, 1987.29.3

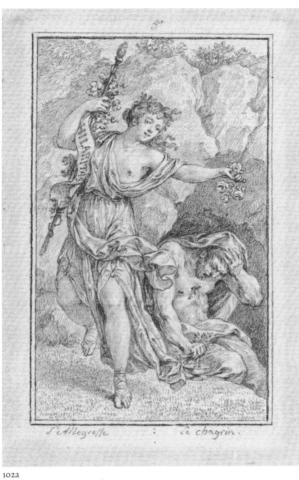

102a

102b

Louis-Jean Desprez · AUXERRE 1743–1804 STOCKHOLM
Claude-Louis Châtelet · PARIS 1749/1750–1795 PARIS
illustrations for the abbé de Saint-Non's *Voyage pittoresque*, 1778

One of the most ambitious private publications of the eighteenth century was the extraordinarily impressive and handsomely illustrated *Voyage pittoresque ou description des royaumes de Naples et de Sicile* (Picturesque Journey or Description of the Realms of Naples and Sicily), published in four parts in five folio volumes between 1781 and 1786 by Jean-Claude Richard, abbé de Saint-Non (1727–1791).[1] It was much more than the "picturesque journey" of the title, however, for while it provided considerable information about monuments, buildings, antiquities, towns, villages, travel routes, and notable attractions that would be of interest to the armchair traveler, it also included elements of modern and ancient history, social commentary, religious customs, cultural traditions, and true-life experiences. In addition, the volumes were ornamented with more than 450 prints, including tailpieces, text ornaments, and maps; images of ancient coins and medals; copies after old master paintings; floor plans and elevations of buildings; and above all, representations of scenic views, townscapes, significant landmarks, picturesque locales, and other places of note. The abbé himself had traveled in Italy some years earlier, in 1759/1761, spending time with both Hubert Robert (cats. 82–85) and Jean-Honoré Fragonard (cats. 86–92), and drawings made at that time by both of those artists were incorporated into the new project. Many more drawings were needed to fulfill the abbé's vision, however, and in the end, a total of eighty-one draftsmen and engravers participated. Of the twenty draftsmen who supplied drawings, the two most prolific contributors were Louis-Jean Desprez and Claude-Louis Châtelet, the authors of the two drawings presented here. Together they were responsible for well over half of the designs used for illustrations: 132 by Châtelet and 136 by Desprez.

Both artists were hired in 1777 specifically to make drawings on-site in southern Italy and Sicily. Châtelet was already working on the project, which had originally involved the production of illustrated volumes on Switzerland and Italy under the direction of Jean-Benjamin de Laborde (1734–1794).[2] Because of difficulties in the publication of the first fascicles on Switzerland, however, Laborde invited the abbé de Saint-Non to take over the supervision of the Italian part of the project. For financial reasons, the Swiss and Italian endeavors were eventually separated, with the abbé assuming all responsibility for the Italian volumes. To further reduce the costs, he then decided to limit the scope of the books to include only the realms of Naples and Sicily, which were less well known than the northern parts of Italy and the areas around Rome and were therefore thought to have a somewhat more exotic appeal. In spite of the various changes in the program, Châtelet's participation was a seamless continuum, during which he completed his work in Switzerland, returned to Paris, and then traveled on to Naples in the fall of 1777. Desprez was already in Italy, having recently arrived in Rome as a winner of the Prix de Rome for architecture, but at the request of the comte d'Angiviller, the king's superintendent of buildings in Paris, who had jurisdiction over the French Academy in Rome, he was temporarily released from his regular studies to join the *Voyage pittoresque* expedition. Another architect and Prix de Rome winner who had already completed his stay at the French Academy, Jean-Augustin Renard (1744–1807), was also hired to work and travel with them, though ultimately only twenty-three of his drawings were engraved for the volumes. The last member of the group was Dominique-Vivant Denon (1747–1825), a friend of Laborde's, who not only supervised the artists on the trip and planned the itinerary but also contributed (anonymously) the commentary about their travels and the places they visited. The four began their work in Naples in the middle of December of 1777, focusing their attention first on that city, Pompeii, and the nearby environs. They then spent nine months traveling around southern Italy and Sicily, returning to Naples in December 1778.

The two drawings in the National Gallery's collection are fine examples of the kinds of works that Châtelet and Desprez customarily produced during their travels. Both images show the artists to be able draftsmen and watercolorists, each with his own idiosyncrasies, strengths, and charms. Châtelet's watercolors tend to be airy and atmospheric, delicately colored, and drawn with a light calligraphic touch (cat. 103b). The terrain can sometimes look more like clouds than solid earth or rock, and his figures are often quick little ideographs that convey the sense of pose and gesture without much physical substance. Desprez's pen lines, on the other hand, are usually firmer and more declarative, and as a result of his training as an architect, his buildings and spaces are well constructed and defined (cat. 103a). In addition, because of his interest in stage design, his renderings often have a scenographic effect—especially so in his representations of local pageants and ceremonies—and his figure groupings can be rather theatrical.[3]

Like many of the other surviving drawings for the *Voyage pittoresque*, the two Washington sheets are attached to eighteenth-century mounts that are identical in color and design and are inscribed on the verso in the same distinctive hand. Apparently, when the drawings arrived in Paris to be reviewed and engraved, the abbé de Saint-Non had each one mounted in order to protect it from being damaged and then inscribed on the verso the location represented and the draftsman responsible.[4]

The drawing by Desprez shows the main square and cathedral of San Nicola Pellegrino in the port town of Trani, situated on the Adriatic Sea on the east coast of southern Italy. The scene was etched in the same direction by Jean Duplessis-Bertaux (1747–1819) and finished with engraving by François Dequevauviller (1745–1807) for plate 16 of the third volume of the *Voyage pittoresque* (published in 1783), where it was positioned opposite page 36. The print diverges from the drawing only in the replacement of the two dark-cloaked

103a

Louis-Jean Desprez
The Cathedral at Trani, 1778

pen and gray-black ink and watercolor over graphite
215 × 352 (8 ½ × 13 ⅞)
inscribed in brown ink across the original mount below the drawing: *Vüe de La Place publique et de l'Eglise de Trani, près de Barletta, dans la Pouille.*; at lower right in the same

hand: *Des Prez del.*; on the verso, inscribed by the abbé de Saint-Non in pen and brown ink: *Vüe de La place publique de l'Eglise de Trani/près de Barletta dans La Pouille/dessinée par Des Préz*
Samuel H. Kress Collection, 1963.15.6

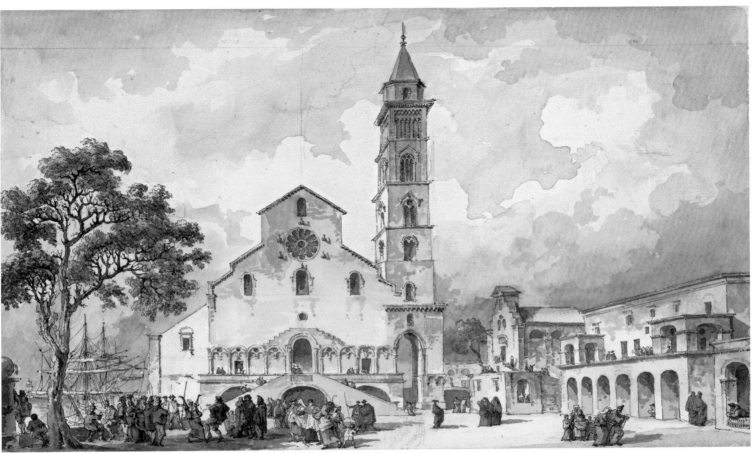

103a

figures at far right by a dog and a single person swathed in white. The accompanying commentary notes that the church was built by the Normans, who used a number of ancient columns in its construction but left the portal unfinished. The interior is praised for its great beauty, and its gothic style is described as "of a noble type."[5] Desprez made numerous studies in preparation for his final watercolors, paying special attention to the general proportions and specific architectural details. Four studies related to his work on the view of Trani are known, all contained in a sketchbook in the collection of the Royal Academy of Fine Art, Stockholm.[6] Most closely related to the Washington drawing is a preliminary pen study that shows the church almost exactly as it appears in the watercolor, but with the buildings and arcade beside it seen more frontally and extending farther to the right.[7] In both the Stockholm and National Gallery renderings, Desprez shows the church façade with tracery elements in the blind arcade that flanks the main entrance, but no such embellishments are seen on the church as it stands now.[8] Either he invented them or, more likely, they were removed at some subsequent date in order to return the church to a more authentically Norman appearance. Desprez did alter the proportions of the windows in the bell tower, however, lengthening them slightly so they fill up more of the wall space on each of the separate levels. In reality the tower is quite plain, but in Desprez's rendering the fenestration provides an extra bit of ornament and visual interest. Finally, whereas the cathedral now seems isolated in its situation next to the town harbor, in the watercolor it fronts on a busy piazza, shaded by the tree on the left and bordered on the right by the smaller church and arches that are no longer there. Desprez seems to have taken special delight in drawing the figures that enliven the scene, including a dancing couple, some sailors and family groups, and rather humorously at lower center, a man enthusiastically embracing a woman, observed with some consternation by a passing priest.

Châtelet's watercolor of Agrigento was engraved by Jacques Couché (1750 or 1759–1802 or after) as plate 95 of the first part of the fourth volume of the *Voyage pittoresque* (published in 1785), where it was placed opposite page 227. The print is in the same direction as the drawing and identical to it, except that the large group of figures at lower center has been reduced in the print to one man on foot, a dog, and two horsemen leading a packhorse. As the inscription on the mount states, this was the "second view" of the Agrigento countryside,[9] which was extolled in the text of the printed volume as one of the few that can provide so many pleasant views because of the "richness and liveliness" of the sites and the large number of ancient monuments that can be found there.[10] Dominating the middle distance of the view seen here is the ancient Temple of Concord, a famous local landmark built around 450 BC. Farther away, in the center of the composition, is a small monument that served as a church for an order of Capuchin monks. Behind that lies Monte Camico and the city of Girgenti, partially hidden by the tree at right. Typical of Châtelet's views is the lively band of travelers in the foreground, adding charm and an air of informality to the scene. As is the case with many of Châtelet's watercolors, this one exists in another version (location unknown),[11] actually a replica made by the artist himself so that both Laborde and the abbé de Saint-Non could own the image.[12]

The 268 drawings by Châtelet and Desprez that were engraved for the *Voyage pittoresque* were essential contributions to the overall beauty of the volumes and played a critical role in making it one of the great illustrated books of the eighteenth century. Once they had finished their work, however, the two artists each followed different career paths that led in unexpected directions.[13] For a time, Châtelet continued to produce watercolor landscapes of the type he had made in Italy, including several albums of drawings of the Petit Trianon at Versailles that Queen Marie-Antoinette presented as gifts to special guests. With the

onset of the Revolution, however, he became a radical member of the Jacobins and served not only on the Committee of Public Safety but also on the execution committee of the Revolutionary Tribunal. When the political winds changed, he suffered for his overzealous service by being condemned himself and guillotined in May 1795.[14] Desprez, on the other hand, returned to Rome to complete his studies at the French Academy, but in 1784 was lured away to Stockholm by King Gustav III of Sweden to serve as the stage designer at the royal opera. He was soon appointed royal architect and was responsible for several important projects, but professional jealousy on the part of other court artists and the death of his patron in 1792 made his life a misery. He remained in Stockholm at the command of the new king, but was given little of importance to do. At his death, he left an enormous number of drawings and sketchbooks, now in the collection of the Royal Academy of Fine Arts in Stockholm, but his reputation today, like that of Châtelet, rests mainly on the watercolors he made for the *Voyage pittoresque*.

103A · PROVENANCE
Possibly M. Paignon-Dijonval, Paris (1708–1792), and by descent to Charles-Gilbert, vicomte Morel de Vindé (1759–1842); Richard Owen, Paris; purchased in 1935 by Samuel H. Kress, New York (1863–1955); gift to NGA in 1963.

103B · PROVENANCE
Christian Humann, New York (sale, Sotheby Parke Bernet, New York, 30 April 1982, lot 49); NGA purchase via David Tunick, New York, with funds donated by the Charlottesville/Albemarle Foundation.

103b

Claude-Louis Châtelet
Second View of the Agrigento Countryside, 1778

brown and black ink with watercolor and gray wash over graphite with a partial framing line in brown and gray ink

236 × 345 (9 5/16 × 13 9/16)

inscribed in brown ink on the mount below the drawing: *Seconde Vue prise dans Les Campagnes d'Agrigente—*, and at lower right: *Chatelet del.*; on the verso, inscribed by the abbé de Saint-Non in brown ink: *Sde Vue prise dans Les Campagnes d'Agrigente/Chatelet*; in graphite at lower right: *6484/Human*; and some mathematical calculations in graphite in a modern hand

Gift of the Charlottesville/Albemarle Foundation for the Encouragement of the Arts in honor of J. Carter Brown for meritorious contribution to the world of arts, 1982.57.1

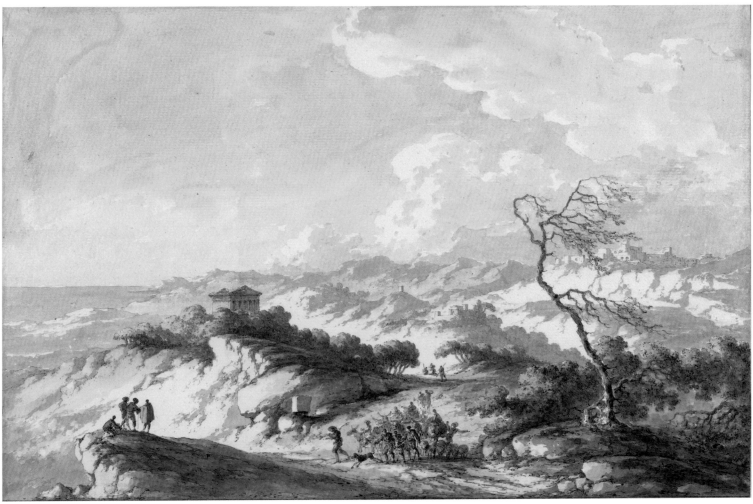

103b

104 Jean-Baptiste Pillement · LYON 1728–1808 LYON
Shepherds Resting by a Stream, 1779

gouache and pastel on linen
770 × 1010 (30 5/16 × 39 3/4)
signed and dated in black chalk at lower left: *J. Pillement 1779*
Robert H. and Clarice Smith Fund, 1983.72.1

In the eighteenth century, pastels were generally the domain of portraitists, but Jean-Baptiste Pillement appropriated them for other genres, including pastoral landscapes, peasant scenes, tempests and shipwrecks, and the *chinoiseries* that were perhaps his most important contribution to the French rococo style.[1] Like his subject matter, Pillement's method of using the pastels was unorthodox, as he often combined them with gouache on fabric in order to achieve a denser and more paintlike visual effect than was possible with pastels alone.[2] At the same time, the powdery pigments added texture to the overall surface, while also giving more depth to the colors and volume to the strokes. Many of Pillement's pastel-and-gouache compositions were executed on an unexpectedly grand scale, and those that survive in fine condition, such as the one presented here, make it clear why these complex color pieces rank among the artist's most admired works.

Pillement pursued his career almost completely outside the art establishment of Paris and in fact spent an inordinate part of his life working elsewhere in France and other European countries. He trained in his native Lyon with Daniel Sarrabat II (1666–1748) before moving to the French capital, where he worked as a draftsman at the Gobelins tapestry manufactory for two years from 1743 to 1745. Thereafter, his travels took him, sometimes for several years at a time, to Spain, Portugal, England, Austria, Italy, Poland, and Switzerland. Within France, he lived and worked for long periods in Avignon, the Languedoc region, and Lyon. A good part of his production focused on landscapes and seascapes, but he also specialized in ornamental designs, including *chinoiseries* and fantastic flowers (fig. 1),[3] which were frequently engraved. Many were published in booklets and design manuals that then served as models for textile designers, porcelain painters, wood carvers, silversmiths, embroiderers, furniture makers, and so on. Pillement's painted decorations in the royal palace at Warsaw earned him a post as painter to the king of Poland in 1767; eleven years later, in 1778, Marie-Antoinette (1755–1793) made him her personal painter. Undoubtedly his idyllic pastoral landscapes populated by contented peasants held a special appeal for her, delighting as she herself did in pretending sometimes to be a milkmaid or shepherdess.

The National Gallery landscape is a particularly grand example of Pillement's work in pastel and gouache, not only because of its large scale and refined execution but also because of the calm perfection of the composition. Like most of the artist's landscapes, it presents a peaceful Arcadian vision, complete with shepherds and their flocks, a meandering stream with fishermen, a waterfall, stands of trees, distant mountains, and picturesque ruins. These are some of the stock elements that Pillement employed again and again in different combinations in his landscapes, regardless of the medium he was using at the moment—oils, gouache, pastel, or black chalk. For this reason, many of his scenes, especially those made later in his career, have an unnatural, rather decorative quality, but here, in this work dating from the heart of his career, the composition as a whole is assembled with a particularly luminous fresh-

ness and charm that prevent it from becoming too formulaic. The fact that the arrangement is slightly off-center, with extra weight given to the right side by the strong vertical of the tree and the massing of the figures and flocks in the foreground, suggests that this work might originally have been paired with another of the same dimensions that would have balanced the composition and served as a pendant. No other work of this scale from about the same time is known, however.[4] In fact, only a few of Pillement's pastel-and-gouache landscapes equal or surpass the present work in size, thus giving it a position of special importance in his oeuvre.[5]

PROVENANCE
Galerie Cailleux, Paris; NGA purchase with funds donated by Mr. and Mrs. Robert H. Smith in 1983.

FIGURE 1: Jean-Baptiste Pillement, *Pagoda Flowers and Roses*, c. 1770, black and red chalk. National Gallery of Art, Washington, Ailsa Mellon Bruce Fund, 1983.54.1

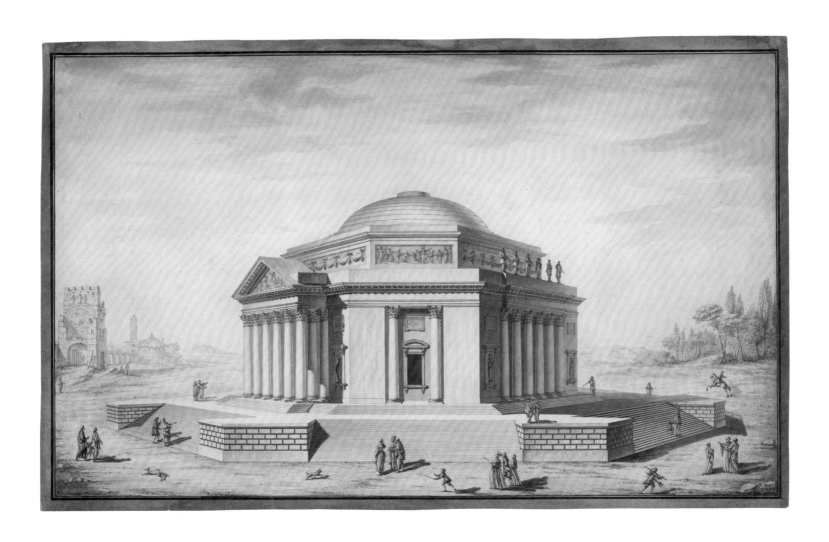

pen and black ink with gray and brown washes over graphite with framing line in brown ink
594 × 839 (23 ⅜ × 33 ¹⁄₁₆)
Patrons' Permanent Fund, 1991.185.1

One of the great visionary architects of the Age of Enlightenment, Étienne-Louis Boullée exerted a profound influence on the course of French architecture, even though he built few of the structures he designed. Trained first as a painter with Jean-Baptiste-Marie Pierre (1714–1789) and then as an architect with Jacques-François Blondel (1705–1774), Boullée quickly aligned himself early on with the nascent neoclassical movement. He was an inspired teacher and a distinguished academician as well as a founding member of the Institut de France. In the late 1780s, he wrote a treatise, "Architecture, essai sur l'art," unpublished during his lifetime, in which he set out many of his ideas about architecture.[1]

Between 1780 and 1782, when Boullée was controller of buildings at the École militaire in Paris, he produced a number of drawings, including the present sheet, related to at least three different variant designs for a magnificent metropolitan church.[2] His idea was to create a vast, monumental building whose symmetrical design, harmonious proportions, and beautifully ordered interior would enhance the spirit of exaltation inspired by the most solemn and important religious ceremonies.[3] In all his designs for the so-called Metropole, which he termed his "Poème

Epique," or epic poem, of architecture,[4] Boullée's basic plan was a Greek cross with unusually high, intricately coffered barrel vaults arching above long rows of Corinthian columns topped by elaborate entablatures. Dwarfed by the gigantic scale of the surrounding architecture, the altar was placed in the center of the crossing, below a tall dome reminiscent of Saint Peter's in Rome. All Boullée's designs for the church illustrate to elegant effect his view that the regularity and symmetry of geometrical volumes, imbued with infinite variety by the play of light and shadow, are the basis of beauty.[5] Especially dramatic are the rich optical effects created through the use of repetitious, almost mesmerizing patterns of ceiling coffers and row upon row of Corinthian columns. Two drawings in the Bibliothèque nationale, Paris, show the same basic configuration of the interior presented in the National Gallery sheet, but with significant differences in the coffering around the high arches and in the details of the entablature above the colonnades.[6] An alternative presentation of the interior, seen from a more distant perspective down a vast central nave flanked by two grand side aisles, is found in a drawing in the collection of the Royal Institute of British Architects, London.[7] Of the four known

renderings of the Metropole's interior, only the National Gallery's version includes the cloud-borne hosts hovering in the dome, thus adding an unexpected touch of whimsy to a project that is in every other respect a perfect model of neoclassical grandeur.[8]

The National Gallery drawing is thought to belong to Boullée's earliest work on the church project. It was certainly completed by the second half of 1781, for the artist included this particular view of the church's interior—omitting only the clouds, the staircases, and the monumental incense burners—as a stage set in one of the section drawings he made of his proposed design for a new opera house in Paris (fig. 1).[9] (The old one had burned down on 8 June 1781.) The arches of the church's barrel vaults follow perfectly the curve of the proscenium, and the whole design fits neatly into the space beyond. What seems so impossibly grand—and unbuildable—in the Washington drawing makes a surprisingly effective setting for an imaginary theatrical performance.

PROVENANCE
Emilio Terry, Paris (1890–1969); Galerie J. Kugel, Paris, 1972; Lodewijk Houthakker, Amsterdam (1926–2008), by 1974; Hazlitt, Gooden & Fox, London, 1991; NGA purchase in 1991.

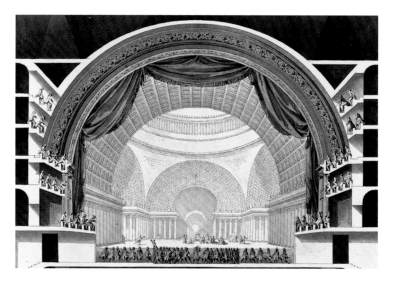

FIGURE 1: Étienne-Louis Boullée, *Design for an Opera House* (detail), 1781, pen and brown ink with brown wash with touches of watercolor. Bibliothèque nationale de France, Paris

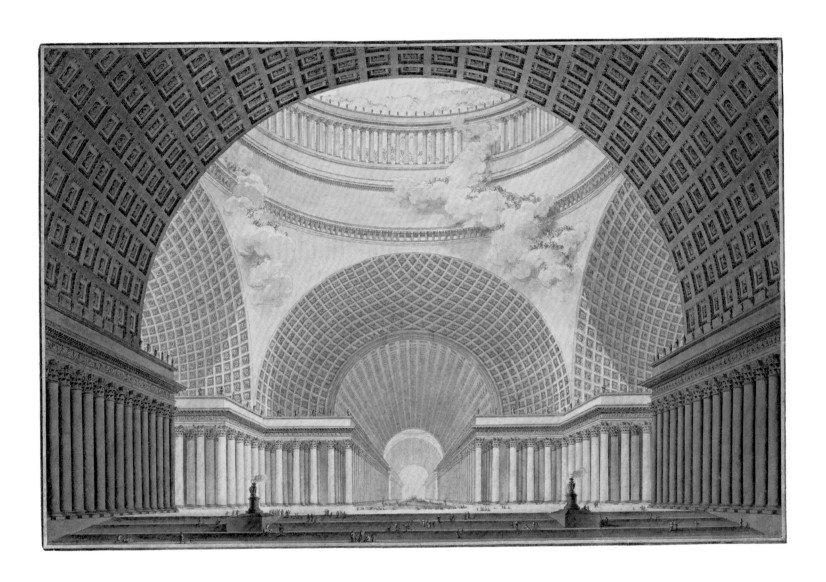

Jean-Jacques de Boissieu · LYON 1736–1810 LYON
A Sunlit Landscape with Hilltop Houses, c. 1782

brush and black ink with gray and gray-brown washes over graphite
268 × 384 (10 9/16 × 15 1/8)
watermark: D & C BLAUW and VRYHEYT (lion in circle with crown), similar to Churchill 82
Ailsa Mellon Bruce Fund, 2007.69.1

This luminous landscape is the work of the Lyonnais draftsman and printmaker Jean-Jacques de Boissieu, who developed a personal way of representing the world around him that had little to do with the contemporary artistic visions and theories espoused by the Académie royale in Paris.[1] Boissieu was strongly influenced instead by the northern realist tradition and from his earliest years devoted himself to the study of nature and drawing in the open air. When he did spend time in Paris in 1759 and the early 1760s, his abilities as a draftsman earned him the support and encouragement of such notables as Claude-Joseph Vernet (1714–1789), Johann Georg Wille (1715–1808), and Jean-Baptiste Greuze (cats. 73–76). Friendship with Louis-Alexandre, duc de La Rochefoucauld (1743–1792), led to a yearlong trip to Italy in 1765–1766 in the duke's company. By the time he returned to France, Boissieu was a fully formed artist and the demand for his drawings soared, with collectors from as far away as Russia seeking to acquire his works. From 1772 onward he lived permanently in Lyon and its environs, and in spite of the distance from Paris his popularity never flagged. In addition to hundreds of drawings executed in his signature wash technique, sometimes embellished with watercolor, Boissieu produced about 140 etchings that were equally admired.[2]

Boissieu's landscape drawings reflect to a great extent the influence of the Dutch Italianists of the seventeenth century, such as Cornelis van Poelenburch (1594/1595–1667), Bartholomeus Breenbergh (probably 1599–1657), and Jan Asselyn (c. 1610–1652), especially in the translucent quality of the washes, the bright contrasts of light and dark, the overall sense of nature observed, and the rustic character of the figure groupings. Boissieu's special genius lies mainly in the way he manipulates light, in the form of reserves of white paper, to define contours, textures, and surfaces. Particularly adept in the National Gallery drawing are such delicate passages as the row of backlit plants and the rickety fence that sit atop the stone wall at upper left; the wall of the house that is half in shadow and half in light in the same area; the light that edges the foliage of the tall trees at left; and the haloing of the puffy clouds to set them off against the sky. Equally adroit is his use of quick flicks of black ink to situate plants and clumps of grass in the foreground and to create the effect of scintillating light among the leaves of the trees at right. His continuous, delicately controlled modulation of the gray washes, from the darkest areas in the foreground to the palest, almost mistlike tones in the farthest distance, is utterly magical. Paradoxically, while the washes themselves are vaporous and translucent, they nevertheless create palpably solid forms — buildings, rocks, trees, figures — that have both weight and mass.

Although the National Gallery drawing is not dated, its composition and execution link it most closely to works that are datable to the early 1780s. The handling compares well to *Hilly Landscape with the Ruins of a Fortress*, dated 1783 (location unknown),[3] a smaller Boissieu drawing that was formerly owned by the same dealer as the Washington sheet, Nicolaas Teeuwisse in Berlin. Also related in the quality of the washes and the effects of light is a view of *A Rustic House near Saint-Chamond* from about 1780 (Hessisches Landesmuseum, Darmstadt).[4] As opposed to that last drawing, which shows an actual view, the Washington composition may have been constructed, at least in part, from the artist's imagination, incorporating motifs and ideas gained from his years of studying nature and the landscape around him.

Among Boissieu's most surprising drawings, completely different in visual effect from the beautifully rendered view presented here, are some of the wash studies he made while he was in Italy in 1765/1766, one of which is in the National Gallery's collection (fig. 1).[5] Sketched with the simplest combination of loosely brushed washes, blots of ink, and reserves of untouched paper, these earlier studies are remarkably abstract and evocative, with an unexpectedly Asian quality to them. For their time, they are extraordinarily forward-looking and bear further witness to Boissieu's importance as one of the most innovative landscapists of the eighteenth century.

PROVENANCE
Nicolaas Teeuwisse, Berlin; NGA purchase in 2007.

FIGURE 1: Jean-Jacques de Boissieu, *Mount Cairo from across the Melfa River*, 1765/1766, brush and gray wash. National Gallery of Art, Washington, Ailsa Mellon Bruce Fund, 1990.42.1

112a

4th page, folio 88, with five drawings after painted and sculpted figures, 1775/1780
black chalk, gray wash over black chalk, and pen and brown ink with gray wash
album page: 486 × 330 (19 ⅛ × 13); individual drawings ranging from 132 × 70
(5 ³⁄₁₆ × 2 ¾) to 135 × 165 (5 ⁵⁄₁₆ × 6 ½)
inscribed in pen and brown ink on the album page at upper right: *88 cinq dessins*; and

at lower right in a different hand: *4e Cinq Dessins*; each of the drawings bears the paraphs
in pen and brown ink of the artist's sons, Eugène and Jules David (Lugt 839, 1437);
the last drawing inscribed by the artist in pen and gray ink across the bottom: *Sur un
Sarcophage au museum du pape*
Patrons' Permanent Fund, 1998.105.1.k–o

112a

Many of the drawings bear annotations indicating the location of a work that David copied or a site he sketched, such as the inscription on the drawing at lower right on the 4th page, folio 88 (cat. 112a), *sur un Sarcophage au museum du pape* (on a sarcophagus in the pope's museum), or the notes on all four of the views on the 11th page, folio 131 (cat. 112b). The drawing at lower left on that same page was apparently one of the last David made in Rome, for he noted that he finished it "at the inn of Bargino [about fifteen miles south of Florence] on the return from Rome." Similarly, on the 9th page, folio 74, a drawing after a sculpture of two women walking bears an inscription that identifies it as "the last of this kind of sketch made in Rome in 1780 the 17th of July and I left the 18th."[9] A few others were made elsewhere, most notably Florence and Milan (for example, the view inscribed *la canonica a Milano* on the 12th page, folio 136).[10] It is interesting to note that David completed some of the drawings only after they were mounted on the album pages, for the ink washes run over onto the album sheets themselves (see cat 112c; 14th page, folio 231).[11]

David may have referred to his albums of Roman drawings when he was starting on new paintings, but ultimately very few of those studies can be connected directly to his work on specific compositions. Only two of the copied figures in *Roman Album No. 4*, for example, seem to have inspired him in this way. *A Distraught Woman with Her Head Thrown Back* (see cat. 112d; 17th page, folio 24), copied from the figure of Creusa in a basrelief of *Medea in Corinth*, was clearly the inspiration for the grieving woman, in reverse, situated in the foreground of an elaborate compositional drawing of *Alexander the Great at the Deathbed of the Wife of Darius* (École nationale supérieure des Beaux-Arts, Paris), made in 1778 or 1779, when David was still in Rome.[12] David may have also been referring to this same figure in 1794 when he made his compositional drawing of *The Sabines* (Musée du Louvre, Département des Arts graphiques, Paris) and presented one of the women in the same pose, though again in reverse.[13] (That figure was considerably altered in the final painting, now in the Louvre.) Likewise, the figure of a man about to stab another at top left on the 4th page, folio 88 (cat. 112a), copied from a painting by Pier Francesco Mola (1612–1666),[14] has strong similarities with one of the figures in the left foreground of David's two compositional drawings of *The Triumph of the French People* (Musée du Louvre, Département des Arts graphiques, and Musée Carnavalet, Paris).[15] The position of the arms and legs of the man in David's compositions and his specific motion of drawing back the sword in preparation for a thrust forward are similar enough to Mola's figure to suggest that David could have had the copy in front of him when he was working on the later drawings.

David's albums probably served many purposes: as a visual diary of his years as a student in Rome; as a pictographic dictionary of classical statuary, lightly sprinkled with motifs from paintings by Renaissance and baroque masters; as a teaching tool for his many students who had not yet—or might never—experience Rome and its artistic riches in person; as a nostalgic journey through his beginnings as an artist; and as a starting point for figures and ideas that he would then develop and change as he worked on his compositions. The importance of his original albums for him, both personally and professionally, cannot be overestimated, and the individual drawings present an important and revealing cross-section of David's work in Italy and the early evolution of his art. As such, the albums have attained the highest status within the artist's oeuvre, to the extent that when *Roman Album No. 5* (now in the Louvre) suddenly reappeared in 2005, it was declared by the French government to be a national treasure.

PROVENANCE

Estate of the artist (sale, Paris, 17 April 1826, under no. 66, unsold); the artist's widow, Marguerite-Charlotte Pécoul (1764–1826); in the possession of the artist's family (all the drawings, but none of the tracings, bear the paraphs of David's two sons, Eugène and Jules, Lugt 839, 1437) (second David sale, Paris, 11 March 1835, under no. 16); according to the inscription on the flyleaf, in the collection of one of David's pupils, Mlle. [name obliterated]; by descent in her family; Galerie de Bayser, Paris, 1998; NGA purchase in 1998.

112b

11th page, folio 131, bearing four drawings with views of Rome, 1775/1780
pen and black or brown ink with gray wash over black chalk
album page: 486 × 330 (19 ⅛ × 13); individual drawings each measuring about 153 × 211 (6 × 8 ⁵⁄₁₆)
inscribed in pen and brown ink on the album page at upper center: *131 quatre dessins*; in graphite at lower center in a different hand: *La Rotonde* and *Place du Peuple*; and in pen and brown ink at lower right in another hand: *11e quatre dessins*; each drawing

bears the paraphs in pen and brown ink of the artist's sons, Eugène and Jules David (Lugt 839, 1437); each is inscribed by the artist at proper lower right (beginning with the drawing at lower left and moving clockwise): *La Rotonde finie a lauberge de bargino en/Revenant de Rome*; *place de la Rotonde/ou pantheon* (with a more modern inscription in graphite at upper left: *Panthéon*); *monte cavallo* (with a more modern inscription in graphite at upper left: *Quirinal*); *L'Entrée de Rome vu/la porte du peuple*
Patrons' Permanent Fund, 1998.105.1.jj – mm

112b

112C

The Church of Sant' Onofrio, Rome, 1775/1780

from the 14th page, folio 231
gray wash over black chalk on pale blue paper, some strokes of wash going beyond the
edges of the drawing onto the album page below
168 × 216 (6 ⅝ × 8 ½)

inscribed by the artist in black chalk at center right: *du sens contraire*; inscribed in
pen and brown ink with the paraphs of the artist's sons, Eugène and Jules David
(Lugt 839, 1437)
Patrons' Permanent Fund, 1998.105.1.vv

112C

112d

A Distraught Woman with Her Head Thrown Back, 1775/1780

from the 17th page, folio 24

pen and black ink with gray wash over black chalk

200 × 150 (7⅞ × 5⅞)

inscribed in pen and black ink at upper right: *27*; inscribed with the paraphs of the artist's sons, Eugène and Jules David (Lugt 839, 1437)

Patrons' Permanent Fund, 1998.105.1.bbb

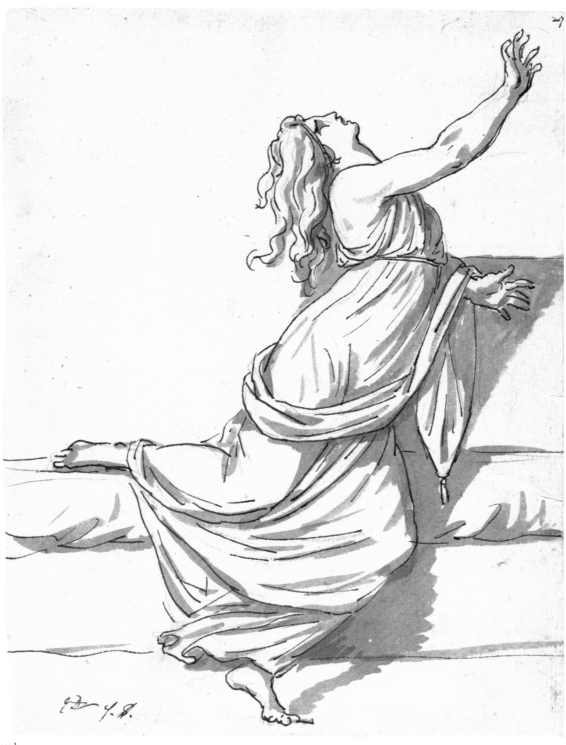

112d

Jacques-Louis David · PARIS 1748 – 1825 BRUSSELS
Thirius de Pautrizel, June or July 1795

pen and gray ink with gray wash and pale brown wash (on the face) over touches of graphite, heightened with white gouache on an old circular mount
diameter: 192 (7 9/16)
signed in black ink at lower right: *L David*; inscribed in brown ink on the mount around the circumference of the drawing, from middle left clockwise to middle right: *THIRUS DE PAUTRIZEL Capitaine de Cavallerie en 1785, Représentant de la NATION FRANÇAISE en 1794 et 1795.*; on the verso, in graphite at lower center in a modern hand: *A66*
Gift of Walter H. and Leonore Annenberg in Honor of the 50th Anniversary of the National Gallery of Art, 1990.47.2

After his return to France from Italy in the fall of 1780, David established himself as one of the leading artists in Paris, committed to painting grandly moralistic episodes from ancient history in the famously restrained yet eloquent neoclassical style. He was also an outstanding portraitist who combined psychological depth with beautifully rendered fabrics and settings, sometimes working on an impressive life-size scale.[1] With the advent of the French Revolution, David embraced the radical policies of the Jacobins, led by Jean-Paul Marat, Georges-Jacques Danton, and Maximilien de Robespierre, and when he was elected as a deputy for Paris, he became one of the extremist Montagnards (mountain men), so called because they sat on the highest benches at the National Convention. He also worked to reform the rigid rules and traditions of the Académie royale and eventually played an important role in abolishing it altogether. (The Institut de France replaced it in 1795, with David as a founding member.) As so often happened in the rapidly fluctuating political situation, however, David was imprisoned twice, first for five months at the end of 1794, after Danton and Robespierre were executed, and then for two months in mid-1795, after a failed uprising that resulted in the Montagnards finally being stripped of all power.

During his second incarceration in the Collège des Quatre-Nations, David made a compelling series of likenesses of several of his fellow Montagnard inmates, brilliantly combining his talents as both portraitist and draftsman. It is not known how many images he made, though at least thirteen other deputies were held with him and nine drawings are currently known, including this one of Jean-Baptiste-Louis Thirius de Pautrizel (1754 – ?).[2] All were executed in the same profile format within a roundel (measuring between about 180 and 195 millimeters), reminiscent of ancient coins and medals and imitating the appearance of the official engraved

portraits that were made of each of the deputies serving in the national legislature. Four of the drawings bear inscriptions (not necessarily in David's hand) that date them specifically to the period of the artist's imprisonment; one dramatically describes him as *in vinculis* (in chains).[3] Apparently made within a period of just two months, the works form a remarkably coherent group in format, technique, and execution. All but one were drawn in the same beautifully controlled and nuanced combination of pen and wash.[4] As the present sheet shows, David was a master of the brush, just as adept at creating broad areas of tone with closely calculated variations in levels of light and shadow as he was in using the tip of the brush to pick out the smallest details of the face, to model the features, and to express the texture of the coat and hair. The artist was equally skilled with the pen, adding expression to the eye and mouth with a few quick strokes and defining more clearly the contours of the profile. Relieving the austerity of the profile presentation is the complex arrangement of the clothing with its angular shapes, multiple layers, and patterned fabrics. In fact, all the men in the group are surprisingly well dressed — though some are more soberly garbed than others — and were it not for the identifying inscriptions, one would surely never think to associate this rather innocuous set of gentlemen with the radical activists who took part in some of the bloodiest episodes of the French Revolution.

The man presented here, Thirius de Pautrizel, was born on the Île de Ré, off the west coast of France, on 25 August 1754. As the inscription on the mount notes, he became a captain in the French cavalry in 1785, and was elected to the revolutionary Convention — though in 1792 rather than 1794 — as a deputy from the Caribbean island of Guadeloupe, where he owned property. He was denounced and imprisoned on 27 May 1795 (three days before David). The date of his release is not known, nor is there any record of his life or fate thereafter, not even the year of his death.

David's purpose in making these portraits is uncertain. Although it is possible he drew simply to pass the time in prison, the strong uniformity of the series — even to the mounting of seven of the drawings on the same circular mount with a green wash border and gold filet — could indicate that he attached a more considered meaning to these works. It has been suggested that the portraits may have been intended to serve as symbols of the group's solidarity, shared beliefs, and common defiance at their political failure and their looming fates, for they did not immediately know that they would all eventually be freed.[5] The inscription on one work, the drawing of André Jeanbon, who was known as Jean-Bon-Saint-André (Art Institute of Chicago), however, indicates that it was made as a gift from the artist to the sitter,[6] and two others are known to have remained in the sitters' families, at least for a time.[7] With his friends' lives hanging in the balance and his own future equally uncertain, David may have created each portrait not only as a token of his friendship, esteem, and moral support but also as a memorial of sorts: the drawings were potentially the last images that would ever be made of the sitters, and had David himself been executed, these would have been the last works he produced. Fortunately, he survived for another thirty years and was destined to reach the pinnacle of his career under the patronage of Napoléon Bonaparte.

PROVENANCE

Georges Gairac, Paris; Wildenstein, New York, 1957; Curtis O. Baer, New Rochelle, New York (1898 – 1976); his son and daughter-in-law, Dr. and Mrs. George Baer, Atlanta, Georgia; NGA purchase with funds donated by Mr. and Mrs. Walter Annenberg in 1990.

THIRUS — DE PAUTRIZEL. — Capitaine de Cavallerie en 1785. Représentant de la NATION FRANÇAISE en 1794 et 1795.

David

Jean-Baptiste Isabey · NANCY 1767 – 1855 PARIS
Hubert Robert, 1787

black chalk and stumping, heightened with white gouache on a drawing block prepared by Niodot fils
265 × 207 (10 ⅜ × 8 ⅛)
dated indistinctly in black chalk at lower left: *1787;* on the verso of the mount: label of Niodot fils, Md. Papetier (similar to Lugt 1944a); on upper verso, inscribed in red ink on sticker: *1886;* center verso, in brown ink by a later hand: *Portrait d'Hubert Robert/par Isabey;* center verso, in graphite by a later hand: *esquisse est au musée d' Orléans*
Gift of John Morton Morris, 2000.176.1

This exquisite drawing was made as a gesture of heartfelt homage from a young artist who was just starting out on his career to a much older one who was just passing his peak. Jean-Baptiste Isabey met Hubert Robert (cats. 82–85) when they were both working at Versailles in 1787, when Isabey was only twenty and Robert was fifty-four. As Isabey wrote many years later, "It is from that moment that dates my intimacy with Robert, landscape painter, man of talent and resources. I began to work under his direction at the château de Beauregard which then belonged to the comte d'Artois.... Robert had infinite taste; he transformed [the gardens of] Beauregard completely."[1] Even though he ended up working with Robert on landscape design, it was Isabey's training as a portraitist and miniaturist that had brought him to Versailles. While still in his teens, he had been recommended to Marie-Antoinette (1755–1793) as a capable artist who could render portrait miniatures of the young duc d'Angoulême and duc de Berry that would make suitable gifts for the children's mother, the comtesse d'Artois. The queen was pleased with Isabey's work, and he remained at court for a period of time, becoming something of a favorite who, because of his diminutive stature, was known affectionately as the "little court painter."[2]

As this drawing demonstrates, Isabey was not only a brilliant portraitist but also a master of the *manière noire* (black manner), in which the abundant use of black chalk imitates the appearance of British mezzotint engravings. He used the technique for a number of other portraits from the late 1780s onward, including one from 1789 of his teacher and mentor Jacques-Louis David and another from 1798 of Dr. Duchanoy (both in the Musée du Louvre, Département des Arts graphiques, Paris), as well as a portrait of a woman wearing a riding habit from 1792 (Museum of Art and Archaeology, University of Missouri, Columbia) and one of the actor Simon Chenard from 1796 (Musée des Beaux-Arts, Orléans).[3] The National Gallery's portrait of Robert is one

of the most beautifully and richly executed, with extraordinary variety in the blacks and exceptional delicacy in the handling of the whites. The existence of at least six other versions of this likeness attests to the high regard it received in Isabey's own time.[4] The composition was also engraved, in the same direction, by Simon-Charles Miger (1736–1820) in 1799.[5]

Among the several known versions of this portrait, two stand out for the sensitivity of the drawing and the high quality overall: this one in the National Gallery and another belonging to Roberta Olson and Alexander Johnson (see note 4). It seems very possible that these two were the first made by Isabey, and that one was meant as a gift for his sitter, while the other was intended for the artist himself to keep, thus explaining the care and attention he lavished on the execution of both.[6] Of the two, however, the Washington sheet is in better condition and is notable for the exceptional freshness and palpable velvetiness of the blacks. In addition, there are numerous passages of exquisite delicacy that mark this work as a small masterpiece. The drawing of the partially transparent neck cloth, for example, especially where it doubles over itself and overlaps the striped waistcoat, is remarkably fine. The waistcoat itself is also beautifully rendered, with the curves and undulations of the fabric suggested by the manipulation of the linear pattern and the subtle grading of the grays. The drawing of the hair, picked out with a combination of fine touches of white, clever reserves of paper, and a few strokes of black chalk is brilliantly set off against the dark background, but most arresting of all are the eyes and the thick, bushy black brows that were Robert's most distinctive feature.

Because of the dating of the print by Miger, the various drawings have all been placed in about 1798/1799. The date on this drawing, however, barely legible at lower left but discernible nonetheless in very strong light, locates it much earlier, in 1787, very close to the time Isabey and Robert first met in Versailles. Robert's physical appearance

at almost the very same moment—just one year later—can be seen in a portrait painted by Élisabeth-Louise Vigée-Le Brun (1755–1842) in 1788 and now in the Louvre.[7] Though hers is a livelier likeness, in that Robert is given a more active pose, leaning on a parapet and responding to something outside the picture plane, the apparent age of the sitter in both works is so similar as to confirm that the two works are much closer in time than had generally been supposed.

The early promise Isabey demonstrated in drawings such as this one was fulfilled in an exceptionally long career that brought the artist considerable fame and fortune. The gift for social intercourse that he had displayed at the court of Versailles allowed him to move smoothly through the Revolution and into the Napoleonic era, ultimately gaining favor with the emperor himself, both of his wives, and innumerable courtiers. Among the honors bestowed on Isabey were a knighthood in the Légion d'Honneur (he later became a commander) and appointments as draftsman of the emperor's cabinet and first painter to the Empress Joséphine. He was also an early experimenter with the new printmaking technique of lithography, for which his work in the *manière noire* had prepared him well.

PROVENANCE
Private collection (sale, Loiseau-Schmitz-Digard, Commissaires Priseurs, Villennes-sur-Seine, 11 April 1999, page 2 [no lot number]); purchased by Hazlitt, Gooden & Fox, London; gift to NGA in 2000.

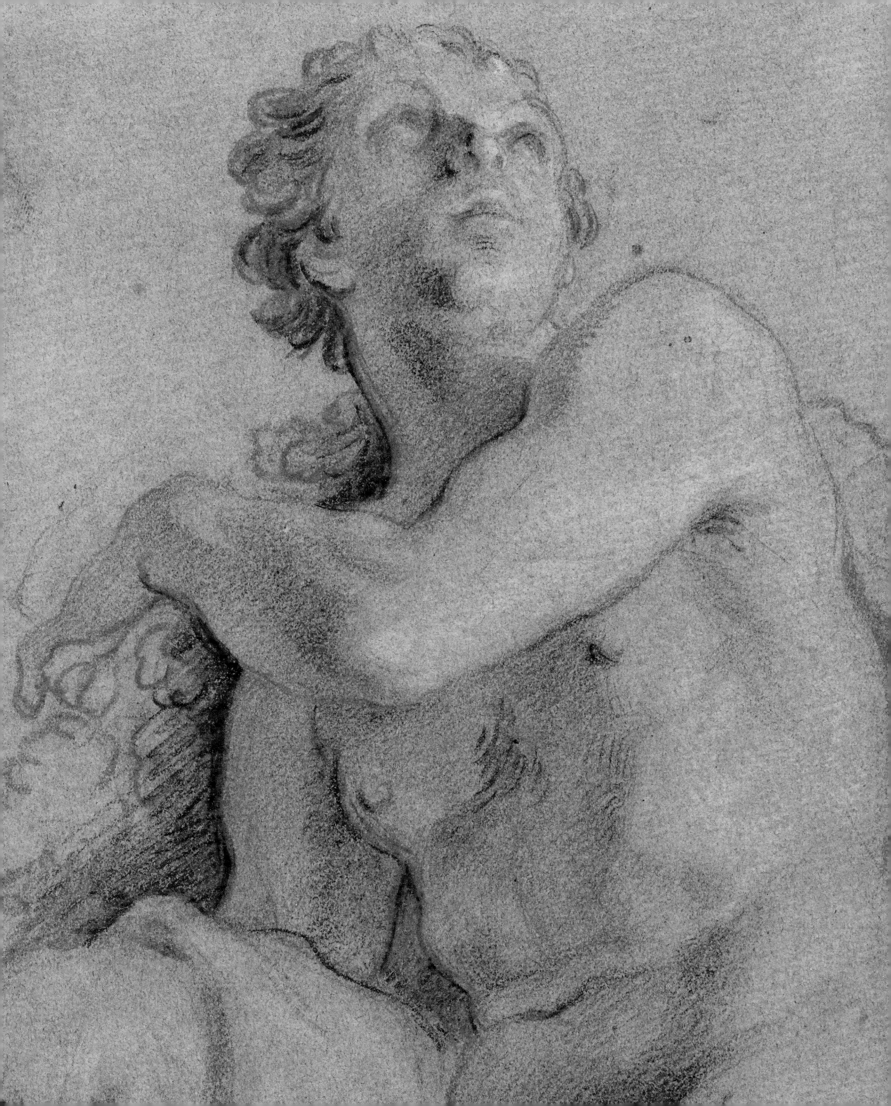

References

1 · Jean Poyet
The Coronation of Solomon by the Spring of Gihon

1. The best summary in English on Poyet is given in Wieck et al. 2000, 15–47. The only monograph on Poyet is Hofmann 2004, published in German.

2. All the documentary sources relating to Poyet's career are reviewed in Wieck et al. 2000, 15–17; the record of payment for the Book of Hours is quoted in the original French and in English translation on pages 15–16.

3. By Jean le Maire de Belges in *La plaincte du désiré*, published in Lyon in 1509 but apparently written in 1503 at the time of the death of Louis de Luxembourg. See the original text with English translation in Wieck et al. 2000, 18.

4. By Jean Brèche in *De verborum significatione*, published in Lyon in 1556. See the original text with English translation in Wieck et al. 2000, 19. Jean Fouquet (c. 1425–c. 1478), to whose family Poyet is so favorably compared, was the leading artist in France in the fifteenth century and served as painter to the king.

5. John Plummer was the first to connect Poyet's name with several illuminations; see exh. cat. New York 1982–1983, 85–89, nos. 111–114. For discussions of the various illuminations and manuscripts attributed to Poyet, see Wieck et al. 2000, 20–39.

6. Backhouse 1987, 227–228.

7. London: inv. 1874-6-13-538, 1874-6-13-539; Rotterdam: inv. FI 1; Chicago: inv. 1965.16. All are reproduced in Hofmann 2004, pls. 130–134 (*Cain Killing Abel* in color).

8. See Backhouse 1987, 225–226; Avril and Reynaud 1993, 318, under no. 175; Hofmann 2004, 43; and Janet Backhouse in Grove Dictionary 1996, 25:405.

LITERATURE

Hannema 1955, no. 219a, pl. 88 (as French School, c. 1500); exh. cat. Malibu and elsewhere 1983–1984, under no. 23; Backhouse 1987, 225–228; Avril and Reynaud 1993, 308; Janet Backhouse in Grove Dictionary 1996, 25:405; Wieck et al. 2000, 33, 192, fig. 25; Hofmann 2004, 43–44, 285, pl. 133.

2a–f · French School
drawings for a *Speculum Principis* for François d'Angoulême

1. The illustrations and accompanying inscriptions, most of which have been obliterated, have been extensively studied by Jean Michel Massing, most exhaustively in Massing 1995. Another smaller drawing, which does not appear to have belonged to the original series and may be by a different hand, was pasted onto the back endpaper of the binding (reproduced in Massing 1995, 211). The location of that drawing is not known.

2. See sale cat., Sotheby's, London, 11 March 1964, lot 147 (double-page illustration with *"Avoid the Trodden Way,"* fol. 29v–30r, now in the Morgan Library & Museum, New York, inv. 1974.11; reproduced in Massing 1995, 180–181) and lot 148 (*Dialogue between a Man and a Fool on Choosing a Short Wife*, fol. 11r, present location unknown, which includes on the verso the left half of the two-page image *"Do Not Sit on the Grain Measure,"* fol. 11v, the right half of which is in the National Gallery, fol. 12r, inv. 2006.11.60; reproduced in Massing 1995, 143–145). Folio 1 with the Greek letter Upsilon ("Y"), fol. 5v with some text about Apelles, and fol. 21r with an illustration of a lesson from Plutarch, *To Pull out a Horse's Tail Slowly Strand by Strand*, are missing (reproduced in Massing 1995, 123, 132, 163).

3. According to Massing 1995, 2 n. 6, the photographs and negatives are preserved in the photographic collection of the Warburg Institute, and some bear annotations by Saxl and Gertrud Bing.

4. See Massing 1987a, 215. Examples of Demoulins' handwriting are reproduced in Massing 1987b, 263–269, figs. 1–7.

5. See Massing 1995, 10–11. Photographs of the brown calf binding, now lost, and a discussion of it can be found in Massing 1995, 6–8, reprod. pp. 121, 212.

6. Two details of Saturn's chariot in *"Do Not Turn Back When You Arrive at the End"*—the two dragons biting their tails and the zodiac signs for Capricorn and Aquarius inscribed on the wheels—were borrowed from a woodcut illustration on fol. iiiir in the edition of the *Opus aureum* by Hyginus published by Olivier Senant on 24 May 1512. Reproduced in Massing 1995, fig. 2.

7. Sale cat., Sotheby's, London, 15–17 November 1937, lot 546. As Massing notes, perceived similarities between the National Gallery drawings and marginal pen sketches, made by Holbein and his brother Ambrosius (c. 1494–c. 1519), in Osualdus Myconius' personal copy of *Praise of Folly* by Erasmus are due to correspondences in iconography. See Massing 1995, 12. The Holbein sketches are reproduced in facsimile in Schmid 1931; a few are reproduced in Massing 1995, figs. 26–31.

8. See Linda Papaharis in exh. cat. New York and elsewhere 1973–1974, nos. 2–35. Her tentative attribution to the Master of the Clubfeet is convincingly rejected in Massing 1995, 13–14.

9. Massing's most complete analysis of the sources can be found in Massing 1995, 15–36, 52–59, 63–104.

10. Folio 40r, inv. 2006.11.43; reproduced in Massing 1995, 201.

11. The two images illustrating this verse are: *Credulity Preparing to Nurse the Mother of Hope*, fol. 18v, and *Hope Reaching for Heaven Stands among Sad and Happy Men, Joys, and Fears*, fol. 19r, inv. 2006.11.32, 2006.11.33; reproduced in Massing 1995, 158–159.

12. Folio 42r, inv. 2006.11.41; reproduced in Massing 1995, 205.

13. *The Statue of Opportunity and the Passer-by*, fol. 7v, and *The Statue of Opportunity, a Passer-by, and Remorse*, fol. 8r, inv. 2006.11.57, 2006.11.58; reproduced in Massing 1995, 136–137.

EXHIBITIONS

New York and elsewhere 1973–1974, nos. 2–35 (as Studio of Jean Perréal); Washington 1995–1996, no. 25.

LITERATURE

Maggs Brothers 1941, no. 30; Saxl 1942, 82–134; Butler 1974, 56, fig. 6; Massing 1983, 75–82, figs. 33–36, 38; Massing 1987a, 215–216, pl. 61; Massing 1990, 48, 67, 81, 93, 284–285, pl. 8A; Massing 1995 (the whole book is devoted to discussion and analysis of the manuscript and illustrations).

3 · Benvenuto Cellini
A Satyr

1. Cellini [1983 ed.], 131–132.

2. Only the well-known *Nymph of Fontainebleau* (Musée du Louvre, Paris) and two figures of *Victory with a Trumpet* were cast in bronze before Cellini left France (the first by 1543, the second in 1544), although the two *Victories* are now known only through plaster casts (Musée du Louvre). For a recounting of this enterprise, see Pope-Hennessy 1982, 406–412, and Pope-Hennessy 1985, 133–146.

3. Inv. 85.SB.69.

4. Inv. 94784; reproduced in Marsden and Bassett 2003, 553, fig. 3.

5. Pope-Hennessy 1982, 411. A photomontage showing the spatial relationship between the two satyrs and the semicircular *Nymph of Fontainebleau* in the proposed gateway is reproduced in Marsden and Bassett 2003, 557, fig. 13.

6. A back view of the Getty bronze is reproduced in exh. cat. Washington 1995–1996, 196, fig. 2, and in Marsden and Bassett 2003, 558, fig. 14. The small bronze of the second satyr in the Royal Collection is left similarly incomplete where the figure's back would be positioned against a wall. See Marsden and Bassett 2003, 558, fig. 15.

7. Virginia Bush (in Bush 1976, 265) noted that the pose of the satyr with a club is closely similar to the spiraling pose of the slave placed at right center of the tomb of Julius II. Denise Allen (first cited in Marsden and Bassett 2003, 555, and reiterated by Allen herself in exh. cat. Ottawa 2005, 282, no. 102) has pointed out that the pose of the satyr in the Royal Collection "pays homage" to the *David*. She also mentions that Cellini would have known the monumental marble statue of *Hercules* by Michelangelo, now lost, that was displayed in the gardens at Fontainebleau.

8. See, for example, Winner 1968, 296–297; Pope-Hennessy 1982, 410; Diane De Grazia and Margaret Morgan Grasselli in exh. cat. Washington 1995–1996, no. 47; and Marsden and Bassett 2003, 559. The National Gallery drawing is certainly not a copy of the Getty bronze, for there are distinct differences between the two, particularly in the proportions, the expression of the face, and the articulation of the musculature.

9. In exh. cat. Ottawa 2005, 283, no. 102.

10. A similar inscription, also couched in the past tense, is found on one other Cellini drawing, a half-length chalk study of *Juno* in the Musée du Louvre, Département des Arts graphiques, Paris (inv. 2740); see Avery and Barbaglia 1981, no. 31. That, too, was connected with a Fontainebleau project, a set of twelve life-size silver torchères. The *Juno*, like the *Satyr*, was never cast.

EXHIBITIONS

Newark 1960, no. 25; New York 1965–1966, no. 82; Notre Dame and Binghamton 1970, no. D7; New York and elsewhere 1971–1972, no. 14; Paris 1972–1973, no. 51; Ottawa 1973, no. 51, pl. 67; Los Angeles 1976, no. 26; Malibu and elsewhere 1983–1985, no. 18; Vienna and Munich 1986, no. 23; Madrid 1986–1987, no. 28; London 1987, no. 20; New York 1990a, no. 26; Washington 1995–1996, no. 47; Ottawa 2005, no. 102.

LITERATURE

Heikamp 1966, 53; Vitzthum 1966, 110, fig. 58; Hayward 1967/1968, 264; Winner 1968, 294; Parronchi 1969, 43, fig. 10; Lyons 1972, 31; Bush 1976, 265–266, fig. 279; Perrig 1977, 81, pl. 56; Avery and Barbaglia 1981, no. 33, pl. 12; Pope-Hennessy 1982, 409, fig. 14; Cellini [1983 ed.], 150, pl. 64; Matteson 1983, 386; Pope-Hennessy 1985, 135–136, pls. 70, 71; Avery 1986, 62; Gardner 1987, 122, reprod. 123; Radcliffe 1988, 930; Cummings 1988, 107 (reprod.); Poeschke 1992, 210, 211, pl. 115; NGA Guide 1992, 314, reprod. 318; Ekserdjian 1995, 45; Scalini 1995, 21, fig. 44; Jones 1995, 50, fig. 2; Annesley 1995, 54; Cox-Rearick 1995/1996, 290–291, 360, fig. 16; Poeschke 1996, 211; Alessandro Nova in Grove Dictionary 1996, 6:141–142; exh. cat. Saarbrücken 1997, 15, 20, fig. 23, 27 n. 84, 150, fig. 2 (detail), 152, 301 n. 3; Avery 1998, 113, fig. 1, 116; Fogelman et al. 2002, 40; Bliss 2003, 77–79, 81, 88, fig. 4.; Marsden and Bassett 2003, 552, 555, 557, 559; Jestaz 2003, 107, 116, fig. 11.

4 · Luca Penni
The Banquet of Achelous

1. No monograph on Penni's life and work has yet been written and relatively little is known about him. A small cache of about twenty drawings is preserved in the Département des Arts graphiques at the Musée du Louvre, but otherwise works by him are very rare. (Three others are listed in note 2, below.)

2. Compare, for example, two drawings of *The Entombment*, one in the Royal Collection at Windsor Castle (inv. 0.407; reproduced in exh. cat. Paris 1972–1973, no. 136), and another in the J. Paul Getty Museum, Los Angeles (inv. 85.GG.235; reproduced in Goldner et al. 1988, no. 29); *Three Marys at Christ's Tomb* in the Musée du Louvre, Département des Arts graphiques, Paris (inv. 1394; reproduced in exh. cat. Paris 1972–1973, no. 137); and *Hecatomb Offered to Apollo by the Achaeans* in the École nationale supérieure des Beaux-Arts, Paris (inv. M.1384; reproduced in exh. cat. Paris and elsewhere 1994–1995, no. 43).

3. For prints by Léon Davent after Penni, see Zerner 1969, L.D. nos. 67, 70–72, 74, 76, 85–92. For prints by Jean Mignon, see Zerner 1969, J.M. nos. 29–34, 37–46, 48–53, 56–57, 60. For prints by Giorgio Ghisi, see *Illustrated Bartsch* 31, nos. 40, 43, 58, 64. The attributions of some of the original designs to Penni are speculative; very few of the prints are inscribed with his name, though some of the original drawings survive (e.g., *Christ Falling under the Cross*, Musée du Louvre, Département des Arts graphiques, inv. 1403, which served as the model for a print by Jean Mignon [Zerner 1969, J.M. no. 29]).

4. See exh. cat. Paris 1972–1973, no. 138.

5. Ovid [trans. Humphries] 1958, 198–199.

6. Ovid [trans. Humphries] 1958, 199.

7. See Amico 1996, 50.

8. Reproduced in Amico 1996, figs. 34, 36. The history of grottoes is explored in detail in Miller 1982; Amico 1996, 46–53, offers a brief summary of the grotto in Renaissance France.

EXHIBITIONS

Paris 1972–1973, no. 138; Munich and elsewhere 1977–1978, no. 36; Lucerne 1979, no. 110; Vaduz 1995, no. 2; New York 1996–1997, no. 2.

LITERATURE

Miller 1982, 53, fig. 40; Goldner et al. 1988, 78, under no. 29; exh. cat. Paris and elsewhere 1994–1995, 136, under no. 43; Amico 1996, 49, 50, fig. 35.

5 · Jean Cousin the Elder
Design for a Morion-Burgonet

1. Vasari [trans. de Vere] 1979, 2:1260 (where Cousin is referred to by the Italian form of his name, Giovanni Cugini). Cousin's *Livre de perspective* was published in 1560; his *Livre de portraicture* was published posthumously in 1571 by his son Jean (c. 1522–c. 1594), also an artist. The National Gallery owns a first edition of the *Livre de perspective* (inv. 1985.61.481); the NGA library has the 1608 edition of the *Livre de portraicture*.

2. Conversation between George Wanklyn and Sylvie Béguin, May 1989 (mentioned in exh. cat. Washington 1995–1996, no. 51).

3. See Béguin and Grasselli's entry in exh. cat. Washington 1995–1996, no. 51. Both works are reproduced in exh. cat. Paris 1972–1973, nos. 59, 401; the print by Master N.H. (inv. Ed. 8) is also reproduced in exh. cat. Washington 1995–1996, 208, fig. 1.

4. Inv. RF 2373 and 884.3.1; both are reproduced in exh. cat. Paris 1972–1973, nos. 56, 57. *Charity* is also reproduced in exh. cat. Washington 1995–1996, 208, fig. 2.

5. Drawings from the album, entitled *Dessins originaux pour armures de luxe destinées à des rois de France* (Original Drawings for Luxury Armors Destined for the Kings of France), were the subject of four articles by Bruno Thomas in Thomas 1959, 1960, 1962, and 1965. According to the catalogue for the Grosjean-Maupin sale in Paris in 1958 (lot 43), that album contains two tracings of the Washington design on fol. XIII (not reproduced there or in Thomas).

6. Inv. 34.559; reproduced in Thomas 1959, 65, fig. 716.

7. See Thomas 1959, 67.

EXHIBITIONS

New York 1990a, no. 23 (as attributed to Rosso Fiorentino); Washington 1995–1996, no. 51.

6 · Geoffroy Dumoûtier
Saint John on Patmos

1. Several drawings by Thiry are reproduced in exh. cat. Paris and elsewhere 1994–1995, nos. 33–41.

2. All are reproduced in Zerner 1969, G.D. nos. 1–26.

3. Reproduced in Zerner 1969, G.D. nos. 2 and 10.

4. Zerner 1969, G.D. nos. 7 and 11.

5. When the composition was drawn on the copper plate in order to be etched, the figure of Saint John originally faced in the same direction as in the drawing. The image was then reversed as a result of the printing process.

6. Reproduced in Zerner 1969, G.D. no. 23. The other two prints by Dumoûtier that feature ornamental frameworks are also reproduced in Zerner 1969, G.D. nos. 25, 26.

7 · Étienne Delaune
The Backplate of a Suit of Parade Armor

1. During his short stay at the mint, Delaune designed a portrait medal of the king, of which the National Gallery owns three versions: one in silver (inv. 1957.14.1136.a/b), one in gilt bronze (inv. 1985.27.1.a/b), and one in bronze (inv. 1997.114.7.a/b).

2. See cat. 5, note 5. Drawings for arms and armor designed specifically by Delaune are the subject of Thomas 1960, Thomas 1962, and Thomas 1965, with many of Delaune's drawings illustrated in each article.

3. The two harnesses are reproduced in Thomas 1965, figs. 43, 47, 65, 92, 96–99; a detail of the *Emperor Harness* is also reproduced in exh. cat. Washington 1995–1996, 211, fig. 2. The present entry is an adaptation of the one written by this author for that catalogue, no. 52.

4. Inv. 14.524 (385 × 192) and 14.459 (378 × 297); reproduced in Thomas 1965, 79, figs. 103, 105.

5. Inv. 34.537; reproduced in Thomas 1965, 79, fig. 104. In the red chalk copy after the Washington sheet, the man mounting the mule is included in the design at upper right instead of in its more logical position at lower right. See Thomas 1965, 79, fig. 105.

6. Thomas 1965, 80.

7. Inv. E5279-1958; reproduced in exh. cat. Washington 1995–1996, 211, fig. 3.

EXHIBITIONS

New York 1990a, no. 91; Washington 1995–1996, no. 52.

8 · Jacques Androuet du Cerceau
A Triumphal Arch with Caparisoned Horses and Ornamented Pinnacles

1. The National Gallery has a number of prints and illustrated books by Androuet du Cerceau, which came in part with gifts from the Rosenwald Collection in 1943 and 1964, and in part with the acquisition of the Mark J. Millard Architectural Collection of illustrated books on Western European architectural design and theory in 1985. For the books in the Millard Collection, see Wiebenson and Baines 1993, nos. 4–13. The Gallery also owns a pen sketch of *The "Palais Tutelle" near Bordeaux*, inv. 1971.46.1, that was purchased as the work of Androuet du Cerceau (reproduced in exh. cat. Providence 1978, 73, no. 8). That attribution has been rejected by Peter Fuhring (e-mail of 7 April 2009). I am indebted to Mr. Fuhring for kindly reviewing this entry and offering corrections and suggestions that considerably improved it.

2. Albums of drawings by Androuet du Cerceau are in the collections of the Musée du Louvre, Département des Arts graphiques, Paris (inv. RF 54235); École nationale supérieure des Beaux-Arts, Paris (inv. E.B.A. no. 1760, recueil 41); Fitzwilliam Museum, Cambridge (inv. 904* 1); Musée Condé, Chantilly (Ms. 395 [1919] and Ms. 396 [1918]); and the Canadian Centre for Architecture, Montreal (inv. DR 1986:0108:001–081). Two volumes in the British Museum, London, were disbound in 1886 and the bindings are now lost (inv. 1972.U.793–910); another in the Vatican Library, Rome, was also dismantled, but the binding has been preserved (Cod. Barb. Lat. 4398).

3. The twelve drawings remained together until 2006, when they were sold separately at Christie's, London, 4 July 2006, lots 79–88. All the drawings are reproduced in color in the auction catalogue.

4. All the architectural elements from French royal châteaux and noble residences that are mentioned hereafter in relation to the triumphal arch are illustrated in Androuet du Cerceau [ed. Thomson] 1988, 134–139 (Verneuil), 160–161 (Gaillon), 196–197 (Fontainebleau), 272–273 (Écouen).

5. The book was published simultaneously in both Latin and French editions; the National Gallery owns copies of both (inv. 1985.61.331 and 1985.61.332; Wiebenson and Baines 1993, nos. 5, 6).

6. Peter Fuhring kindly pointed out (in an e-mail of 7 April 2009) that a closely related drawing for another tripartite triumphal arch surmounted by pinnacles and horses is in the collection of the Vatican Library; pen and black ink with gray wash on vellum, 390 × 560; Cod. Barb. Lat. 4398 [not reproduced]).

9 · François Quesnel
Portrait of a Noblewoman (Madame de Pellagars?)

1. In exh. cat. Cleveland and elsewhere 1989–1990, 102.

2. The identification of the sitter as the princesse de Condé dates back to at least 1909 and the catalogue of the sale of Charles Wickert's collection in Paris on 3 May. Comparisons with other presumed portraits of the princess, however, show notable differences in the shape of the nose and the overall proportions of the face. See Adhémar 1973, nos. 112 (illustration wrongly numbered 111), 150, 231, 443, 460.

3. Inv. Na 22, rés (Album Villeflix); reproduced in Adhémar 1973, 154, no. 224. The connection with the inscribed drawing in the Bibliothèque nationale and the resulting identification of the model as Madame Pellegars was first proposed by this author in exh. cat. Washington 1995–1996, 230, no. 60. Much of the entry from that catalogue is repeated verbatim here.

4. In the sixteenth and seventeenth centuries, orthography was not fully standardized and many of the inscriptions identifying the sitters in old French portrait drawings use unusual, sometimes barely identifiable spellings of their names. A note about the de Pellegars de Malortie family is included in Seréville and Saint Simon [1976], 782.

5. Miriam Stewart, assistant curator of drawings at the Fogg Art Museum, Harvard University, noted that the costume was in vogue between 1585 and 1595 (cited in exh. cat. Malibu and elsewhere 1983–1985, no. 55, and exh. cat. Cleveland and elsewhere 1989–1990, no. 48). Louis Dimier, in Dimier 1925, 2:244, 261, nos. 136 and 18, proposed dates of c. 1594 for the Washington drawing and c. 1593 for the version in the Bibliothèque nationale, without realizing that the two drawings represented the same woman.

6. Sale cat., Galerie Georges Petit, Paris, 3 May 1909, 4.

7. Inv. Na 22 rés. See Adhémar 1973, 150–157.

8. As noted in Adhémar 1973, 150.

9. The Washington drawing sold at that time for 5,000 francs. The next highest price was 3,000 francs, paid for lots 20, 41, and 46.

EXHIBITIONS

Toledo 1941, no. 3; New York and elsewhere 1971–1972, no. 55; Malibu and elsewhere 1983–1985, no. 55; Vienna and Munich 1986, no. X, reprod. (color) XXV (exhibited in Munich only); Madrid 1986–1987, no. 87; Cleveland and elsewhere 1989–1990, no. 48; Washington 1995–1996, no. 60.

LITERATURE

Moreau-Nélaton 1924, 2:99, 3:152–153 (unattributed); Dimier 1925, 2: no. 1006; exh. cat. New York and elsewhere 1973–1974, under "Additions and Corrections to Woodner Collection I," n.p., no. 55.

10 · Antoine Caron
Ancient Roman Warriors Riding into Battle

1. A number of drawings by both Primaticcio and dell'Abate are reproduced in exh. cat. Paris and elsewhere 1994–1995, nos. 17–27, 29–31.

2. Both projects are discussed by Jean Ehrmann in Ehrmann 1986, 52–78, 85–104. The surviving drawings related to both stories are in the Musée du Louvre, Département des Arts graphiques, Paris, and the Bibliothèque nationale, Paris. See Ehrmann 1986, figs. 30–68, 74–97.

3. Inv. 29726, 29752.9; reproduced in Ehrmann 1986, figs. 76, 83.

4. Inv. 25143; brown wash over black chalk, heightened with white on gray paper, 240 × 429. Reproduced in Ehrmann 1986, 210, fig. 199. The drawing is unfortunately disfigured by a large stain at lower center.

5. Inv. MR 1639; reproduced in Ciprut 1967, fig. 16.

6. For a discussion of the *Belle Cheminée*, which was originally about seven meters high, and Jacquet's sculptures for it, see Ciprut 1967, 54–62. For the participation of Caron in the design of the fireplace, see Ehrmann 1975, 117–125. The *Belle Cheminée* was dismantled in 1725 by order of Louis XV so the room could be transformed into a theater.

11 · Jacques de Bellange
Dancer with a Tambourine

1. The most detailed information about Bellange's life and career, including complete transcriptions of documents pertaining to his activities, can be found in exh. cat. Rennes 2001, 48–83.

2. The painting is *The Ecstasy of Saint Francis* in the Musée historique Lorrain, Nancy (inv. 554; reproduced in exh. cat. Rennes 2001, no. 7). In the absence of a catalogue raisonné of Bellange's drawings, the best source of images and information is exh. cat. Rennes 2001, which presents fifty-five studies. For Bellange's etchings, the standard catalogue is Walch 1971, but the most recent work on Bellange as an etcher is exh. cat. London and elsewhere 1997, written by Antony Griffiths and Craig Hartley.

3. According to Hilliard Goldfarb (exh. cat. Cleveland and elsewhere 1989–1990, 30, no. 7), when the drawing first appeared, Christopher Comer rejected the attribution to Bellange and suggested instead that the drawing was close to the work of Georges Lallemant (c. 1575–1636).

4. Inv. 1961.61.37. Similar figures can also be found in Bellange's prints, such as *The Adoration of the Magi* and *Christ Carrying the Cross* (Walch 1971, nos. 20 and 23), both reproduced in exh. cat. Rennes 2001, nos. 51, 53(2).

5. In addition to fig. 1, see the print of the same composition; the etching of *The Holy Family with Saint John the Evangelist, Saint Catherine and an Angel*; the prints and drawings of garden statuary known as "Hortulanae"; the drawing of *Diana and Orion* in the Morgan Library & Museum, New York (inv. 1971.8); and the *Study of a Saint* in the Musée des Beaux-Arts, Rennes (inv. 794.1.2627), all reproduced in exh. cat. Rennes 2001, nos. 25, 26, 38–43, 72, 75.

6. Compare, for example, the etching of *Three Saints* and the drawing related to the *Resurrection of Lazarus* in the Musée du Louvre, Département des Arts graphiques, Paris (inv. 23712), both reproduced in exh. cat. Rennes 2001, nos. 70, 71.

7. Exh. cat. Cleveland and elsewhere 1989–1990, no. 7.

8. That drawing is not universally accepted as the work of Bellange himself, but even if it was made by a follower, its conception surely originated with the master.

9. Exh. cat. Rennes 2001, no. 37.

10. See the discussion of the chronology of Bellange's prints by Anthony Griffiths and Craig Hartley in exh. cat. London and elsewhere 1997, 28–30. Only one print by Bellange includes a date, the *Ex-Libris of Melchior de la Vallée*, which is dated 1613 (exh. cat. Rennes 2001, no. 64).

EXHIBITIONS

Cleveland and elsewhere 1989–1990, no. 7; Rennes 2001, 193, no. 36.

LITERATURE

Rosenberg 1990, 432; Thuillier in exh. cat. Nancy 1992b, under nos. 44 and 81b; Goldfarb 1995, 66.

12 · Claude Deruet
Imperfectorum Academia (Academy of the Imperfects)

1. The identity of the drawing's author puzzled scholars for many years. A possible attribution to Pierre Brébiette (c. 1598–c. 1650) was suggested by Anthony Blunt (letter of 4 May 1959), who also mentioned Claude Vignon (1593–1670) as a candidate. In the 1960s, Pierre Rosenberg proposed Jacques Stella (cat. 19) as the author (oral communication, date unknown). F.-G. Pariset correctly published the drawing as the work of Deruet in 1965, but the attribution was not given serious consideration until both Jean-Claude Boyer (e-mail of September 2003) and Alvin L. Clark Jr. (oral communication, Fall 2003) independently suggested the attribution again.

2. The inventory made after Deruet's death included well over 2,500 drawings, most of which are presumed to have been made by the artist himself. See Jean-Claude Boyer in exh. cat. Nancy 1992b, 212, under no. 56.

3. See, for example, *Couple on a Horse* in the Nationalmuseum, Stockholm (inv. NM 178./1863; reproduced in Bjurström 1976, no. 354); *Mounted Amazon with a Spear* in the Morgan Library & Museum, New York (inv. 1959.4; reproduced in exh. cat. Cleveland and elsewhere 1989–1990, no. 8); and *The Conversion of Turkish Warriors* in the Musées royaux des Beaux-Arts, Brussels (inv. 4060/462; reproduced in exh. cat. Nancy 1992b, no. 57).

4. As Elizabeth Milroy pointed out in exh. cat. Burlington and elsewhere 1979, 32, a number of aesthetic and literary academies with similarly evocative names were established in Italy in the early 1600s, including the academies of Humorists and Fantastics in Rome and the academy of The Immature in Venice. More recently, Jean-Claude Boyer has suggested that the drawing stems from a French context and belongs to the later part of Deruet's career when he was frequently in Paris (Boyer 2008, 55–58). He proposed relating it to the circle of Gaston d'Orléans, brother of Louis XIII, who at one time thought of founding a private academy. (This article was kindly brought to my attention by Alvin L. Clark Jr.)

5. Another interpretation of the allegory is offered by Milroy in exh. cat. Burlington and elsewhere 1979, no. 19, suggesting that it incorporates humor and references to love. For her, the alembic symbolizes profane love, but its connection with alchemy may point to yet another rich area of meaning to be explored.

EXHIBITIONS

Binghamton and elsewhere 1970, no. 73 (as French, early 17th century); Burlington and elsewhere 1979, no. 19 (as anonymous 17th century); New York 1990b, no. 22 (as French, 17th century).

LITERATURE

Pariset 1965 [1966], 67, pl. VI, fig. 1 (opp. p. 68); Jean-François Méjanès in exh. cat. Paris 1993, 70, under no. 18; Boyer 2008, 49–58, fig. 3.

13 · Jacques Callot
recto and verso: *Studies of Horses* (after Antonio Tempesta)

1. Among the most important and useful books dealing entirely or extensively with Callot's drawings are Ternois 1962a, Ternois 1973, Ternois 1999 (supplement to Ternois 1962a), exh. cat. Washington 1975 (H. Diane Russell), and exh. cat. Nancy 1992a (Ternois et al.). The National Gallery owns an extensive collection of Callot's prints, numbering well over 1,000 works (mainly from the Rosenwald and Rudolf L. Baumfeld collections). In addition to the three drawings exhibited here, the Gallery also owns a red chalk *Study of Four Horsemen* (inv. 1961.17.51; Rosenwald Collection; see p. 4, fig. 2).

2. Reproduced in *Illustrated Bartsch* 36, nos. 941–968.

3. See Ternois 1962a, nos. 25–36; Ternois 1999, nos. S. 1459–S. 1466. For many years, Daniel Ternois placed these copies in the middle of Callot's Florentine period, 1616/1617, but in exh. cat. Nancy 1992a, 158, he proposed for the first time that they might date instead from the very end of Callot's stay in Rome or very soon after his move to Florence, 1612/1613, a dating that seems more logical.

4. See *Illustrated Bartsch* 36, nos. 946–948, 953, 957–959. The horses drawn along the lower edge of the verso were not copied after Tempesta's horses, but instead appear either to have derived from some other as yet unidentified source or to have been invented by Callot himself.

5. Ternois 1962a, nos. 27, 28, 31, 34; Ternois 1999, nos. S. 1459, S. 1460, S. 1464.

6. Inv. HZ 1717; reproduced in color in Cordellier et al. 2007, no. 34.

7. The one exception is the horse from Tempesta's plate 15 (*Illustrated Bartsch* 36, no. 955), which appears in the right middle ground of Callot's *The Stag Hunt*, in reverse and in exactly the same attitude but now ridden by a huntsman. That print was etched by Callot around 1619, when he was still in Florence.

EXHIBITIONS

London 1966, no. 15; Nancy 1992a, no. 43.

LITERATURE

Ternois 1973, 218, 219 n. 30, 240, suppl. n. 7, reprod. 216–217, figs. 5, 6; Ternois 1992, 363; Ternois 1999, 22, S.1466, recto and verso, reprod. 61.

14 · Jacques Callot
Gobbi and Other Bizarre Figures
verso: *A Human Leg and the Head of an Animal*

1. Lieure 1924–1927, nos. 188, 1416; reproduced in exh. cat. Washington 1975, nos. 129, 139.

2. Lieure 1924–1927, nos. 169–172, 178–182. For descriptions of the festivals and reproductions of the prints, see exh. cat. Washington 1975, 60–65, 84–95, nos. 49–51, 54–58.

3. Reproduced in exh. cat. Washington 1975, no. 54.

4. See, for example, *Parade in the Amphitheater* and *One of the Infantry Combats*, reproduced in exh. cat. Washington 1975, nos. 50, 51.

LITERATURE

Ternois 1962a, 51, no. 53 (recto reproduced); Ternois 1962b, 111, 112, 114, 130, pl. 4a (recto).

15 · Jacques Callot
The Holy Trinity in the Tree of Life Adored by Franciscans

1. The large majority of Callot's compositions are drawn either in pen and ink or in brown wash over black chalk underdrawings. Among the few composition drawings executed solely in black chalk are a preliminary idea for the *Fair of the Impruneta* (Gabinetto disegni e stampe degli Uffizi, Florence, inv. 613 P); two views of Paris (British Museum, London, inv. 1861.7.13.1 and .2); and three small landscape sketches (State Hermitage Museum, Saint Petersburg, nos. 932, 933, and 1393 of the Jullienne album). Also remarkable is a group of four red chalk sketches of *Perseus and Andromeda* (Gabinetto disegni e stampe degli Uffizi, Florence, inv. 2657F–2660F). All are reproduced in Ternois 1962a, nos. 172, 903–904, 1353–1355, 537–540.

2. Lieure 1924–1927, no. 303.

3. Although the drawing is pasted down on an old mount, the main features of the watermark can be discerned in raking light, even if the specific details remain unclear. See exh. cat. Washington 1975, no. 156. Many examples of double-C watermarks on papers used by Callot are reproduced in an appendix to the same catalogue, 321–327.

4. See exh. cat. Washington 1975, 155–156, 162–163, 168–169 nn. 2–11, 32–36.

5. Exh. cat. Washington 1975, 163.

6. Exh. cat. Washington 1975, 163.

7. Félibien 1725, 382.

8. Exh. cat. Washington 1975, 162.

EXHIBITIONS

London 1962, no. 169; Providence 1970, no. 64; Washington 1975, 163, 189–190, no. 155; Cleveland and elsewhere 1989–1990, no. 12; Nancy 1992a, no. 629.

LITERATURE

Ternois 1962a, no. 423; Schab [1964], no. 99; Schab [1968], no. 147; McCullagh 1990, 235, reprod. 234, fig. 85.

16 · Lagneau
Bust of an Old Woman Wearing a Head Scarf

1. See Maxime Préaud in exh. cat. Chantilly 2005, 9. For his publication of the Leblond estate inventory, see Préaud 2002.

2. Transcribed in Duplessis 1872, 60. The abbé makes special note of the "fantasy" quality of Lagneau's work.

3. Summaries of the various theories that have been offered regarding Lagneau's activities as an artist are given by Dominique Cordellier in exh. cat. Paris 1984–1985a, no. 17, and Hilliard Goldfarb in exh. cat. Cleveland and elsewhere 1989–1990, no. 49. An accounting of the most recent scholarship is offered by Maxime Préaud and Barbara Brejon de Lavergnée in exh. cat. Chantilly 2005, 7–24.

4. See Maxime Préaud in exh. cat. Chantilly 2005, 7. For reproductions of both drawings, see exh. cat. Paris and elsewhere 1994–1995, no. 92, and exh. cat. Chantilly 2005, no. 31. Neither inscription provides an actual date for the portraits on those sheets, but rather a terminus.

5. Reproduced in Adhémar 1973, 343–344, nos. 720–727; two are reproduced in color in exh. cat. Chantilly 2005, nos. 26, 27. As Maxime Préaud pointed out (in exh. cat. Chantilly 2005, 8), the small hatchet carried by the man in no. 26 is a *czekan*, which was carried by the Polish king's guards, the *hajducy*.

6. Inv. Na 21 b, rés; see Adhémar 1973, 342–347, nos. 697–765, where all the drawings are reproduced. Several were reproduced in color in exh. cat. Chantilly 2005, nos. 1, 15, 16, 20, 22, 25–28, 32–34.

7. Reproduced in exh. cat. Chantilly 2005, 61, no. 25.

8. Reproduced in Adhémar 1973, 344, nos. 727, 731. The second drawing is also illustrated in color in exh. cat. Chantilly 2005, no. 15. The similarity between this last image and the woman on the Washington sheet goes well beyond the pose and expression, however, for the two physically resemble each other so closely that were it not for the different placement of the moles on their faces, one could easily imagine that the same model had sat for both likenesses wearing different costumes.

17 · Simon Vouet
Creusa Carrying the Gods of Troy

1. The most comprehensive book on Vouet's drawings is Brejon de Lavergnée 1987, which catalogues and reproduces more than 275 drawings by the artist, including examples of all the different types of drawings he made.

2. Cummings notified the National Gallery about the connection between the painting, whose existence was previously unknown, and the drawing on 30 January 1986 (note in the object file). The canvas had surfaced at a sale in Saint Maur, France, at the Hôtel de Ville de Saint Maur, 11 December 1985, as "attributed to Simon Vouet" (reproduced in the sale catalogue, p. 3). Cummings purchased it there and subsequently sold it to the San Diego Museum of Art (inv. 1987:124).

3. *The Aeneid*, 2.650–795. See Virgil [trans. Fairclough] 1942, 339–347. A classic rendering of *Aeneas Fleeing Troy* is the painting by Federico Barocci (c. 1535–1612) of 1598, now in the Galleria Borghese, Rome (reproduced in Turner 2000, 108, fig. 95).

4. *Aeneid* 2.679–709; Virgil [trans. Fairclough] 1942, 341–343.

5. *Aeneid* 2.713–720; Virgil [trans. Fairclough] 1942, 343. In these lines, Aeneas instructs Anchises to take the statues, and no mention is made of Creusa as their guardian. This is apparently Vouet's invention.

6. According to Hilliard Goldfarb (exh. cat. Cleveland and elsewhere 1989–1990, no. 58), William R. Crelly, the author of the standard catalogue raisonné of Vouet's paintings (1962) suggested a date between 1635 and 1640, and Arnaud Brejon de Lavergnée proposed a date in the early 1630s for the painting. The Washington drawing was catalogued by Barbara Brejon de Lavergnée (in Brejon de Lavergnée 1987, no. XCIX) without any specific proposal for a date, but she placed it among works she dated to about 1640. Goldfarb himself (in exh. cat. Cleveland and elsewhere 1989–1990, no. 58) proposed the same approximate date, based on the highly sculptural style of the drawing and the disposition of the figures in the painting.

7. The painting is reproduced in color and discussed at considerable length in exh. cat. Strasbourg 2005–2006, 112, cat. 1.

EXHIBITIONS

Toronto and elsewhere 1972–1973, no. 149, reprod. (color) 98, pl. II; Washington 1974, no. 52; Washington 1978a, 67; Cleveland and elsewhere 1989–1990, no. 58.

LITERATURE

Brejon de Lavergnée 1987, 127, no. XCIX; McCullagh 1990, 234–235; Rosenberg 1990, 432–433.

18 · Nicolas Poussin
Road along a Winding River

1. The two prime references on Poussin's drawings are Friedlaender and Blunt 1939–1974, with 458 numbers (but with versos catalogued separately from rectos and with different numbers), and Rosenberg and Prat 1994, who accept 382 drawings as authentic.

2. Félibien 1725, 5; facsimile reprint in Pace 1981, 110.

3. Mariette 1851–1860, 4:204.

4. In his biography of Pieter van Laer (c. 1592–1642), Sandrart specifically mentioned that he (Sandrart), Claude, Poussin, and Van Laer all went together on a sketching trip to Tivoli. The passage is reprinted in English in Roethlisberger 1961a, 1:52.

5. In Rosenberg and Prat 1994, 704, no. 365; reproduced in color in exh. cat. Bilbao and New York 2007–2008, 277, no. 59 (the painting is no. 58).

6. Félibien 1725, 4:59; facsimile reprint in Pace 1981, 124. See also exh. cat. Paris and London 1994–1995, 389, for a discussion of the painting's history.

7. See exh. cat. Bilbao and New York 2007–2008, 194, fig. 75; nos. 46, 48, 50, 60 (the NGA drawing), 72–77, 84–92; and the introductory texts, 307–310.

8. Inv. 1937-12-11-1; reproduced in color in exh. cat. Bilbao and New York 2007–2008, no. 48.

EXHIBITIONS

Cambridge 1958, no. 37; Washington and elsewhere 1985–1987, no. 55; Paris and London 1994–1995, no. 232; Bilbao and New York 2007–2008, no. 60.

LITERATURE

Shearman 1960, 1:183; Friedlaender and Blunt 1939–1974, 4: nos. 250, pl. 203 (verso), 290, pl. 222 (recto); Badt 1969, 1:253; Rosenberg and Prat 1994, 1:xx, 680, under no. 351, no. 365; Clayton 1996, 469.

19 · Jacques Stella
October: Honey-Gathering

1. The first book devoted to Stella was published in 2006, the same year the first monographic exhibition of his work was presented. See Thuillier 2006 and exh. cat. Lyon and Toulouse 2006–2007.

2. This information was first provided by André Félibien in his 1666 biography of Stella and was repeated by Roger de Piles (Piles 1715, 485) and Pierre-Jean Mariette (Mariette 1851–1860, 5:253).

3. Twenty-two drawings illustrating episodes from the Life of the Virgin are reproduced in Thuillier 2006, 273–282.

4. That is the number of drawings recorded in the possession of Stella's niece Claudine Bouzonnet Stella (1636–1697) nearly forty years after her uncle's death, when she drew up a household inventory in 1693/1697. See Guiffrey 1877. The number of drawings in Stella's original bequest may well have been higher.

5. See Thuillier 2006, 232–241, 243–261, 287–293.

6. A set of *The Months* is preserved in the Bibliothèque nationale de France, Paris, in a folio volume, ED-82-Fol; *October* is on page 162.

7. For the drawings in the Getty Museum (inv. 86.GG.619) and the private collection, see exh. cat. Lyon and Toulouse 2006–2007, nos. 157, 159 (both reproduced in color); for the Fogg Art Museum drawing (inv. 2001.114), see http://www.artmuseums.harvard.edu/collections/basicSearch.smvc.

8. As early as the first century AD, Pliny the Elder wrote that bees "delight in the clash and clang of bronze, and collect together at its summons." See Pliny [trans. Rackham] 1940–1963, 3:475.

9. Paris: inv. RF 34728; reproduced in exh. cat. Lyon and Toulouse 2006–2007, no. 86. Private collection: reproduced in exh. cat. Lyon and Toulouse 2006–2007, no. 98.

LITERATURE

Exh. cat. Lyon and Toulouse 2006–2007, 224, under no. 157.

20 · Laurent de La Hyre
The Presentation in the Temple

1. A highly detailed drawing copying the painting preserves its original appearance with the arched top (Musée du Louvre, Département des Arts graphiques, Paris, inv. 27484; reproduced in exh. cat. Grenoble and elsewhere 1989–1990, 278, no. 243c).

2. Inv. 27499–27515; reproduced in exh. cat. Grenoble and elsewhere 1989–1990, nos. 206–208, 210–211, 213–215, 217–219, 222–226, 228. For a discussion of the tapestry series and its probable date, see pp. 250–254.

3. See, for example, exh. cat. Grenoble and elsewhere 1989–1990, nos. 206–208, 210–211, 213.

4. Inv. 1964.52.1; reproduced with the related painting (in the Szépmüvészeti Múzeum, Budapest), dated 1646, in exh. cat. Grenoble and elsewhere 1989–1990, nos. 229–230, and in Whiteley 2000, 1:141, fig. 10, and 2: pl. 423.

EXHIBITIONS

Binghamton and elsewhere 1970, no. 62; Hartford and elsewhere 1973–1974, no. 17; Burlington and elsewhere 1979, no. 16; Cleveland and elsewhere 1989–1990, no. 86.

LITERATURE

Rosenberg in exh. cat. Toronto and elsewhere 1972–1973, 172; Rosenberg and Thuillier [1985], no. 44; exh. cat. Grenoble and elsewhere 1989–1990, no. 242.

21 · Claude Gellée, called Claude Lorrain
Landscape with a Bridge

1. The German artist Sandrart was in Rome between 1628 and 1635 and knew Claude at that time. He wrote his biography of Claude much later, including it in *Der Teutschen Academie zweyter Theil* published in Nuremberg in 1675. Baldinucci in his later years met Claude and interviewed him and his nephews before he wrote his biography of Claude, which was not published until 1728 (in Florence) in the fourth volume of *Notizie de' professori del disegno*. Both biographies were translated into English and printed in their entirety in Roethlisberger 1961a, 1:47–50, 53–62.

2. In his biography of the Netherlander Pieter van Laer, Sandrart specifically mentions that he (Sandrart), Claude, Poussin, and Van Laer all went together on a sketching trip to Tivoli. See Roethlisberger 1961a, 1:52.

3. Several are reproduced in color in exh. cat. San Francisco and Williamstown 2006–2007.

4. See Roethlisberger 1973a, 510; and exh. cat. Washington and Paris 1982–1983, 208, no. 9A.

5. Whether the album first belonged to Queen Christina of Sweden remains unclear, but the next owner was certainly Don Livio Odescalchi, for the album is listed in the inventory drawn up after his death in 1713. The drawings remained together in the Odescalchi family until 1957, when eight were removed and sold to the London dealer Hans Calmann. Thirteen others, including the present study of a bridge, were also removed at an unknown date prior to 1960. The volume with the remaining sixty drawings was then acquired by Georges Wildenstein, who sold it to Norton Simon in 1962 (hence the names by which the album has been known). It was subsequently dismantled for conservation reasons, and beginning in 1980 fifty-three of the drawings were dispersed through the New York dealer E. V. Thaw. On the Wildenstein album, see Roethlisberger 1962; Roethlisberger 1968, 1:65–66; and H. Diane Russell in exh. cat. Washington and Paris 1982–1983, 231.

6. Pen and brown ink with brown wash, 216 × 312; reproduced in Roethlisberger 1968, no. 530.

7. Pen and brown ink with brown wash and black chalk on blue paper, 215 × 308; reproduced in Roethlisberger 1968, no. 531. The inscription reads *ponte di molo faict a foro di Tivoli* (the pier bridge made outside Tivoli). That drawing was part of another album, the so-called Tivoli book, which featured at least thirty-two drawings made by Claude in and around that scenic spot near Rome. See Roethlisberger 1968, 62–63.

EXHIBITIONS

Washington and Paris 1982–1983, 208–209, no. 9A.

LITERATURE

Roethlisberger 1973a, 510; Roethlisberger 1973b, 656, fig. 26; NGA Guide 1992, 312.

22 · Claude Gellée, called Claude Lorrain
Two Women in Classical Dress

1. About Sandrart's biography, see cat. 21, note 1. For the passage about Claude's figures see Roethlisberger 1961a, 1:49.

2. About Baldinucci's biography, see cat. 21, note 1. For the passage about Claude's figures, see Roethlisberger 1961a, 1:56.

3. See Roethlisberger 1979, 28. Beginning in the 1630s, Claude began to record his paintings in detailed copy drawings that he kept all together in the album he dubbed his *Liber Veritatis*. Originally containing 195 drawings (five more were added after Claude's death) and now disbound but preserved in its entirety in the British Museum, London, the *Liber Veritatis* served not only as a safeguard against forgers but also as a record of the owners of his works, a source book for other compositions, and a pattern book that could be shown to prospective patrons. See Kitson 1978, in which the 1647 *Pastoral Landscape* (inv. 1957.12.14.11) is reproduced, pl. 112.

4. The direct relationship between a study of figures and dogs in the British Museum, London (inv. Oo.7-153), and a painting in the Fine Arts Museums of San Francisco, *View of Tivoli at Sunset*, was established only after the picture was cleaned and X-radiographs and infrared reflectographs were made. See Richard Rand in exh. cat. San Francisco and Williamstown 2006–2007, 99–100, 202 n. 87, figs. 56, 57.

5. Roethlisberger 1979, 28, mentions five other Claude paintings that feature similar pairs of women; all are reproduced in Kitson 1978, pls. 91, 94, 134, 143, 169.

6. See Roethlisberger 1968, 1:55–57. Claude's reluctance to sell his drawings, even those he had made long before, is noted in a letter of 22 July 1662 to Cardinal Leopold de' Medici from his agent Jacopo Salviati: "Mr. Claude has some old drawings, but in small number, and he does not want to part with them, saying that he uses them. Now that he is old it seems too tiresome to him to make new things." Quoted in English in Roethlisberger 1968, 1:21.

7. Black chalk and brown wash, heightened with white on apricot-prepared paper, 170 × 225. Roethlisberger 1968, 1: no. 711; reproduced in color in exh. cat. New York 1990a, no. 93. The New York drawing is closely related to a painting of *Christ on the Road to Emmaus* of 1652, now lost but known through Claude's *Liber Veritatis* drawing (reproduced in Kitson 1978, pl. 125).

EXHIBITIONS
Washington and Paris 1982–1983, 242–243, no. 39.

LITERATURE
Roethlisberger 1979, 28, fig. 41.

23 · Claude Gellée, called Claude Lorrain
Landscape with Ruins, Pastoral Figures, and Trees

1. Kitson 1970, 409, no. 4.

2. See the eighteenth-century prints of Giovanni Battista Piranesi (1720–1778), which show the ruined temples before they were fully excavated, as they are now (Wilton-Ely 1994, 1: pls. 182, 242, 243, 340, 341).

3. A drawing related to the print, but with the temple placed on the right, as in the National Gallery sheet, is *Pastoral Landscape*, c. 1650, in the collection of the Earl of Leicester, Holkham Hall; reproduced in Roethlisberger 1968, 2: no. 685; and Roethlisberger 1961a, 2: fig. 225.

4. Three states of the print and a counterproof are reproduced in exh. cat. Washington and Paris 1982–1983, 397–399, under no. 47, where the Holkham Hall drawing is shown by H. Diane Russell to date from 1650. Claude repeated the main elements of that composition in 1654 in his painting *Hagar and the Angel* (private collection), reproduced in Roethlisberger 1961a, 2: fig. 224.

EXHIBITIONS
Washington 1978a, 68; Washington and Paris 1982–1983, 245, no. 41; Boston and elsewhere 1989, no. 82.

LITERATURE
Kitson 1970, 409, pl. 43; Walker 1984, 672, no. 1073.

24 · Claude Gellée, called Claude Lorrain
The Rest on the Flight into Egypt

1. The earliest known painting of the subject dates from about 1631 (collection of the Duke of Westminster; reproduced in Roethlisberger 1961a, 2: fig. 14) and the earliest drawing, in the Metropolitan Museum of Art, New York (inv. 07-282), dates from about 1635 (reproduced in Roethlisberger 1968, 2: no. 73). See also Richard Rand's discussion of the subject in exh. cat. San Francisco and Williamstown 2006–2007, 150–156.

2. Marcel Roethlisberger believes that the inscription was written by the earliest known owner of the drawing, the British artist Jonathan Richardson Sr., who was perhaps transcribing Claude's own signature and date, now lost. See Roethlisberger 1968, 415, no. 1129.

3. Inv. Oo. 8-265; blue and gray wash with touches of pen and brown ink over traces of black chalk, heightened with white on blue paper, 163 × 284. Reproduced in Roethlisberger 1968, 2: no. 1116.

4. Inv. 62.151.

5. Inv. 1957.12.14.94; pen and brown ink with brown wash, heightened with white on blue paper, 260 × 197. Reproduced in color in exh. cat. San Francisco and Williamstown 2006–2007, fig. 100. For more information about the *Liber Veritatis*, see cat. 22, note 3.

6. H. Diane Russell in exh. cat. Washington and Paris 1982–1983, 297, under no. 75.

EXHIBITIONS
Washington and Paris 1982–1983, 297, no. 75.

LITERATURE
Roethlisberger 1961b, 354, reprod. 352, fig. 7; Roethlisberger 1968, no. 1129; Langdon 1989, 150, 153, pl. 120.

25 · Robert Nanteuil
Marin Cureau de La Chambre

1. Petitjean and Wickert 1925, 1:211–212, no. 93; 2: pl. 93. The National Gallery's impression (the first state of five; inv. 1943.3.9131), is part of the exceptionally strong collection of Nanteuil prints in the Rosenwald Collection.

2. The inscription on the print reads: "MARIN. CVRAEVS DE LA CHAMBRE, REGI A SANCT. CONSIL. ET MEDICVS ORDINARIVS." The title "regi a sanctioribus consiliis" designates the sitter as "advisor to the king in his distinguished counsels." See Bouvy 1924, 148.

3. See *Nouvelles observations et coniectures sur l'iris*, Paris, 1650. In an age when scholarly texts were almost invariably written in Latin, Cureau de La Chambre chose to write in French, making his works accessible to a wider audience.

4. See *Caractères des passions*, 5 vols., Amsterdam, 1640–1662; and *L'art de connoistre les hommes*, Amsterdam, 1660.

5. Petitjean and Wickert 1925, 1:212.

EXHIBITIONS
Buffalo 1935, no. 44; Rotterdam and elsewhere 1958–1959, no. 27; Toronto and elsewhere 1972–1973, no. 95; Washington 1985, no. 19; Cleveland and elsewhere 1989–1990, no. 104.

LITERATURE
Bouvy 1924, 170; Fromrich 1957, 212, 213, fig. 4; exh. cat. Washington 1982b, 125, under no. 41, fig. 41a; Eaves 1992, 218, fig. 4.28.

26 · Atelier Assistant of Charles Le Brun
Head of a Macedonian Soldier

1. Inv. 2895. All five battle paintings are reproduced in color, with some color details, in Gareau 1992, 196–225 (*The Battle of Arbela*, 215–219).

2. On separate visits to the National Gallery in 2006, both Alvin L. Clark Jr. and Jean-François Méjanès expressed their doubts to the present author about the attribution of the drawing and mentioned Verdier as a possible alternative.

3. The pastels were included in the after-death inventory of the sculptor François-Benoît Masson (1669–1728), drawn up on 29 December 1728. See Wildenstein 1967, 86.

4. Inv. 29878, 29880, 29877. The connection of those three works with the group of eighteen by Verdier in the Masson inventory was first made, somewhat tentatively, by Geneviève Monnier in Monnier 1972, nos. 6–8. Supporting that identification is the fact that the three Louvre pastels are laid down on mounts featuring gold bands (visible in the images available for viewing online at http://arts-graphiques.louvre.fr/fo/visite?srv=rom), a detail that is specifically mentioned in the Masson inventory: "dans leurs bordures dorées" (in their gilded borders). See Wildenstein 1967, 86. All three pastels are reproduced in Beauvais 2000, 1: nos. 1689, 1690, 1717.

5. When Le Brun died, the contents of his workshop were claimed by the king, since Le Brun had been his first painter. Almost three thousand drawings by Le Brun and his assistants entered the royal collection and are still preserved together in the Département des Arts graphiques at the Louvre. This invaluable resource was catalogued by Lydia Beauvais in Beauvais 2000.

6. Beauvais 2000, 1: nos. 1778–1826.

7. Inv. 29428, 27899, 29355; reproduced in Beauvais 2000, 1:487, 490, 491, nos. 1778, 1791, 1792.

8. See Beauvais 2000, 1: nos. 1960–1964; and 2: nos. 2556–2558, 2560–2561, 2563–2566, 2574–2575, 2577–2586.

EXHIBITIONS
Binghamton and elsewhere 1970, no. 63 (as Charles Le Brun); Toronto and elsewhere 1972–1973, no. 76 (as Le Brun); Boston 1981–1982, supplement II to catalogue, no. 37 (as Le Brun).

LITERATURE
Vitzthum 1970, 554 (as Le Brun); Beauvais 2000, 1:490, under no. 1792.

27 · Adam Frans van der Meulen
French Troops before Salins and the Surrounding Hills

1. The National Gallery owns one volume with forty-seven of these prints in the Mark J. Millard Architectural Collection, inv. 1985.61.439. See Wiebenson and Baines 1993, no. 47, 106–107.

2. A good overview of Van der Meulen's work on *The History of the King* tapestries can be found in exh. cat. Dijon and Luxembourg 1998–1999.

3. Inv. R. F. 4928; graphite on two joined sheets, 485 × 973. Reproduced in exh. cat. Dijon and Luxembourg 1998–1999, no. 105.

4. A counterproof is essentially a monoprint taken from a drawing made in a friable medium—red chalk, charcoal, black chalk, or pastel—by covering the original drawing with a dampened sheet of paper and passing the two pages together through a press. The top, dusty layer of medium is thus transferred from the drawing (without harming it) to the second sheet, where the image can be seen in reverse.

5. The print by Boudewijns is reproduced on a minute scale in exh. cat. Dijon and Luxembourg 1998–1999, fig. 102. The copper plates are in the collection of the Chalcographie at the Musée du Louvre (inv. 722).

6. For the inventory of the complete holdings of drawings by Van der Meulen and members of his studio in the Mobilier national, see Starcky 1988. The drawings in the Musée du Louvre can be accessed through the museum's website at http://arts-graphiques.louvre.fr/fo/visite?srv=rom.

7. Two others include *View of Bethune*, in the Mobilier national, Paris (inv. 23; reproduced in Starcky 1988, no. 7), and *View of Besançon*, in the collection of Jeffrey E. Horvitz, Boston (inv. D-F-1150). The latter was acquired in 2004 and shares the same provenance as the Washington drawing; it has not been reproduced, but the original drawing (in reverse) was sold at Christie's, London, 2 July 1991, lot 323; reproduced in color in the sale catalogue.

28 · Michel Corneille II
The Purification of Aeneas

1. Claudine Lebrun Jouve believes that the drawing should instead be attributed to Michel Corneille's brother, Jean-Baptiste Corneille (1649–1695), and she very generously shared with this author her visual evidence in an e-mail of 17 March 2009. The features that she pointed out as indicators of Jean-Baptiste's hand, however—the manner of rendering the fingers, mountains, trees, feet, and eyes, for example—are also found in Michel's work. In addition, the specific execution of the heads and features in the Washington drawing seems to correspond more closely to Michel's work, especially in his many drawings after Annibale Carracci in the Musée du Louvre, Département des Arts graphiques, than to Jean-Baptiste's. Drawings by both artists are reproduced on the Louvre's website: http://arts-graphiques.louvre.fr/fo/visite?srv=rom.

2. Monbeig Goguel 1988, 821–835.

3. A large number of these are in the Musée du Louvre. See Guiffrey and Marcel 1907–1921, vol. 3, which lists more than 350 drawings by Corneille. Almost all are reproduced on the Louvre's website: http://arts-graphiques.louvre.fr/fo/visite?srv=rom.

4. The watermark was identified as Italian in 1994 by Judith A. Walsh, former paper conservator at the National Gallery of Art and now associate professor of paper conservation at Buffalo State University, New York.

5. Reproduced in color in exh. cat. Paris and London 1994–1995, no. 228.

6. Robert-Dumesnil 1835–1871, 5:303, no. 26 (not reproduced).

7. Vienna: inv. 11766; pen and brown ink with brown wash over red chalk, heightened with white, 261 x 423. Reproduced in color in Widauer 2004, 146, no. F.812, pls. xxiv–xxv. Warsaw: inv. T. 173 nr 116; pen and brown ink over black chalk with brown wash, heightened with white, 135 x 267. Reproduced in exh. cat. London and elsewhere 1980, no. 20, pl. 35. These drawings were kindly brought to my attention by Alvin L. Clark Jr. (personal communication, February 2008) and Claudine Lebrun Jouve (e-mail of 17 March 2009).

8. Ovid [trans. Humphries] 1958, 356–357.

9. Claudine Lebrun Jouve (e-mail of 17 March 2009) has suggested that the inclusion of Apollo may be a reference to Louis xiv and that the composition may be an allegory honoring one of the king's victories—Dunkirk in 1663 or Holland and the Franche-Comté in 1672–1674.

29 · Michel Corneille II
Studies of Women's Heads

1. Drawings of this type can be found in the Musée du Louvre (inv. 26651; reproduced in exh. cat. Paris 1985–1986, no. 130); the Musée Fabre, Montpellier (inv. 870.1.36; reproduced in exh. cat. Cambridge and elsewhere 1998–2000, under no. 24, fig. 3); the Courtauld Institute, London (inv. 2377; reproduced in exh. cat. London 1991, no. 10); Staatliche Graphische Sammlung, Munich (inv. 3331; reproduced in Rosenberg 1970, no. 46); the private collections of Louis Antoine Prat (reproduced in exh. cat. New York and elsewhere 1990–1991, no. 27), Jeffrey E. Horvitz (reproduced in exh. cat. Cambridge and elsewhere 1998–2000, no. 24), and Mr. and Mrs. Guy-Philippe de Montebello (reproduced in exh. cat. Toronto and elsewhere 1972–1973, no. 31, pl. 54).

2. See, for example, two sheets in the Musée du Louvre, inv. 31094, in which Mignard notes that a youth has "too much forehead," and inv. 31289, in which a foot is described as "too long." Images can be accessed through the Louvre's website: http://arts-graphiques. louvre.fr/f0/visite?srv=rom.

3. London: inv. D.1053-1900; pen and ink with wash, 305 × 339. Reproduced in Ward-Jackson 1979–1980, 2: no. 1279 (as "School Unknown: late 18th century," but later recognized as the work of Corneille). Paris: Drouot Montaigne, Paris, 12 December 1988, lot 11; red chalk with watercolor and gouache, 400 × 570. Reproduced in color in the sale catalogue.

4. For many examples, see Rosenberg and Prat 1996, especially pls. 482, 484, 520, 521, 557, 562, and 608.

LITERATURE
Cambridge and elsewhere 1998–2000, 364, no. 24, note 2.

30 · François Verdier
The Rape of Deianira

1. Very little has been written about Verdier as an artist in general and no monograph of his life or catalogue raisonné of his oeuvre has yet been published.

2. Beauvais 2000, 1:18.

3. Schnapper 1967, cat. nos. I 1–2, I 31–39, I 50–52, II 1–3; thirteen reproduced, figs. 3, 24–31, 40–42, 66.

4. Bern: inv. 6740–6772; reproduced in Corpus Gernsheim, nos. 148152–148184. Uffizi: inv. 8240S–8241S, 8243S, 8245S–8246S, 8248S–8261S; reproduced in Corpus Gernsheim, nos. 168686–168704.

5. Oxford: inv. 1863.51–1863.68; reproduced in Whiteley 2000, 2: pls. 484–501. Edinburgh: inv. RSA 459–460, RSA 226A–H, RSA 226J–R; reproduced in Corpus Gernsheim 134234, 134236–134353.

6. Inv. 3976.

7. Ovid [trans. Humphries] 1958, 212–217.

31 · French School
Kneeling Man Bound to a Tree

1. For more information about life-drawing classes at the Académie royale in Paris, see Pevsner 1940, 82–109; and James Henry Rubin's introduction to exh. cat. Princeton 1977, 17–42.

2. In exh. cat. New York and elsewhere 1973–1974, no. 91, this drawing was compared to a number of nude studies at the Musée du Louvre that were catalogued under his name (Guiffrey and Marcel 1907–1921, 8: nos. 6775, 6780, 6781, 6788, 6792, 6800, 6803, 6810, 6817, 6871), but with a commentary (p. 78) that indicated they were the work of someone working in his studio.

3. See this author's entry in exh. cat. Washington 1995–1996, no. 75, which served in part as the basis for this one.

4. The attribution to La Fosse was proposed by Clémentine Gustin-Gomez, while the attribution to Jouvenet was suggested by Sylvain Bédard. Jouvenet's authorship had been rejected in exh. cat. Washington 1995–1996, no. 75, but when the drawing was donated to the National Gallery in 2006, at the very moment Bédard's article was published, it was accessioned under Jouvenet's name.

5. See Gustin-Gomez 2006, 2:275–283, nos. D. 228–D. 240 (reproduced in color), all in the École nationale supérieure des Beaux-Arts, Paris (inv. 2972–2984).

6. Inv. 517. See Bédard 2006, 489, fig. 2.

7. Exh. cat. New York and elsewhere 1973–1974, no. 91.

8. Gustin-Gomez 2006, 293.

9. Bédard 2006, 489–490.

EXHIBITIONS
New York and elsewhere 1973–1974, no. 91 (as Charles Le Brun); Washington 1995–1996, no. 75.

LITERATURE
Bédard 2006, 487–492, fig. 1 (color) (as Jean Jouvenet); Gustin-Gomez 2006, 2:293, no. D. 261 (as Charles de La Fosse).

32 · Charles de La Fosse
Angels and Putti Flying with a Garland

1. The most recent and most lavishly illustrated book on La Fosse is Gustin-Gomez 2006, though Stuffmann 1964 is also still very useful.

2. Numerous examples of Rubens' *trois-crayons* drawings are reproduced in color in exh. cat. New York 2005.

3. Reproduced in Gustin-Gomez 2006, 1:51, 52; 2:29.

4. The extant painting in the church's cupola is in very poor condition, but its appearance is recorded in a tondo in the Musée Magnin, Dijon (inv. 1938.F.567), which either served as a model for the final painting or a record of it. See Gustin-Gomez 2006, 2: P. 33, P. 34, reproduced in color.

EXHIBITIONS
New York 1999b, no. 13.

LITERATURE
Gustin-Gomez 2006, 2:297, no. D. 272.

33 · Charles de La Fosse
Two Young Women Seated on the Ground
verso: *Young Woman Kneeling and Reaching Forward*

1. Inv. 2002.025; Gustin-Gomez 2006, 2:74, no. P. 106.

2. See, for example, *The Triumph of Pandora* (private collection) and *The Consecration of the Virgin* (Musée Malraux, Le Havre), both reproduced in Gustin-Gomez 2006, 2:59, 96, nos. P. 86, P. 137.

3. Gustin-Gomez places it slightly earlier than a second version of *The Finding of Moses* (now in the Musée du Louvre, Paris) that was commissioned from La Fosse in 1701. See Gustin-Gomez 2006, 2: nos. P. 106, P. 134. In a red chalk compositional drawing related to that version of the subject (Musée des Beaux-Arts et d'Archéologie, Besançon, inv. D 2722; reproduced in Gustin-Gomez 2006, 2:195, no. D. 43), a woman is seated on the ground in the same pose as the woman at center in the Washington sheet, but in reverse.

4. For discussions about the relationship between La Fosse and Watteau, see Grasselli 1987c, 181; Grasselli [1994], 9–13; and Gustin-Gomez 2006, 1:109–118.

LITERATURE
Grasselli 2003, 10; Gustin-Gomez 2006, 1:186–187, 2:195–196, no. D. 44.

34 · Louis de Boullogne the Younger
Male Nude Seated on the Ground

1. Hélène Guicharnaud has written numerous articles on individual projects by Boullogne, and it is hoped that she will soon complete and publish her catalogue raisonné of his work.

2. The Musée du Louvre, Paris, owns 186 drawings by Boullogne, 162 of which are catalogued (many reproduced) in Guiffrey and Marcel 1907–1921, 2:66–95, nos. 1437–1599. See also Schnapper and Guicharnaud [1986] for a brief study of Boullogne as a draftsman, with fifty-one reproductions.

3. Two drawings executed in red chalk with sanguine wash are in the Musée du Louvre, Paris (Guiffrey and Marcel 1907–1921, 2: nos. 1551–1552). Both are studies for medals executed in the early 1720s.

4. A similarly signed double *académie*—with two posed models—dated 1710 is in the Museum of Art, Rhode Island School of Design, Providence (reproduced in Schnapper and Guicharnaud [1986], no. 41).

5. Numerous other drawings are initialed in the same way (see Schnapper and Guicharnaud [1986], nos. 16–31, 37–40, 45–49).

35 · Antoine Coypel
Seated Faun

1. Oxford: inv. 1955.45. See Whiteley 2000, 1: no. 339, reproduced 2: pl. 339. Ottawa: inv. 6827; reproduced Ottawa and elsewhere 2004–2005, no. 14. London: Sotheby's, London, 17 March 1975, lots 33, 34. Antoine Schnapper first proposed the attribution to Coypel in a letter to Hugh Macandrew, 8 May 1969, regarding the drawing in the Ashmolean Museum. In 1988, Eunice Williams, unaware of Schnapper's earlier suggestion, arrived at the same attribution to Coypel for other drawings in the series that were still catalogued as the work of Louis de Boullogne the Younger. See exh. cat. New York 1989a, no. 1.

2. See Schnapper and Guicharnaud [1986] for reproductions of a number of drawings by Boullogne.

3. See Garnier 1989, figs. 185–282, and especially figs. 195–198.

EXHIBITIONS
London 1957, no. 31 (as Louis de Boullogne); New York 1989a, no. 1; Washington 1991, 82–83.

LITERATURE
Whitely 2000, 1:115, under no. 339.

36 · Antoine Coypel
Cupid Stealing Venus' Floral Crown

1. For a history of the ceiling, see Garnier 1989, no. 110. Details of the ceiling and photographs of all the related drawings are reproduced in Garnier 1989, figs. 308–339. With the exception of the National Gallery sheet, all the known drawings related to *Love Triumphing over the Gods* are in the collection of the Musée du Louvre, Département des Arts graphiques, Paris (Garnier 1989, nos. 415–431, all reproduced).

2. The fresco was removed from the Hôtel d'Argenton (now destroyed) after the house was purchased by the Banque de France at the turn of the twentieth century. It was discovered intact more than twenty years ago in a warehouse belonging to the bank in Asnières, outside Paris. Although the commission and the subject were known from old references and descriptions, the ceiling had never been engraved or photographed prior to being placed in storage. It was therefore unknown to modern art historians until it was published by Nicole Garnier with a number of detail photographs in Garnier 1989, which is the most complete and useful text on the artist and his oeuvre.

3. A study for a seated god, either Pluto or Neptune, was executed in red chalk with white heightening. See Garnier 1989, no. 422.

4. *Trois-crayons* drawings by Coypel are known for projects that are datable to 1680 (a study for an engraved portrait of Catherine Monvoisin; Garnier 1989, fig. 4) and 1681 (a study for Coypel's reception piece *Louis XIV Resting on the Breast of Glory after the Peace of Nijmegen*; Garnier 1989, fig. 9).

EXHIBITIONS

New York and elsewhere 1973–1974, no. 92; Malibu and elsewhere 1983–1985, no. 57; Madrid 1986–1987, no. 92; Vienna and Munich 1986, no. 77; London 1987, no. 75; New York 1990a, no. 95; Washington 1995–1996, no. 76.

LITERATURE

Garnier 1989, no. 414.

37 · Claude Gillot
Scene from "The Tomb of Master André"

1. Translated by this author from the French text quoted verbatim in Tonkovich 2002, 2:249, no. 422.

2. Émile Dacier was the first to point out the connection between the print in Gherardi's book and Gillot's choice of subject, in Dacier 1924–1926, 119. The frontispiece by an anonymous artist is reproduced in Tonkovich 2006, 466, fig. 3.

3. Gillot made etchings of four of his drawings of theater scenes in a series called *Quatre scènes comiques du théâtre italien*. Gabriel Huquier (1695–1772) later made prints of twelve others for his series called *Livre de scènes comiques inventées par Gillot*. See Populus 1930, nos. 17–20, 342–353, figs. 35, 37, 71; thirteen of the drawings are catalogued in Tonkovich 2002, 2:179–237, nos. 1–13, all reproduced.

4. Département des Arts graphiques, inv. 26753; reproduced in Tonkovich 2006, fig. 2. In the Louvre drawing, Gillot shows Harlequin on his donkey entering the stage from the left, accompanied by two other mourners at left and only two trumpeters at right. Master André's "tomb" is far less elaborate than the one in the National Gallery drawing, and the barrels are arranged differently.

5. See, for example, the completed drawings in the Musée du Louvre, which are all executed in pen and black ink with brown or sanguine wash. See Guiffrey and Marcel 1907–1921, 6: nos. 4194–4198, 4201, all reproduced.

6. Rosenberg and Prat 1996, 1: no. 169.

7. Mentioned in the biography of Watteau included in the *Abrégé de la vie des plus fameux peintres*, Paris, 1745, by A. J. Dezallier d'Argenville, reprinted in Rosenberg 1984, 44–52. See page 47 for the passage in which Dezallier states that "one could hardly distinguish the works" of master and pupil.

LITERATURE

Tonkovich 2006, 465–467, 475, no. 1, 484 n. 3, fig. 1.

38 · Claude Gillot
A Performance by the Commedia Dell'Arte
verso: *Ornamental and Architectural Studies*

1. Polichinelle is similarly dressed as a captain, though with a less elaborate plume on his hat, in the print *D'un fidelle valet voilà le caractère* (Behold the Character of a Faithful Valet) engraved by Gabriel Huquier (1695–1772) after a drawing by Gillot. Described (but not reproduced) in Populus 1930, no. 351. The stock characters from the commedia dell'arte are identified and discussed by François Moureau in Moreau 1984a, 507–516.

2. Inv. 1989.193.

3. Inv. Hdz 2469.

4. Gabriel Huquier engraved another composition by Gillot, *Mezetin comprend bien qu'il luy faut du secours* (Mezzetin Well Knows That He Needs Help), which shows a woman having her hair brushed while she sits at her dressing table. (Reproduced in exh. cat. Washington 1995–1996, 283, fig. 2.) There is nothing in that scene, however, to link it to the three drawings discussed here.

5. Reproductions of Gillot's ornament designs can be found in Populus 1930, figs. 49–55.

EXHIBITIONS

New York and elsewhere 1973–1974, no. 95; Malibu and elsewhere 1983–1985, no. 56; Vienna and Munich 1986, no. 78; Madrid 1986–1987, no. 93; London 1987, no. 76; New York 1990a, no. 96; Washington 1995–1996, no. 77.

LITERATURE

Exh. cat. Chicago 2000, 34, under no. 10; Tonkovich 2002, 1:108, 166; 2:267–271, 273, 274, cat. 26; 3: figs. 44, 45.

39 · Antoine Watteau
The Bower

1. The complete title is *Figures de différents caractères, de paysages, et d'études dessinées d'après nature par Antoine Watteau* (Figures of Different Characters, Landscapes, and Studies Drawn from Nature by Antoine Watteau). The first volume was published in 1726; the second appeared in February 1728.

2. Twenty-seven ornament drawings were catalogued as the work of Watteau in Parker and Mathey 1957, a number that was reduced to ten in Rosenberg and Prat 1996.

3. The figures in *The Bower* are very similar in execution to figures in Watteau's most important compositional drawing, *The Finding of Moses* (École nationale supérieure des Beaux-Arts, Paris), which is generally dated c. 1716. See Rosenberg and Prat 1996, 2: no. 379.

4. Dacier et al. 1921–1929, 3: no. 25; 4: pl. 25. Also reproduced in Rosenberg and Prat 1996, 372, fig. 234b. For an illuminating article on Huquier's interpretations of Watteau's ornament designs, see Eidelberg 1984.

5. For an explanation of the process by which a counterproof is made, see cat. 27, note 4.

6. A counterproof version of the National Gallery composition (in reverse to it), formerly in the collection of Lodewijk Houthakker, Amsterdam, is thought by some to have been taken from the National Gallery drawing. However, in that version, which has been coarsely strengthened and overdrawn, the details are sufficiently different and the execution is so much cruder overall that it seems more logical to think that the counterproof was taken from a copy after the Washington drawing, not directly from it. See Fuhring 1989, 74, under no. 52.

EXHIBITIONS

Washington and elsewhere 1984–1985, 57, 60, 107, 140, 142, 144, 213, no. 70; Washington 1990, no. 82; New York and Ottawa 1999–2000, no. 9.

LITERATURE

Goncourt 1875, 210; Fourcaud 1908–1909, 131 n. 2; Deshairs 1913, 292; Dacier et al. 1921–1929, 3:16, no. 25; Parker 1930, 8, pl. 7; Parker 1931, 19; Adhémar 1950, under no. 25; Parker and Mathey 1957, no. 192; Mathey 1959, 45; Cormack 1970, under no. 7; Zolotov 1971, opposite p. 54; Eidelberg 1984, 158, 164 n. 8; Roland Michel 1984, 118, 128, 284; Börsch-Supan 1985, no. 56; Sutton 1985, 150, pl. 1; Eidelberg 1986, 105; Grasselli 1987a, 303–304, 409–410, no. 186, fig. 376; Opperman 1988, 359; Fuhring 1989, 1:74, under no. 52; Launay 1991, 375, pl. 10 and fig. 31; Grasselli 1993, 126 n. 12; Rosenberg and Prat 1996, 1:372–373, no. 234.

40 · Antoine Watteau
A Man Reclining and a Woman Seated on the Ground

1. Among the earliest examples of drawings executed in black and red chalks in Watteau's oeuvre are his studies of Savoyards (Rosenberg and Prat 1996, nos. 294–297, 299–301) and Persians (Rosenberg and Prat 1996, nos. 283–284). The drawings of Persians can be dated to February 1715 because of the presence of an embassy from Persia in Paris at that time.

2. The comte de Caylus described Watteau's unorthodox working method in a biography that he read at the Académie royale on 3 February 1748. See Rosenberg 1984, 78–79.

3. The paintings in Boston and Switzerland are reproduced in Washington and elsewhere 1984–1985, 301, no. 25, and 379, no. 54; the X-radiograph of the Boston painting is reproduced in Rosenberg and Prat 1996, 792, fig. 475a. The print by Le Bas is reproduced in Dacier et al. 1921–1929, 4: pl. 139.

EXHIBITIONS

London 1932, no. 738 (commem. cat. no. 780); Buffalo 1935, no. 60; exhibited almost continuously with the Armand Hammer Collection around the United States and abroad from late 1970 through 1987 (for a complete listing of the venues and dates, see exh. cat. Washington 1987); Washington 1974, no. 71; Los Angeles 1976, no. 149; Washington 1978a, 79; Washington and elsewhere 1984–1985, 109, 150, 379–380, fig. 2, no. 79; Washington 1987, no. 17.

LITERATURE

Fourcaud 1904–1905, 106; Réau 1928, 54, no. 38; Parker 1931, 39, 49, no. 92, pl. 92; Eisenstadt 1932, 239–240 (as Philippe Mercier); Parker 1932, 38 n. 8; Adhémar 1950, under no. 170; Parker and Mathey 1957, no. 665 (with incorrect dimensions); Mongan 1962, no. 686; Nemilova in Zolotov et al. 1973, 139, under no. 6 (1985 ed., 98, under nos. 8–11); Posner 1984, 208, 288 nn. 18, 19, fig. 166; Börsch-Supan 1985, no. 91; Nochlin 1985, 80; Boerlin-Brodbeck 1987, 163 n. 2; Grasselli 1987a, 188, 272–273, 290 n. 72, no. 193, fig. 329; Grasselli 1987b, 96 n. 8; Grasselli 1987c, 181, 183, fig. 3, 189, 194 n. 24; Ingamells 1989, 351; Rosenberg and Prat 1996, 2:792, no. 475; exh. cat. New York and Ottawa 1999–2000, 29, reprod. 30, fig. 21.

41 · Antoine Watteau
Two Studies of a Violinist Tuning His Instrument

1. See, for example, *Three Studies of a Seated Woman, Two Playing the Guitar* and *Three Studies of the Head of a Black Boy* (Musée du Louvre, Département des Arts graphiques, Paris; inv. R. F. 774 and R.F. 28721); *A Man Playing the Guitar* (private collection, New York); *A Woman Seated on the Ground and a Study of a Face* (Musée Condé, Chantilly; inv. A.I. 304; N.I. 446); *Torso of a Man with His Left Hand on the Hilt of a Sword and the Head of a Man Wearing a Beret* (Rijksprentenkabinet, Rijksmuseum, Amsterdam; inv. 1953:188); and *Two Studies of the Bust of a Woman* (Metropolitan Museum of Art, New York; inv. 1978.12.3). All are reproduced in Rosenberg and Prat 1996, nos. 596–597, 600, 602–603, 608.

EXHIBITIONS

Toronto and elsewhere 1972–1973, no. 154, fig. 72; Washington 1978a, 78–79; Washington and elsewhere 1984–1985, 156, 361–362, fig. 7, no. 104.

LITERATURE

Tourneux 1904, 4, 20, 22; Bouyer 1921, 98; Parker 1931, 31, 44, no. 38; Shoolman and Slatkin 1950, 52, pl. 30; Parker and Mathey 1957, 2: no. 850 (the corresponding plate incorrectly numbered 849); exh. cat. Paris 1963, under no. 33; Börsch-Supan 1985, no. 69; Rosenberg and Prat 1996, 2:594.

42 · Antoine Watteau
Italian Comedians Taking Their Bows

1. An excellent assessment of Watteau's contacts with the theater and the kinds of performances available to him can be found in Moureau 1984b, 475–493.

2. Watteau's use of theater costumes was mentioned by the comte de Caylus in his 1748 biography: "He had gallant outfits, some from the comedies, with which he dressed people of one sex or the other." See the original French text in Rosenberg 1984, 78–79. Identifications of many of the characters from both the Italian Comedy and the French Comedy who appear in Watteau's paintings can be found in Moureau 1984a.

3. Inv. 1933-5-16-1; red chalk, 166 × 181. Rosenberg and Prat 1996, 2: no. 552.

4. Inv. 1608; red chalk, 175 × 217 (on the verso of a study of three soldiers). Rosenberg and Prat 1996, 1: no. 179 verso (reproduced p. 281).

5. Inv. 1592; red chalk, 145 × 179. Rosenberg and Prat 1996, 2: no. 621.

6. For discussions of the dating of all four drawings, see Eidelberg 1965/1977, 30–33; Grasselli in exh. cat. Washington and elsewhere 1984–1985, 178–180, nos. 101–102; Grasselli 1987a, 2:381–383; Rosenberg and Prat 1996, 1:179; 2:552, 621–622.

7. Chicago: inv. 1975.343; red chalk and graphite, 195 × 264. See Rosenberg and Prat 1996, 2: no. 599. The Dresden painting is reproduced in color in Posner 1984, 209, pl. 33.

EXHIBITIONS

Washington 1982a, no. 24; Washington and elsewhere 1984–1985, 56, 60–61, 77, 163, 176, 201, 510, 512–513, 440, fig. 4, 444, no. 101.

LITERATURE

Parker 1931, 35 n. 2; Eisenstadt 1932, 238; Parker 1933–1934, 2; Parker and Mathey 1957, 2: 875; Cormack 1970, 25 (mentioned in the caption to plate 30); Boerlin-Brodbeck 1973, 160–161; Zolotov et al. 1973, 18–20 (1985 ed., 17, 28); Eidelberg 1965/1977, 31–32, 46, fig.18; exh. cat. London 1980–1981, under no. 42; Posner 1984, 265, 291 n. 64; Roland Michel 1984, 117, 137; Börsch-Supan 1985, no. 115; Sutton 1985, 149–150, fig. 8; Grasselli 1987a, 345 n. 38, 382–383, 399, 405, no. 246, fig. 471; Tomlinson 1987, 206 n. 20; Rosenberg and Prat 1996, 2: no. 622; exh. cat. New York and Ottawa 1999–2000, 18, fig. 7.

43 · Antoine Watteau
Three Studies of a Woman's Head and a Study of Hands
verso: *View of a House, a Cottage, and Two Figures*

1. The painting was offered for sale at Sotheby's, New York, 21 May 1998, lot 125, but remained unsold. Before that time, the painting was dated to about 1715 by Jacques Mathey (in Mathey 1959, 68) based on the engraving by Étienne Brion (active c. 1730) (Dacier et al. 1921–1929, 4: pl. 177). Study of the painting itself, however, reproduced in color in the Christie's sale catalogue of 21 May 1998, makes it clear that it should be placed in the last years of Watteau's career, 1718 or later, and may have been left unfinished at his death in 1721. The most complete discussion of the dating of the Washington drawing appears in Grasselli 1987b, 99–100, which revises the earlier, incorrect dating (c. 1715) proposed by the same author in exh. cat. Washington and elsewhere 1984–1985, no. 36.

2. Inv. 1060; red, white, and black chalk on beige paper, 230 × 353. Reproduced in color in Rosenberg and Prat 1996, 2:481.

3. The print is no. 195 in the second volume of *Figures de différents caractères*, published in 1728 by Jean de Jullienne. Reproduced in exh. cat. Washington and elsewhere 1984–1985, 101, fig. 2; Rosenberg and Prat 1996, 2:1057, fig. 620a.

4. *An Alley of Trees*, inv. 11855. See Rosenberg and Prat 1996, 1: no. 238. The twelve prints for which the original drawings are currently lost are: *Figures de différents caractères*, nos. 8, 23, 79, 91, 97, 146, 167, 230, 256, 272, 283, 293 (reproduced in Rosenberg and Prat 1996, 3: G. 1, 6, 29, 34, 37, 59, 66, 90, 93, 98, 100, 105).

5. Some other double-sided drawings with landscapes on one side are reproduced in Rosenberg and Prat 1996, 1: nos. 28, 115, 135, 136, 138, 321, 338. The last of those, a drawing in the Städelsches Kunstinstitut, Frankfurt (inv. 1040), bears a watermark similar to the one on the present sheet (FONTAINE with a heart). On one side is a study in sanguine and graphite of Watteau's friend Nicolas Vleughels (1668–1737), who lived with him in 1718/1719, the likely date of that drawing and coincidentally the same date associated with the Washington sheet.

EXHIBITIONS

Washington and elsewhere 1984–1985, no. 36; New York and Ottawa 1999–2000, nos. 44a, 44b.

LITERATURE

Goncourt 1875, under no. 572; Parker and Mathey 1957, 2: no. 781; Eisler 1977, 300–301, no. dK 505, fig. 265; Jean-Richard 1978, under no. 101; Roland Michel 1984, 87–88, 177, 253 n. 33; Börsch-Supan 1985, no. 84; Grasselli 1987a, 240 n. 10, 410 n. 55, 427–428, no. 257, figs. 519, 520; Grasselli 1987b, 99–100, figs. 10, 12; Roland Michel 1987b, 119 n. 2; Rosenberg and Prat 1996, 2:620; sale cat., Sotheby's, New York, 21 May 1998, 166, under lot 125, fig. 2.

44 · Antoine Watteau
Seated Woman Looking Down

1. The drawing was etched, in reverse, by Laurent Cars (1699–1771) for the second volume of *Figures de différents caractères* (no. 273), published in 1728. For more about those volumes, see cat. 39.

2. Amsterdam: inv. 1954:52; reproduced in Rosenberg and Prat 1996, 2: no. 655. The identification of the sitter as Rosalba was made in 1931 by Karl T. Parker, who called the drawing an "unflattering impression of the celebrated Venetian" (Parker 1931, 21). The second work (location unknown) is reproduced in Rosenberg and Prat 1996, 2: no. 654. The identification of the sitter there as Rosalba was first mentioned in Parker and Mathey 1957, 2:380, no. 927.

3. Several self-portraits by Rosalba at various ages are reproduced in Sani 1988, figs. 10, 11, 42, 242, 243, 284.

4. Pierre Rosenberg and Louis-Antoine Prat regard the identification of the model as Rosalba as inconclusive. See Rosenberg and Prat 1996, 2: nos. 654–655.

5. The identification of the sitter in the National Gallery drawing as Rosalba was first proposed by this author in exh. cat. Washington and elsewhere 1984–1985, 209, no. 129, but Rosenberg and Prat (1996, 2: no. 667) remain unconvinced.

EXHIBITIONS

London 1932, no. 713 (commem. cat. no. 765); exhibited almost continuously with the Armand Hammer Collection around the United States and abroad from late 1970 through 1987 (for a complete listing of the venues and dates, see exh. cat. Washington 1987); Washington 1978a, 80; Washington and elsewhere 1984–1985, 187, 196–197, 202, 209, no. 129; Washington 1987, no. 18.

LITERATURE

Goncourt 1875, under no. 652; Parker and Mathey 1957, no. 577; Grasselli 1981, 312; Börsch-Supan 1985, no. 125; Grasselli 1987c, 191, 192, fig. 15, 194 n. 29; Rosenberg and Prat 1996, 2: no. 667; exh. cat. New York and Ottawa 1999–2000, 35, reprod. 36, fig. 29.

45 · Nicolas Lancret
Two Elegant Women in Polish Dress

1. See especially exh. cat. New York and Fort Worth 1991–1992, the first monographic exhibition devoted to Lancret's art. Some articles on Lancret's drawings include Grasselli 1985–1986; Raux 1992; Akpabio 2002; and Grasselli 2006. The standard catalogue of Lancret's paintings is Wildenstein 1924.

2. This style of dress was derived from a Polish *kontusik*, a fur-trimmed garment with split sleeves that was introduced into France in the early eighteenth century. See Eric Zafran in Munger et al. 1992, 123, no. 68, and Leloir 1961, 286, under "Pologne." For some unknown reason, however, the women who wear this mode in Lancret's paintings are almost invariably referred to as "belles grecques" (beautiful Greeks), though they should more appropriately be called "polonaises" (Polish women). Two paintings of a woman wearing this costume are titled *La belle grecque*, one in the Wallace Collection, London (reproduced in *Wallace Collection* 1968, 168, P450), and the other formerly in the collection of the princesse de Poix, Paris (location unknown; reproduced in Wildenstein 1924, fig. 170).

3. Reproduced in Wildenstein 1924, fig. 47.

4. See Launay 1991, no. 159, fig. 184. Like the National Gallery sheet, this one had once been owned by the Goncourt brothers in Paris, though they acquired it from a different source.

5. For the Boston drawing, inv. 65.2580, see Munger et al. 1992, no. 68; for the Stockholm drawing, inv. NM 15/1897, see Bjurström 1982, no. 1010; for the one in Switzerland, see exh. cat. Bremen and Zurich 1967, no. 30. The Berlin drawing, inv. KdZ 4355, has not been published.

EXHIBITIONS

Paris 1860, no. 280; Paris 1879, no. 494; Paris 1883–1884, no. 211; Paris 1933a, no. 322 (a photograph of the drawing exhibited); Rotterdam and elsewhere 1958–1959, no. 63, pl. 44; New York and Fort Worth 1991–1992, cat. 27, pl. 32; New York and Ottawa 1999–2000, no. 61.

LITERATURE

Bocher 1875–1882, 4:88; Chennevières 1879, 192 (1880 ed., 96); Goncourt 1881, 1:99–100; Goncourt 1887–1896, 1:800 (8 September 1860); Grüneisen 1930, 320; *Wallace Collection* 1968, 168, under P450; Walker 1984, 677, no. 1085 (color); Launay 1991, 341, no. 158, fig. 54.

46 · Hyacinthe Rigaud
Monseigneur Louis-Charles d'Orléans de Saint-Albin, Archbishop of Cambrai

1. Inv. 88.PA.136. Saint-Albin paid 3,000 livres for the portrait, the highest price charged by Rigaud for a three-quarter-length image. See Roman 1919, 196. The painting is reproduced on the museum's website at http://www.getty.edu/art/gettyguide/artObjectDetails ?artobj=940.

2. Other drawings by Rigaud made in preparation for engravings are discussed in O'Neill 1984a, 674–683.

3. Portalis and Béraldi 1880–1882, 3 (pt. 2):509. The print is somewhat larger than Rigaud's drawing, with the plate mark measuring 514 × 376.

4. Very few of the drawings after Rigaud's painted portraits were executed by Rigaud himself. Instead, he employed other artists to make copies of them—whether as records of his works, as models for engravers, or as model-book drawings that could be shown to other prospective clients to help them in the selection of their own poses. Rigaud would then imbue some life into these often rather pedestrian black chalk copies by embellishing them with deftly applied white heightening. See, for example, O'Neill 1984b, 186–194, pls. 26–28; and exh. cat. Cambridge and elsewhere 1998–2000, no. 28.

EXHIBITIONS

New York 2002, no. 20.

47 · Jean-Baptiste Oudry
The Scene with the Tall La Baguenodière

1. The paintings, all now in the Musée de Tessé, Le Mans, are reproduced in exh. cat. Le Mans 2004, 32–53. The attribution to Coulom, which stemmed from a 1794 inventory, was retained until 2004, when a signature, *Martin*, was discovered on one of the paintings. That led to the suggestion that the artist was Pierre-Denis Martin or, less likely, Jean-Baptiste Martin (1659–1735), both of whom were battle painters and landscapists employed at the Gobelins tapestry works. See Françoise Chaserant's essay in exh. cat. Le Mans 2004, 24–31, especially 29–31. The evolution of Oudry's illustrations of *Le roman comique* is well explained by Hal Opperman in an article (Opperman 1967) and in two exhibition catalogues, Paris 1982–1983, 110–125, nos. 49–54, and Fort Worth and Kansas City 1983, nos. 29–31.

2. Opperman notes that the character of the brushwork with which the copies after the Martin paintings were drawn is unusual for Oudry, even though he is known to have used the same technique of black wash heightened with white on blue paper (see cat. 48). Opperman does accept them as the work of Oudry, though with a slight hesitation, and suggests that they were made rather quickly and with little regard for precise details (exh. cat. Paris 1982–1983, 117–118; exh. cat. Fort Worth and Kansas City 1983, 131–132).

3. Of Oudry's thirty-eight drawings, twenty-eight of them are vertical compositions that measure about 330 by 280 millimeters (see fig. 1); the other ten are much larger works that match the present drawing in scale and orientation.

4. The English translation quoted here is from Scarron 1700, 1:235–236.

5. See Opperman in exh. cat. Paris 1982–1983, 112–113, which gives a complete list of the drawings with notes as to which ones were engraved. Oudry engraved the first ten images in the proper order, just as he had made the drawings. Huquier, however, selected works for publication in more random fashion.

6. Six of the National Gallery drawings, all in the smaller vertical format described in note 3 above, were engraved. The one other drawing, which was not engraved, *Ragotin Reciting Verses; the Peasants Think He Is Preaching* (inv. 1952.8.276), was drawn on the same scale and in the same format as *The Scene with the Tall La Baguenodière*. In fact, a total of seven of the ten large-scale compositions were never translated into print form, undoubtedly because of their greater size and complexity.

EXHIBITIONS

Paris 1982–1983, no. 55.

LITERATURE

Cohen and Ricci 1912, cols. 943–944; Opperman 1967, 333, 348, no. 37, 335, fig. 9; Opperman 1972/1977, 2:679, no. D206; exh. cat. Fort Worth and Kansas City 1983, 132–133, fig. 76; exh. cat. Berlin 2004, 66; exh. cat. Le Mans 2004, 53, 109.

48 · Jean-Baptiste Oudry
The Partridge Saves Her Young

1. This information came from abbé Louis Gougenot (1724–1767), who read a biography of Oudry to the Académie royale, Paris, on 10 January 1761. See Dussieux et al. 1854, 2:379–380.

2. Inv. 1942.9.1617–1618; four volumes bound in two.

3. Sotheby's, London, 3 July 1996, lot 96 (with ten works illustrated, plus one more on the back cover of the catalogue).

4. To mention a few examples, six of the drawings are in the Musée du Louvre, Département des Arts graphiques (inv. RF 36464–36469); two in the collection of Jeffrey E. Horvitz, Boston (inv. D-F-626, 627); four in the Morgan Library & Museum, New York (one reproduced in exh. cat. Paris and New York 1993–1994, no. 41); two in the Metropolitan Museum of Art, New York (inv. 1976.99, 1976.188; see Bean and Turčić 1986, nos. 219–220); three in the Art Institute of Chicago (inv. 1976.282–284; reproduced in exh. cat. Paris 1982–1983, nos. 80–82); one in the National Gallery of Canada, Ottawa (inv. 26551; reproduced in exh. cat. Ottawa and elsewhere 2004–2005, no. 38); four in the Rijksmuseum, Amsterdam (1978:53–56; three are reproduced in exh. cat. Paris 1982–1983, nos. 76–77, 83).

5. The story appears on page 3 in volume 4 of the 1755–1759 edition. Translation by this author.

EXHIBITIONS
Washington 1978a, 80–81.

LITERATURE
For the literature on the whole group of La Fontaine drawings, see exh. cat. Paris 1982–1983, 157, under nos. 76–85; for this particular drawing, see Opperman 1972/1977, 2: no. 428.

49 · Edme Bouchardon
Rocaille Fountain with Venus, Amorini, and Swans

1. No monograph has yet been written on Bouchardon, and his total production as an artist has not yet been fully defined. A good bibliography is presented in the note on him in Grove Dictionary 1996, 4:511.

2. See Cochin 1880, 85; Mariette 1851–1860, 1:164.

3. See Guiffrey and Marcel 1907–1921, 1: nos. 371–794; 2: nos. 795–1293. All the Louvre drawings can be accessed through the museum's website: http://arts-graphiques.louvre.fr/fo/visite?srv=rom.

4. The collection in the Musée du Louvre includes at least 350 copies by Bouchardon (Guiffrey and Marcel 1907–1921, 1: nos. 371–721).

5. Another version of this drawing, in reverse (probably a counterproof), was in the Boussac collection (sale, Paris, 10 May 1896, lot 148) and the Lasquin collection (sale Galerie Georges Petit, Paris, 7 June 1928, lot 14).

6. Twenty-four studies of fountains are in the Musée du Louvre's Département des Arts graphiques (Guiffrey and Marcel 1907–1921, 2: nos. 795–818). Others are in the collection of the Metropolitan Museum of Art (exh. cat. New York 1991–1992, no. 18) and the Jeffrey E. Horvitz Collection, Boston (inv. D-F-961). On Bouchardon as a designer of "imaginary" fountains, see Kopp 2008, especially 75.

7. Inv. OR 14640; red chalk, 487 × 284 on two joined sheets. Reproduced in exh. cat. London 2001–2002, no. 40.

8. Inv. 24275; red chalk, 475 × 281. Reproduced in Guiffrey and Marcel 1907–1921, 2:5, no. 810.

9. For an explanation of the iconography of Venus with a tortoise, see Tervarent 1958, 383.

50 · François Boucher
Aurora

1. For more on the Figures de différents caractères, see cat. 39.

2. Reproduced in Ananoff and Wildenstein 1976, 1: no. 86.

3. Compare, for example, drawings of female nudes in exh. cat. New York and Fort Worth 2003–2004, nos. 27, 29, 32, 34, and 36, all reproduced in color.

4. The identification of the model as Boucher's wife was put forward by Regina Slatkin in exh. cat. Washington and Chicago 1973–1974, no. 20. Alastair Laing first disputed that identification in exh. cat. New York and elsewhere 1986–1987, 138, noting that the features of Aurora in the drawing and the painting were clearly different from Mme. Boucher's as they were known from other works.

5. Red and white chalk on brown paper, 350 × 298. Reproduced in exh. cat. New York and Fort Worth 2003–2004, 27, fig. 18.

EXHIBITIONS
Washington and Chicago 1973–1974, no. 20; Washington 1982a, no. 1; Washington 2000–2001, 180–181.

LITERATURE
Shoolman and Slatkin 1950, no. 34; Mongan 1962, no. 694; Valléry-Radot 1964, pl. 58; Ananoff and Wildenstein 1976, 1: no. 86(1), p. 221, fig. 368; Jacoby 1982/1986, 265, III.A.1 (reprod.); exh. cat. New York and elsewhere 1986–1987, 136, 138 (under no. 18); exh. cat. Paris and elsewhere 1991–1992, 385–386, 389, fig. 2; exh. cat. New York and Fort Worth 2003–2004, 28, reprod. 27, fig. 17.

51 · François Boucher
Sancho Fleeing from the Servants of the Duke

1. The drawings are in the so-called Album Cazes in the Musée du Louvre, Département des Arts graphiques, Paris (inv. 25155–25181). See exh. cat. Paris 2003–2004, 25–29, no. 7.

2. An extended discussion about this suite and many other sets of illustrations of the Don Quixote story, with special reference to the tapestries and prints in the collection of the Stiftung Preussische Schlösser und Gärten, Berlin, can be found in exh. cat. Berlin 2004, 143–231, specifically 214–218, N.1–24. See also Cohen and Ricci 1912, cols. 214–215.

3. La Mercure de France, April 1737, 764. The print by Aveline is reproduced in Jean-Richard 1978, 81, no. 207.

4. The books and chapters of the story are divided up differently in the various versions and translations. The text used for this entry was the 1885 translation by John Ormsby, available online through many different websites. The specific version used here was http://ebooks.adelaide.edu.au/c/cervantes/c41d/.

5. Tanjé's print is reproduced in exh. cat. Berlin 2004, 222.

6. See exh. cat. Berlin 2004, 218–224, N.25.

LITERATURE
Bénard 1810, 144, no. 3396; Mantz 1880, 86; Michel et al. [1906], no. 2618; Jean-Richard 1978, 81, under no. 207.

52 · François Boucher
Apollo

1. Inv. P485.

2. For summaries of the details of the commission, see Jo Hedley in exh. cat. London 2004–2005, 105, 108–109; and Jean Vittet in exh. cat. Versailles and elsewhere 2002–2003, 367–369.

3. See, for example, Regina Slatkin in exh. cat. Washington and Chicago 1973–1974, no. 68.

4. This was posited by Jo Hedley in exh. cat. London 2004–2005, 112.

5. This is Alastair Laing's idea, put forth in exh. cat. New York and Fort Worth 2003–2004, 107.

6. A chalk-manner print copying this drawing, made under the direction of Louis-Marin Bonnet (1736–1793) and printed in red ink, was first published in 1773 and later republished in about 1791 as part of a "notebook" of four académie prints. The print is reproduced in Jean-Richard 1978, 118, no. 370, and catalogued in Hérold 1935, nos. 158 and 1049(4).

EXHIBITIONS
Paris 1953, no. 20; New York 1957, no. 18; Minneapolis 1960, no. 9; Minneapolis and elsewhere 1968, no. 22; Hempstead 1973, no. 29; Washington and Chicago 1973–1974, no. 68; Los Angeles 1976, no. 153; New York and Fort Worth 2003–2004, 106–107, 235, 246, no. 33.

LITERATURE
Slatkin 1967, 56; Wallace Collection 1968, 41, under P485; Williams 1974, 173; Ananoff and Wildenstein 1976, 2:111, fig. 1201, 114; Davis 1978, 1624–1625, fig. 3; Jean-Richard 1978, 119, under no. 370; Brunel 1986, 296; Ingamells 1989, 72; exh. cat. London 2004–2005, 112, reprod. 111, fig. 87.

53 · François Boucher
The Adoration of the Shepherds

1. See, for example, Regina Slatkin in exh. cat. Washington and Chicago 1973–1974, 87, no. 67, who mentions "some twenty variations on this theme." Four are reproduced in sale cat. Christie's, London, 6 July 1982, no. 88; sale cat. Hôtel Drouot, Paris, 2 June 1981, no. 31; sale cat., Paris, 12–13 May 1919, no. 48 (Michel-Lévy collection); and sale cat., Christie's, London, 10–14 July 1936, no. 411 (Oppenheimer collection).

2. In exh. cat. New York and Fort Worth 2003–2004, 206, no. 80.

3. A copy by an unknown artist of the National Gallery drawing is in the Musée des Beaux-Arts, Lille. Inv. Pluchart 1125; reproduced in the Corpus Gernsheim, no. 18603.

4. Reproduced in Jean-Richard 1978, 291, no. 1177. For the related drawings, see Ananoff 1966, figs. 111, 112.

5. With Flavia Ormond Fine Arts, London. Pen and brown ink with brown wash, heightened with white on pink-prepared paper, 292 × 368; reproduced in exh. cat. New York and Fort Worth 2003–2004, 207, no. 80. The drawing appears to have served as the model for a print by Nicolas Tanché (b. c. 1740), reproduced in Jean-Richard 1978, 384, no. 1592.

6. Reproduced in Ananoff and Wildenstein 1976, 2:144, no. 466.

EXHIBITIONS
Washington and Chicago 1973–1974, no. 67; Washington 1982a, no. 3.

LITERATURE
Michel et al. [1906], no. 759; Jeanneret 1932, 76; Ananoff 1966, no. 628, fig. 110; Ananoff and Wildenstein 1976, 2:144, under no. 466, fig. 1309a.

54 · François Boucher
Crêpes

1. Denis-Pierre Papillon de La Ferté noted that Boucher had made "several exquisite little pictures in the Flemish manner" when he was in Rome (Papillon de La Ferté 1776, 2: 657).

2. According to Jean-Claude-Gaspard de Sireul (c. 1710/1720–1781), another of Boucher's patrons, the trip took place in either 1763/1764 or in 1766. In the foreword to the sale catalogue of Randon de Boisset's collection (Paris, 27 February 1777, p. ix), Sireul placed the trip in 1766, but in his obituary of Randon de Boisset that appeared in the Almanach historique, also written in 1777, he stated that the trip to Flanders took place "shortly after his [Boucher's] return" from his second trip to Italy in 1763 (see Le Brun 1776/1777, 155). Alastair Laing, in exh. cat. New York and Fort Worth 2003–2004, no. 77, has pointed out that the records of Boucher's attendance at the meetings of the Académie royale suggest that the artist did not have time for such a journey in 1766 and believes that the trip took place instead in 1763/1764.

3. See the sale catalogue of Boucher's estate auction, which took place in his apartment in the Louvre between 18 February and 8 March 1771, lots 9–34, 111–116, 122–124, 127–129 (paintings); 221–319 (drawings); 539–562 (prints); 1818–1842 (mixed).

4. See Alastair Laing's discussion of Boucher's early kitchen scenes in exh. cat. New York and elsewhere 1986–1987, 145–148, under no. 21.

5. See, for example, Ananoff 1966, nos. 84, 98, figs. 18, 19; and Jean-Richard 1978, nos. 465, 639, 860, 1135, 1136, 1143, 1188, 1390, 1577, 1624 (all reproduced).

6. The composition is also known through two prints: a chalk-manner engraving printed in red ink, in reverse, by Gilles Demarteau the Elder (1722–1776), reproduced in Jean-Richard 1978, no. 639; and an etching finished with engraving in the same direction as the drawing by Gabriel Huquier (1695–1772), reproduced in Jean-Richard 1978, no. 1143. The existence of Demarteau's chalk-manner print suggests that Boucher or a member of his studio produced a chalk version of the composition (possibly Ananoff 1966, no. 85, a red chalk drawing that passed through an anonymous sale on 26 February 1900, lot 13).

10. See, for example, the sanguine drawing of the Capitoline from 1762 in the Musée des Beaux-Arts, Valence (Cayeux 1985, no. 22; exh. cat. Washington 1978–1979, no. 11); *The Colonnade of Saint Peter's Square* (inv. D 83, Musée des Beaux-Arts, Valence; reproduced in Cayeux 1985, no. 34); the *Capriccio Based on Bernini's Colonnade* in a private collection (exh. cat. Washington 1978–1979, no. 16); and the *Architectural Capriccio Inspired by Bernini's Colonnade* of about 1762 in the Graphische Sammlung Albertina, Vienna (reproduced in color in exh. cat. Rome 1990–1991, no. 113, pl. XXX).

11. Paris: inv. RF 31266; Valence: inv. D.85. Both reproduced in exh. cat. Rome 1990–1991, no. 17 and fig. 17a, and in Cayeux 1985, 72, fig. 6 and no. 4. Other comparable red chalk drawings are *The Nave of Santa Maria degli Angeli*, c. 1758, and *The Interior of the Colosseum*, 1759, both in the Musée des Beaux-Arts, Valence (inv. D.73, D.100; reproduced in Cayeux 1985, nos. 1, 2).

LITERATURE

Henriot 1926–1928, 3 (pt. 2):391–392.

83 · Hubert Robert
Architectural Fantasy with a Triumphal Bridge

1. The nickname probably came from the critic and encyclopedist Denis Diderot (1713–1784), though its exact origin remains undocumented. See Marianne Roland Michel in exh. cat. Paris 1984–1985b, 342.

2. The red chalk drawings of Fragonard and Robert from about 1759/1761 can be remarkably similar in facture, and it can be very difficult to distinguish between their hands. Compare many of the drawings from those dates included in exh. cat. Washington and elsewhere 1978–1979 and exh. cat. Rome 1990–1991. Robert's best-known imitator and copyist was Jean-Robert Ango, about whom very little is known beyond the fact that he was in Rome by 1760 and died there in 1773. For examples of his copies after Robert, see exh. cat. Rome 1990–1991, 32, figs. 1, 2, 252–254, and exh. cat. Washington 1978–1979, 149.

3. Inv. 1957.34.1.

4. Red chalk, 200 × 260, signed and dated *Roberti Ra 1760*. The counterproof is in the Fonds P.A. Pâris, Ms 452, no. 45, and is reproduced in Feuillet 1926, pl. LXXIX.

5. Inv. 12431; pen and ink with watercolor over black chalk, 345 × 445. Reproduced in color in exh. cat. Rome 1990–1991, 153, pl. XVII.

6. Inv. 5648; reproduced in exh. cat. Rome 1990–1991, no. 53.

7. Reproduced in color in exh. cat. Rome 1990–1991, pl. XIII, p. 125.

EXHIBITIONS

Washington 1989, [no. 5].

LITERATURE

Exh. cat. Rome 1990–1991, under no. 50.

84 · Hubert Robert
The Oval Fountain in the Gardens of the Villa d'Este, Tivoli

1. Even before work on the garden and fountains was complete, Étienne Dupérac (c. 1525–1601) published an engraving of the entire plan in 1573 (reproduced in Coffin 1960, pl. 1, and Lombardo 2005, 8), which was followed two years later by a reworking of the same view, with changes in some of the details, by Mario Cartaro (c. 1540–1620) (reproduced in Lombardo 2005, 17). For the history and iconography of the gardens of the Villa d'Este, see Coffin 1960, Dernie 1996, and Lombardo 2005.

2. The abandoned park of Auteuil outside Paris had similarly attracted a number of artists in the 1740s, including Jean-Baptiste Oudry (cats. 47, 48) (see exh. cats. Paris 1982–1983, 232–244, nos. 129–138; Fort Worth and Kansas City 1983, 188–194, nos. 67–71) and Charles-Joseph Natoire (cat. 81), who was the director of the French Academy in Rome when Fragonard and Robert were studying there (see exh. cat. New York and Washington 2007, no. 57).

3. The information that Fragonard and Saint-Non were staying in Tivoli was included in a letter of 27 August 1760 from Charles-Joseph Natoire to the marquis de Marigny (see Montaiglon and Guiffrey 1887–1912, 11:354). For opposing views about Robert's presence at the Villa d'Este in the summer of 1760, see Victor Carlson in exh. cat. Washington 1978–1979, no. 6, and Pierre Rosenberg in exh. cat. Besançon 2006–2007, 51, 64.

4. A weaker version of this composition, with some differences in the details, was once attributed to Fragonard (Ananoff 1961–1970, 3: no. 1577, fig. 415), but is now regarded as possibly a copy after a lost drawing by him (present location unknown; sold at Christie's, Paris, 17 March 2005, lot 383, as by Pierre-Adrien Pâris; reproduced in color). A counterproof of that drawing bears an old pen-and-ink inscription on its mount, *frago. Roma 1760* (location unknown; sold, Artcurial, Hôtel Dassault, Paris, 11 April 2006, part of lot 9; reproduced in Ananoff 1961–1970, 3: no. 1577a, fig. 416). A painting in the same direction as the counterproof is universally accepted as the work of Fragonard (location unknown; reproduced in Cuzin 1987, no. 89, and exh. cat. Besançon 2006–2007, fig. 120a).

5. The slight difference in viewpoint between the Washington drawing and the closely related sheet cited in note 4 above, possibly copied after a lost original by Fragonard, suggests that the two artists could indeed have been working side by side.

6. For photographs of the Oval Fountain as it looks today, see Coffin 1960, figs. 30, 31; Dernie 1996, 74–75, 78. Its appearance in the seventeenth century is recorded in prints made by Dominique Barrière (1610–1678), Gabriel Perelle (1603–1677), and Giovanni Francesco Venturini (1650–1710), all reproduced in Lombardo 2005, 37, 39, 40.

EXHIBITIONS

Washington 1978–1979, no. 6; Richmond 1981, no. 25; New York 1990c, no. 40; Washington 1991, 98.

LITERATURE

Herzog 1989, 39, fig. 7; exh. cat. Rome 1990–1991, 23, fig. 5, 27, 30 n. 14; exh. cat. New York and Montreal 1993, 169, fig. 2; sale cat. Christie's, Paris, 17 March 2005, under no. 383; exh. cat. Besançon 2006–2007, 206, fig. 120b.

85 · Hubert Robert
Herdsmen Crossing a Waterfall

1. Boucher's development of the pastorale is discussed by Jo Hedley in exh. cat. London 2004–2005, 138–143. Robert's connections with Boucher were first elucidated by Jean Cailleux in Cailleux 1959, 100–107. See also Victor Carlson in exh. cat. Washington 1978–1979, 22 and 90, under no. 32.

2. In exh. cat. Washington 1978–1979, no. 32, Carlson specifically mentions several paintings by Boucher in connection with this composition: Ananoff and Wildenstein 1976, 2: nos. 547 (1761), 586 (1764), 635 (1766), and 681 and 683 (both 1769). To that group can be added nos. 380 (1751), 458 (1755), and 655 (1768).

3. Estate sale of Pierre-Louis-Paul Randon de Boisset (1708–1776), Paris, 27 February 1777, lots 217–219. Both the collector and the author of the catalogue, the expert Pierre Rémy, knew Boucher and Robert personally. See Cailleux 1959, 102, and Carlson in exh. cat. Washington 1978–1979, no. 32.

4. See Cailleux 1959, 100–107. Hubert Robert's estate sale took place in Paris on 5 April 1809 and included works by Boucher in lots 32–35, 57, 155–157, 161–162, 169, 178, 224–236. The sale catalogue is transcribed in Gabillot 1895, 256–271. See also Carlson in exh. cat. Washington 1978–1979, 22 and 90, under no. 32.

5. Both Jean Cailleux (letter of 19 December 1977 in the NGA object file) and Victor Carlson (exh. cat. Washington 1978–1979, no. 32) have dated the drawing to 1770/1775.

6. The drawings were acquired as a pair by Galerie Cailleux, Paris (see letter of Jean Cailleux, 19 December 1977, in the NGA object file).

7. Sale, Christie's, London, 25 June 1968, lot 84 (purchased by Katz).

8. The National Gallery owns two reworked counterproofs by Robert: *Ruined Farm* (inv. 1963.15.27; pen and black ink with gray and brown wash and blue watercolor over black chalk counterproof, 365 × 290) and *The Peasant Dance* (inv. 1963.15.26; pen and black ink with gray and brown wash and black chalk over black chalk counterproof, 362 × 283). Both are reproduced in exh. cat. Washington 1978–1979, nos. 33, 34.

EXHIBITIONS

Washington 1978a, 88; Washington 1978–1979, no. 32.

86 · Jean-Honoré Fragonard
The Avenue of Cypresses at Villa d'Este

1. The best information about Fragonard as an artist and draftsman is provided by Eunice Williams in exh. cat. Washington and elsewhere 1978–1979 and by Pierre Rosenberg in exh. cat. Paris and New York 1987–1988. Fragonard's years in Rome are studied in detail by Rosenberg, Jean-Pierre Cuzin, and Catherine Boulot in exh. cat. Rome 1990–1991.

2. All ten are reproduced in color in exh. cat. Besançon 2006–2007, nos. 14–23. See also exh. cat. Paris and New York 1987–1988, nos. 24–25, 27–30, 32–35.

3. See Ananoff 1961–1970, 2: figs. 229, 244, 711; exh. cat. Rome 1990–1991, cat. 73, color plate xx. The original drawing from which the counterproof of the *Avenue of Cypresses at Villa d'Este* was taken is in Besançon, inv. D. 2842 (fig. 1). For two other National Gallery drawings in this catalogue that include significant use of counterproofing in their execution, see cats. 27, 39 (by Van der Meulen and Watteau).

4. That this particular drawing was exhibited is proved by Gabriel de Saint-Aubin's summary sketch in the copy of the Salon *livret* in the Musée du Louvre, Département des Arts graphiques, Paris (reproduced in exh. cat. Besançon 2006–2007, 52, pl. 23, and exh. cat. Paris and New York 1987–1988, 107, fig. 6).

5. Inv. 12.735; brown wash over black chalk, 465 × 343. Reproduced in exh. cat. Paris and New York 1987–1988, no. 31.

EXHIBITIONS

Vienna and Munich 1986, no. XIII; Madrid 1986–1987, no. 100; London 1987, no. 83; New York 1989b (not in catalogue); New York 1990a, no. 104; Washington 1995–1996, no. 88.

LITERATURE

Roland Michel 1987a, 32, fig. 23; exh. cat. Paris and New York 1987–1988, under no. 30, fig. 2; exh. cat. Rome 1990–1991, 115, under no. 66; exh. cat. Besançon 2006–2007, 65, fig. 19b; exh. cat. New York and Washington 2007, 152 n. 4.

87 · Jean-Honoré Fragonard
A Stand of Cypresses in an Italian Park

1. Inv. D. 2841.

2. Pierre Rosenberg in exh. cat. Paris and New York 1987–1988, 130, no. 74.

EXHIBITIONS

Paris 1921, no. 181; Providence 1931, no. 13; Cambridge 1934, no. 12; Rotterdam and elsewhere 1958–1959, no. 44, pl. 70; Cambridge 1962, no. 9; London 1968, no. 252; Washington and elsewhere 1978–1979, no. 7; Rome 1990–1991, no. 74; Washington 1992, 33, 43, no. 32.

LITERATURE

Portalis 1889, 2:316; Ananoff 1961–1970, 2: no. 904, 4:383; exh. cat. Paris and New York 1987–1988, under no. 34, p. 111, fig. 2 (erroneously captioned).

88 · Jean-Honoré Fragonard
Terrace and Garden of an Italian Villa

1. The drawing, which had always been considered the work of Fragonard, was attributed to Hubert Robert by Colin Eisler in 1977 (see Eisler 1977, 341, no. dK452), but was restored to Fragonard the following year by Eunice Williams, who dated it to 1760/1762 (see exh. cat. Washington and elsewhere 1978–1979, no. 8). Pierre Rosenberg dated it "1760?" in exh. cat. Rome 1990–1991, no. 76.

2. Fragonard repeated the composition, with variations, in two red chalk drawings (in different New York private collections); a retouched counterproof (fig. 1); an etching (see, for example, the impression reproduced in exh. cat. Baltimore and elsewhere 1984–1985, no. 46, in the collection of Mr. and Mrs. R. Stanley Johnson, Chicago); a gouache (private collection); and a painting (Wallace Collection, London). See exh. cat. Paris and New York 1987–1988, 153–154, no. 66, figs. 3–6, and exh. cat. New York and Washington 2007, no. 59.

3. For the dating of the print, see Victor Carlson's entry in exh. cat. Baltimore and elsewhere 1984–1985, no. 46; for the retouched counterproof, see this author's entry in exh. cat. New York and Washington 2007, no. 59. The gouache may date from as late as 1775, based on its similarities with another gouache by Fragonard, *Fête at Rambouillet*, in a private collection (exh. cat. Washington and elsewhere 1978–1979, no. 51, and exh. cat. Paris and New York 1987–1988, nos. 168, 169).

EXHIBITIONS

Paris 1925a, no. 439; Washington and elsewhere 1978–1979, no. 8; Washington 1990, 132, 171, no. 85; Rome 1990–1991, no. 76.

LITERATURE

Ananoff 1961–1970, 1: no. 313; Eisler 1977, 341, no. dK452, fig. 306 (as Hubert Robert); Massengale 1993, 30, fig. 38.

89 · Jean-Honoré Fragonard
A Prayer for Grandpapa

1. Fragonard's wash technique and his use of it in his drawings are cogently discussed by Eunice Williams in exh. cat. Washington and elsewhere 1978–1979, especially in the Introduction (pp. 22–24) and in many of the individual entries (e.g., nos. 22, 23, 27, 33, 41, 43, 44, among many others).

2. See Eunice Williams in exh. cat. Washington and elsewhere 1978–1979, nos. 46, 47; Pierre Rosenberg in exh. cat. Paris and New York 1987–1988, nos. 224, 227. Very similar in handling and spirit and executed on the same scale is *The First Riding Lesson* (Brooklyn Museum, inv. 57.189; reproduced in exh. cat. Washington and elsewhere 1978–1979, no. 44), which is thought to have been etched in 1778 by Fragonard's sister-in-law, Marguerite Gérard (1761–1837).

3. Inv. P 404; reproduced in exh. cat. Paris and New York 1987–1988, 417, fig. 5.

4. Both prints are reproduced in exh. cat. Paris and New York 1987–1988, 425, fig. 19, and 458, fig. 7.

5. Reproduced in exh. cat. Paris and New York 1987–1988, 417, fig. 6.

6. *Grandfather's Reprimand* is the title that has been most commonly used for this drawing, first appearing in the 1826 sale of Baron Dominique-Vivant Denon. *The Visit to the Doctor* was the title given in the Blumenthal sale in 1932; "*Beg Grandpapa's Pardon*" was used in exh. cat. Paris and New York 1987–1988, no. 224.

EXHIBITIONS

Paris 1860, no. 12 (as *La prière*); Paris 1921, no. 133; exhibited almost continuously with the Armand Hammer Collection around the United States and abroad from late 1970 through 1987 (for a complete listing of the venues and dates, see exh. cat. Washington 1987); Washington 1978a, 87; Washington and elsewhere 1978–1979, 23, 120–121, no. 46 (as *Grandfather's Reprimand*); Washington 1987, no. 21; Paris and New York 1987–1988, no. 224 (as "*Demandez pardon au grand-papa*"); Paris 1999–2000, no. 591 (as *La réprimande du grand-papa*).

LITERATURE

Portalis 1889, 2:310–311 (as *La prière, La prière au grand-père*, and *La réprimande du grand papa*); Réau 1956, 206 (as *La visite au docteur*); Ananoff 1961–1970, 1: no. 41, 2:294; White 1972, 460; Dalevèze 1977, 11, fig. 8; Walker 1984, no. 1082; Massengale 1993, 38–39, fig. 55 (as *Ask Grandfather's Pardon*).

90 · Jean-Honoré Fragonard
The Little Preacher

1. Reproduced in exh. cat. Paris and New York 1987–1988, 465, fig. 1.

2. See exh. cat. Washington and elsewhere 1978–1979, no. 47.

EXHIBITIONS

Exhibited almost continuously with the Armand Hammer Collection around the United States and abroad from late 1970 through 1987 (for a complete listing of the venues and dates, see exh. cat. Washington 1987); Washington 1978a, 23; Washington and elsewhere 1978–1979, no. 47; Washington 1987, no. 22; Paris and New York 1987–1988, no. 227.

LITERATURE

Goncourt 1880–1882, 2:350, 374; Portalis 1889, 1:114; 2:200, 310; Réau 1956, 205, fig. 79; Ananoff 1956, reprod. 42; Ananoff 1961–1970, 1: no. 40, fig. 18, 3:290; Gimpel 1963, 22; White 1972, 460; Dalevèze 1977, 11, fig. 7; Cuzin 1987, 193, 194, fig. 237.

91a–b · Jean-Honoré Fragonard
illustrations for Cervantes' *Don Quixote*

1. Théophile Fragonard's notes on his grandfather were printed in full in Valogne 1955, 1, 7, 9. The importance of the passage about the *Don Quixote* and *Orlando furioso* drawings was emphasized by Pierre Rosenberg in exh. cat. Paris and New York 1987–1988, 508. (The translation used here comes from the English version of that catalogue.)

2. On the Don Quixote drawings, see primarily Marie-Anne Dupuy-Vachey in exh. cat. Paris 2007–2008, 140–151, nos. 72–80, and exh. cat. Paris 1999–2000, no. 592; Pierre Rosenberg in exh. cat. Paris and New York 1987–1988, 508–509; and Eunice Williams in exh. cat. Washington and elsewhere 1978–1979, 148, no. 60.

3. The project is discussed at length by José-Luis de Los Llanos in exh. cat. Paris 1992–1993, 191–274, nos. 128–184. In 1789, the Paris publisher Didot announced plans for a new edition of La Fontaine's *Contes* with eighty illustrations by Fragonard. Only sixteen prints after Fragonard's designs and four after designs by other artists were published in 1795 before the project was abandoned. See exh. cat. Paris 1992–1993, 192–193.

4. This idea was proposed by Marianne Roland Michel in exh. cat. Paris 1987, n.p. (opp. no. 78).

5. The composition, with the horse seen from below, has some striking similarities with Fragonard's illustration for *Orlando furioso* in which Rinaldo, mounted on the magic horse Baiardo, flies off after Angelica (see cat. 92, fig. 2).

6. In addition to the four works reproduced here, the National Gallery owns *Don Quixote about to Strike the Helmet* (inv. 2000.9.6), illustrating a scene from chapter 1, and *The Muleteer Attacking Don Quixote as He Lies Helpless on the Ground* (inv. 2000.9.13), showing an episode in chapter 4. Both are reproduced in exh. cat. Washington 1982, nos. 7, 8.

7. One of Denon's etchings is reproduced in exh. cat. Paris and New York 1987–1988, 509, fig. 2. Théophile Fragonard wrote that Denon acquired the drawings with the specific purpose of etching them. See Valogne 1955, 9.

8. Valogne 1955, 9. Translated in exh. cat. Paris and New York 1987–1988, 508.

EXHIBITIONS

Washington 1982a, nos. 9, 12; Paris 2007–2008, no. 76 (cat. 91a only).

LITERATURE (on the series as a whole)

Portalis 1877, 1 (pt. 2):224, 229; Portalis 1889, 2:215, 299; Mongan et al. 1945, 19–20, 35; Ananoff 1961, 155–157 (attributed to Alexandre-Évariste Fragonard); Ananoff 1961–1970, 4: no. 2667 (attributed to Alexandre-Évariste Fragonard); Williams in exh. cat. Washington and elsewhere 1978–1979, under no. 60; Rosenberg in exh. cat. Paris and New York 1987–1988, 508–509; Laughton 1996, 400–401; Dupuy-Vachey 2003, 8; Dupuy-Vachey in exh. cat. Paris 2007–2008, 140–142.

92a–b · Jean-Honoré Fragonard
illustrations for Ariosto's *Orlando furioso*

1. On the stylistic characteristics and dating of these drawings, see especially Eunice Williams in exh. cat. Washington and elsewhere 1978–1979, 152–153.

2. Reproduced in Mongan et al. 1945, pl. 42, and exh. cat. Paris and New York, 1987–1988, 509, fig. 3.

3. Valogne 1955, 9.

4. For some illustrations of scenes in the first four cantos that exhibit the relatively restrained underdrawing, spare forms, and angular contours found in the *Don Quixote* drawings, see Mongan et al. 1945, plates 2, 4, 5, 9, 12, 14–18. Marie-Anne Dupuy-Vachey has suggested that three drawings that were formerly identified as scenes from *Don Quixote* actually illustrate episodes in *Orlando furioso*. See Dupuy-Vachey 2003, nos. 1, 120, 133.

5. Ariosto [trans. Waldman] 1974, 35. Ariosto describes the physical attributes of the hippogryph in Canto IV, 18: "begotten by a gryphon out of a mare. He had his father's wings and feathers, his forefeet, his head and beak; in all else he took after his mother." Ariosto [trans. Waldman] 1974, 32. In the National Gallery drawing, however, the hippogryph looks more like Pegasus, the winged steed of ancient Greek mythology, than a cross between a bird of prey and a horse. The animal's beak is more apparent in two other illustrations to Canto IV. See Dupuy-Vachey 2003, nos. 29, 31.

6. Ariosto [trans. Waldman] 1974, 78. This was Marie-Anne Dupuy-Vachey's choice as the inspiration for Fragonard's drawing (Dupuy-Vachey 2003, no. 68).

7. Ariosto [trans. Waldman] 1974, 103. Jean Seznec suggested that this was the source of Fragonard's drawing in Mongan et al. 1945, 69, pl. 66.

8. The two other drawings in the Gallery's collection, in addition to the four reproduced here, are *Orlando and Angelica Arrive at Charlemagne's Camp* (inv. 1978.10.4), illustrating Canto I, and *Orlando Confronts the Orc* (inv. 1978.10.3), illustrating Canto XI. Reproduced in Dupuy-Vachey 2003, nos. 2, 103.

EXHIBITIONS

Washington 1945, nos. 22, 24; Northampton 1946, no. 23 (cat. 92a only); Washington 1978a, 84–85 (cat. 92b only); Paris and New York 1987–1988, no. 261 (cat. 92b only); Paris 2007–2008, no. 62 (cat. 92b only).

LITERATURE (on the series as a whole)

Portalis 1877, 1 (pt. 2):222–223, 228; Portalis 1889, 2:214–215, 311; Cohen and Ricci 1912, col. 97; Ricci 1923a, [11–12]; Mongan et al. 1945; Williams in exh. cat. Washington and elsewhere 1978–1979, 152–153; Rorschach in exh. cat. Philadelphia 1985, 26–27; Rosenberg in exh. cat. Paris and New York 1987–1988, 508–510; Dupuy-Vachey 2003; Dupuy-Vachey in exh. cat. Paris 2007–2008, 121–122.

93a–d
Charles Eisen
Charles Monnet
Jean-Michel Moreau the Younger
illustrations for Ovid's *Metamorphoses*

1. Basan and Le Mire used the French translation by abbé Banier (1673–1741), which was first published in Amsterdam in 1732. They also reprinted the abbé's extensive commentaries at the end of each of the fifteen *libri*, or books.

2. One of the *Coronis* drawings is partially disfigured by a green stain. The drawing was presumably damaged early on, and Moreau must have copied it to provide the printmaker with a clean model.

3. Inv. 1942.9.1794–1797. The National Gallery also owns a complete, unbound set of the Ovid illustrations, which came as the gift of Lessing J. Rosenwald (inv. 1943.3.6264–6403).

4. Eisen apparently demanded that engravers should be completely faithful to his designs when they transformed them into prints. In 1759 he and Le Mire nearly came to blows when Eisen showed the printer that he had made mistakes in engraving one of his drawings. Eisen filed a complaint, in which he stated that Le Mire had threatened to run him through with his sword and that if others had not been present to hold the engraver off, his life would have been in jeopardy. See Portalis 1877, 1 (pt. 2):193 n. 1.

5. Inv. 1942.9.942, 1942.9.983, 1942.9.1035, and 1942.9.1055.

6. See Ovid [trans. Humphries] 1958, 11–12.

7. See Ovid [trans. Humphries] 1958, 41–44.

8. Monnet's activities as an illustrator are discussed at length in Portalis 1877, 2 (pt. 1):399–413. Other notable works illustrated by him include the 1778 edition of Voltaire's *La Pucelle d'Orléans*, Fénelon's *Aventures de Télémaque* of 1785, and the fourteen-volume set of *Oeuvres complètes de Berquin* of 1803.

9. See Ovid [trans. Humphries] 1958, 100–114.

10. Inv. 1942.9.866, 1942.9.920, and 1942.9.1005.

11. The related print by Jean-Charles Baquoy (1721–1777) illustrates Book II, Fable 1 (pl. 24).

12. See Ovid [trans. Humphries] 1958, 285–286.

13. Ovid [trans. Humphries] 1958, 286.

14. Inv. 1942.9.954, 1942.9.1102, and 1942.9.1111.

15. The story is told in Book VIII, Fable 7. Ovid [trans. Humphries] 1958, 204–208.

LITERATURE (for all the *Metamorphoses* drawings)

Portalis 1877, 1 (pt. 1):33, 40; 1 (pt. 2):199–200, 211, 286, 293, 358; 2 (pt. 1):399–400, 402–403, 411, 426–427, 459; 2 (pt. 1):687; Cohen and Ricci 1912, col. 772; Ricci 1923b, [21].

———

94 · Jean-Michel Moreau the Younger
May Ball

1. Engraving with etching, 30 × 42. Portalis and Béraldi 1880–1882, 3 (pt. 1):29, no. 23. Reproduced in exh. cat. Washington 1982a, 56, fig. 16.

2. Souchal 1967, 699, no. 190.

3. Another indication that this is a professional performance is the character of the steps being executed by several trios of dancers. As Dr. Sarah Cohen observed in an e-mail of 6 February 2009 to the present author, these kinds of movements with complex arm-holds and extended touching among men and women were presented only on the stage during the eighteenth century, not in social dances. Similar pas de trois were drawn by Gabriel de Saint-Aubin on both the recto and verso of his 1748 sketches of the ballet performed during *The Rival Fairies* (cat. 65).

EXHIBITIONS

Washington 1982a, no. 22 (as Michel-Ange Slodtz).

LITERATURE

Sharp and Oppé 1924, pl. 52 (as Slodtz); Souchal 1967, 463, 699, no. 190 (as Slodtz).

———

95 · Jean-Michel Moreau the Younger
A Dancer

1. The Widener Collection at the National Gallery of Art includes the three volumes from 1774, 1778, and 1783 (inv. 1942.9.1787–1789).

2. The best account of the evolution of these works is given by Antony Griffiths in Griffiths 2004, 87–92. See also Widener 1923, 4:487–563 (with illustrations and discussions of all the prints), and exh. cat. Baltimore and elsewhere 1984–1985, no. 85.

3. The finished model drawing of the entire composition, showing the same differences, is part of a Rothschild family trust on loan to Waddesdon Manor in England. Inv. 203.2003; pen and black ink with brown wash over black chalk, 268 × 223. Reproduced in color in exh. cat. London and Nottingham 2007–2008, 121, no. 44.

EXHIBITIONS

San Francisco 1940, nos. 71; Montreal 1950, no. 85; Philadelphia 1950–1951, no. 67; Richmond 1956; Los Angeles 1961, no. 56; London 1968, no. 476.

LITERATURE

Portalis 1877, 2 (pt. 1):461; Goncourt 1880–1882, 2:251; Bocher 1875–1882, 6:495 (under no. 1368), 697, 713, 717; Cohen and Ricci 1912, col. 361; Widener 1923, 4:559, 588, under no. 33; Ricci 1923a, [8–9].

———

96 · Claude Bornet
An Elderly Lady in a Mauve Silk Dress

1. See Jeffares 2006, 64, who lists a total of eleven with locations for only five. Reproductions available online at www.pastellists.com.

2. He was described in the 1776 *Almanach des peintres* as painting enamel miniatures "supérieurement." See Jeffares 2006, 64. Examples of his miniatures can be seen in Lemoine-Bouchard 2008.

3. Bornet's images for *Gil Blas* are available online on the ImageBase website of the Fine Arts Museums of San Francisco: http://search2.famsf.org:8080/search.shtml?keywords=Vol&artist =&country=&period=&sort=&start=321.

4. Inv. RF 31.367; pastel on paper laid down on canvas, 635 × 530. Reproduced in Monnier 1972, no. 25, and on the Louvre's website at http://arts-graphiques.louvre.fr/fo/visite?srv=rom.

5. In the *Almanach des peintres* of 1776. See Jeffares 2006, 64.

EXHIBITIONS

Paris 1927, no. 115, pl. LXXIX; Paris 1933b, no. 3.

LITERATURE

Ratouis de Limay 1946, 163, pl. LV, fig. 83; Jeffares 2006, 64 (reprod.).

———

97 · Augustin Pajou
The Muse Terpsichore

1. Several examples—a few of which incorporated some black chalk in addition to the red—were included in exh. cat. Paris and New York 1997–1998, nos. 41, 43, 44, 47, 48, 80, 113.

2. Pajou made a record drawing after his important *Monument to Buffon*, for example (exh. cat. Paris and New York 1997–1998, no. 113).

3. See Guilhem Scherf's brief discussion of the problem of determining to what stage these finished drawings belong in exh. cat. Paris and New York 1997–1998, under no. 44.

4. Several of Pajou's Roman drawings were included in exh. cat. Paris and New York in 1997–1998, nos. 2–16. The National Gallery owns six others (inv. 1999.75.1–6).

5. A brief summary of the project appears in exh. cat. Paris and New York 1997–1998, 115–118, together with discussions of five drawings related to it, nos. 44–48. See also Stein 1912, 177–193.

6. *Comedy*: inv. RF 29097; red chalk, 308 × 218. *Music*: inv. D-F-218; red chalk, 309 × 195. Both are reproduced in exh. cat. Paris and New York 1997–1998, nos. 47, 48. Henri Stein in Stein 1912, pl. VII, was the first to link the drawing of *Comedy* (sometimes also identified as representing the muse Thalia) to Pajou's work on the Royal Opera at Versailles; see also Guilhem Scherf in exh. cat. Paris and New York 1997–1998, nos. 47, 48.

7. Scherf in exh. cat. Paris and New York 1997–1998, 123–124.

8. Red chalk, 298 × 204. Sold at Christie's, London, 12 April 1983, lot 150 (reprod.).

9. Ripa and Baudoin 1644, pt. 2:71, 75 (facsimile edition in Bar and Brême 1999, vol. 2).

LITERATURE

Exh. cat. Paris and New York 1997–1998, 123, under no. 48.

———

98 · François-André Vincent
Noah Leading the Animals into the Ark (after Giovanni Benedetto Castiglione)

1. Vincent stayed in Naples with Jean-Honoré Fragonard (cats. 86–92) and his patron Pierre-Jacques-Onésyme Bergeret de Grancourt (1715–1785) between mid-April and June. See Cuzin [1988], 11, and exh. cat. Rome 1990–1991, 246–247, under no. 173. Many of the dates and signatures on Vincent's drawings were added by the artist himself toward the end of his life, but in this case, the inscription at lower left is contemporary with the drawing.

2. A remarkably faithful copy of Vincent's drawing signed by Jean-Jacques Lagrenée the Younger (1739–1821) and dated 1776 is in the collection of the Musée Fabre, Montpellier (inv. 837-1-1146; brown wash heightened with white on tinted paper, 440 × 550; reproduced in color in exh. cat. Paris 1996, no. 42). Dated two years after Vincent's, Lagrenée's drawing must have been made in Paris after Vincent returned there from Rome in 1775. Eunice Williams first called attention to the compositional similarities between the two drawings in a letter of 22 March 1988 to Niall Hobhouse at Hazlitt, Gooden & Fox after that firm acquired the Castiglione at auction (a copy of the letter is in the National Gallery's object folder). The existence of the Vincent was not known at that time. I am indebted to Ms. Williams for putting me in touch with Laurie Bervillé, who has done considerable research on Lagrenée and very helpfully provided me with the exhibition reference for the Musée Fabre drawing.

99 · François-André Vincent
Park of an Italian Villa

1. The inscription on the verso of the drawing suggests that the attribution to Fragonard was once endorsed by Georges Wildenstein, although Wildenstein never published the drawing. It was catalogued as the work of an anonymous eighteenth-century French artist in Eisler 1977, no. dK508.

2. See exh. cat. Rome 1990–1991, 249, no. 177.

3. The red chalk drawing is *Landscape in the Roman Campagna with Draftsmen at Work*, in the Musée des Beaux-Arts, Orléans (inv. 1141; reproduced in Cuzin [1988], pl. 7, and in color in exh. cat. Orléans and Vevey 2006–2007, no. 2); the black chalk drawing is *Landscape near Tivoli with Draftsmen at Work* in the Fondation Custodia, Institut néerlandais, Paris (inv. 1974.T.23; reproduced in Cuzin [1988], pl. 6); and the one executed in black chalk and white gouache is *The Gardens of the Villa Negroni* in a private collection, New York (reproduced in exh. cat. New York and Washington 2007, no. 61). The dates on all three works were probably added by Vincent later on, toward the end of his career, but since he made few, if any, landscape studies after he left Italy, the dates are probably trustworthy.

4. Metropolitan Museum: inv. 62.124.1; Quimper: inv. 143. Both are reproduced in Cuzin [1988], pls. 28, 30.

EXHIBITIONS

Washington 1990, 132–133, fig. 86 (as Anon. French 18th century); Rome 1990–1991, no. 177.

LITERATURE

Ananoff 1961–1970, 3: no. 1529 (as Jean-Honoré Fragonard); Eisler 1977, 341, no. dK508, fig. 307 (as Anon. French, 18th century); Cuzin 1983, 116–117, 123 n. 59, fig. 28; Cuzin [1988], no. 18; Cuzin and Salmon 2007, 98, fig. 143 (color).

———

100 · François-André Vincent
The Drawing Lesson

1. See especially Cuzin 1983, 103–124; Cuzin [1988], nos. 19, 20, 26; and exh. cat. Rome 1990–1991, nos. 173, 175–178.

2. When the painting was exhibited at the Salon in 1777, it was listed as "A young man giving a drawing lesson to a young lady" ("Un jeune homme donnant une leçon de dessin à une demoiselle"). That title was eventually shortened to *The Drawing Lesson*.

3. The identity of this loving pair has been the subject of considerable speculation over the years, but still remains a mystery. Proposed identifications include Bergeret de Grancourt and his mistress; Fragonard and his wife or Fragonard and his sister-in-law (and pupil) Marguerite Gérard (1761–1837); and the Swedish miniaturist Peter Adolph Hall (1739–1793) and his wife. None of these has met with universal agreement. See Cuzin 1983, 107.

EXHIBITIONS

Paris 1947, no. 533; London 1950, no. 88; Paris 1951, no. 147; Washington 2000–2001, 194–195; New York and Washington 2007, no. 65.

LITERATURE

Sutton 1949, 60, pl. LVI; Roland Michel 1987a, 27, 106, fig. 36; Cuzin [1988], no. 27; exh. cat. Rome 1990–1991, under no. 170, fig. 170a.

———

101 · Sigmund Freudenberger
Early Morning

1. The National Gallery owns a drawing from this period, *Corner of a Rustic Barn* (inv. 1991.93.1); reproduced in exh. cat. Washington 1992, 40–41, 45, cat. 38.

2. Portalis and Béraldi 1880–1882, 2 (pt. 2):546, no. 18. Two impressions are in the collection of the National Gallery of Art (inv.1942.9.2341 and 1942.9.2342). The second state, without the letters, is reproduced in Widener 1923, 2: no. 177.

3. The text on the third (published) state indicates that the drawing was "Tiré du Cabinet de Monsieur De Sandoz Rollin, Conseiller d'Ambassade de sa Majesté le Roy de Prusse" (taken from the cabinet of M. de Sandoz-Rollin, counselor of the embassy of His Majesty the King of Prussia). The Sandoz-Rollin coat of arms is also included at center.

4. Bourcard 1893, 239.

LITERATURE
Widener 1923, 2:253, under no. 177.

102a–b · Charles-Nicolas Cochin II
illustrations for *Almanach iconologique*

1. For a complete listing of Cochin's book illustrations, see Michel 1987, 170–386, nos. 1–214.

2. The National Gallery owns an unusual eighteen-volume set of the *Almanach iconologique*, inv. 1988.59.1–18, which includes a volume for 1764 that is identical in every way to the volume for 1765, except for the date on the title page. (See fig. 1.)

3. This is mentioned in both the *Almanach* of 1775 (page 1) and in an article published in the *Année Littéraire* of 1775 which explains some of the changes Cochin was introducing into the volumes (transcribed in part by Michel 1987, 312). The article mentions specifically that a group of four figures would present "a richer spectacle" than a single figure alone and would reduce the number of plates from four to one.

4. This replaces the Envy-like motif advocated by Ripa of snakes encircling the man's heart.

5. This is a departure from Ripa, who portrayed Hatred as a man holding a sword and shield painted with a reed and a fern.

6. Cochin's highly refined work as an illustrator is further represented in the National Gallery's collection by seven of his designs for the 1754 publication of *De rerum natura* (On the Nature of Things) by the first-century-bc poet Lucretius (inv. 1942.9.1168–1172 and 1942.9.1174–1175), and six for the 1757–1761 edition of Giovanni Boccaccio's *Decameron* (see cat. 63e). In addition, the Gallery owns a drawing for an *Allegory of Fame* from 1773 and two of his small-scale profile portraits, drawn with exquisite care and sensitivity and presented in a roundel format that imitates the appearance of ancient coins and Renaissance medals (inv. 1992.87.23 and 1986.49.1–2).

LITERATURE
Portalis 1877, 1 (pt. 1):123; Goncourt 1880–1882, 2:125; Cohen and Ricci 1912, col. 455; Michel 1987, 314, nos. 152p, 152q.

103a–b
Louis-Jean Desprez
Claude-Louis Châtelet
illustrations for the abbé de Saint-Non's *Voyage pittoresque*

1. The most complete information about the history of this elaborate project and the personalities involved with it is provided by Petra Lamers in Lamers 1995, 21–102. See also Antony Griffiths' summary in Griffiths 2004, 93–97. The National Gallery owns a set of volumes from the first edition, first issue, in a contemporary red morocco binding, part of the Mark J. Millard Architectural Collection, inv. 1985.61.2660–2664. See Wiebenson and Baines 1993, no. 148.

2. Laborde's *Tableaux topographiques pittoresques … de la Suisse et de l'Italie* was envisioned as a six-volume set, with one volume on Switzerland and five others on Italy containing a total of two hundred illustrations. See Lamers 1995, 28–37. The Swiss part became a separate four-volume enterprise and resulted in the publication of *Tableaux de la Suisse ou voyage pittoresque fait dans les XIII cantons et états alliés du corps helvétique*, 1780–1788.

3. Illustrating some of the stylistic differences between Châtelet and Desprez are color reproductions in Lamers 1995, 22–23, 26–27, 34, 35 (Châtelet); and 38–39, 42–43, 46–47, 66–67 (Desprez).

4. See Lamers 1995, 96.

5. *Voyage pittoresque* 3:37. The passage is quoted in Lamers 1995, 219, under no. 201.

6. Inv. P 49:1, pages 55–56, 59–61. Two of the drawings are reproduced in Lamers 1995, 218–219, figs. 201a, 201b.

7. Inv. P 49:1, pages 60–61; pen and black ink over black chalk, 275 × 370 (a two-page spread). Reproduced in Lamers 1995, 218, fig. 201a.

8. Many photographs of San Nicola Pellegrino are available on the Web. See, for example, http://www.turismo.regione.puglia.it/at/10/luogosacro/778/en.

9. A total of three views of the area around Agrigento were included in the first part of the fourth volume of the *Voyage pittoresque*, plates 94–96. See Lamers 1995, 174–176, nos. 132–133d.

10. *Voyage pittoresque* 4 (pt. 1):228. Part of the description is quoted in Lamers 1995, 174, under no. 131.

11. Pen and gray and black ink with watercolor, 235 × 337, formerly with Didier Aaron in Paris (Lamers 1995, no. 131b, reproduced).

12. Lamers 1995, 97.

13. Detailed biographies of both artists are provided in Lamers 1995, 77, 79 (Châtelet); 80–82 (Desprez).

14. Although Châtelet's death date is almost universally given as 1794, Lamers places it specifically in May 1795.

103a · Desprez

EXHIBITIONS
Toronto and elsewhere 1972–1973, no. 42, pl. 120.

LITERATURE
Possibly Bénard 1810, under no. 4058 (61 watercolor landscapes and views by Desprez); Wollin 1939, 355, no. 14; Eisler 1977, 349, no. dK386, fig. 320; Lamers 1995, 220, no. 201c, reprod. 219, fig. 201c (mislabeled "201").

103b · Châtelet

EXHIBITIONS
New York 1966, no. 58.

LITERATURE
Lamers 1995, 174, no. 131a, reprod. 173, fig. 131a.

104 · Jean-Baptiste Pillement
Shepherds Resting by a Stream

1. See Gordon-Smith 2006, the most recent and most lavishly illustrated book on the artist, for reproductions of all types of works by Pillement in all media. See also Jeffares 2006 for many reproductions of pastels by Pillement; available online at www.pastellists.com.

2. Pillement's extensive use of gouache in the National Gallery landscape remained unrecognized until Kimberly Schenck, senior paper conservator, studied the piece carefully in 2008 and performed some restoration work on it in preparation for this exhibition in 2009. It is very likely that many other Pillements currently described only as having been executed in pastel also include gouache.

3. The National Gallery owns a set of four ornament designs with fantastic flowers in octagonal format, inv. 1983.54.1–3 and 2001.148.2, one of which is reproduced in fig. 1. Several other designs of this type are in the Rothschild Collection at Waddesdon Manor, Aylesbury, Buckinghamshire. See Laing et al. 2006, 1: nos. 275–279d, where these flora are referred to as "Chinese foliage."

4. Jeffares 2006 lists several works from 1779, all of which are smaller.

5. Jeffares 2006 lists four works that similarly measure more than a meter in one dimension (though measurements are lacking for several works). A number of others approach one meter in scale (see Gordon-Smith 2006, figs. 209–215, 217–219). It should be noted, however, that in 1763, Pillement executed eighteen blue monochrome pastels on canvas to decorate a salon—which came to be known as the Blue Pastel Room—at the Blue Court of Laxenburg, in Austria, all of which measured more than one meter in one dimension with several of them exceeding one meter in both height and width (Gordon-Smith 2006, figs. 92–104).

LITERATURE
Jeffares 2006, 420 (incorrectly recording the date as 1771; reproduced online, but not in the print edition); Gordon-Smith 2006, 191, 402–403, no. 183, fig. 183 (in color).

105 · Alexis-Nicolas Pérignon the Elder
The Potager of the Hôtel de Valentinois

1. The history of the hôtel de Valentinois and Benjamin Franklin's stay there comes from Meredith Martindale's informative article on the subject; see Martindale 1977.

2. Dezallier d'Argenville 1772, 12 (translation by the present author).

3. In Eisler 1977 the drawing was catalogued as the work of Pérignon, but it has otherwise been qualified until now as "attributed to Pérignon" in all other publications and in the National Gallery's own records. In letters of 14 February and 21 April 1969, Jean Cailleux suggested an attribution to Louis-Nicolas van Blarenberghe (1716 or 1719–1794).

4. Inv. 32321–32330. The largest measures 123 × 357; the smallest measures 118 × 217. All are reproduced on the Louvre's website: http://arts-graphiques.louvre.fr/fo/visite?srv=rom.

5. See exh. cat. London 1977, no. 67. The Louvre owns two works by Pérignon executed in gouache on canvas, both measuring 535 × 770 (inv. 32316, 32317). Both are reproduced in color on the Louvre's website (see note 4, above).

6. Gouache, 210 × 286; reproduced in Martindale 1977, pl. v. From the poor color illustration, it appears to be somewhat damaged. For other views of the hôtel and its grounds, see Martindale 1977, pls. vi–x, and Martindale 1988, 160.

EXHIBITIONS
Washington 1983, 18; Washington 1990, 81.

LITERATURE
Eisler 1977, 345, no. dK379, fig. 309; Martindale 1983, page 157; Martindale 1988, 160; Tan Bunzl and Rothschild 1990, under no. 29.

106 · Louis-Gustave Taraval
Hexagonal Temple in an Italianate Landscape

1. The National Gallery owns two other drawings by Taraval: the one reproduced as fig. 1, and *Façade for a Church with a Sculpture Representing Faith* (inv. 1996.73.5), reproduced in Fuhring 1989, 2: no. 777.

2. The cataloguers at Sotheby's had apparently not noticed the inscription on the verso indicating Taraval's authorship.

3. Inv. D.1211; watercolor, 270 × 470. Reproduced in Lundberg 1972, 301, no. 1074, and in Bjurström 1982, no. 1203.

4. A few examples are known in which Taraval presents alternate solutions as two different halves of a single façade. See, for example, Berckenhagen 1970, no. 4867, reprod. p. 358 (*Alternative Designs for the Façade of a City Hall*).

5. This entrance is closely analogous in the arrangement of the specific architectural elements to another design for a church by Taraval (Institut Tessin, Paris; pen and black ink with gray wash, 213 × 202); reproduced in Lundberg 1972, 304, no. 1068.

107 · Étienne-Louis Boullée
Perspective View of the Interior of a Metropolitan Church

1. Boullée's text, which is preserved in the Bibliothèque nationale, Paris (Ms. 9153), was finally published in its entirety by Helen Rosenau in Rosenau 1953.

2. The project is discussed in Pérouse de Montclos 1969, 155–162, and in Pérouse de Montclos 1994, 114–125.

3. See Boullée's discussion of a "Monument designed for the celebration of Corpus-Christi," transcribed in Rosenau 1953, 39, 94.

4. Boullée in Rosenau 1953, 94.

5. See Helen Rosenau's introduction to Boullée's essay, in Rosenau 1953, 11–13.

6. Reproduced in Pérouse de Montclos 1994, 118–119, figs. 119, 120.

7. Reproduced in Pérouse de Montclos 1994, 123, fig. 123.

8. Similar clouds and angelic figures are included in two section drawings of the entire building, both in the Bibliothèque nationale, Paris (reproduced in Pérouse de Montclos 1994, 117, 124, figs. 118, 124).

9. Inv. Ha 55, pl. 11.

EXHIBITIONS

Amsterdam 1974, 26–27, 132–133, no. 19; Nice 1982, no. 230; Oberlin 1986, no. 19; Washington 1992, 3 (reprod.), 37–39, 46, no. 42; Washington 2000–2001, 196–197.

LITERATURE

Monnier et al. 1979, 140–141; Fuhring 1989, 2: no. 802; Pérouse de Montclos 1994, 123, 249–250, reprod. 125, fig. 126.

108 · Jean-Jacques de Boissieu
A Sunlit Landscape with Hilltop Houses

1. The most useful work on Boissieu is Pérez 1994, the revision with new commentary of the catalogue raisonné of the etchings written by Alphonse de Boissieu, the artist's grandson, in 1878. Many of the related drawings are reproduced.

2. See Pérez 1994.

3. Pen and gray ink with gray wash, 144 × 225; reproduced in Teeuwisse 2006, no. 12.

4. Inv. HZ 64; gray wash, 169 × 240. Reproduced in Cordellier et al. 2007, no. 225.

5. The Gallery also owns two other drawings by Boissieu: *A Country Road across an Ancient Bridge* (inv. 1989.41.1), brown wash over graphite, 189 × 251 (reproduced in Arnoldi-Livie 1989, no. 4b), and *A Farmyard* (inv. 1985.1.19), pen and brown and black ink with gray wash, 300 × 488 (unpublished).

EXHIBITIONS

Paris 2007, no. 14.

109 · Louis-Gabriel Moreau the Elder
Panoramic View across a Terraced Park

1. See Eisler 1977, 346.

2. For similar park scenes, see Wildenstein 1923, figs. 107–110, 112, 116, 118, 135, 138, 181, 190, 202. Some of the same compositional elements were also used by Moreau in his etchings; see Wildenstein 1923, figs. 253, 255, 259.

3. See Wildenstein 1923, 36. For some of the works by Moreau that include figures by Taunay, see Lebrun Jouve 2003, 408.

4. The Gallery owns three other gouaches by Moreau, all from the Kress collection: a pair of landscapes with farmhouses and a view in a park (inv. 1963.15.18–19, 1963.15.22). All are reproduced in Eisler 1977, figs. 313, 314, 322 (this last classified by Eisler as in the "manner of" Moreau, although it is certainly the artist's own work). One other drawing, also in the Kress collection (inv. 1963.15.21), has turned out to be a copy after a drawing that was sold at the Galerie Jean Charpentier, Paris, 14–15 December 1933, lot 65, pl. XIX (reproduced in Eisler 1977, fig. 316, where it was catalogued as by an imitator of Moreau).

EXHIBITIONS

Washington 1978a, 89; Washington 1990, 124, 127, 171, no. 79, reprod. 126.

LITERATURE

Eisler 1977, 346, no. dK385, fig. 315.

110 · Pierre-Adrien Pâris
Architectural Fantasy: Ruins of a Circular Temple Seen through a Natural Arch

1. Pâris organized his drawings by subjects in nine volumes, which he bequeathed to his native Besançon. They are now held in the Bibliothèque municipale, Besançon, Fonds Pâris, vols. 476–484.

2. See Lamers 1995, 73–77, 310–331, nos. 323–374.

3. For an inventory of the drawings by other artists in his collection, now in the Musée de Besançon, see Cornillot 1957.

4. For several drawings by Pâris related to theater productions, see exh. cat. Fontainebleau 2005–2006, nos. 118, 119, 124–130, 132, 133, 135–139, 141, 142, 144, 148–150.

5. The subject of views under bridges is discussed in Langner 1976 [1978]. For many examples by a variety of artists, see exh. cat. Rome and elsewhere 1976, nos. 14, 46, 58, 62, 63, 85, 124, 127, 129, 156, 172–174, 176, 184, 186, 191.

6. Reproduced in color in exh. cat. Fontainebleau 2005–2006, 182–183, no. 146.

111 · Adélaïde Labille-Guiard
A Fashionable Noblewoman Wearing a Plumed Hat

1. The standard catalogue raisonné, Passez 1973, lists 150 works, of which almost one-third are unlocated or are known only through old references.

2. Inv. 53.225.2; reproduced in Passez 1973, no. 62, pl. XLIX. For reproductions of other portraits by Labille-Guiard of women wearing striking hats (as opposed to fancy lace caps), see Passez 1973, nos. 52, 53, 63, 65, 91, 99.

3. See Passez 1973, no. 89.

4. See Hennequin 1932, 50. The portrait of the vicomtesse is one of 850 produced by the inventor of the physionotrace, Gilles-Louis Chrétien (1754–1811), and his associate Edme Quenedey (1756–1830) between July 1788 and August 1789, and its number in their catalogue (G 75) places it among the last works they produced.

5. The dealer's note on this pair of pastels mentions that they will be included with this identification in a supplement to Passez 1973, which has not yet been published. They were sold as the work of Simon-Bernard Lenoir (1729–1791) as portraits of unnamed sitters at Sotheby's, Monaco, 9 December 1984, lot 610.

EXHIBITIONS

Paris 1926, no. 56.

LITERATURE

Passez 1973, no. 89, pl. LXXII; Grasselli 2000a, 8; Jeffares 2006, 271.

112a–d · Jacques-Louis David
Roman Album No. 4: Italian Landscapes and Antiquities

1. Inv. 3692; reproduced on the French cultural website "Joconde" at http://www.culture.gouv.fr/documentation/joconde/fr/recherche/rech_libre.htm.

2. The origins, history, and importance of the twelve albums are addressed in detail in Rosenberg and Prat 2002, 1:391–406.

3. Albums 2 and 12 are currently lost. No. 1 (fragmentary and remounted) is in the Fogg Art Museum, Harvard University, Cambridge; no. 3 is in the Nationalmuseum, Stockholm; nos. 5, 7, and 9 are in the Musée du Louvre, Département des Arts graphiques, Paris; no. 8 is in the Morgan Library & Museum, New York; no. 11 is in the Getty Research Institute, J. Paul Getty Museum, Los Angeles; nos. 6 and 10 were disbound in 1978 and 1958, respectively, and the drawings were sold individually and are now widely dispersed. Two of the drawings from Album 6, for example, are in the collection of the National Gallery (inv. 1980.21.1 and 1980.21.2; reproduced in Rosenberg and Prat 2002, 1: nos. 682, 687); and two from Album 10 have been given with reserve of life interest by Cecily and Roy Langdale-Davis (reproduced in Rosenberg and Prat 2002, 1: nos. 1021, 1024). For a complete listing of the known drawings, see Rosenberg and Prat 2002, 1: nos. 452–1202 (excluding the contents of Album 5, which was only rediscovered in 2003 and was acquired by the Louvre in 2005, inv. RF 54299–54394).

4. See the discussion in Rosenberg and Prat 2002, volume 1, especially pages 393, 394, 397.

5. References to individual pages from *Roman Album No. 4* will here include both the new numbering added by the family as an ordinal number (e.g., 3rd page) followed by David's original number (e.g., folio 85).

6. Inv. 1998.105.1.i; graphite on greenish paper, 486 × 328 (dimensions of the entire album page); Rosenberg and Prat 2002, 1: no. 595.

7. The books were Gori 1731/1732, a catalogue of carved gems in the Medici collection, and the third volume of d'Hancarville 1766/1767, on the antiquities in the collection of Sir William Hamilton. The specific images traced in *Roman Album No. 4* are identified in Rosenberg and Prat 2002, 1: nos. 650–670.

8. Inv. 1998.105.1.000; pen and brown ink with gray wash on oiled paper, 240 × 500 (Rosenberg and Prat 2002, 1: no. 655).

9. Inv. 1998.105.1.ff; pen and black ink with gray wash over black chalk, 144 × 187 (Rosenberg and Prat 2002, 1: no. 620). Translation by this author.

10. Inv. 1998.105.1.nn; pen and black ink with gray wash over black chalk, 148 × 211 (Rosenberg and Prat 2002, 1: no. 628). This is a view of the church of San Michele sul Dosso in Milan with the canonica of Sant' Ambruogio in the distance at right.

11. See also *A Fortified Villa with a Stone Bridge* (inv. 1998.105.1.ss) on the 13th page, folio 230; pen and gray ink over black chalk on grayish paper, 165 × 215 (Rosenberg and Prat 2006, 1: no. 633; a detail showing the wash on the album page is reproduced on p. 400, fig. 13).

12. Inv. 730; Rosenberg and Prat 2002, 1: no. 30.

13. Inv. RF 5200; Rosenberg and Prat 2002, 1:146.

14. The painting by Mola is *The Martyrdom of Saints Abdon and Sennon*, Church of San Marco, Rome (reproduced in Rosenberg and Prat, 481, fig. 598a).

15. Inv. RF 71 and D 4852; Rosenberg and Prat 2002, 1: nos. 128, 129.

LITERATURE

(For the album): Rosenberg and Prat 2002, 1:392–394, figs. 2–5, 399, 400, fig. 13, 403–404, 477–507, nos. 589–670; (for cat. 112a): Rosenberg 2000, 39, fig. 42; Rosenberg and Prat 2002, 1: nos. 598–602; (for cat. 112b): Rosenberg and Prat 2002, 1: nos. 624–627; (for cat. 112c): Rosenberg and Prat 2002, 1: no. 636; (for cat. 112d): Rosenberg and Prat 2002, 1: no. 642.

113 · Jacques-Louis David
Thirius de Pautrizel

1. See, for example, the 1788 portrait, almost three meters in height, of *Antoine-Laurent Lavoisier and His Wife* (Metropolitan Museum of Art, New York, inv. 1977.10); reproduced in exh. cat. Paris and Versailles 1989–1990, no. 84.

2. See Rosenberg and Prat 2002, 1:164–173, nos. 147–155. The group of nine drawings is discussed on page 164.

3. Rosenberg and Prat 2002, 1: nos. 147–150. The phrase "in vinculis" is used in the inscription on the portrait of *Jean-Bon-Saint-André* in the Art Institute of Chicago (inv. 1973.153; Rosenberg and Prat 1: no. 148).

4. *Portrait of an Unidentified Man* (location unknown; Rosenberg and Prat 2002, 1: no. 147) was drawn in pen and black ink only, with some touches in pen and brown ink. An inscription on the back of the frame notes that this particular work was drawn in less than twenty minutes.

5. Rosenberg and Prat 2002 1:164.

6. Inv. 1973.153; Rosenberg and Prat 2002, 1: no. 148. The inscription on the mount reads, in part, *Donum amicitiae. Amoris solatium.* (Gift of friendship. Solace of love.).

7. These are the portraits of *Bernard de Saintes*, now in the J. Paul Getty Museum, Los Angeles (inv. 95.GB.37), and *Barbau du Barran* (private collection, New York). Both are reproduced in Rosenberg and Prat 2002, 1: nos. 150, 151.

EXHIBITIONS

Caracas 1957, no. 8; Charleroi 1957, no. 32; Los Angeles 1961, no. 61; Atlanta 1981, no. 1; Washington and elsewhere 1985–1987, no. 66; Paris and Versailles 1989–1990, no. 134.

LITERATURE

Sérullaz 1991, under no. 204; Lajer-Burcharth 1994, 226, 240 n. 15; Lajer-Burcharth 1999, 89, 92, fig. 42, 100–101, 103–104, 116; Rosenberg and Prat 2002, 1:170, no. 152.

114 · Jean-Baptiste Isabey
Hubert Robert

1. The quote comes from Isabey's own memoirs, portions of which were published by his nephew, Edmond Taigny, in the biography he wrote of his uncle in 1859. See Taigny 1859, 15; the same passage is quoted in Basily-Callimaki 1909, 14. Translation by this author.

2. See Taigny 1859, 13; Basily-Callimaki 1909, 9.

3. The two drawings in the Louvre are Inv. RF 3819 and RF 3823, respectively (reproductions available at http://arts-graphiques. louvre.fr/fo/visite?srv=rom); the Missouri drawing is inv. 73.12 (reproduced on the museum's website at http://maa.missouri.edu/collections/euro_american.html); the Orléans drawing is inv. 794 (reproduced in exh. cat. Orléans and Vevey 2006–2007, no. 61).

4. One unfinished version, drawn in graphite with stumping, is in the Musée des Beaux-Arts, Orléans (inv. 793; reproduced in exh. cat. Orléans and Vevey 2006–2007, no. 62); a second, much closer in appearance to the National Gallery drawing, is in the Minneapolis Institute of Arts (inv. 69.131; reproduced in exh. cat. Minneapolis and elsewhere 1968, no. 31); a third is owned by Roberta Olson and Alexander Johnson, New York (reproduced in color in exh. cat. New York 1999a, no. 97); a fourth, executed in pen and black ink, is in the Musée des Beaux-Arts André Malraux, Le Havre (inv. AD.71); and two others were auctioned at Drouot in Paris, the first on 11 June 1990, lot 58, as "attributed to Isabey," and the second, formerly in a Parisian private collection (reproduced in Cayeux 1985, 33), on 23 May 2000, lot 8.

5. Reproduced in exh. cat. New York 1999a, 224. fig. 97.1.

6. A portrait of Robert by Isabey "dessiné au pointillé" (drawn in stipple) is mentioned in the after-death inventory of Robert's widow. See Gabillot 1895, 252, no. 256.

7. Inv. 3055; reproduced in Cayeux 1985, 27, fig. 1. Also available in color through the French cultural website "Joconde": http://www.culture.gouv.fr/documentation/joconde/fr/recherche/rech_libre.htm.

EXHIBITIONS
London 2000, no. 4.

LITERATURE
Exh. cat. New York 1999a, 225, under no. 97.

115 · Jean-François-Pierre Peyron
Venus and the Graces Crowning Thémire

1. According to the eyewitness account of Toussaint-Bernard Emeric-David published in 1823; quoted in Rosenberg and Van de Sandt 1983, 46, 54.

2. Inv. Dess. III.10. All five are drawn in the same technique and on the same scale as the National Gallery drawing and are reproduced in Rosenberg and Van de Sandt 1983, figs. 134, 137–140.

3. The print is reproduced in Rosenberg and Van de Sandt 1983, fig. 136.

4. Translations by this author. The complete text, in French, of *Le temple de Gnide* is available online at Project Guttenberg: http://www.gutenberg.org/files/24260/24260-8.txt.

LITERATURE
Rosenberg and Van de Sandt 1983, 138, no. 147.3 (mentioning the drawing as lost).

116 · Jean-Baptiste Mallet
An Ancient Well with a Peasant Family and Their Animals

1. Mallet was the subject of a monographic exhibition, Grasse 2004, organized by Andrea Zanella, but his work has otherwise been discussed only within the context of books and exhibitions on more general themes. See, for example, Guth 1957, 28–33; Burollet 1980, nos. 162–169; exh. cat. Paris and elsewhere 1984–1985, 538–541; and Roland Michel 1987a, 42, fig. 27.

2. Several drawings by Lavreince are reproduced in Burollet 1980, nos. 150–158.

3. Among the scenes of this type are *The Baptism* (private collection; reproduced in color in exh. cat. Grasse 2004, 49); *The Farmer's Family* (Musée Cognacq-Jay, Paris; reproduced in Burollet 1980, no. 168); and *The Morning Toilette* (location unknown; reproduced in Guth 1957, 31).

4. Gouache, 313 × 392; reproduced in color in exh. cat. Grasse 2004, 47. The work is not dated, nor is a date suggested by Andrea Zanella, but its placement in the catalogue, which is arranged chronologically, would suggest a date of about 1795.

5. *A Surprised Bacchante*, formerly in the collection of Baron Portalis, was sold at Drouot, Paris, 2–3 February 1911, lot 146. *Nymphs Bathing* was sold at Galerie Charpentier, Paris, 1 June 1949, lot 30. Both are reproduced in the sale catalogues.

117 · Jean-Baptiste Hüet
Market Scene with a Fantastic Sculpture

1. During a visit in April 1999, Laure Hug noted that Hüet made a painting of the Washington composition, but with significant changes at left and in the setting (Musée d'Agesci, Niort, France; inv. M.N.R. 80); inventoried in Compin and Rouquebert 1986, 277 (not reproduced).

2. See, for example, exh. cat. Washington 2003–2004, nos. 24–26. No comprehensive monograph on Hüet has yet been published. Laure Hug is the primary authority on his work and has published articles on different aspects of his production. See Hug 1997 and Hug 2002.

3. On this subject, see Hug 2002 and Clouzot 1927.

4. See, for example, *Bulldog, Donkey, and Sheep* in the Musée des Beaux-Arts, Lyon (pen and watercolor, 305 × 230; reproduced in Corpus Gernsheim, no. 6074); and *Farmyard Scene* in the Biblioteca Reale, Turin (inv. 16336l; pen and watercolor heightened with white, 398 × 297; reproduced in Corpus Gernsheim, no. 153736).

5. Hüet made a number of very fine watercolor studies of vegetables, including *Two Gourds* in the Ashmolean Museum, Oxford (inv. 1942.25; watercolor and gouache, 253 × 384; reproduced in Whiteley 2000, no. 740, fig. 740); and *Studies of Corn and Wheat* in the Morgan Library & Museum, New York (inv. 1992.2; watercolor with touches of gouache over black chalk, 254 × 401; reproduced in exh. cat. Paris and New York 1993–1994, no. 85). The National Gallery owns several red chalk studies of plants and grasses by Hüet (inv. 1987.57.1–5).

6. Alastair Laing pointed out, in a visit during the summer of 1989, that Hüet made a study of a closely similar monument, but with some differences in the base and with an obelisk instead of a pillar surmounted by a sphere, in a drawing at Waddesdon Manor in England (inv. 1281; pen and brown ink with brown wash over graphite, 179 × 115); reproduced in color in exh. cat. London and Nottingham 2007–2008, no. 26, and in black and white in Laing et al. 2006, no. 186.

EXHIBITIONS
New York 1983, no. 8.

LITERATURE
Laing et al. 2006, 254, under no. 186; exh. cat. London and Nottingham 2007–2008, 78, fig. 20.

OPPERMAN 1988
Opperman, Hal N. Review of Washington and elsewhere 1984–1985. *Art Bulletin* 70, no. 2 (June 1988): 354–359.

OVID [TRANS. HUMPHRIES] 1958
Ovidius Naso, Publius. *Metamorphoses*. Translated by Rolfe Humphries. Bloomington, Ind., 1958.

PACE 1981
Pace, Claire. *Félibien's Life of Poussin*. London, 1981.

PAPILLON DE LA FERTÉ 1776
Papillon de La Ferté, Denis-Pierre. *Extrait des différents ouvrages publiés sur la vie des peintres*. 2 vols. Paris, 1776. Facsimile edition, Geneva, 1972.

PARFAICT 1767
Parfaict, François and Claude. *Dictionnaire des théâtres de Paris*. 7 vols. Paris, 1767.

PARISET 1965 [1966]
Pariset, François-Georges. "De Bellange à Deruet." *Bulletin de la Société de l'Histoire de l'Art Français, Année 1965* (1966): 61–73.

PARKER 1930
Parker, Karl T. "Critical Catalogue, with Illustrations, of the Drawings of Watteau in the British Museum." *Old Master Drawings* 5, no. 7 (June 1930): 2–28.

PARKER 1931
Parker, Karl T. *The Drawings of Antoine Watteau*. London, 1931.

PARKER 1932
Parker, Karl T. "Mercier, Angélis and De Bar." *Old Master Drawings* 7, no. 27 (December 1932): 36–40.

PARKER 1933–1934
Parker, Karl T. "An Etching and a Drawing by Antoine Watteau." *British Museum Quarterly* 8 (1933–1934): 1–3.

PARKER AND MATHEY 1957
Parker, Karl T., and Jacques Mathey. *Antoine Watteau, catalogue complet de son oeuvre dessiné*. 2 vols. Paris, 1957.

PARRONCHI 1969
Parronchi, Alessandro. "Une tête de satyre de Cellini." *Revue de l'Art* 5 (1969): 43–45.

PASSEZ 1973
Passez, Anne Marie. *Adélaïde Labille-Guiard, 1749-1803, biographie et catalogue raisonné de son oeuvre*. Paris, 1973.

PÉREZ 1994
Pérez, Marie-Félicie. *L'oeuvre gravé de Jean-Jacques de Boissieu, 1736-1810*. Geneva, 1994.

PÉROUSE DE MONTCLOS 1969
Pérouse de Montclos, Jean-Marie. *Étienne-Louis Boullée (1728–1799): De l'architecture classique à l'architecture révolutionnaire*. Paris, 1969.

PÉROUSE DE MONTCLOS 1994
Pérouse de Montclos, Jean-Marie. *Étienne-Louis Boullée*. Paris, 1994.

PERRIG 1977
Perrig, Alexander. *Die "Michelangelo"-Zeichnungen Benvenuto Cellinis*. Frankfurt, 1977.

PETITJEAN AND WICKERT 1925
Petitjean, Charles, and Charles Wickert. *Catalogue de l'oeuvre gravé de Robert Nanteuil*. 2 vols. Paris, 1925.

PEVSNER 1940
Pevsner, Nikolaus. *Academies of Art: Past and Present*. Cambridge, England, 1940. Reprint with a new preface by the author, New York, 1973.

PILES 1715
Piles, Roger de. *Abrégé de la vie des peintres, avec des reflexions sur leurs ouvrages, et un traité du peintre parfait; de la connoissance des desseins; de l'utilité des estampes*. Paris, 1715.

PLINY [TRANS. RACKHAM] 1940–1963
Pliny the Elder. *Natural History with an English Translation in Ten Volumes*. Translated by Harris Rackham. London and Cambridge, Mass., 1940–1963.

POESCHKE 1992
Poeschke, Joachim. *Die Skulptur der Renaissance in Italien, 2: Michelangelo und seine Zeit*. Munich, 1992.

POESCHKE 1996
Poeschke, Joachim. *Michelangelo and His World: Sculpture of the Italian Renaissance*. New York, 1996 (translation of 1992 edition in German).

POPE-HENNESSY 1982
Pope-Hennessy, John. "A Bronze Satyr by Cellini." *Burlington Magazine* 124, no. 952 (July 1982): 406–412.

POPE-HENNESSY 1985
Pope-Hennessy, John. *Cellini*. New York, 1985.

POPULUS 1930
Populus, Bernard. *Claude Gillot (1673-1722): Catalogue de l'oeuvre gravé*. Paris, 1930.

PORTALIS 1877
Portalis, Baron Roger de. *Les dessinateurs d'illustrations au dix-huitième siècle*. 2 parts in 4 vols. Paris, 1877.

PORTALIS 1889
Portalis, Baron Roger de. *Honoré Fragonard: Sa vie et son oeuvre*. 2 vols. Paris, 1889.

PORTALIS AND BÉRALDI 1880–1882
Portalis, Baron Roger de, and Henri Béraldi. *Les graveurs du dix-huitième siècle*. 3 vols. in 6. Paris, 1880–1882.

POSNER 1984
Posner, Donald. *Antoine Watteau*. London and Ithaca, 1984.

PRÉAUD 2002
Préaud, Maxime. "L'inventaire après décès de Jean Iᵉʳ Leblond (vers 1590–1666), peintre et éditeur d'estampes." *Nouvelles de l'Estampe*, no. 182 (May–July 2002): 19–37.

RADCLIFFE 1988
Radcliffe, Anthony. Review of Pope-Hennessy 1985. *Burlington Magazine* 130, no. 1029 (December 1988): 929–932.

RATOUIS DE LIMAY 1946
Ratouis de Limay, Paul. *Le pastel en France au XVIIIème siècle*. Paris, 1946.

RAUX 1992
Raux, Sophie. "Les dessins de Lancret au Musée des Beaux-Arts de Lille: Une mise au point sur les récentes attributions." *Revue du Nord* 74, nos. 297–298 (July–December 1992): 647–662.

RAUX 1995
Raux, Sophie. *Catalogue des dessins français du XVIIIe siècle, de Claude Gillot à Hubert Robert, Palais des Beaux-Arts, Lille*. Lille, 1995.

RAY 1982
Ray, Gordon Norton. *Art of the French Illustrated Book, 1700 to 1914*. 2 vols. New York, 1982.

RÉAU 1928
Réau, Louis. "Watteau." In *Peintres français du XVIIIe siècle*, edited by Louis Dimier, 1–60. Paris and Brussels, 1928.

RÉAU 1956
Réau, Louis. *Fragonard*. Brussels, 1956.

REINACH 1897–1910
Reinach, Solomon. *Répertoire de la statuaire grecque et romaine*. 4 vols. in 5. Paris, 1897–1910.

REYNOLDS [ED. WARK] 1997
Reynolds, Sir Joshua. *Discourses on Art*. 1797. Reprint, edited by Robert Wark. New Haven and London, 1997.

RICCI 1923a
Ricci, Seymour de. *The Roederer Library of French Books, Prints, and Drawings of the Eighteenth Century*. Philadelphia, 1923 [n.p.].

RICCI 1923b
Ricci, Seymour de. *A Check-List of the More Important French Illustrated Books of the Eighteenth Century*. Philadelphia, 1923.

RIPA AND BAUDOIN 1644
Ripa, Cesare, and Jean Baudoin. *Iconologie, ou, Explication novvelle de plvsievrs images, emblèmes, et avtres figvres Hyeroglifiques des Vertus, des Vices, des Arts, des Sciences, des Causes naturelles, des Humeurs differents, & des Passions humaines*. 2 parts. Paris, 1644 (a facsimile included as vol. 2 of Bar and Brême 1999).

RIVERS 1913
Rivers, John. *Greuze and His Models*. London and New York, 1913.

ROBERT-DUMESNIL 1835–1871
Robert-Dumesnil, A.-P.-F. *Le peintre-graveur français, ou catalogue raisonné des estampes gravées par les peintres et les dessinateurs de l'école française*. 11 vols. Paris, 1835–1871. Facsimile edition, Paris, 1967.

ROBISON 2000
Robison, Andrew. "A National Collection of Master Drawings." *Master Drawings* 38, no. 3 (Fall 2000): 293–302.

ROCHETTE 2000
Rochette, Christelle. *Jean-Baptiste Greuze (1725–1805) et les collections du musée Greuze de Tournus*. Tournus, 2000.

ROETHLISBERGER 1961a
Roethlisberger, Marcel. *Claude Lorrain: The Paintings*. 2 vols. New Haven, 1961. Reprint, New York, 1979.

ROETHLISBERGER 1961b
Roethlisberger, Marcel. "Drawings by Claude Lorrain in American Museums." *Art Quarterly*, 24, no. 4 (Winter 1961): 346–355.

ROETHLISBERGER 1962
Roethlisberger, Marcel. *Claude Lorrain: The Wildenstein Album*. Paris, 1962.

ROETHLISBERGER 1968
Roethlisberger, Marcel. *Claude Lorrain: The Drawings*. 2 vols. Berkeley and Los Angeles 1968.

ROETHLISBERGER 1973a
Roethlisberger, Marcel. "Neun Zeichnungen von Claude Lorrain." *Du* 33 (1973): 508–517.

ROETHLISBERGER 1973b
Roethlisberger, Marcel. "A Painting by Claude." *Burlington Magazine* 115, no. 847 (October 1973): 652–657.

ROETHLISBERGER 1979
Roethlisberger, Marcel. "Additional Works by Goffredo Wals and Claude Lorrain." *Burlington Magazine* 121, no. 910 (January 1979): 20–28.

ROLAND MICHEL 1984
Roland Michel, Marianne. *Watteau: Un artiste au XVIIIe siècle*. Paris and London, 1984.

ROLAND MICHEL 1987a
Roland Michel, Marianne. *Le dessin français au XVIIIe siècle*. Fribourg, 1987.

ROLAND MICHEL 1987b
Roland Michel, Marianne. "Watteau et les *Figures de différents caractères*." In Moureau and Grasselli 1987, 117–127.

ROMAN 1919
Roman, Joseph Hippolyte. *Le Livre de Raison du peintre Hyacinthe Rigaud*. Paris, 1919.

ROSASCO 1980
Rosasco, Betsy. "Notes on Two Gabriel de Saint-Aubin Drawings and the Statues They Depict." *Studies in the History of Art* 9 (1980): 51–57.

ROSENAU 1953
Rosenau, Helen, ed. *Boullée's Treatise on Architecture: A Complete Presentation of the "Architecture, Essai sur l'art," which Forms Part of the Boullée Papers (Ms. 9153) in the Bibliothèque nationale, Paris*. London, 1953.

ROSENBERG 1970
Rosenberg, Pierre. *Il seicento francese. I disegni dei maestri*. Milan, 1970.

ROSENBERG 1984
Rosenberg, Pierre, ed. *Vies anciennes de Watteau*. Paris, 1984.

ROSENBERG 1990
Rosenberg, Pierre. Review of Cleveland and elsewhere 1989–1990. *Master Drawings* 28, no. 4 (Winter 1990): 432–433.

ROSENBERG 2000
Rosenberg, Pierre. *From Drawing to Painting: Poussin, Watteau, Fragonard, David, and Ingres*. The A. W. Mellon Lectures in the Fine Arts, 1996, Series XXI. Princeton, 2000.

ROSENBERG 2002
Rosenberg, Pierre. *Le livre des Saint-Aubin*. Collection Solo, no. 22. Paris, 2002.

ROSENBERG AND PRAT 1994
Rosenberg, Pierre, and Louis-Antoine Prat. *Nicolas Poussin, 1594–1665: Catalogue raisonné des dessins*. 2 vols. Milan, 1994.

ROSENBERG AND PRAT 1996
Rosenberg, Pierre, and Louis-Antoine Prat. *Antoine Watteau, 1684–1721: Catalogue raisonné des dessins*. 3 vols. Milan, 1996.

ROSENBERG AND PRAT 2002
Rosenberg, Pierre, and Louis-Antoine Prat. *Jacques-Louis David, 1748–1825: Catalogue raisonné des dessins.* 2 vols. Milan, 2002.

ROSENBERG AND THUILLIER [1985]
Rosenberg, Pierre, and Jacques Thuillier. *Laurent de La Hyre, 1606–1656.* Cahiers du dessin français, no. 1. Paris, [1985].

ROSENBERG AND VAN DE SANDT 1983
Rosenberg, Pierre, and Udolpho van de Sandt. *Pierre Peyron, 1744–1814.* Neuilly-sur-Seine, 1983.

ROSENFELD 1992
Rosenfeld, Nan. "La culture de Largillière." *Revue de l'Art,* no. 98 (1992): 44–53.

SALMON [1996]
Salmon, Xavier. *Jacques-André Portail, 1695-1759.* Cahiers du dessin français, no. 10. Paris, [1996].

SANDOZ 1977
Sandoz, Marc. *Jean-Baptiste Deshays, 1729–1765.* Paris, 1977.

SANI 1988
Sani, Bernardina. *Rosalba Carriera.* Turin, 1988.

SAXL 1942
Saxl, Fritz. "A Spiritual Encyclopedia of the Later Middle Ages." *Journal of the Warburg and Courtauld Institutes* 5 (1942) 82–134.

SCALINI 1995
Scalini, Mario. *Benvenuto Cellini.* Library of Great Masters. New York, 1995.

SCARRON 1700
Scarron, Paul. *The Whole Comical Works of Monsr. Scarron.* London, 1700. Facsimile edition with an introduction by Josephine Grieder, New York, 1973.

SCHAB [1964]
William H. Schab Gallery. *A Distinguished Collection of Important Original Etchings, Engravings and Woodcuts by Great Old Masters; Etchings, Lithographs, and Woodcuts by Modern Masters; and Drawings by Great Old and Modern Masters.* Catalogue 36. New York, n.d. [probably 1964].

SCHAB [1968]
William H. Schab Gallery. *Old Master Prints and Drawings of the 16th to 18th Centuries from Distinguished Collections.* Catalogue 42. New York, n.d. [probably 1968].

SCHAB [1972]
William H. Schab Gallery. *Master Prints and Drawings from the Fifteenth to the Twentieth Centuries.* Catalogue 52. New York, n.d. [probably 1972].

SCHAB [1985]
William H. Schab Gallery. *Master Prints and Drawings of Five Centuries.* Catalogue 67. New York, n.d. [probably 1985].

SCHMID 1931
Schmid, Heinrich Alfred, ed. *Erasmi Roterodami Encomium moriae, i.e., Stultitiae laus/Praise of Folly, published at Basle in 1515 and decorated with the marginal drawings of Hans Holbein the Younger now reproduced in facsimile.* Translated by Helen H. Tanzer. 2 vols. Basel, 1931.

SCHNAPPER 1967
Schnapper, Antoine. *Tableaux pour le Trianon de marbre, 1688–1714.* Paris and The Hague, 1967.

SCHNAPPER AND GUICHARNAUD [1986]
Schnapper, Antoine, and Hélène Guicharnaud. *Louis de Boullogne, 1654–1733.* Cahiers du dessin français, no. 2. Paris, [1986].

SERÉVILLE AND SAINT SIMON [1976]
Seréville, Étienne de, and Fernand de Saint Simon. *Dictionnaire de la noblesse française.* Paris, n.d [1976].

SÉRULLAZ 1991
Sérullaz, Arlette. *Musée du Louvre, Cabinet des dessins. Inventaire général des dessins: École française, dessins de Jacques-Louis David, 1748–1825.* Paris, 1991.

SEZNEC AND ADHÉMAR 1957–1967
Seznec, Jean, and Jean Adhémar, eds. *Diderot salons.* 4 vols. Oxford, 1957–1967.

SHARP AND OPPÉ 1924
Sharp, Cecil J., and Adolf Paul Oppé. *The Dance: An Historical Survey of Dancing in Europe.* London, 1924.

SHEARMAN 1960
Shearman, John. "Les dessins de paysages de Poussin." In *Actes du Colloque Nicolas Poussin,* edited by André Chastel, 1:179–188. 2 vols. Paris, 1960.

SHERIFF 1990
Sheriff, Mary. *Fragonard: Art and Eroticism.* Chicago, 1990.

SHOOLMAN AND SLATKIN 1950
Shoolman, Regina, and Charles Slatkin. *Six Centuries of French Master Drawings in America.* Oxford and New York, 1950.

SLATKIN 1967
Slatkin, Regina Shoolman. Review of Ananoff 1966. *Master Drawings* 5, no. 1 (Spring 1967): 54–66.

SOUCHAL 1967
Souchal, François. *Les Slotdtz, sculpteurs et décorateurs du roi (1685–1764).* Paris, 1967.

STARCKY 1988
Starcky, Laure C. *Paris, Mobilier national: Dessins de Van der Meulen et de son atelier.* Inventaire des collections publiques françaises, 33. Paris, 1988.

STEIN 1912
Stein, Henri. *Augustin Pajou.* Paris, 1912.

STERLING 1932
Sterling, Charles. "Boucher et les O'Murphy." *L'Amour de l'Art* 13, no. 6 (June 1932): 191–194.

STUFFMANN 1964
Stuffmann, Margret. "Charles de La Fosse et sa position dans la peinture française à la fin du XVIIe siècle." *Gazette des Beaux-Arts* 64 (July 1964): 1–121.

SUTTON 1949
Sutton, Denys. *French Drawings of the 18th Century.* London, 1949.

SUTTON 1985
Sutton, Denys. "Antoine Watteau: Enigmatic Ironist." *Apollo* 121, no. 277 (March 1985): 146–156.

TAIGNY 1859
Taigny, Edmond. *J.-B. Isabey: Sa vie et ses oeuvres.* Paris, 1859 (printed as a separate extract from *La Revue Européenne*).

TAN BUNZL AND ROTHSCHILD 1990
Tan Bunzl, Yvonne, and Kate de Rothschild. *Master Drawings.* London, 1990.

TEEUWISSE 2006
Teeuwisse, Nicolaas. *Ausgewählte Handzeichnungen/Selected Drawings II.* Berlin, 2006.

TERNOIS 1962a
Ternois, Daniel. *Jacques Callot: Catalogue complet de son oeuvre dessiné.* Paris, 1962.

TERNOIS 1962b
Ternois, Daniel. *L'art de Jacques Callot.* Paris, 1962.

TERNOIS 1973
Ternois, Daniel. "Callot et son temps: Dix ans de recherches (1962–1972)." *Le Pays Lorrain* 54, no. 4 (1973): 211–248.

TERNOIS 1992
Ternois, Daniel. "Dessins de Jacques Callot: Quelques attributions récentes et leurs enseignements—ses méthodes de travail, son atelier, ses continuateurs." In *Actes du Colloque Jacques Callot (1592-1635),* 357–422. Paris and Nancy 1992.

TERNOIS 1999
Ternois, Daniel. *Jacques Callot: Catalogue de son oeuvre dessiné. Supplément (1962–1998).* Paris, 1999.

TERVARENT 1958
Tervarent, Guy de. *Attributs et symbols dans l'Art profane, 1450–1600: Dictionnaire d'un langage perdu.* Geneva, 1958.

THOMAS 1959
Thomas, Bruno. "Die Münchner Harnischvorzeichnungen im Stil François Ier." *Jahrbuch der kunsthistorischen Sammlungen in Wien* 55 (1959): 31–74.

THOMAS 1960
Thomas, Bruno. "Die Harnischvorzeichnungen des Étienne Delaune für die Emblem- und die Schlangen-Garnitur Heinrichs II. von Frankreich." *Jahrbuch der kunsthistorischen Sammlungen in Wien* 56 (1960): 7–62.

THOMAS 1962
Thomas, Bruno. "Die Münchner Waffenvorzeichnungen des Étienne Delaune und die Prunkschilde Heinrichs II. von Frankreich." *Jahrbuch der kunsthistorischen Sammlungen in Wien* 58 (1962): 101–168.

THOMAS 1965
Thomas, Bruno. "Die Münchner Harnischvorzeichnungen mit Rankendekor des Étienne Delaune." *Jahrbuch der kunsthistorischen Sammlungen in Wien* 61 (1965): 41–90.

THUILLIER 2006
Thuillier, Jacques. *Jacques Stella, 1596–1657.* Metz, 2006.

TOMLINSON 1987
Tomlinson, Robert. "Fête galante et/ou foraine? Watteau et le théâtre." In Moureau and Grasselli 1987, 203–211.

TONKOVICH 2002
Tonkovich, Jennifer. "Claude Gillot and the Theater, with a Catalogue of Drawings." 3 vols. Ph.D. dissertation, Rutgers, State University of New Jersey, 2002.

TONKOVICH 2006
Tonkovich, Jennifer. "A New Album of Theater Drawings by Claude Gillot." *Master Drawings* 44, no. 4 (Winter 2006): 464–486.

TOURNEUX 1904
Tourneux, Maurice. "La collection Jacques Doucet: Pastels et dessins." *Les Arts* 36 (December 1904): 2–28.

TURNER 2000
Turner, Nicholas. *Federico Barocci.* Paris, 2000.

VAILLAT AND RATOUIS DE LIMAY 1923
Vaillat, Léandre, and Paul Ratouis de Limay. *J.-B. Perronneau (1715–1783): Sa vie et son oeuvre.* Paris, 1923.

VALLÉRY-RADOT 1964
Valléry-Radot, Jean. *French Drawings: Fifteenth Century through Géricault.* New York, 1964.

VALOGNE 1955
Valogne, C. "Fragonard, mon grand-père, par Théophile Fragonard." *Les Lettres Françaises,* 17 February 1955, 1, 7, 9.

VASARI [TRANS. DE VERE] 1979
Vasari, Giorgio. *Lives of the Most Eminent Painters, Sculptors, and Architects.* Translated by Gaston Du C. de Vere, with an introduction by Kenneth Clark. 3 vols. New York, 1979.

VERONESE [ED. SPARACELLO] 2006
Carlo Antonio Veronese, Théâtre. Edited by Giovanna Sparacello. Les savoirs des acteurs italiens, collection directed by Andrea Fabiano, 2006. Available online at http://www.irpmf.cnrs.fr/Savoirsitaliens/Carlo%20Antonio%20Veronese.pdf.

VILAIN 1979
Vilain, Jacques. "Nantes. Musée Thomas-Dobrée: Dessins de l'époque néo-classique." *La Revue du Louvre et des Musées de France* 29, nos. 5–6 (1979): 464–470.

VIRGIL [TRANS. FAIRCLOUGH] 1942
Virgil. Translated by H. Rushton Fairclough. Harvard Classics. 2 vols. Cambridge, Mass., 1942.

VITZTHUM 1966
Vitzthum, Walter. Review of New York 1965–1966. *Burlington Magazine* 108, no. 755 (February 1966): 109–110.

VITZTHUM 1970
Vitzthum, Walter. "Drawings from the Collection of Julius Held." *Burlington Magazine* 112, no. 809 (August 1970): 554.

VOLTAIRE [1877–1885 ED.]
Oeuvres complètes de Voltaire. 52 vols. Paris, 1877–1885.

WALCH 1971
Walch, Nicole. *Die Radierungen des Jacques Bellange: Chronologie und kritischer Katalog.* Munich, 1971.

WALKER 1984
Walker, John. *National Gallery of Art, Washington.* New York, 1984.

WALLACE COLLECTION 1968
Wallace Collection Catalogues: Pictures and Drawings. 16th ed. Edited by Francis J. B. Watson. London, 1968.

WARD-JACKSON 1979–1980
Ward-Jackson, Peter. *Italian Drawings.* 2 vols. Victoria and Albert Museum Catalogues. London, 1979–1980.

List of Artists